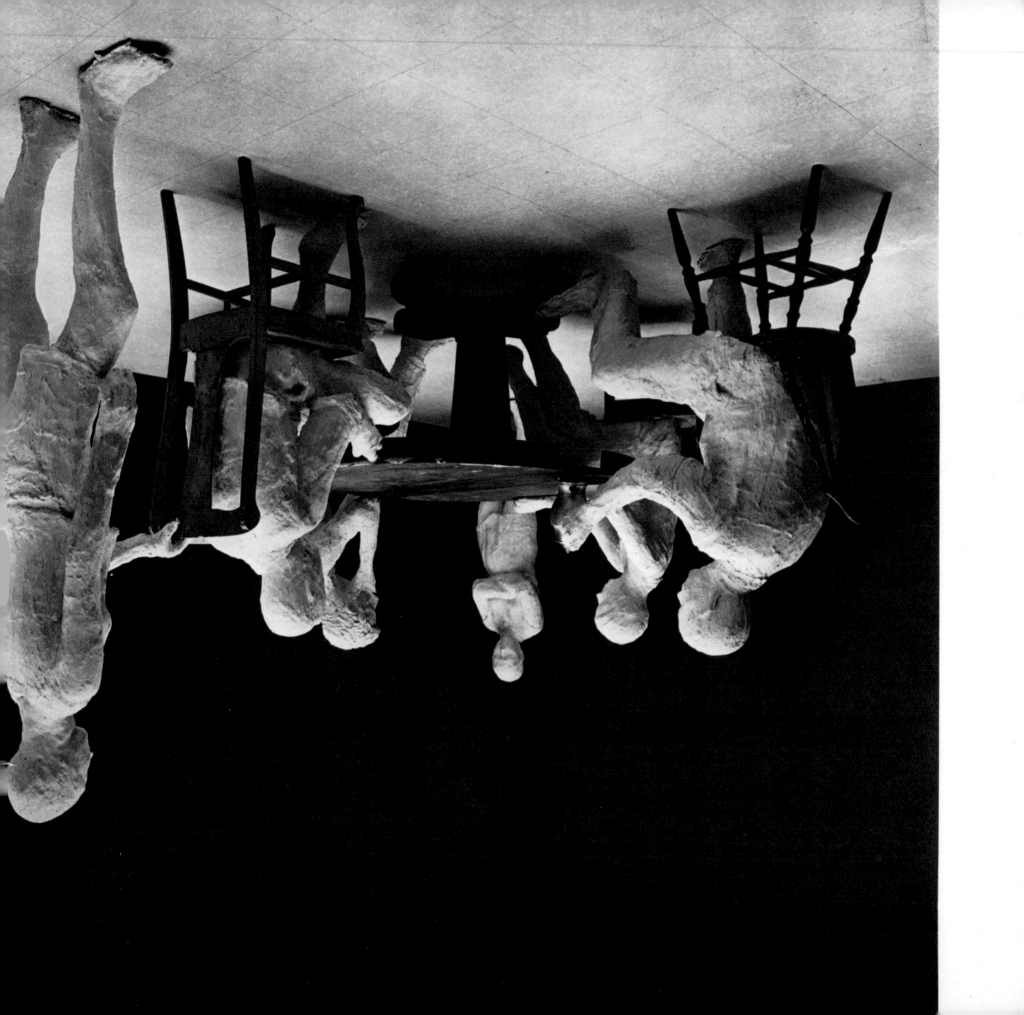

GEORGE SEGAL

1. *The Dinner Table.* 1962.
 Plaster, wood, metal, and mirror,
 6' × 10' × 10'.
 Schweber Electronics, Westbury, N.Y.
 (See plate 18 for commentary.)

GEORGE

JAN VAN DER MARCK

SEGAL

HARRY N. ABRAMS, INC., PUBLISHERS, NEW YORK

FOR INGEBORG

Nai Y. Chang, *Vice-President, Design and Production*
John L. Hochmann, *Executive Editor*
Margaret L. Kaplan, *Managing Editor*
Barbara Lyons, *Director, Photo Department, Rights and Reproductions*
Bitita Vinklers, *Editor*
Deirdre Silberstein, *Picture Editor*
Wei-Wen Chang, *Designer*

Library of Congress Cataloging in Publication Data
Segal, George, 1924-
 The sculpture of George Segal.
 Bibliography: p.
 1. Segal, George, 1924- I. Van der Marck,
Jan, 1929- II. Title.
NB237.S44V36 730′.92′4 74-13110
ISBN 0-8109-0488-8

Library of Congress Catalogue Card Number: 72-3235
Published by Harry N. Abrams, Incorporated, New York, 1975
Printed and bound in Japan

I thank George and Helen Segal for their friendship, patience, and cooperation. To me, their home in South Brunswick has been a haven for many years. Innumerable hours, in the last few years, were spent discussing the contents of this book. George Segal submitted to long taping sessions and allowed me to quote him in these pages. I can truly say that for me this book has been an education equal to the inspiration the sculpture provided.

For obtaining information on the whereabouts of the sculpture, photographs, and biographical and bibliographical data, I am greatly indebted to the Sidney Janis Gallery and Mr. Manuel Gonzalez, who helped me beyond the call of duty.

Ms. Nancy R. Reinish lent indispensable skills to the editing and typing of the manuscript.

Jan van der Marck

CONTENTS

LIST OF PLATES

Colorplates are marked with an asterisk.

1. The Dinner Table. 1962

*2. Untitled. 1957

*3. Untitled. 1957

*4. Untitled. 1957

*5. Untitled. 1958

*6. Lot and His Daughters. 1958

*7. Untitled. 1968–70

*8. Untitled. 1968–70

GEORGE SEGAL

I count heavily on the human ability to spot metaphor. The urge to read poetry into things is universal.

GEORGE SEGAL

It was the spring of 1962. Abstract Expressionism and its issues had lost their sharp focus, but the eminence of its practitioners was as yet uncontested. Jasper Johns and Robert Rauschenberg were, by all odds, the most interesting painters. Duchamp's presence, Cage's teaching, and Motherwell's anthology, a veritable Trojan horse, had set the scene afire with Dada. The underground produced and attended Happenings. "The Art of Assemblage" at The Museum of Modern Art had caused a run on hardware stores. Without a welding torch one was not fit to be a sculptor. But there were rumors that the figure was making a comeback in some quarters. At the Green Gallery, George Segal, a refugee from the Hansa, showed plaster casts said to be modeled on live bodies.

It is not surprising that Segal's sculpture posed perceptual problems and raised intellectual questions in 1962. But we may well ask why, numerous evaluations and interpretations notwithstanding, in the years since then no coherent attempt at formal analysis has been made and no conclusive suggestions have been offered as to what stylistic trend or grouping the artist belongs to.

Critics have noticed the art-versus-life dialectic in Segal's sculpture. They have placed him in the context of Happenings and have classified him as an assemblagist. Duchamp and the ready-made have been standard points of reference, making Segal more Dada than seems warranted. Of course, the influence of Abstract Expressionism has been duly acknowledged and the teachings of Hans Hofmann have been seldom overlooked. But at this point most critics have settled for standby definitions.

It has been customary to accept the notion that Segal is a Pop artist and therefore belongs in every treatise or discussion of that subject. But then, it is argued that Segal is not *really* a Pop artist, that his work is either more important or too subtle for inclusion in that category; consequently, the issue is quickly settled with one paragraph and one picture, consigning it, in effect, to footnote or appendix status. No attempt has been made to transfer Segal to another chapter or category and there to deal with the work exhaustively.

It is difficult to resist dealing with some of the fashionable clichés in the Segal literature. Lucy R. Lippard, in a specialized context, characterizes Segal as a "twentieth-century genre artist, concerned with simple everyday activities

that bring out a generalized humanity."[1] Another reference to genre can be read, implicitly, in an article by Robert Pincus-Witten, who calls Segal "the wholly unanticipated heir of Edward Hopper."[2] Comparisons with Hopper were also made, as early as 1965, by William C. Seitz and Mario Amaya. Whatever the validity of this comparison—and I believe it to be slight—Segal's similarity to Hopper has been noted at least half a dozen times.

The artist's friendship with Allan Kaprow, his marginal involvement with the art form Kaprow pioneered, and the environmental and figurative aspects of his sculpture have all prompted comparison with Happenings. It has therefore become customary to use the term "frozen happening" in referring to Segal's more crowded tableaux. Irving Sandler coined it;[3] Lucy R. Lippard gave it currency. The Segal literature has reverberated with it ever since.

In general, the plaster figures have been given a great deal of attention whereas their complements, the props that define and the space that surrounds them, have been treated perfunctorily or not at all. That, in fact, may account for most critics' exclusive consideration of the communicative character of Segal's art at the expense of recognizing formal ambitions that should be equally obvious. A critically more developed understanding of Claes Oldenburg, Roy Lichtenstein, James Rosenquist, or Andy Warhol has left no doubt as to the preeminence, in their work, of formal innovation over novelty of content. It has helped to invalidate whatever usefulness and credibility adhered to Pop Art as a stylistic label. Segal, in his work, confirms with equal eloquence that form rules content and is, itself, a function of the artist's expressive intentions.

He cannot be denied consideration in terms of abstract art: he claims to be primarily interested in aesthetic statement and has said that the one thing he insists on is the attainment of abstract form—"for its power to move us is paramount." This study, which takes all of Segal's sculptures from 1961 to 1972 into account, attempts to correct an imprecise, incomplete, or partial interpretation of the artist's accomplishments and intentions which, until now, has kept him undeservedly ensconced in an art-historical limbo.

II

When Henry Geldzahler asked George Segal, in a 1964 interview, "What caused you to move from painting into sculpture?" Segal had this unequivocal answer: "My dissatisfaction with all the modes of painting that I had been taught that couldn't express the quality of my own experience."[4] He had been painting for twenty years. Ignoring this fact limits our understanding of Segal's sculpture and, most notably, its preoccupation with form and space. In addition, it would suggest that Segal's sculpture sprang from a confluence of ideas, such as assemblage and Happenings, emerging in the late fifties, whereas really its origins can be traced directly to the artist's background as a painter. His sculpture is a reaction to the art of the previous generation, the Abstract Expressionists, not a part of the revival of Dada or an aesthetic in the spirit of Duchamp.

In 1941 George Segal enrolled in the foundation art course at Cooper Union in New York. This was to train him as a teacher, for his parents could see an art education serving no other useful purpose. For one year, Segal was trained in self-expression with Bauhaus formality. But then World War II broke out and his older brother was drafted into the army, so George had to leave school to help out on the family's South Brunswick, New Jersey, chicken farm. In order not to interrupt completely an education that had just begun, he took evening courses in English literature, history, philosophy, and psychology at nearby Rutgers University. It seemed the only thing to do if he wanted to survive the boredom of raising chickens.

 In 1946 George Segal married Helen Steinberg and continued to work for his father. He resumed full-time art training in 1947, enrolling at the Pratt Institute of Design, but feeling its educational philosophy was limited he switched to New York University the following year. Finally some of what was happening in the art world at the time was available to him firsthand.

 At New York University, Segal joined fellow students Larry Rivers and Alfred Leslie in an art-education class. William Baziotes taught painting and Tony Smith gave a course in collage. Segal remembers painting tight little landscapes in the manner of Cézanne, liking Cubism, and having an even greater admiration for the German Expressionists. Baziotes tried to jolt him out of this, but was unsuccessful. Attracted to expressionism, Segal nonetheless felt incapable of

painting in an abstract vein. So he cut Baziotes' course, out of frustration. Tony Smith made greater inroads with the young artist, teaching him to appreciate order in chaos and imparting a clear discernment for formal organization. But Segal's real education took place off campus. The Club was right around the corner, and he went there to see and hear his heroes as they argued about painting.

The artists he met there scorned the Social Realism of the thirties and heatedly discussed Surrealism and the writings of Breton. Geometric and Purist art were criticized also, but Segal couldn't quite understand this. "Why this great emphasis on a ragged instead of a precise line?" he asked himself. One was not supposed to use a ruler because it was the gesture that counted. Segal recalls stymied debates at the Club about the *humanness* of art and the *reality* of things. He liked to hear his heroes talk about "exteriorizing inner realities and translating them into concrete form." He enjoyed the words, the passion, the muscularity, the toughness of those men; moreover, he thought, they looked great. The people with whom he had grown up considered art unmanly and somewhat disreputable. Yet these artists were strong, battle-scarred veterans, full of vitality and high intelligence.

Segal recognized the seriousness and philosophical depth of the Abstract Expressionists he met at the Club and in the classroom. He was impressed with their style, its spiritualism and plasticity. He admired their painting those "interior portraits without ever holding up a mirror to the visual world." But, in his own painting, he could not divorce himself from the figure with its sensual and tactile appeal.

He felt hampered by pedagogical prescriptions that a painting had to be flat, with no illusion of depth and three-dimensionality. He also felt that it wasn't quite honest: "While the Abstract Expressionists were talking about retaining the flatness of their paintings, they aimed at the same time at an *implied three-dimensional thrust.*" So Segal struggled to combine different modes of expression and find a grammar and a vocabulary flexible enough to incorporate everything he wanted to express in a painting.

In 1949 Segal graduated from New York University with a B.S. in art education, little inclination to teach, and a strong desire to paint as often as his work on the farm would allow. That summer he built a set of chicken coops on his own property and, with his wife's help, went into business for himself. Life proved hard for Segal, and it was not very conducive to painting. Relieved of the prospect of teaching, he now was shackled with an operation yielding marginal profits in return for round-the-clock work. Yet he hung on as a chicken farmer for eight years, driven by a strong desire to be financially independent and a wish to paint whenever and whatever he chose.

In 1953 George Segal met Allan Kaprow, then teaching at Rutgers University and renting a house in Segal's neighborhood. It was the beginning of a lasting friendship based on mutual respect and interaction. Kaprow introduced Segal to the Hansa Gallery, an artists' cooperative founded by students and admirers of Hans Hofmann. Hofmann's principles were then the current methodology and were as accessible outside the master's studio as in it. Both abstract and figurative painters sought his guidance and flocked to his classes. For four summers, from 1956 through 1959, the Segals went to Provincetown, where Hofmann spent the season. Though Segal never studied with Hofmann and never more than sketched while at the Cape, he met the renowned teacher and was lastingly affected by his personality and ideas.

What attracted Segal to Hofmann (who had a one-man exhibition at Rutgers University in the spring of 1956) was the latter's belief that creative observation of nature should draw on hearing and touch, as well as on the uncanonized senses of space and movement. "Inner vision" was Hofmann's term for such consciously enriched perception—a synthesis of all avenues of communication from environment to man. Also, Segal sensed that for Hofmann there was no real war between the figurative and the abstract. And indeed Hofmann appealed to many artists who, like Segal, wanted to combine in their work tendencies of style and feeling previously thought to be contradictory. Hofmann admired Mondrian for the purity of his abstract structure, but also Kandinsky for his automatism and fluid color. While the architectural basis of his own painting derived from a study of Cézanne and from Cubism, he was probably as close to Matisse as to any modern master.[5]

Segal loved Matisse, but also Mondrian and the German Expressionists. If Hofmann had been able to reconcile these contradictions and embrace opposing modes of expression, so then could he. He felt himself vindicated by the older painter and encouraged to go his own way. Segal glowingly remembers Hofmann as a "beaming, radiant, healthy, vigorous, optimistic teacher and painter who encompassed German inner turmoil and total encyclopedic weltanschauung, French savor and gusto, and American expansiveness."[6] There is no doubt that Hofmann struck a responsive note in the aspiring painter and future sculptor, as he stressed the student's need to find an art form most consonant with his own personality. In fact, he may even deserve some credit for having pointed Segal in the direction to sculpture.

"The mystery of plastic creation," said Hofmann, "is based upon the dualism of the two-dimensional and the three-dimensional." Segal found it difficult to resolve satisfactorily these interrelated factors of vision and experience, which contributed to the simultaneity of flatness and space. He struggled with what Hofmann called "push and pull" in his canvases, trying to activate,

2. *Untitled.* 1957. Oil on canvas, 6 × 8′.
Collection the artist
3. *Untitled.* 1957. Oil on canvas, 6 × 8′.
Collection the artist
4. *Untitled.* 1957. Oil on canvas, 6 × 8′.
Collection the artist
5. *Untitled.* 1958. Oil on canvas, 6 × 8′.
Collection the artist
6. *Lot and His Daughters.* 1958.
Oil and charcoal on canvas, 6 × 8′.

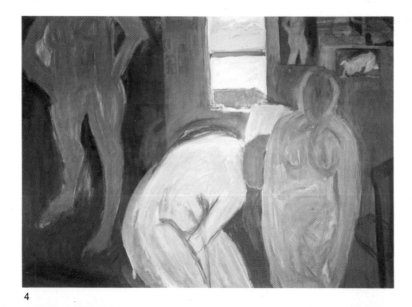

4

2

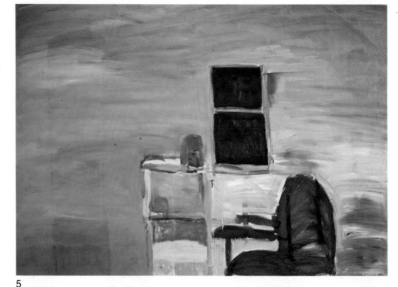

5

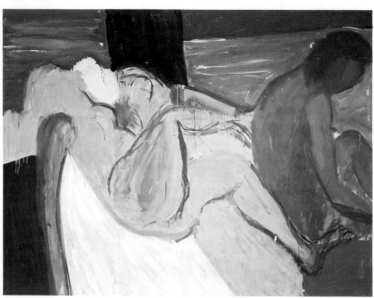

3

6

but not violate, the picture's two-dimensionality. But Hofmann pointed beyond the flat plane to the properties of sculpture, perhaps a mere speculation to him but one not taken lightly, we may assume, by his eager student.

"Sculpture deals with basic forms. . . . All basic forms exist as volumes. . . . Volumes penetrate each other and in this way are no longer single formations. . . . Through penetration, space is created in its entirety—every portion of space results from it. . . . Basic forms are positive space volumes; negative space is created through the opposition of these positive space volumes. Positive space is life fulfilled—negative space is force impelled. Both exist simultaneously—both condition each other—neither is conceivable without the other. Only the simultaneous existence of positive and negative space creates a plastic unity."[7] These were some of the philosophical underpinnings of Segal's inevitable move from painting into sculpture.

The Hansa Gallery represented for Segal "an embryo that hinted at most of the major directions in art in New York." In 1956 he had his first one-man show at the gallery, exhibiting interior and still-life paintings, full of colorful objects from his immediate environment—coffee pots, rubber plants, chintz drapes, electric lightbulbs. Hints of Bonnard's light and Matisse's drawing style, as well as a flatness of composition, showed Segal's infatuation with French art. A sense for raw color, manipulation of paint, a rather nonchalant drawing technique, a firm structure, and a fundamental reliance on imagery summarize the character of Segal's painting at that time. Robert Pincus-Witten was not incorrect in observing that Segal wanted to be a great French painter.[8] Seven years later, Segal specifically stated that the "Frenchness of modern art—defined as the tactile and visual delight of the material worked by the artist's hand" had been a major source of inspiration for him.[9]

Segal's second one-man exhibition at the Hansa Gallery, one year later, reaffirmed his interest in French art. His palette was more saturated, and the subject matter was now primarily female nudes in interiors. For the first time he showed pastels, which reminded critics of Degas and Lautrec. But, in addition, a German Expressionist influence was evident, as well as an acknowledgment of his admiration for De Kooning.

The third one-man exhibition of Segal's paintings at the Hansa Gallery, in 1958, caught the eye of critic John Ashbery, who wrote that Segal offered "unmorbid Expressionist paintings of nudes. . . . The figures are powerfully situated in space. . . . The palette is sensuous and acrid (mauve-red-mahogany); the pigment juicy, worked up in a fine yet calculating frenzy; behind their surface turbulence these paintings have a cool detachment."[10] The work had achieved an authoritative look and the six-by-eight-foot size of the canvases contributed to that look. It permitted Segal to enlarge his figures to almost life size, and it

encouraged new speculation in the artist's mind about the tenuous relationship of figure to space.

In 1958 Segal painted a series of pictures on a single theme from the Old Testament, the legend of Lot and his daughters. They were powerful yet abstractly treated images in which religious myth was invested with a sense of human concern. In terms of painting, the artist admits having reached a point of crisis. He had more and more trouble in handling space and was increasingly dissatisfied with the old academic formulas. Still clinging to the Abstract Expressionist requirement of flatness, he could not forget the Renaissance concept of space as a window through which the viewer is invited to enter the picture plane. Not sure whether he wanted flat or illusionistic space, Segal mixed modes and was conscious of the ambivalent result. What would happen, he soon thought, if indeed he tried to work in real space? Yielding to a growing dissatisfaction with painting, he decided to enter the literal space of sculpture.

Segal recalls that this decision was determined by "a strong urge for total experience." Do we detect, perhaps, a Kaprowesque ring? The artist readily admits that the idea of intruding upon the environment—composing space rigorously and in literal terms—bears a relationship with Happenings and their development from "four-sided collages." Kaprow's first Happening took place during a Hansa Gallery picnic on Segal's farm. As a new art form, the Happening was indebted to Abstract Expressionism and, in particular, to Jackson Pollock, whose concept of space Kaprow and others had set out to extend.

Kaprow claimed that the confines of the rectangular field were ignored by Pollock in favor of experiencing a continuum extending in all directions, simultaneously, *beyond* the work's literal dimensions. "Pollock, as I see him," Kaprow wrote in a historic assessment, "left us at the point where we must become preoccupied with and even dazzled by the space and objects of our everyday life, either our bodies, clothes, rooms, or, if need be, the vastness of Forty-second Street. Not satisfied with the *suggestion* through paint of our other senses, we shall utilize the specific substances of sight, sound, movements, people, odors, touch. Objects of every sort are materials for the new art: paint, chairs, food, electric and neon lights, smoke, water, old socks, a dog, movies, a thousand other things which will be discovered by the present generation of artists."[11]

Commenting on his friendship with Kaprow, Segal feels that he, more reflective, and Kaprow, more impetuous, were nonetheless "in the same boat, dissatisfied with our work and sensing the possibility of new ideas floating around." Together they explored what the art world had to offer. They attended exhibition openings, performances of new dance and electronic music, and the Happenings of Claes Oldenburg, Jim Dine, and Red Grooms. John Cage had

become a real force in the avant-garde, especially through his influence on Rauschenberg and Johns, but also through his lectures at the New School, attended by Kaprow and the painters, poets, and composers who went on to form Fluxus.

Cage encouraged the blurring of boundaries between various forms of art, as well as between art and life; this flexibility, along with his Socratic questioning of all accepted values, made him particularly pertinent to Segal. With Rauschenberg and Johns he also felt an alliance of spirit. They too were heirs of Abstract Expressionism and had struggled to free themselves and their work from it. More oriented toward Dada and the aesthetics of Duchamp, they nonetheless asked the same basic questions about the nature of their own reality and that of their own experience—and these questions were never simple or direct ones.

On the level of a liberation of spirit and life style, Segal was equally entranced: "Those were the days of the great mix. Writers and painters making films together. Happenings and the art of assemblage. The seductiveness of wearing work clothes, sexual liberation and the first experiments with drugs. A new life style between crumbling studio walls. Everything aimed at personal discovery and religious mysticism. Ideas strained through one's own life and body, and thus transformed into new values."[12]

Ironically, with this feeling of freedom all around him, Segal's daily life became more exacting and difficult. In 1957 he had begun teaching English at Jamesburg High School to avoid near-certain bankruptcy. The chicken farm consumed all his earnings and spare time until, in the spring of 1958, he decided to call a halt to the faltering operation. He could not move as freely and be as unencumbered as his friends at Rutgers or those living in Manhattan. In the fall of 1958 he took another job, teaching industrial arts at Piscataway High School. It required mental stamina and physical energy to teach, to continue painting, and at night and on weekends to keep up with an art world in full ferment.

In the summer of 1958—his coops having been emptied of chickens, while he had quit one job and not yet embarked on another—Segal took this opportunity to teach himself some basic notions about sculpture. He picked up a few discarded mannequins at a local department store and took them apart to find out how they were built. He then constructed his own figures with supports of wood scraps and chicken wire, over which he modeled human forms in plaster. These unglamorous materials were all he could afford: at eight cents a pound, plaster was cheap and in good supply at the local lumber yard. The plaster figures may have been clumsy, but Segal never cared much about working in metal, then at the height of its fashion. "What's so holy about the welding outfit

and its twentieth-century connotations?" he asked himself. Segal later admitted that he was intimidated by metal. With wood and stucco he felt at ease because these had been the materials out of which he had built and constantly repaired his chicken coops: "I had control over them—you have to feel comfortable with a material."

The first human form in plaster was a relief of a reclining figure on an old wooden door, made over a lumber, chicken-wire, and bedsheet reinforcement.[13] The plaster just barely adhered to the "skeleton," so the artist chose burlap for his next relief, a man with arms folded, also mounted on a door. These primitive figures are the incunabula of Segal's sculptural oeuvre; they lend logic to the work that followed. Very rough in appearance, remnants of Abstract Expressionism, they have the tackiness of most excursions into mixed media at the time. Reaching for forms was more important—and showing the trajectory a must—than properly defining them.

At his fourth and last exhibition at the Hansa Gallery, in February 1959, Segal showed a set of large canvases. What made this exhibition memorable— and the first real breakthrough in the artist's work—was a group of three plaster figures exhibited along with the paintings. They were clumsily molded human shapes—one standing, one sitting, one prostrate. The paintings, animated with large figures, were purposely hung low, suggesting that the sculptures had stepped right out of them. The artist never really considered these figures particularly good or original as sculpture. They were meant instead to demonstrate how his painted figures aspired to a third dimension, and illusionistic space to its literal and real equivalent. Their rough definition corresponded with the loosely drawn and brushed figures in the paintings, as the space around them reflected the areas left blank on the canvas. An important Segal principle was first formulated here: a sculpture gains definition not in terms of itself but by its relationship to another consciously presented reality.

Segal's discovery did not go undetected. In a review of the exhibition[14] Sidney Tillim put his finger on what troubled the artist: "His paintings . . . only confirm an impression of a particularly knotty conflict between freedom and limitation that looks to physical means for a solution." But Tillim was not impressed with Segal's solution of the problem: "The three sculptures are outright grotesque, with parts of the armature visible, adding to the effect." He blamed Segal for "an expediency, responsible in varying degrees, for the reckless excitement to which he too readily surrendered his ideas."

What Tillim, and perhaps Segal himself, failed to grasp when he accused the artist of not coming to grips with his medium was that he had gone beyond painterly concerns without as yet claiming sculpture as his new medium. He had been groping for a means of extricating himself from an impasse in his painting. Finish, elegance, and refinement of the work *as sculpture,* or even a fulfillment

of formal demands, were far from the artist's mind and would, in fact, have seemed out of character. Also, Tillim may not have been aware at the time of how much these improvised forms echoed the things then happening in the Reuben and Judson "underground," phenomena soon to explode upon the New York art scene.

The best proof that Segal attributed only minimal importance to these sculptures at the 1959 Hansa Gallery exhibition is that he did not go on to make more of them, but simply continued to paint. Shortly after his exhibition, the Hansa Gallery broke up. Jan Müller, the gallery's finest painter, was dead, and Richard Stankiewicz, its most illustrious sculptor, moved into more established uptown quarters. Nobody wanted to do what was necessary to keep the cooperative alive. Allan Kaprow left to animate the Reuben Gallery, which, with his participation and that of artists such as Oldenburg, Dine, George Brecht, Grooms, Robert Whitman, Lucas Samaras, and Segal, soon became "the cradle of Pop and avant-garde art on the Lower East Side . . . [it] specialized in an impermanent, perishable gutter art that went beyond Surrealism in its involvement with urban industrial subject matter for its own sake."[15] After a short stint as caretaker of the Hansa Gallery, during which he had to preside over its demise, Segal joined the Reuben Gallery, where he participated in two group exhibitions.

Segal continued painting, though he did not stop thinking about sculpture and its potential use in his particular predicament. He wasn't sure, though, how much he actually cared for the expressionistic character of the three figures at the Hansa Gallery. "If they were a free expression, then what did they express?" he asked himself. He felt he was on shifting ground; how much did he have to say? What he wanted was the solidity and necessity that only real, existing forms possess.

What had struck him at the time he made these sculptures was the sudden sense of reality he perceived when he put one of them first on an egg crate and then on a real, broken-down chair. The leg of the chair turned out to be more real and expressive (of the chair as form) than the plaster figure set upon it. While Segal comprehended, and proceeded to act upon, this clue, he did not as yet draw the concomitant conclusion that his plaster figures did not look as convincing and real as they could. That summer he explored these possibilities further, progressing significantly, as far as the object was concerned, but retrogressing in terms of the figure.

He picked up a real bicycle and on it placed a scrap assemblage vaguely engineered, in the best tradition of that season, to look like a man. He must have realized he had reached a dead end, or at least taken a wrong turn, for he removed this contrivance from the bicycle and a few months later replaced it

with the oddly expressionistic, yet more recognizable, shape of a man. It had an Art Brut character in which Segal wasn't particularly interested, but, at a loss for a better solution, he left it that way and included it in a Reuben Gallery group show. That same year he made three more plaster sculptures over wood and chicken-wire armatures—one crouching, one sitting on a chair, and one standing in front of a barn door. All three were shown in a one-man exhibition at the Green Gallery in the spring of 1962. The last work proved to be an important step forward in the direction of creating sculpture in a controlled environment.

For a critic in those years Segal's work could hardly be grasped on its own terms; the artist had just begun to formulate his aesthetic, and his real breakthrough was yet to come with his discovery of the direct casting method. So we find him variously categorized as an assemblagist, a Neo-Dadaist, or a sculptor of the new human image. With the benefit of hindsight we realize that Segal was never really an assemblagist. Assemblage is a tradition based largely on Dada and, with its basically trial-and-error approach, is the very opposite of Segal's planned and careful structuring. Yet Segal admits that Schwitters and, even more so, Duchamp loom importantly in his background. Threading his way through Cubism, Dada, and Surrealism, Segal has never built any strong historical alliances.

Dadaists removed objects from a context in which they could be interpreted as either useful or aesthetic and presented them in a new, often anesthetized setting in which they became weapons or pawns in an artistic stratagem directed against conventional art. Segal, in contrast, sustains the original connotations of art and life in objects; he connects them with life. Duchamp saw another salient difference between Segal's work and that of the Dadaists when he stated, "With Segal it is not a matter of the found object; it's the chosen object."

Those who have explained Segal's work as a search for a new image of man have understood even less about the intellectual premise motivating the artist to seek the space beyond painting and a reality more objective than artistic. Yet, at that time a new type of figuration seemed to spring from a sense of doom, triggered perhaps by the prospect of atomic annihilation, as well as from an interest in primitive and primeval expression. Largely European in origin, the movement hailed artists such as Dubuffet, Germaine Richier, Marino Marini, César, and Paolozzi as new visionaries of the human form. Freaks of nature rather than art—like the bodies of the Pompeians whose shapes were preserved by plaster filling the molds they left in the cinders—were a prime source of inspiration for these artists. And here is where some of the confusion may have arisen about Segal's relationship to Art Brut.

James Schuyler gave birth to this interpretation with a basically perceptive

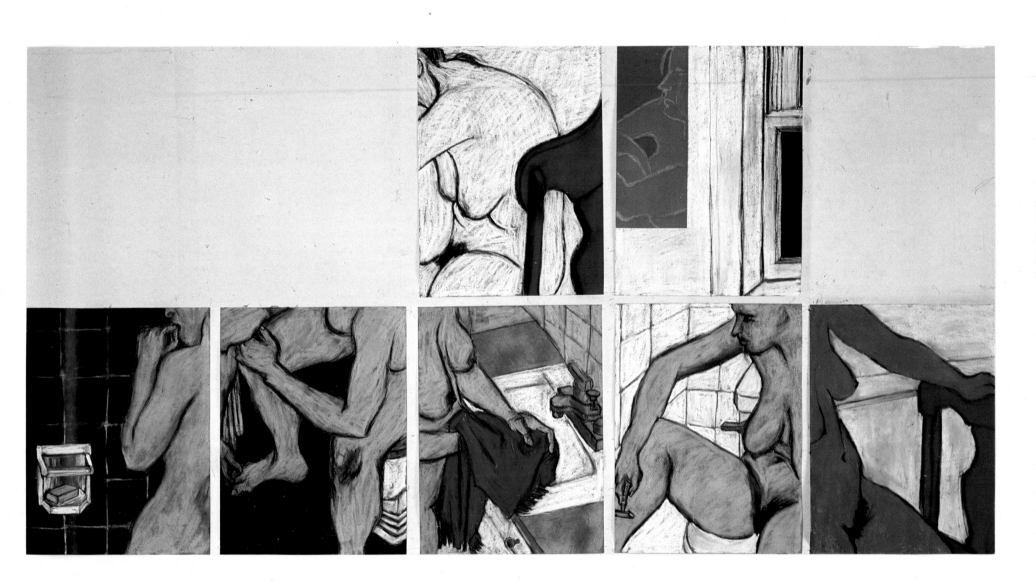

7. *Untitled.* 1968–70. Pastels, 19 × 25″ each

observation about Segal's sculptures in his 1959 exhibition at the Hansa Gallery: "Their effect is of swiftly improvised immediacy, with the arrested movement of a Pompeian dog."[16] While the comparison comes to mind quickly, it has been used entirely too much in the Segal literature. The artist has his own view of this metaphor, referring more to intention than to image: "I never quite agreed with that Pompeii reference. I'm against death and fight death wishes as hard as I can."

Though scheduled for an exhibition of paintings at the Reuben Gallery in 1960, Segal accepted Richard Bellamy's invitation to join the Green Gallery instead, feeling that the Reuben had passed its peak. Bellamy had been a manager of the Hansa, and under his direction the Green Gallery would soon draw the New York avant-garde into focus. In November Segal had a one-man exhibition at the Green Gallery in which he showed a series of lifesize paintings of nudes in interiors. They stood, sat, or sprawled, singly or in groups, naturalistically defined, in flat and indeterminate spaces. Their style continued to rely quite heavily on Matisse and the German Expressionists. One painting, *Red Courbet*, takes its image, though not its form, from Courbet's *Sleep*, which was exhibited, that same year, in a Courbet exhibition at the Philadelphia Museum of Art. Again, as in Segal's last show at the Hansa Gallery, there were a few armature casts, scattered among the paintings, though there was no attempt at spatial integration.

Looking back, we realize that if anything was evident in that exhibition it was the fact that Segal still considered himself a painter. He continued to paint all through the next year, when he did a series of bathers, shown in the same 1962 one-man exhibition at the Green Gallery in which live casts were first introduced. He even attempted to paint one of his armature casts—*Woman Looking Through a Screen Door*. She had green hair, a flesh-colored face, red lips, and so on, applied with Abstract Expressionist brushstrokes; the result was the famous De Kooning grimace come alive. It looked like a horror-house hallucination to Segal, and he rejected its carnival effect because he was more interested in the figure's form than in its expression. So he painted the woman white, leaving her jacket red. This second version of the piece was shown at the Ileana Sonnabend Gallery in Paris in the fall of 1963.

Segal began to realize that while he could free his figures from the imaginary space of painting, he could not treat them, either formally or coloristically, as painting. One anchor had been thrown out into the realm of the real: a simple chair or door was capable of lending a weight and authority to Segal's plasters that they did not have by themselves. Then, in July 1961, he stumbled upon the live casting method which, with one stroke, seemed to put everything into proper perspective. The second anchor struck bottom.

That summer Segal taught an adult painting class in New Brunswick. Dealing with sculpture at some length, he described assemblage as the combination of unlikely materials into a work of art. The ingenious use of junk as a particular form of American realism was received so well that Segal's students came to class with things they might use. The wife of a scientist at Johnson & Johnson came loaded with boxes of bandages of the type used by orthopedic surgeons. Segal took some home, since they suited his need for a material with which to cover the armatures of his sculpture.

Trying a new approach, he sat out in his yard and had his wife wrap him in those bandages after soaking them in wet plaster. After the bandages had set, with great difficulty and additional plaster of Paris for weight and reinforcement, he assembled them into a facsimile of his own body. He then placed the cast on the chair on which he had been sitting, moving it next to a table. A discarded window was nailed to the side of the table. Together these parts became his first authentic sculpture.

Casting from life had long been a practice of fabricators of fashion mannequins; in art it was frowned upon, for a sculptor was supposed to model his forms free-hand *after* but not *from* the human body. In the nineteenth century this skill had reached such awesome perfection that Rodin was once reproached, and then absolved of the charge, for making direct molds from the human body. Segal realized that in casting himself he was violating a taboo, but was perhaps also aware that with few taboos left in art, he was on to something profoundly original. Having searched for several years, and having been unable to control the expressiveness of his sculpture, he now had found a perfect means of making the sculpture express the features and psyche of the sitter directly, not as he would have reinterpreted them.

What seemed deceptively simple and questionable as art was in fact no more than a starting point for the artist. From there, he took full control, giving the sculpture stance, texture and space to move in, and an environment to reflect and define it. "Originally, I thought casting would be fast and direct, like photography," Segal woefully remarks, "but then I found that I had to rework every square inch. I add or subtract detail, create a flow or break up an area by working with creases and angles." What Segal was doing was shaping form, just like any sculptor. But in addition he attempted to control the setting of the work, unlike any sculptor before him.

When turning from painting to sculpture, Segal was unwilling to relinquish that sense of environmental control that painters can exercise over their subjects. He insisted on determining the boundaries of his work, in what light to place it and how to integrate it into the surrounding space. For each of his works he selected or made objects to correspond to, reinforce, or offset his

white plaster casts, creating a dialectic relationship—neither obscure nor emphatic—in which a human situation would come dramatically alive.

Normally, a sculptor's control ends with the surface and texture of his work. Beyond that, architects, landscape designers, interior decorators, lighting experts, and a host of amateurs in all these areas take over. By making environment an integral part of his sculpture, Segal has taken the painter's prerogatives into the domain of sculpture. It should be noted, however, that he did not and does not intend these controls to be dictatorial and absolute, and that he does not aim at locking figure, object, space, and light into an unchanging formula. "The trick is not to juggle them like a school exercise, but to space these elements in a way that they shiver, in a sense, to a real experience," Segal has remarked. He likes to keep his compositions flexible, with a touch of the arbitrary, until they fully express what he wishes them to say, until there is that same tenuous balance which in life, as well as in art, can best be described as open-ended.

Segal's figures have been almost routinely described as lifelike. They may well have seemed that way when first encountered, but continued usage does not make the description accurate. Life is mimicked in these figures—and not reproduced—and they should remind us of art, indeed, more than of life. To associate whiteness and art is irrepressible. Whiteness not only connotes art but also creates aesthetic distance. The other important feature placing Segal's figures unmistakably in the realm of art is a surface entirely worked over by hand, proportioned to, but exceeding by approximately one-eighth of an inch, the shape of the human body. These changes of color, texture, and shape are abstracting devices inherent to medium and method; they should exonerate the artist from association with, or approval of, the naturalistic mode of representation that has gained prominence in recent years.

As he prepares to make a cast, Segal covers his live model, either clothed or nude, with bands and swaths of fabric dipped in hydrostone. In addition to the plaster-impregnated bandages with which he has worked since 1961, Segal has used burlap, cloth rags, and gauze pads. Instead of plaster of Paris, which he first used but which proved too brittle and aged badly, he now uses hydrostone, the tougher and more resilient plaster of which industrial casts are made. For a short while he worked with hydrocal, a type of plaster less fragile than plaster of Paris but not as resilient as hydrostone.

The sitter's hair and face as well as all exposed parts of the body are protected with Vaseline and Saran Wrap; the latter has replaced aluminum foil and polyethylene—earlier, less pliable protectives. The nostrils are left exposed for breathing. Casting proceeds in sections—lower body, upper body, head,

and hands in the average case—and the model has to hold a single pose for up to forty minutes at a time until the plaster has hardened sufficiently to be removed. The cast is then ripped open at a seam on the back or side; a pair of scissors may be needed to free the model of clothes that stick to the inside of the cast.

Reassembling the sections is a more exacting, laborious process than making the mold. It also takes up to ten times as long. A pose can rarely be held without variation, and a model's mood or ability to concentrate may change in the course of a session. But since the plaster shell is thin and flexible, the artist can manipulate and adjust details of form, stance, or gesture. As the wet plaster soaks through the model's clothes, it records the musculature and structure beneath. In addition, the surface is worked over to tone down or accentuate certain features.

Segal never resorts to photography to capture a stance or gesture. Instead, he draws a great deal from the model, a continuous exercise enabling him to study the infinite variations of a body in motion or repose. Concentrating on an arched back, bent knee, stomach fold, or breast contour, these drawings echo, but are never the preliminaries for, the sculpture. Instead, they are complete in themselves, a running commentary—which never stoops to an academic level and is resplendent in its sensuous pastel rendering—on the beauties of the female nude.

It would be just as simple, according to Segal, to take any part of the body or the body as a whole, put plaster on it, let it set, take it off, and use the negative mold to make a positive cast, thus faithfully duplicating the original. But then, Segal is not interested in literal reproduction and demands more control and intervention: "I choose to use the exterior because, in a sense, it's my own version of drawing and painting. I have to define what I want and I can blur what I don't want. It bears the mark of my hand; but it bears not the work of my hand so much as the mark of my decisions in emphasis."

There is growing evidence that the artist may resort to the use of positive casts under certain conditions. It is an accepted characteristic of Segal's independence that he makes rules and breaks them as he goes along. There is room within Segal's poetic framework for literal presentation as well as for artful transformation.

To cast an ideal human form would cause the artist far more problems than his present method, for it could be accomplished only if he employed the eclectic means by which store-window mannequins were originally put together. Segal has no more liking for the ideal than he has for the undiscriminating rendering of form. He wants to retain blemishes and imperfections of the body; believing that casting the "ideal" woman would lead him on a quixotic

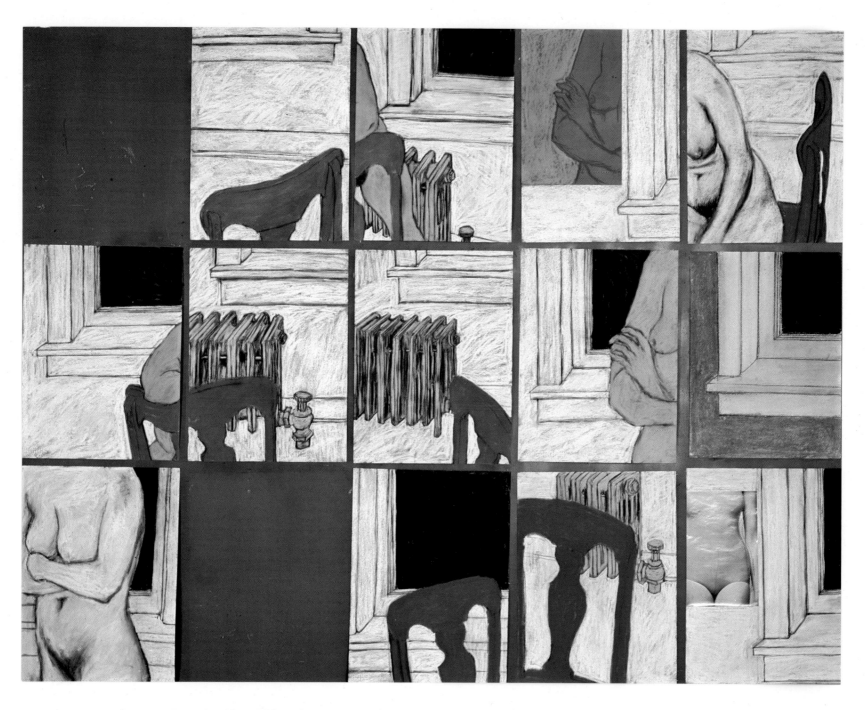

8. *Untitled.* 1968–70. Pastels, 19 × 25″ each

search, he is uninclined to assemble a perfect cast by combining parts of different models' bodies. "Each finger, elbow or calf belongs to one type of person and a collage will only be funny or plain unnatural," he believes. In addition, contrived beauty is inevitably bound to the canons of an era and therefore destined to go out of style with the passing of that era.

Plaster is a reporter as well as a recorder to Segal: "In plaster I can project my own vision of a person." The artist admits to a lot of hidden transformations as well as to the selectivity of ignoring certain gestures. He realizes that when his emotional involvement with a subject is greater the portrayal is more intense and liable to be more specific. Like a cameraman on a movie set, he wants to catch certain delicate and fragile gestures that pass by in the blink of an eye but are incredibly telling. A gesture, to Segal, does not mean the wave of a hand or the flick of a wrist, but rather the whole attitude of the body. "People have attitudes locked up in their bodies. . . . A person may reveal nothing of himself and then, suddenly, make a movement that contains a whole autobiography," the artist marvels.

Because of an intense rapport between the artist and his model, we are permitted, in a sense, to catch that precise moment at which the subject loses his or her self-awareness. The people who pose for Segal are forced to strip, symbolically if not literally, and always reveal their true character. "You cannot assume a social or artificial posture," the artist warns, "for your body tells the truth." It is difficult to pretend with Segal. "My models are just as stoic and brave, or screaming and hysterical, as they normally are. To be a fake is very hard with that kind of wet discomfort over such a long period of time."

THE BUS DRIVER

Segal recalls that the idea for this piece came to him while taking a late evening bus home from New York's Port Authority Bus Terminal. On the bus a few people huddled in the dark, and up front sat the driver, grim and staring, surrounded by navigational machinery. The driver struck Segal as sullen but arrogant, and he couldn't help thinking, "My God, dare I trust my life to this prig?"

The impression was so strong that Segal soon went to the only junkyard in New Jersey that scraps buses and, with a sledgehammer and chisel, hacked out part of the driver's platform to serve as the armor plating in which he wanted to enclose the hulky cast of a man—his brother-in-law this time—posing as the driver. *The Bus Driver,* like *Man Sitting at a Table,* is quiet and composed, confirming the artist's intentions: "I really wanted to order the air around him and give him the dignity of helplessness—a massive, strong man, surrounded by machinery, and yet basically a very unheroic man trapped by forces larger than himself that he couldn't control and least of all understand."

Pose and association lead to historic comparison as well as metaphorical interpretation. A perceptive friend of the artist commented, "You really like Rembrandt, don't you?" and Segal answered, "And Titian, Piero della Francesca, Giotto and Masaccio, all for very special reasons." Martin Friedman was the first to identify an archetype: "The Bus Driver could be Charon, the conveyor of souls." Segal's own account of the work's origin confirms this.

The greatest problem Segal encountered with this work was defining the boundaries of the piece. As he was making it, friends suggested he put the driver in a junked, full-size, New York Transit Authority bus on Fifty-seventh Street and allow visitors to enter. This was a very surrealistic idea and fitted the expansive mood of a time in which "everything went." Yet Segal balked at the idea, for he wanted to exercise more control, define his own space and not let it run wild, thus emphasizing that he is not interested in theatrics or effects of shock and sensationalism.

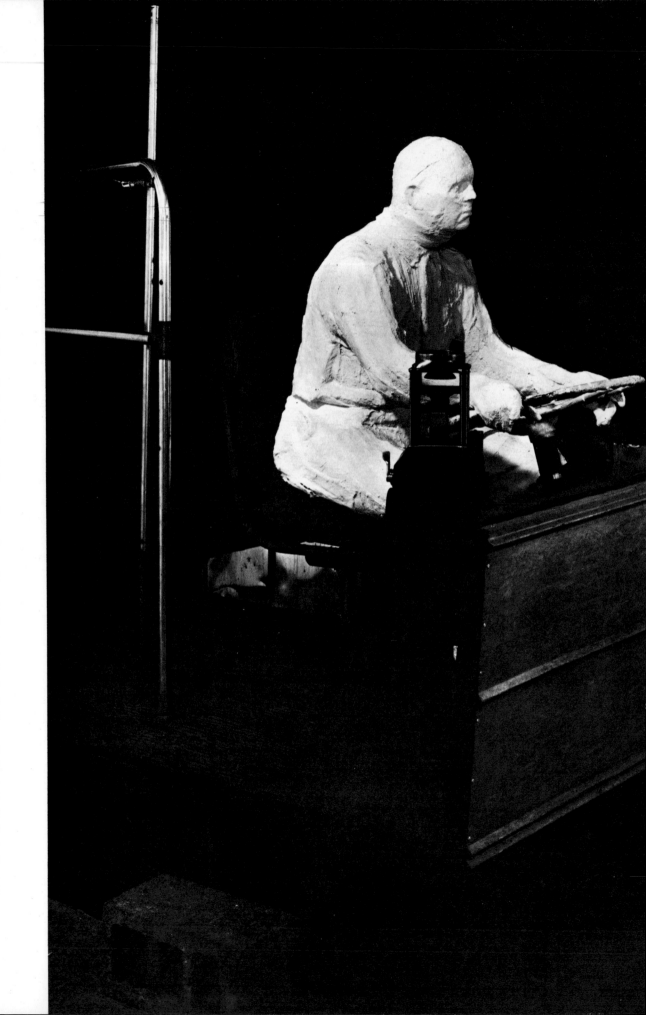

9. *The Bus Driver.* 1962.
 Plaster, wood, and metal, 75 × 52 × 76".
 The Museum of Modern Art, New York
 (Philip C. Johnson Fund)

Pop Art as the label for a new kind of art, inspired by popular sources and dealing with popular culture, was introduced, accepted by critics, and vulgarized by the media within the span of one year. It seemed to fit a broad spectrum of new images, and it sanctioned the use of materials that were cheap and tacky. But it did not imply formal unanimity or the advent of a new style. When Segal exhibited his plaster effigies of real people in lifelike environments, they were welcomed as Pop Art because they lent credence to that burgeoning trend.

The element of shock, stark realism, the use of mundane objects and true-to-life environments placed Segal well within the new trend and made him appear, in the popular press, to be one of its leaders. For better or worse, *Woman in a Restaurant Booth* and *The Bus Driver* had the impact of Oldenburg's make-believe edibles, Warhol's Campbell soup cans, and Lichtenstein's cartoon images. Segal's avant-garde credentials, his age, and the time at which his direct casts burst upon the scene were contributing factors to his historic association with Pop Art.

Yet, as the Pop phenomenon has been reviewed and reconsidered in the years since it took the art world by surprise, no critic still accepts Segal as a Pop artist without serious reservations. Quite obviously, his work is not "hard core" and provides few of the standards by which Pop Art can be defined. A sticky problem, really, Segal has suffered from critical neglect by Pop Art's popularizers. Challenging their categories, he has been a discomfort to some writers. Either Segal will have to be eliminated from that historic grouping, or our understanding of Pop Art will have to be enlarged to accommodate him. Since elimination is merely expedient and distorts the facts, the second solution is the only acceptable one.

There is an alternative, however, to which I do not subscribe. Formalist critics have been claiming since the mid-sixties, and recent historians and biographers seem to be rallying to this view, that Pop Art was really a freak phenomenon, a historic delusion, a mere episode in the history of taste, and an uncomfortable grouping of artists too good to remain trapped by an ill-considered label.

While it may be true that the best Pop artists have broken out of the Pop Art

stereotype and have made a genuine contribution to art on a formal level, there seems to be enough substance in Pop Art to warrant historic consideration and an attempt at critical definition. Since Segal does not object to or apologize for being considered in the context of Pop Art, an understanding of his work is predicated upon our knowledge of the similarities and differences between his work and that of artists whose identification with Pop Art is perhaps more obvious.

When Segal's sculptures first shocked the unsuspecting viewer, their unique and innovative features were more apparent than the logic with which they extended existing concerns, mostly those in his own work. The innovation was the direct recording, in plaster, of the human figure, and the appropriation, from Segal's everyday environment, of elements he transferred to the realm of art. The uniqueness was in their startling combination.

Abstract Expressionism, as culminating in the work of Jackson Pollock, had aimed at creating a total field in which art could happen; it proceeded by exteriorizing inner realities, through *gesture,* on canvas. Segal created an environment, willed into art by a dialectic integration of elements both made and found; he proceeded by expressing everything he knew about art and life, through *gesture,* in space. These philosophical extensions of the Abstract Expressionist aesthetic are a function of the breakthrough Segal achieved when he went from the two-dimensional space of painting to the three-dimensional space of environment; from the fictional treatment of human form and the objects with which man is surrounded, to their direct recording and presentation.

But the breakthrough itself would have been unthinkable without the example of Duchamp as part of the general history of Dada, and the encouragement provided by Johns's and Rauschenberg's challenges to the Abstract Expressionist orthodoxy. Yet, despite this obvious lineage, there are ways in which Segal, like most other artists associated with Pop, broke with their Abstract Expressionist and Neo-Dada predecessors. This we must concentrate on to understand Segal's relation to Pop Art.

Even before Pop Art appeared on the scene, abstraction had ceased to be the only road to heaven. Flatness in painting was no longer mandatory, and the use of a wide range of non-art materials and methods had gained acceptance. What was once a heroic style dominating the art world with unquestioned authority had suffered irreparable damage and loss of prestige under the onslaught of strong rivals. Loath to bend and righteous in resistance, it was headed for academic rigidity and entrenchment. Yet, society was just catching

up with it; the establishment had come to love abstraction, and "The New American Painting" was on world tour.

For the younger artists a credibility gap had developed. At the height of its social acceptance, Abstract Expressionism saw its moral authority called into question. It could no longer pass as the symbol of such avant-garde values as radicalism, intransigence, and high purpose, or count on a philistine public to reject it. Pop Art, most notably, took issue with what had become a false position, not just aesthetically but spiritually as well. The time was right, or so it seemed, for the new guard to challenge the old and for a younger generation to *deserve* the spotlight.

On formal grounds, the break between the old and the new came with Pop and not with Neo-Dada. Abstract Expressionism had fragmented form in a myriad of signs and gestures. True to its Cubist lineage, it saw the universe in terms of its facets and components. The art of assemblage, very much in vogue about the turn of the decade, may have resembled the synthetic more than the analytic phase of Cubism, but it did not abandon its Cubist orientation.

Juxtaposition, a key device of the art of assemblage, was a means of differentiation, not of integration. Despite its attempt at homogenizing particulars, it did not always succeed in making the result look more than a sum of parts. An ambition to replace what had remained a fragmented vision and approach to the making of art, by a bolder, more assertive, and more holistic vision and approach was symptomatic of Pop as it was of Minimal Art. Segal had an early grasp of this need for art to toughen and "shape up," and he applied his insight to increasing advantage.

In his pursuit of a personal aesthetic Segal asked himself questions which he felt his elders had answered ambiguously or left unresolved. Why was abstraction considered superior to the use of the figure? Why would there have to be an incompatibility between the spirit and the flesh? What made subjective gesture more artistic than objective fact? Was there, in truth, a "high" and a "low" road in art, or was that a fiction of those who controlled it? Philosophically inclined, oriented toward synthesis and harmony in art, but nobody's fool when it came to cutting the tangle of myth and staking out new ground, Segal addressed himself to the task of developing a dialectic approach. In this manner he hoped to fashion a personal vehicle allowing him to communicate subjective human experience by objective formal means, generalizing the particular, abstracting the figurative, and pulling the inchoate into focus.

There is no doubt that many artists of Segal's generation have asked themselves these same questions. They smashed old icons in a formal dispute, and not just to replace them with new images. Pop Art heralded a break with the past philosophically, formally, and in terms of subject matter. It attacked the

formlessness of fashionable abstraction but incorporated the abstract as a property of form. Its manner may have appeared spoofing and irreverent, but its formal objectives were achieved with deliberation and discipline.

It is commonly understood that Abstract Expressionism was emotionally "hot," serious, committed, and spiritual, and that Pop Art was "cool," ironic, detached, and materialistic. Anybody taking a hard look at the Abstract Expressionist ethos as practiced in 1962 would have found it hard-boiled, calculating, protective, and ridden with anxiety. Pop Art, at the same time, stood accused of being pushy, self-serving, contemptuous of its audience, and greedy for a market. Its practitioners were called vulgar, expedient, lacking a sense of style, and incapable of making their own forms and inventing their own images. Segal was caught in this cross fire like everybody else, and after many years he still jumps to the defense of Pop Art.

To Segal, what may have seemed a cool, ironic posture of artists employing so-called impersonal techniques to deliver thin messages of blatant redundancy proved to be affectionate and involved underneath. Pop Art genuinely loved what it dealt with, and Pop artists really were carried away by technique and subject matter. Had they chosen those subjects and techniques to shock their audience, then, Segal reasons, this would have been a cynical gesture, worthy perhaps of Dada but out of character with the genuine spirit of discovery and delight in Pop Art about the gregariousness of America and its consumer optimism as it pulled itself out of the doldrums of the fifties. Subjects and feelings were brought back into art that could no longer be adequately expressed in painting and sculpture. This broadening of mandate was accepted by the artists in a spirit every bit as serious as that of the abstractionists who claimed that they could express realities the eye had never seen.

Segal welcomed the new inclusiveness of art. He thought that people misread Pop Art when they said that the images on billboards and the contents of pulp magazines were thrown back at us by Rosenquist, Warhol, or Lichtenstein as a form of criticism or outrage. Pop Art did not prejudge or moralize; giving him the glamour along with the ghastliness, it invited the viewer to be the judge of which is which. To Segal an attitude of honest acceptance is what matters. For him, he admits, there is neither good nor bad subject matter. He is inclined to choose the simple, banal, and undramatic because they relate best to the formal solutions to which, in his work, he aspires.

Subject matter is important in Segal's sculpture as it opens the door on the riches of everyday experience. "Once you decide that anything is all right," says the artist, "you are no longer limited to noble or traditional themes. You can deal with the cup and saucer in front of you at the breakfast table, you can deal with the headlights of a car approaching you, you can deal with the woman in

bed next to you . . . cracks in the sidewalk, dogs and cats. So, if you open up, then the contents of a supermarket are as valid as a beach scene or a landscape."

The subjects, to Segal, are those he stumbles upon in everyday life. There is no forced context or attempt to look prototypically American when he pictures a diner, gas station, or dry-cleaning store; to look middle class when he chooses people around the kitchen table, on a rooftop, or in the bathroom; to look urban when he portrays people making phone calls, taking subway rides, and waiting for the bus. If these are the subjects Pop Art favors, so be it. The artist looks around, on his farm in New Jersey and on his trips into New York City, and he simply records what he sees: " . . . a huge heap of art material . . . all the junky areas and stores that have gone out of business; the bars full of old furniture . . . my own cellar in which I keep things I no longer use."

Segal admires Chartres Cathedral, but also the New Jersey Turnpike. Like Léger he senses the power residing in the world of construction, and work of whatever type is his favorite theme. He speculates on the simultaneous existence of the old and the new, the sensual and the geometric, and he questions their relationships. To the fabrication of alligator cracks in the paint layers of an "old" tenement hallway he applied the same sense of perfection, denoting an interest in the trivia as well as in the nonsense of life, which, in another instance, he lavished on fitting plastic tiles into a chrome molding to re-create a contemporary bathroom. Such polarities are enormously expressive and revealing to Segal. He recognizes them not as arbitrary juxtapositions from which to wrest striking effects, but as common contrasts in the environment in which Americans live.

Pop Art finds inspiration in the cliché notions about bigness, boldness, and rawness that have a peculiar attraction to its artists. The American Dream is its content. Pop Art seemed endowed with that authentically American intelligence that believes it can accomplish anything because it can make up the rules as it goes along. This mock positivism is as characteristically American as it was typical of Pop Art. There seemed to be, in Pop Art, a blissful absence of historic and cultural impediment, a broad stride instead of a measured pace, a liberating sense of space, a comfortable posture, a directness of gesture and approach, a ruggedness of environmental articulation, and an almost naive assumption that any theme can be treated as though it had never been dealt with before. And yet, there was nothing personally naive about Pop Art's practitioners, for they were able to voice their intentions and formulate their objectives with uncanny precision. To all this Segal is no exception.

Stylistically a hybrid, Pop Art seems to distinguish itself by a good deal of unresolved ambivalence. For all its nose-thumbing at traditional art, and its

scandalous extension of subject and sentiment into the never-never land of low and bad taste, Pop Art firmly saluted those artists it admired: Cézanne, Matisse, Léger, Mondrian, Duchamp, Pollock, and Reinhardt, to name the most obvious. Pop artists mined the tradition of Western art and the kaleidoscope of contemporary environment with equal gusto, but by no means indiscriminately. They lived by an intellectual rigor they admired in their elders, but they felt more at ease with and less superior to the milieu where circumstance had placed them.

Ironically, by "hanging loose," Pop Art finally emancipated American art from the dictates of European tradition, a freedom Abstract Expressionism had long promised but failed to deliver. It did so in an almost offhand fashion. There were no binding theories, no pretense at a "school," and no club where Pop artists met to plan a take-over of the art world. Pop Art was the crossroads of diverse and vital talent. Alliances were shunned and differences stressed over similarities. A natural independence led artists away from Pop with the same unapologetic air with which, a few years earlier, they had thrown their hats into the ring. They were quite prepared to "go it alone," unsustained by any mutual support or adulation. No critic kept them in line or took away from their individual independence in return for continued good graces and a ticket to the art world's hall of fame.

The use of ready-made images and commercial techniques and materials effectively served to "demystify" art in terms of fitting content, craft, and manufacture. It was an invitation to get right down to message and intent. This was certainly true for Warhol as it was, to a lesser degree, for Lichtenstein. But it has little bearing on the work of Segal, who has never had any taste for the blunt and radical aspects of Pop Art, its polemics, its intent to shock, its random choice of subject matter, its creative anonymity, its repetition for greater impact. Pop Art runs the gamut from expressionist to formalist. Brydon Smith recognized Segal's expressionist bias and related him to two other artists who seem to share that bias and with whose works Segal admits to feeling comfortable—Oldenburg and Dine.[17]

Form, too, is an extremely important consideration for Segal, but only as it expresses his own interior reality. He does not allow it to become divorced from personal experience, nor does he want to divorce himself from the making of his art, neutralize its manufacture, "become a machine," in Andy Warhol's parlance. Segal's insistence on juggling art and life effectively eliminates him from a contest to play cool, but he has never considered that a loss.

The impersonal element in Pop Art was more programmatic than real. It was neither felt nor shared by all. Lucy R. Lippard ascertained that the intellectual impersonality was a Dada bias derived from Duchamp and the emotional impersonality a purist bias derived from Léger.[18] Segal professes strong affini-

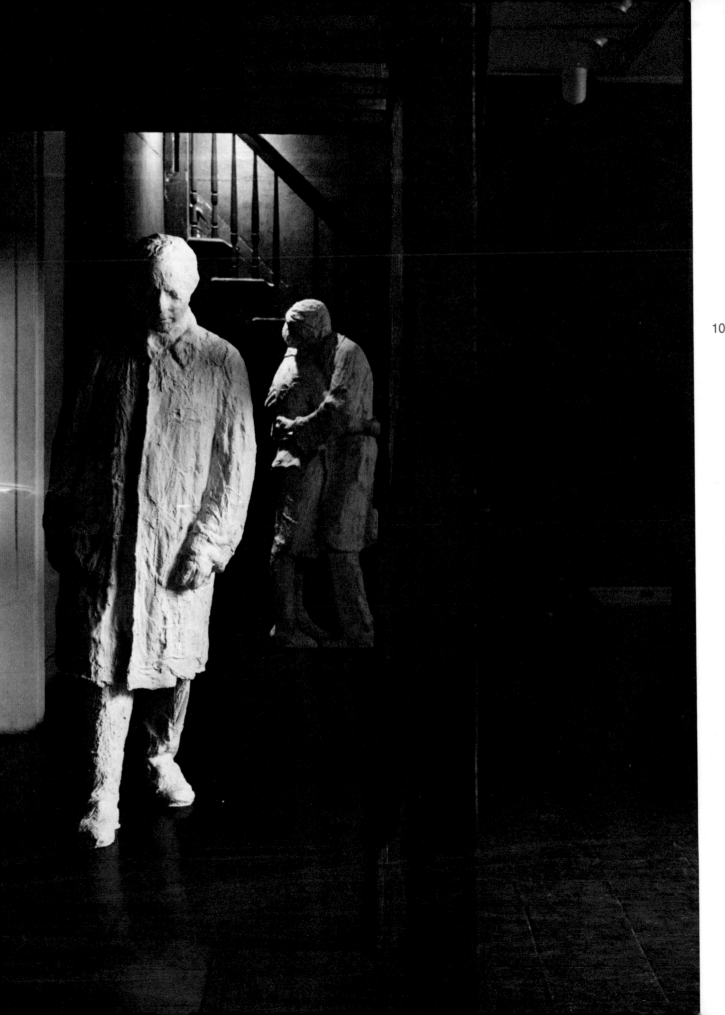

10. *Couple at the Stairs*
 (detail, in background). 1964.
 Plaster, wood, and metal,
 10′ × 8′8″ × 8′. Museum
 Boymans–van Beuningen,
 Rotterdam.
 The Construction Tunnel
 (detail, in foreground). 1968.
 Plaster, wood, and metal,
 14′ × 5′ × 7′9″. The Detroit
 Institute of Arts
 (Founders Society Purchase).
 *(See plates 34 and 102
 for other views.)*

ties for both artists and recognizes that their formal and intellectual principles have been operative in his work also. Yet he feels that whatever impersonality they suggested to him and his friends, the outcome was works soon bearing a super-personal mark and readily recognized as such in the art world.

Pop Art offers more of these seeming paradoxes and reversals. What once looked tough, cheap, or arbitrary now appears sensitive, reasoned, and almost precious. The throwaway has become a collector's prized possession; the lark has become a serious enterprise; the satire has become an affectionate tribute; and the alienation it all seemed to show is now generally recognized as a romantic condition of the sixties.

Pop Art's esoteric qualities and power to shock have been broken down by exposure, and its superficial features have degenerated into commercialized Camp and nostalgic sentiment as a broad public has successfully assimilated them. Segal's sculpture has been relatively untouched by this because he has always steered clear of the topical and popular. But in fairness it should be added that nobody else anticipated or solicited such instant embrace and exploitation. That sense of the preposterous was much more a public interpretation of the stance of Pop Art than its practitioners' invention or intent. What seemed complacent, tongue-in-cheek, or chauvinistic to the uncritical observer was in fact a new way of dealing with art and life without regard for the hierarchic differences so reverentially observed in the past.

Pop Art has been more successfully defined on the basis of image and subject matter than on that of form and style. While it has lent *style* to the vernacular and is recognized for its *stylized* rendering of common content, that does not make Pop Art *a style.* In both instances we have a choice between two possibilities: 1) The common and the vernacular have traveled upward to meet our new standards of respectability and style; 2) Pop Art has made them look "classy" and stylish. Neither affects Pop Art as a style, whatever either possibility may prove about the conditioning of human taste.

Robert Rosenblum was the first to recognize that Pop Art was too much regarded for its imagery and not enough for its style. One immediate drawback he noticed was a lack of formal standards of comparison: "Using iconographical criteria, Pop Art produced illogical groupings."[19] We haven't progressed much since Rosenblum wrote this, and a stylistic analysis of Pop Art is yet to be undertaken. As for Segal, his work has never been subjected to stylistic analysis, nor has it been analyzed in the context of Pop Art as a style. Without that necessary spade work on Pop Art in general, dealing with Segal's style in the context of Pop Art is bound to be inconclusive.

Barbara Rose made another important observation in noticing a common sensibility as expressed through attitudes, interests, experiences, and stance

between Minimal and Pop artists.[20] She does not credit them with a common style, and it might have been premature at the time. A case could be made now for the analysis and definition of Pop Art in terms of the Minimal style. Without our going into extensive analysis, it should be clear to even the superficial observer that Pop and Minimal artists share a cluster of stylistic characteristics: instant aesthetic impact, radical composition, anesthetizing of materials, direct presentation, serial grouping, emphasis on scale, a fascination with the human scale, a unitary concept of form.

George Segal's identification with Pop Art is less apparent on the level of form than it is on that of icon. Chances are it may be deeper. His expressionist bias notwithstanding, there are certain formal characteristics he shares with most Pop artists: one-to-one relationship with reality, emphasis on gestalt, fondness for the use of dialectic opposites, frontality, and shallow space.

Segal's arrangements of plaster figures surrounded by the properties of everyday life are generally presented like actors on a proscenium stage. While they do not always face us, the impression is one of frontality and head-on confrontation. We are looking in as through a large, imaginary window. Both their situation and ours calls for the arrangement. The fact, however, that these tableaux evolved, quite literally, from the art of painting, and that paintings are best seen head-on, may still be the best explanation of their frontality. The rectangular space frame we almost automatically apply is often emphasized by a real back plane, most likely a wall. Spotlights focused on the sculpture are supporting indices of frontality.

Segal will not prohibit our entering the space of the sculpture, but his organization of that space subtly discourages it. Side views are entirely in order, but a frontal or near-frontal view is the most informative and appropriate in the majority of cases. The shallowness of the space and a composition favoring width over depth is another measure of the artist's predilection for head-on presentation. Brian O'Doherty noticed this aspect of Segal's work when he referred to the sculpture as "hollow tableaux."[21] Frontality and shallowness make a programmatic appearance with the boxes, in 1969, which compress and reduce figure, environment, and space. They are clear proof for anybody who would doubt it that limitations of depth and viewing angle are a self-imposed compositional principle and not a formal handicap.

Segal has consistently stressed the importance of subordinating all elements in his work to a single overriding gestalt. Whenever he has eliminated detail, he has done so with an eye toward that ultimate effect. Only minor expressions of Pop Art have been "jazzed up" with detail for cumulative effect; the best works have always been stripped down for greater clarity and eloquence. This tendency toward simplicity became more pronounced as Pop Art

moved into its "classic" stage. It is reductive in essence and, with some artists, has not yet reached its peak.

Since his paintings of the late fifties, Segal has aimed at establishing a one-to-one relationship between his subjects and the world into which he places them. Pop Art, in general, maintained a straightforward relationship of scale to environment, but by no means always. If it painted larger than life, the impression was that of a close-up view; if its objects exceeded the size of those in real life, the impression was that of dream or magic. Rarely do we find a far view or a diminutive effect in Pop Art. Segal's method of casting, and his use of objects taken from everyday environment, is predicated upon the human scale; he can neither enlarge nor miniaturize, and a shift of scale within his work is equally unthinkable.

Dialectic opposites fascinate Segal, but there is some evidence that they are relished by other Pop artists as well. The hard versus the soft is one we singled out. In the Irving Blum series of Campbell soup cans Andy Warhol lovingly painted the crassest product on the supermarket shelf; conversely, he chose the harshest reproduction method to celebrate the world's most adored movie idol. Lichtenstein neutralized images packed with emotion by affecting the deadpan style of cartoons and the reproduction methods of mass printing; conversely, he lavished extravagant formal attention on something as unspectacular as the rendering of a single brushstroke.

Claes Oldenburg put as much conviction into the hard rendering of soft edibles as into the soft rendering of such hard fixtures as appliances and engine parts. Tom Wesselmann derives his effect from contrasting a soft, fleshy nude with the hard, industrial surface of a refrigerator door, television screen, or commercial color reproduction; by the same token, on the body of his nudes he contrasts the pink of unexposed with the tan of exposed skin, making one look tender and private and the other tough and public. In his syncopated images with their dramatic shifts in optics Rosenquist likes to alternate, for instance, the glitter of a car radiator with the gooeyness of Franco-American spaghetti, or a foreground in hard with a background in soft focus.

There is an element of flaunting in Pop Art, a brash come-on which Segal has scrupulously avoided. He never "epitomized" the "spirit of the sixties" like Warhol or Lichtenstein, and he never aspired to the monumental and colossal like Oldenburg and Rosenquist. As quietly and as deliberately as Wesselmann has set his sights on becoming a figurative painter in the classic tradition, through purification of form and color, Segal has developed his idiom in the direction of timelessness and abstraction. His style has remained unassaulted and uncommercialized. Through a process of gradual distillation and search for essence in a medium that is more abstracting than realistic to begin with, Segal

has lifted his subjects *out of* time, in contrast to most Pop artists who situate them *in* time. Despite their physical concreteness, the plaster casts and the mundane objects surrounding them are formally and functionally subservient to a meditative vision of the universe. They are neither weapons in an aesthetic chess game nor comments on contemporary institutions.

Harold Rosenberg understood, when he reviewed the "New Realists" at the Sidney Janis Gallery, that Segal had set out to create a *new feeling* rather than to make a commentary on either art or life.[22] Henry Geldzahler, too, sees Segal as drawing away from Pop Art concerns and ambitions. He calls him "more humanist than Pop artist: he is in touch with contemporary culture and presents us with moments from it but with greater involvement and density, and, consequently, less directness and immediacy both of subject and technique, than we expect from a Warhol or a Lichtenstein."[23]

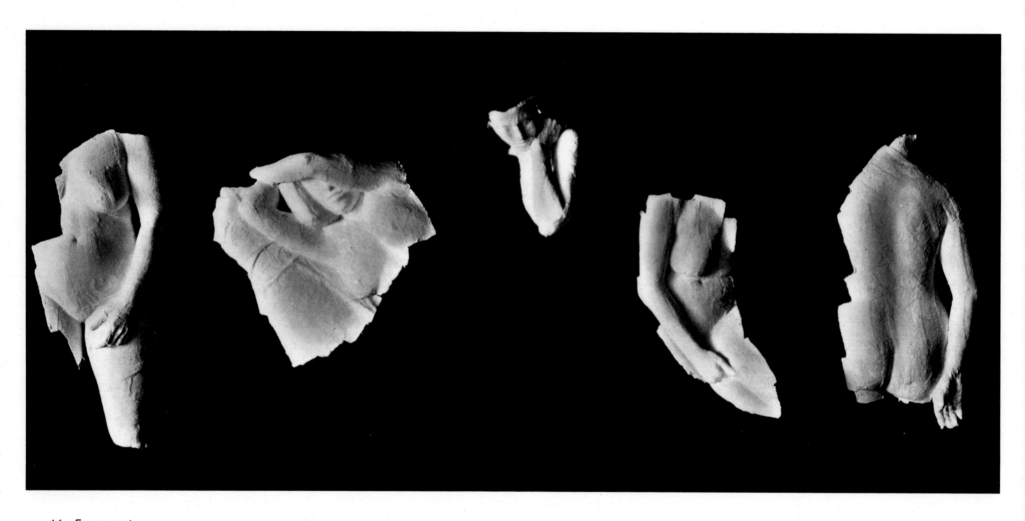

11. *Fragments*

IV

As time passes, styles merge into more unitary configuration, revealing similarities where formerly there were only disparities. Pop and Minimal, those back-to-back spellbinders of the sixties, appear much more akin now than they ever seemed at the time. Though sharing the same sensibility, their practitioners dealt with different subjects and arrived at results iconographically distinct but formally related. They had tired of personalized expressions and abstractions that were subjective, mystic, and seemingly uncontrolled. Reacting against their predecessors, they took a hard look at the outer world. Their anchor was experience. Their attitudes were positivist, empiric, and realist. Instead of smashing the icons of the past, they cut them down to size.

This antiheroic stance did not lower their sights as Pop and Minimal artists alike strove to accomplish the goals they had set for themselves. Nor did it obviate a genuine admiration for those among their elders with whom they could identify. A common cause with Dada and Duchamp, so noticeable in the fifties, is much less in evidence. At a time when the Abstract Expressionist generation had to be fought because it was still kicking and loath to let go, Duchamp had been a good ally and Dada a mighty weapon. But this picture had changed, and the trend was toward an assertion of personally conquered values. Strength could no longer be found in the heat of the battle, but in its cool aftermath—not in taking the crown but in wearing it.

The Minimal style in sculpture, according to Gregory Battcock, is "an obvious step on the path toward a more rigid spatial structuralization within art as well as by art."[24] In a sculpture by Segal, there is a conscious attempt at structuring the space within and around the work. By the same token, the components of that sculpture extend and project themselves onto the surrounding space and structurally affect the room or gallery they inhabit.

The two basic components in a sculpture by Segal, the plaster cast and the environmental properties to which they relate, do not attain that state of grace in which parts turn into a unified whole and the material into art, without a third climactic component, space, handled by the artist to respond to interior and exterior demands. Ever since his first environmental works, Segal has been concerned with the same notions that preoccupied the Minimal artists—space, scale, shape, object, and containment. Whereas Segal went about it in an

empirical fashion, the Minimalists extrapolated theory from physical encounter or applied insights gained in this fashion to the forms at hand.

Since 1961, when Segal's casts from life found real-life complements in simple fixtures like chairs and tables, the Minimalist sensibility has been locked into his work. Don Judd, reviewing Segal's first exhibition at the Green Gallery, noticed "the plain objectness, the simple existence of some recent abstract work"[25] in his sculptures. No doubt he referred to what he himself and his friends were up to at the time.

Segal's environments were severe and uncluttered, spare and succinct. Richard Bellamy was among the first to notice it, and he featured that aspect of Segal's work, implicitly, in his gallery's early group shows. The Green Gallery had managed to attract the most vital artists working in a broad variety of styles. Segal admits that the experience was exhilarating and that he learned enormously from his contact with Green Gallery colleagues. In addition, he credits Bellamy with that rare ability to spot talent in widely different styles as he sensed a common denominator. Since the Green Gallery was the cradle of the Minimal aesthetic, as the Reuben had been that of Pop Art, the common denominator was, beyond a doubt, the Minimal sensibility, an awareness Segal shared with the artists who more obviously pioneered the Minimal style. Here Pop and Minimal seemed to have their first encounter.

"If a real object is placed in a room," Segal reasons, "it's called *Pop.* The same object, abstracted into geometric shape, is called a *Primary Structure.* The impulse behind these objects and the aesthetic they represent are much closer than we usually think." Bellamy demonstrated that artists working in styles that carried different labels shared certain values and could, indeed, be shown together compatibly. To Segal a common sensibility with regard to space was what cemented the Green Gallery artists together. Bellamy was mixing unmixable modes. Segal recognized a "hunt for awesome form" in the works of Robert Morris and Don Judd, and "light as pure plasticity, exalted and intense" in those of Dan Flavin. He showed with them in exhibitions that never seemed to violate that common sensibility.

Like the Minimalists, Segal had rid himself of the illusionism inherent in painting and had opted for literal space as intrinsically more powerful and specific. Yet Segal was slower to adopt the Minimalists' comprehension of form. He did not share in any consistent fashion—although there is increasing evidence in the more recent sculptures—a rejection of multipart, inflected form, nor did he embrace the singleness, wholeness, and indivisibility of form that Morris and Judd insisted upon. If anything, he leans toward Judd, who arrives at gestalt not only by presenting a unitary form, like Morris, but also by symmetrical organization and the repetition of identical or comparable units.

In his work, Segal is as concerned with gestalt as Morris, who says: "In the simpler regular polyhedrons, such as cubes and pyramids, one need not move around the object for the sense of the whole, the gestalt, to occur. One sees and immediately 'believes' that the pattern within one's mind corresponds to the existential fact of the object."[26] The polyhedrons in Morris's work have their real-life counterparts in Segal's tabletops, cinder-block chimneys, Coke machines, air-conditioning ducts, cabinets, stairs, and counters. They are not just props setting a stage for the figures, but plastic presences, powerful in their own right. If, formally, they strike us as complete, it is not merely because their simple shapes can be inferred from our seeing them from just one angle, but, in addition, because they can be brought under the common denominator of everybody's personal experience. Complexity of form or spatial arrangement and crowded surfaces are at odds with the idea of gestalt, since they can neither be grasped in one glance nor identified at once by the greatest number of viewers.

Segal claims that he tries to make the formal solution as different and telling as possible in each sculpture, but he also knows that this violates the Minimal principles prohibiting variation and illustration. But even as abstract a form as a polyhedron contains subject matter through the inevitability of association and memory of similarly shaped real-life objects, and as the carrier of a formal message.

To make a point *tellingly* is an illustrative quality by definition. If that point is made before an audience, in an art gallery where people gather to look, then what is illustrative in private becomes theatrical in public. Following another line of reasoning, Michael Fried sees theatricality as a property of Minimal Art. Quoting Clement Greenberg, who claims that both size and the look of non-art can confer presence, and substituting his own term "objecthood" for the "condition of non-art," Fried goes one step further and asserts that the Minimalists' espousal of objecthood "amounts to nothing other than a plea for a new genre of theatre."[27]

While this provocative statement is untenable in its exclusiveness and rigor for any but Fried's unquestioned and unquestioning students, it correctly reveals presence in a Minimal sculpture as a theatrical effect. But, in addition, Fried pinpoints a quality (although he may call it a defect) more readily identified with figurative than with abstract sculpture. He suggests that it is *theatricality* that links Judd, Morris, and others to artists as disparate as Oldenburg, Segal, Samaras, or Christo. Turned around, this would attribute—and I believe it to be correct—a share in the Minimal aesthetic to Oldenburg's wood and Formica objects, Segal's severe environmental sculptures, Samaras's mirror rooms, and Christo's storefronts.

Besides theatricality, Fried suggests in the same article that a kind of latent or hidden naturalism, indeed anthropomorphism, lies at the core of Minimal theory and practice. The concept of presence all but says as much. If man is the measure of all things Minimal, and Minimal Art is to be acknowledged as essentially human in scale—neither monument nor object—then an objective recording of the human figure should not be inimical to it. This suggests another subterranean connection between Segal and the Minimalists.

A revealing incident is Morris's request that Segal cast him in the nude with arms and legs stretched out, like Vitruvius's modular man describing a square within a circle. Morris wanted to make the cast central to a piece he was then working on. But the pose was contrived, and Morris could not integrate it into his work. Segal would never have chosen this subject, because it was the demonstration of a principle and not the rendering of a fact or situation. Morris's use of the body as a measuring device in his sculpture and basic material in his choreography goes a long way toward substantiating Fried's intuition about the anthropomorphic information of Minimal Art.

Fried has a third and corollary observation on the nature of Minimal Art, bearing some relation to the sculpture of George Segal. The theatricality or stage presence of Minimal Art, he argues, is "a function of the special complicity it extorts from the beholder." Something is said to have presence when it insists that we take it into account, that we treat it as a serious matter and act accordingly. The experience of being *distanced* by a work of Minimal Art is crucial to Fried: "The beholder knows himself to stand in an indeterminate, open-ended and unexacting relation as subject to the impassive object on the wall or floor." The idea of *distancing,* a theatrical notion for which Morris receives credit, is compared to the effect the silent presence of another person has on those who unexpectedly come upon him. Encountering a work of Minimal Art—or, for that matter, a work by Segal—in a darkened room is strongly, if momentarily, disquieting in just this way.

One of the clues to our knowledge of objects is supplied by our sense of the forces of gravity acting upon them in actual space. Our grasp of the weight of an object we have not encountered before relies on associations with volumes and materials we know, as well as on color and stance. In Minimal sculpture, as it appeared in the mid-sixties, color and materials were kept purposely neutral; form defined mass but concealed volume. Stance, therefore, became an important gauge of an object's weight.

For Segal, stance is similarly intriguing. To maintain a physical equilibrium, his plaster figures provide counterweight for the often bulky furniture and fixtures. He may instinctively choose heavy-set models—and their casts, as we know, are thicker by one-eighth of an inch—but their stance will determine the

intuited weight. Segal's figures are shells without color and content—and so are Morris's L-shapes and cubes. The fact that these objects look heavy can be explained only by the way they stand and the environment in which the artists have placed them. A sensitivity to the specific demands of gravity seems to enhance the work of both Segal and Morris, their figurative and abstract persuasions notwithstanding.

Segal, like Morris or Judd, has met with objections like "there is not enough to it," or "anybody can do that." Surprisingly, they have come from critics who would not dream of questioning the validity of Duchamp's ready-mades. This reveals their respect for the primacy of choice over manufacture, but not for the relative elimination of choice from manufacture. To them a Judd box is "dumb" and a Segal figure is "coarse," both for the same reasons. In 1961 Segal decided to substitute faithful recording for free interpretation, and the subject's own body shape for an artist's vision of it. Segal's plaster casts, therefore, have only slightly more art content in the traditional interpretation than Don Judd's galvanized iron, modular, and often factory-made boxes. The shape these boxes exhibit, like the form of a Segal cast, comes from a non-artistic source and, so the argument goes, is not *artistically* treated. In terms of the artisan's ethic, they do not even show *work,* that is, obvious effort and inventiveness of form. The inventiveness, of course, is in the idea, and the effort is no less real for not being immediately apparent. The point is that Segal shares with the Minimalists, on a theoretical if not always on a practical level, a concept of work determined by decision and control.

A reductive tendency is characteristic for more than just Minimal Art and is, indeed, an operative principle in the making of all good art. Segal has delivered repeated and convincing proof that, in his work, less is better. He subjects his work to progressive exclusions and the presentation of a revealing part or fragment in lieu of the whole. Surfaces may be stripped because they divert attention; figures may be eliminated because they crowd the space; objects may be simplified because they resist perception. Assemblage and early Pop Art tended to have a *hot* or *busy* look. When he made *The Gas Station* Segal was tempted to cramp it with specific references to its function and locale: No-Nox gasoline, decals of friendly service managers, tire advertisements, samples of mechanical parts, listings of services provided, and a large circular GULF sign. As he went to Paris, in the fall of 1963, to set up his show at Ileana Sonnabend, he left *The Gas Station* "florid, heavily collaged like an homage to Cubism." A bit of self-flattery may have crept in along with too much historic awareness, for a photograph shows that it had an ill-conceived Pop Art look that would certainly appear very dated had the work been allowed to survive in that state.

In Paris Segal encountered European space for the first time in his life:

"Every square inch was ornamented, and the Frenchmen I met pushed themselves right up to you as they spoke. I held them back at arm's length." He was struck by the fact that everything was smaller, from tables, chairs, and coffee cups—in his sedentary experience—to cars and expressways—in his traveling experience. But there was one glorious exception Segal recalls: the awesome spaces of palaces, churches, and city squares called into being not by ordinary humans, but by the great temporal powers of history who did not pattern their dreams on a human scale.

Since the artist, by his own admission, is more interested in space as a personal than as a public expression, those dehumanized spaces actually bothered him. Space as a dimension of history hung too heavily over him in Europe, and space as an expression of everyday life choked him. He longed for that casual disregard for history, as well as for the isolation, distance, and austerity of his own environment. It is his handling of space and his decorative restraint that make Segal's work look *American* to European observers, not necessarily the objects through which he defines it. It was quite natural that upon his return he removed all but the essential indices from his gas-station environment. "I was no longer interested in side comments," he explains.

As surfaces are bared, simple forms reinforced, and uncluttered space allowed to let the eye wander, a *found* or *accidental* Minimalism shows up in Segal's sculptures. It resembles those saliently reductive details that struck Dan Graham[28] in the styleless features of a suburban landscape with its bungalows, factories, and churches. Segal relishes and takes full advantage, in his work, of factory standardization, mass-produced design, synthetic materials, and unintentional geometry. The evidence can be found in his use of plastic imitation tile or brick, prefab and factory-size units, and metal-strip finish, but also in old doors with panels stacked like boxes, window frames echoing De Stijl, and stairs with a ziggurat profile. To those who question him about the shape and properties of the forms he uses, Segal is liable to give that deadpan line: "Because the materials come that way."

A paramount concern of Minimal Art is how form affects and, indeed, structures the space within and around it. We have never been made more aware of the power and potential of negative space. In Segal's sculpture, space strikes the viewer positively, through enclosure, or negatively, through exclusion. There is never a question of access as we stand before a monument or contemplate a sculpture we can hold in our hands. But because Segal's sculpture is patterned on a human scale, the space it occupies—structured by the forms of figures and objects—either invites or resists our presence.

Segal's space is like a subjective frame put over or on top of reality, but never quite fixed in its position. The viewer may guess or intuit it, but it cannot

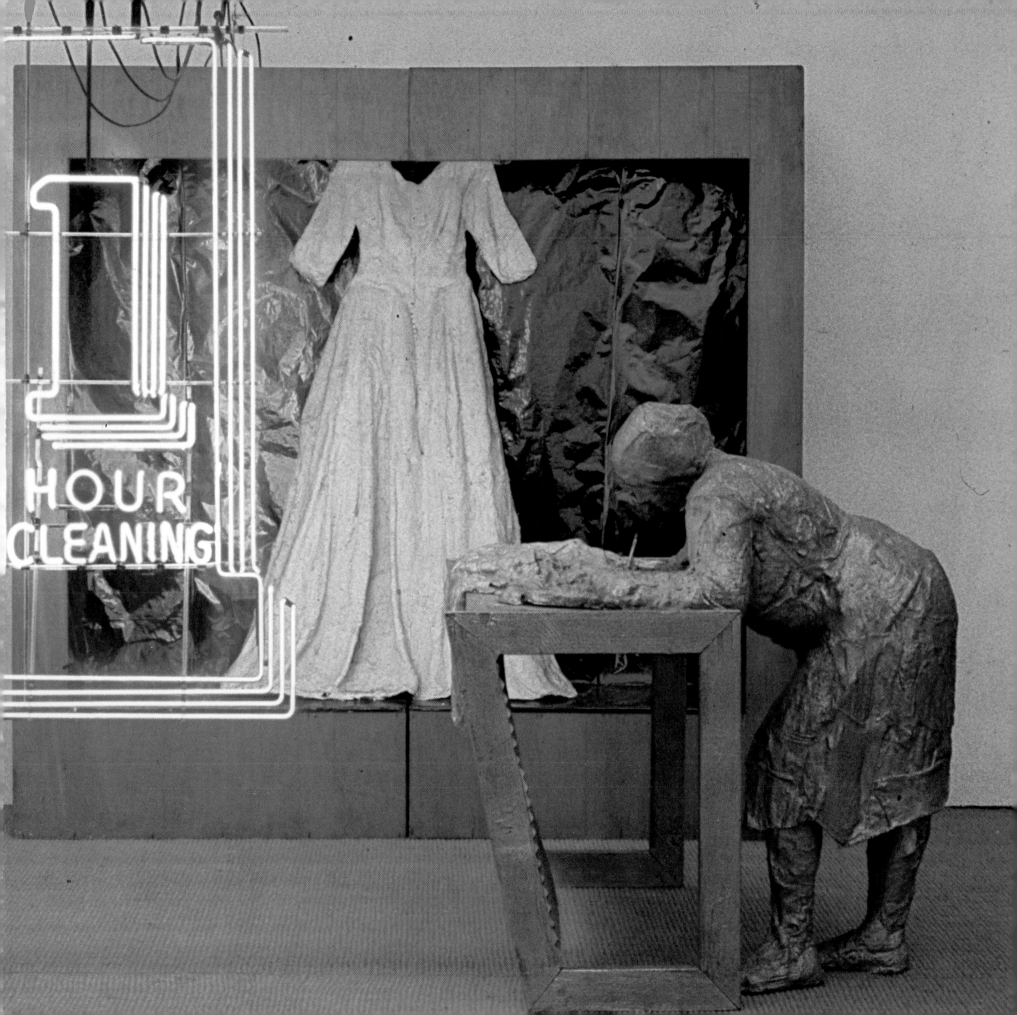

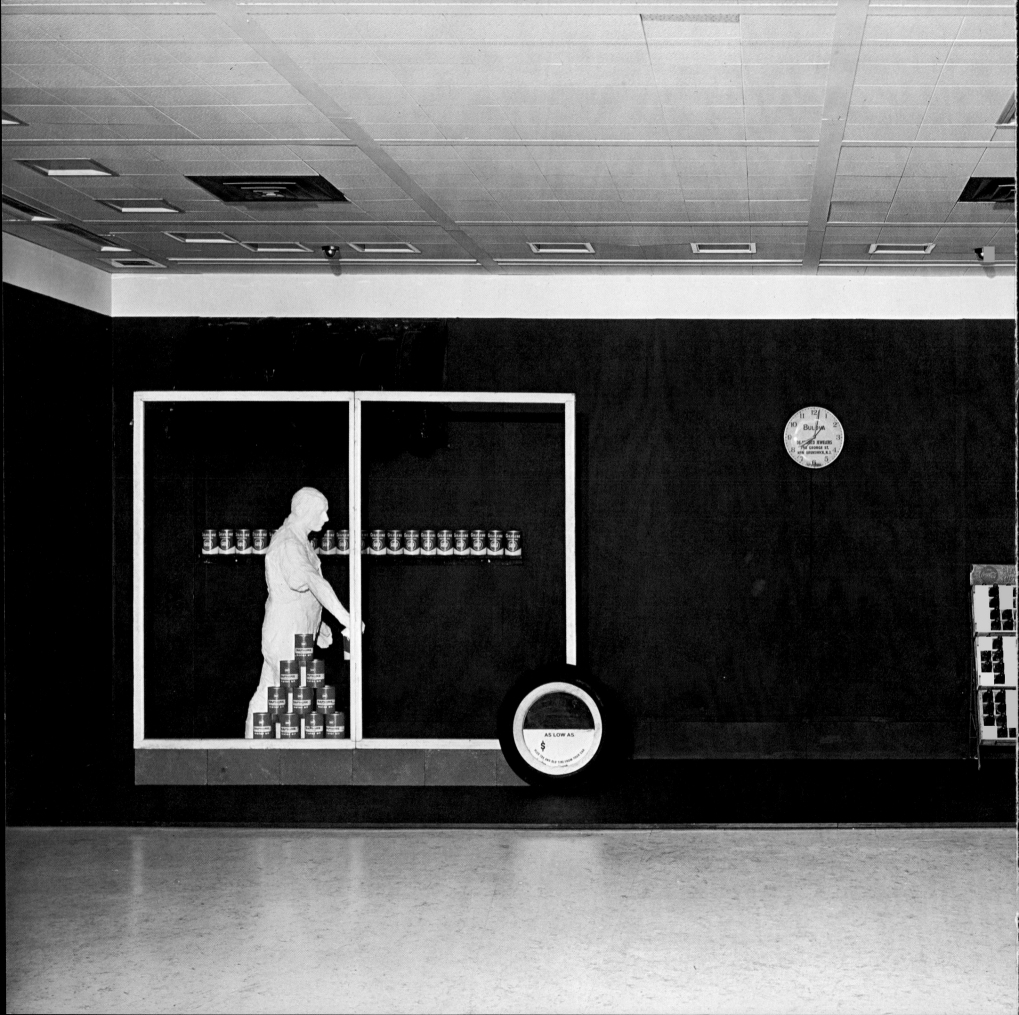

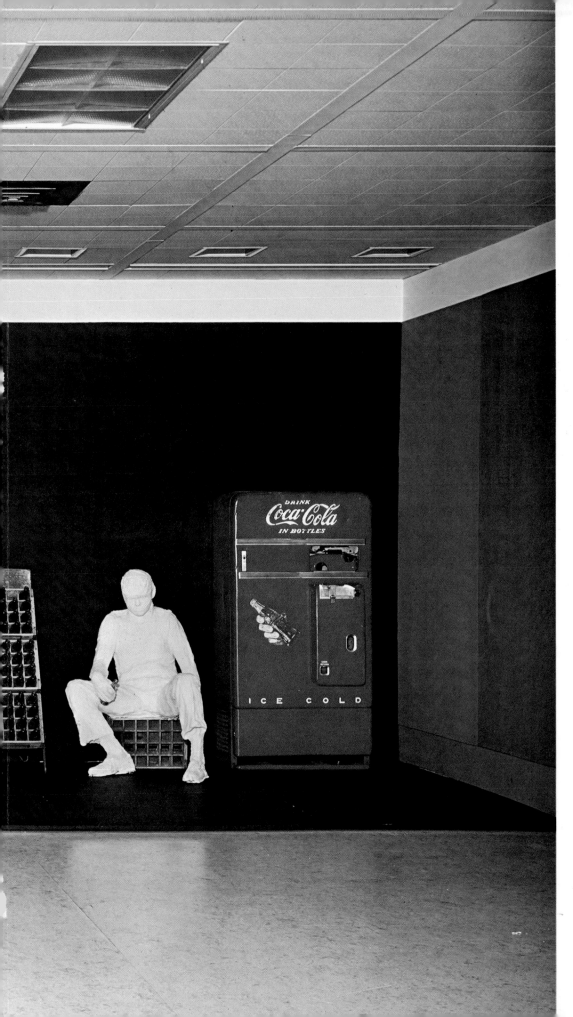

12. *The Gas Station*. 1963–64.
Plaster, metal, glass,
stone, and rubber, 8′ × 22′ × 5′.
The National Gallery
of Canada, Ottawa

THE GAS STATION

Begun before Segal left for Paris in 1963, changed after his return, and finished for a show at the Green Gallery in the spring of 1964, *The Gas Station* was not only longer in the making, but also bigger in size than any of the artist's previous works. The time and effort that went into it were well spent, for *The Gas Station* epitomized Segal's creative powers up to that time and set a standard for later works. Fittingly, its journey to São Paulo in 1965, its inclusion in the Metropolitan Museum of Art's "New York Painting and Sculpture: 1940–1970," and its acquisition by the National Gallery of Canada have no doubt made it the most widely seen sculpture in the artist's oeuvre.

It is rare, indeed, for so many of a sculptor's ideas and means to be combined, harmonized, and forged into unity in any one work. The choice of subject is felicitous as an expression of interest in that American experience, the highway, and the sprawling subculture it produces. The work is a quintessential contribution to Pop Art imagery, with its used-tire rack, pyramids of oil cans, Coke machine, empty-bottle crates, and commercial clock. Two men, one walking and one sitting, were cast to animate the long corridor space, but no dialogue exists between them, for the man who sits on a crate is tired and unresponsive, while the man who carries the oil can is absorbed in the routine of his workaday world. They are prisoners and products of the environment in which they perform mechanically— about as useful and dispensable as the shelved tires and the stacked cans. If Pop Art is weighty with social comment, then *The Gas Station* must be credited with its share of such observations.

Segal tells us that the work's feeling of space originated in his sensation of driving at night when the sides of the road look like the sides of a long black corridor. A gas station appears like an oasis of light in that corridor, but it is still very much connected with the driver's sense of unbroken continuum. Obviously, we are no longer talking about subject matter, but rather about how we perceive space—not realistically, but compressed from the vantage point of a vehicle in motion. It is this abstract and kinesthetic perception of objects in real space—specific objects and primary structures—that Segal brings to his art. In the service of representation he applies general notions about form and space to his carefully composed environments, which parallel those of his Minimalist colleagues.

The Gas Station is a series of checks and balances. The motion of the walking man is pitted against the inertia of the seated man. The rectangle of the open window frame contrasts with the closed and blocklike form of the Coca-Cola dispenser. The serial progression of tires and oil cans, directed from left to right by the walking station attendant and the tire on display, is stopped by the empty-bottle crates, tired driver, and battered Coke machine on the right. A blank and empty space linking the two parts of the composition is punctuated by a clock suggesting a time-space continuum. Figures and surrounding objects are realistic and rigorously defined; space and boundaries are fluid and indeterminate. The scene, which has a readable quality for anybody who has ever made a fuel stop, easily slides into the realm of symbol, archetype, and metaphor.

Who were the models for *The Gas Station*? The man with the oil can is "Phil," who runs a gas station a mile from Segal's home. The artist remembers him as "very vigorous, exactly like all the chicken farmers around here. He was overeducated for his job, like all the Jewish, utopian chicken farmers in that part of New Jersey, a child of the Depression with a natural intelligence and curiosity." The man on the crate is Segal's sculptor friend Gary Kuehn, hardly the weary driver or casual loafer he is made out to be. Though Segal has the uncanny ability to turn a 10:35 P.M. close-up of a Gulf station on Route 1 into a timeless statement of toil and drudgery, his mind is forever ready to turn the tables on reality and those truisms we attach to it: "My private irony is that if I took away the oil can and turned his fingers up, Phil could be St. John the Baptist in coveralls."

13. *The Dry Cleaning Store.* 1964.
Plaster, wood, metal,
aluminum paint, and neon tubing,
8′ × 9′ × 7′2″. Moderna Museet, Stockholm

THE DRY CLEANING STORE

Another quick-service, working-class establishment, *The Dry Cleaning Store* is a logical sequel to *Woman in a Restaurant Booth* and *The Gas Station,* and they are all in the Pop vein—related to consumer culture—that characterizes Segal's sculpture of the early and mid-1960s.

The second work to feature light prominently, it can properly be compared in this respect with *Cinema* of the year before. *Cinema* is a strong single image of unquestionable gestalt; *The Dry Cleaning Store* is subtle and complex in its varied parts. Instead of the dominating white light of *Cinema,* there are the shades and reflections of color that refract all forms and all parts of the composition. One approaches *Cinema* and is stopped in one's tracks; *The Dry Cleaning Store* bids us to enter and explore it. This invitation springs from the light—a tease of neon versus an assault of fluorescent; from the product touted—softly laundered clothes versus hardsell dreams; and from the plaster occupants of this imagined situation—a woman bending down versus a man reaching up.

The Dry Cleaning Store presented Segal with a novel set of problems, none of them easily solved. The inclusion of neon, a fickle and treacherous light, forced him to rethink the joining of figure and environment in unified colors. He didn't like the colored light bouncing off the white plaster, so he painted the figure a metallic gray—the closest he could come to a neutral, unspecific, yet responsive surface. The woman is joined to the counter over which she is leaning as she checks off a laundry list, through the counter's same metallic color. This establishes another color and surface connection; the blue metallic paper sets off the white wedding dress in its prestigious display niche, with the garish emphasis of a popular neighborhood store. As the entire piece is lighted by the red neon "1-Hour Dry Cleaning" sign, the mostly metallic surfaces sputter with hot pinks, purples, and blues in an intriguing yet not fully resolved way.

The Dry Cleaning Store is as specific—and this may be a source of trouble—as *The Gas Station* is unspecific in its spatial definitions and its reproduction of a real-life model. There is a dry cleaning store in New Brunswick almost like it, where Segal remembers seeing such a wedding dress looking absolutely splendid in its grimy surroundings.

The sign, suspended from the ceiling, had to be custom-made because none of those readily available were proportioned to satisfy the artist. Making the sign flash on and off was rejected because Segal hated to see the almost psychedelic strobe-light effect shatter the solid contours of his forms. The woman posing, despite a lumpiness of posture and the sloppy bend of her back, exudes a down-to-earth sensuality which has not gone unappreciated; when *The Dry Cleaning Store* returned from its first showing at the Green Gallery, the silver paint had worn off the laundress's behind, a sure if unsubtle compliment to her physical appeal.

Segal has volunteered his own symbolic interpretation. He sees the woman as the guardian of the bride's chastity—a chaperone or duenna. The bride is, of course, alluded to in the wedding dress, pristinely guarded in its gaudy showcase. Worn for one day and laundered the next to be closeted forever, it implies purity, the loss of purity, and the tricks life plays on the pure at heart; it is also a sad metaphor for women's loss of dreams and expectations. "We are dealing with another level of ordinary human activity," the artist states, "but somehow one cloaked in an aura of mystery. The fact that the store is so crummy brings it back to the 'I am going to put you in your place, Charlie' atmosphere of America. This is the way we treat ancient, powerful myths," he ruefully concludes.

be physically defined or put into precise dimensional terms. It resides in the mind, perhaps more than in the eye, but is recognizable and seems conditioned by our frame of mind as much as by the exterior factors of direct and ambient light. In addition, it is kinesthetic, for it changes as we move and seek another viewing angle. This combination of psychic and physical determinants corresponds to the artist's intent to keep space fluid and is borne out by the variety of ways in which a work by Segal can be, and has been, photographed.

If the stance of his figures and the shape of his objects are firmly rooted in the artist's experience, so is the quality of space. Indeterminate in the early sculptures, like the space surrounding the figures in his paintings, it soon assumed the particulars of the artist's environment, either that of his attic studio or the abandoned chicken coops. Consciously or not, Segal lifted the space from his environment along with the figures and objects as he prepared to install them in a museum or gallery.

One can often tell in which of Segal's two working areas a sculpture has been conceived. Compression and more depth are likely to refer to the attic, while linearity and frontality betray the railroad-car configuration of the chicken coops. A low ceiling sets a height limit in both places, which accounts for the scarcity of oversized works such as *The Billboard* and *Man on a Scaffold*. The intimacy of Segal's sculpture is readily explained by the intimate character of the place in which it was executed. It reminds us of Brancusi, whose ambition was to populate his living space with his sculptures, and it contrasts with those sculptors who want to move their work out into the open, such as David Smith at Bolton Landing. Minimal sculpture, despite its more recent forays into Land Art, is more at ease inside for much the same reasons as Segal's. They both need an interior space to provide them with the *psycho-formal* equivalent of acoustic shell.

Those who have visited that unique setup of abandoned chicken coops, three hundred feet long and a mere eight feet high, have not failed to be impressed by its starkness, relieved only by casually scattered plaster figures and their furnishings looming in the crepuscular light. Haunted by the ghosts of work completed, it is also pregnant with works yet to be born. We can be sure that these works will be marked by the same spatial characteristics. There are times Segal feels as though he has been working on one continuous sculpture.

There is a consistency of space and mood in Segal's sculptures that may produce *déja` vu* but never appears repetitious. A chronological review of the artist's works is the armchair equivalent of years of walking through those chicken coops, stopping and pausing and reflecting on sculpture in progress— yesterday's, today's, and tomorrow's.

It is not easy to maintain a natural continuity when works are torn from such

a fitting context. But increasingly Segal has become a master in transferring and re-creating that fabric of formal, spatial, and psychological relationships. He asks himself the question: "How can I make the space flow and how can I make the viewer travel through that space so he will have a whole series of shocks and encounters with the figures as well as with the objects?" In a gallery, he has to overcome the handicaps, singly or combined, of a lack of space and a central instead of a linear orientation. In a museum, he is more likely to run into too much overhead space and not enough light control. Yet Segal has superbly demonstrated that his work can be inserted in unlikely locations without losing its effectiveness. In particular, he has managed to create clusters of night-time situations in extremely tight space. They were marvels of openness and spatial revelation despite the need for compression.

Segal is better at compressing space than at drawing it out. It is perhaps a truism to say that he makes the most of his limitations, but in the area of exhibition design it is not generally recognized that less space can be better. Segal proves it with great authority and remarkable success. Through close proximity individual sculptures become mutually supportive. They invade each other's spaces as boundaries are erased or kept purposely ambiguous. Beyond theme or mood, they demonstrate a real kinship of space.

A landmark installation at the Darthea Speyer Gallery in Paris in 1969 not only enhanced the individual works shown there but proved that, with miraculous economy and stunning results, neutral space can be turned into art space. Segal recalls the impression of a Rothko exhibition at The Museum of Modern Art in which the canvases were put closely together in small cubicles: "People looked beautiful within them because they were intensely beautiful spaces. The paintings emanated, and the viewers bathed in, glowing light."

If we assume that a reduction of the space within and around a Segal sculpture enhances its evocative power, how then does this principle apply to a reduction of form? In 1969 Segal began making partial casts that were shown directly on the wall or in shallow boxes—dramatically reduced versions of full-size environments. It must have been tempting, as an exercise, for a sculptor whose work relies so heavily on spatial and environmental articulation, to reduce exactly those elements in order to see with how little he could get by. Already he knew from experience that the cast of a single nude body on a plaster mattress was articulate enough to show space and environment as well as the identity of its maker. But what if he selected just one telling part of the body? Would it still be comprehended as sculpture, and would it still be his?

Fragments are like glimpses—they grow and complete themselves in the mind of the beholder. Glimpses are lost on the slow and the dumb. They require a fair amount of experience and knowledge from the observer. But they may

also yield more, as they license the imagination to go beyond what is directly visible. Such are the advantages and disadvantages of glimpses in art. In Segal's sculpture the fragments function as flashes of memory as well as glimpses of people actually seen. Isolated, they are formal notations, poetic and brief. But hung on a gallery wall, with space between them, at some distance from the viewer (the rudiments of an environment), they come alive. They seem more than they are, they trigger the imagination, and they are as clearly Segal's as any full-scale work.

The boxes, when arranged in a row, are a visual shortcut for walking down a street and catching glimpses of people and things in windows and doorways. What we see in these abbreviated versions is all the artist cared to notice or happened to remember. Segal speculates on the origins of his boxes: "What's the edge of a glimpse? We see 180 degrees wide but can focus on a small detail, only dimly aware of the rest of the field. With a camera we can choose arbitrary limits as a metaphor for psychological focus. Couldn't I carve out an arbitrary chunk of space and see a glimpse of a figure in relation to part of an object, in relation to that amount of space?" The focus he requires is both psychological and physiological. since the mind edits what the eye, however fleetingly, sees.

The artist suspends the dimension of time as he combines the seen with the remembered. But he also destroys the literalist's concept of form, as he invites us to fill in form where there is none. Reduction of form seems to give Segal more options to move between reality and illusion, but it diminishes his control over both the space and the viewer.

Segal's figures show arrested motion and weighty repose. They seem caught in a moment of stasis, and balanced between an act or sentence just completed and the unquestioned prospect of more of the same. We never encounter crisis, a critical moment, an apotheosis, or a decisive act. The narrative, if any, is held to a minimum. Instead, we are shown bodily routine, a state of mind, a random moment in time. There tends to be a minimum of specific and a maximum of general information. This explains why Segal's figures strike us as low-key and always appear silent.

Segal admits having an interest in silence, and his white plaster figures attest to that in more ways than the obvious. Silence, pregnant and telling, is a pervasive condition of Segal's work. It induces contemplation and triggers speculation as to where that impression of silence originates other than in the stage presence of these figures. Associations with the theater are obvious, and yet silence is the very opposite of what the theater normally produces. People as seen in Segal's sculptures are not only in repose or quietly going about their business; they appear withdrawn, uncommunicative, or downright dour and sullen. In the few instances where a conversation or address is implied by the

sculptor, the impression that we have entered during a lull in the conversation, or a pause in the speech, is felt even more.

The ectoplasmic character of what Kaprow called Segal's "vital mummies" might be another clue to what strikes us as silence. Spirits are not known to have voices. The plaster casts, white and depersonalized, are like the ghosts that haunt our conscience and wander, mute and noiseless, through the corridors of our dreams. We suspect a human presence stilled and muffled inside those shells, so uncomfortably reminiscent of the imprint of the dead. Have they fled the pages of what Barbara Rose has called "our own Book of the Dead"? Instead of animating their surroundings, they perform the opposite function. Nobody talks, after all, with walls or inanimate objects. The nocturnal setting of so many of Segal's compositions, propitious to stage and spirit associations, hush and silence the viewer.

Mirrors are to space what ghosts are to people. They add illusion but no substance. They also reinforce silence in a mysterious way, perhaps because we encounter ourselves and no words are uttered in the confrontation. Segal, who recognizes layers of mystery in his work, has made an auspicious use of mirrors to underscore this. But even more, he includes the mirror for the way it catches telling details, startling angles, sudden beauty. They turn an environment inside out, while reducing it in the process. Or, they highlight one facet that in no other way could have entered the field of our vision.

Moreover, a mirror stresses multiplicity of viewpoint and the three-dimensionality of space. Most important, it lures the viewer into the composition, breaks down whatever barriers exist, and turns spectator into actor or accomplice. If already we feel pressed into embarrassing association or closeness, voyeurs against our will, then a mirror is a visual equivalent of that pinch in the arm to prove to ourselves that we are awake and not sleeping. Windows offer psychological escape, mirrors act as a mock escape that only heightens our sense of imprisonment.

Segal's more elaborate tableaux are like a silent version of a Happening. The early sculpture and Kaprow's Happenings make the comparison valid, to a point. Of course, this is not a reflection on the genesis of the work, nor does Segal encourage such interpretations. He has never made the viewer a participant, actual or by implication, because it clashes with his sense of space, control, and direction. But the visual association lingers somehow. Since Happenings had a loose structure and low information output, and since neither action, nor space, nor time were predetermined, the nonparticipant tended to be at a loss for clues. The simultaneity and discontinuity added to the confusion: everyone seemed to be doing something everywhere, all at the same time. The time-space-action focus in Segal's work is left equally ambiguous.

We sense that these effigies are engaged in something, for all their immo-

bility; that the space represents reality, for all its abstractness; that their time is our time and not the theater's compressed or history's suspended version. Since Segal's personages do not address or perform for an audience (even the actors he has portrayed are less than persuasive), they are inner-directed like the participants in a Happening. They offer the viewer the same discomfort, embarrassing him, while making him feel superfluous or unwanted.

But there is an important difference between Segal's sculpture and Happenings. The kaleidoscopic structure of Happenings, and their time-space-action overlap, are reminiscent of a breakup of form that stretches from the Cubists through Pollock. It is against that fragmentation that Segal has consistently directed his efforts. If there is any specific reason why the comparison with Happenings is invalid, it is this. One might speculate whether Yvonne Rainer's innovative dance might not offer a more fitting parallel than the "classic" Happening. Her work shows a lack of incident, uses "found" movement, "tasklike" activities, neutralized performance, low energy investment, and is *unspectacular* in the original sense. Neither seeks virtuosity: however unconsciously, Segal avoids Rodin as Rainer avoids Petipa.

It should be clear that both artists—one in sculpture, the other in dance—employ different but kindred means, draw strength and conviction from the same aesthetic—the Minimal, to be sure. That they are unemphatic and unspectacular is not to be confused with a poverty of diction or a failure of the imagination. The dance *material* is intended to speak for itself, just as in Segal's sculpture form, space, and gesture are more important than narration or subject.

Robbing sculpture of its color is as "natural" as draining a man of his blood. Throughout the history of sculpture, color, inherent or applied, has been the rule, neutral white at best an exception, at worst a classicist aberration. When Segal decided to leave his plaster casts white, he made a deliberate decision. It can be compared with Robert Morris opting for gun-metal gray and Tony Smith for flat black. The fact that the decision against color was made by a painter, in the aftermath of Abstract Expressionism and on the brink of Pop Art, both unthinkable without color, makes us question Segal's motives.

Any painter who has abandoned his brushes to become a sculptor is likely to have done so, in part, because he was disaffected with the use and weary of the potential of color in his art. Segal had been a gutsy but never an original colorist. The art of assemblage employed color as a property and function of the materials it utilized. Was this, perhaps, an approach he could pursue? For all its spontaneity of appearance and appeal to chance, formal and coloristic decision making was very much in evidence. The assemblagists' reasoned use of color lent legitimacy to Segal's reliance on the inherent coloration of plaster and environmental properties. It coincided, moreover, with a shifting of aesthetic

priorities in his work from color to form and space.

When, on occasion, Segal has applied color directly to his white plaster casts, he has done so with the antinaturalistic bias of the Abstract Expressionists. *Woman Looking Through a Screen Door* may serve as an example in which such colors were used within one no longer existing work. *The Costume Party* is a more recent example in which red, green, yellow, silver, blue, and black were used, not all in one work but ranging over six figures, each a different color.

A definitive rejection of the Abstract Expressionist bias came when Segal decided to paint a plaster figure that seemed too harsh in the neon glare of a 1-Hour Dry Cleaning sign in metallic gray—a neutralizer and not a color. The fact that it occurred at the very moment and for the very reason he introduced light into his work lends strength to my contention that, as early as 1963, *light as color* became Segal's alternative to *color as paint.* The metallic gray, used in half a dozen instances, is really a non-color on the order of the non-colors used by the Minimal sculptors.

Light in lieu of color has the combined virtues of reducing specific and reinforcing general coloration. Color is a fragmenting, light a unifying device. When Minimal Art was at its grayest (or low-key monochrome), the manipulation of gallery lights rose to almost fine-art status. His Green Gallery colleagues chided Segal for insisting on spotlit isolation. But to them, light was similarly important. All subsequent museum exhibitions devoted to Minimal Art and Primary Structures have borne this out.

Spotlights, an auxiliary and not intrinsic element of the sculpture, represent the only instance where an argument about propriety and suitability can be reasonably entertained. The same work may be exhibited to equal advantage in the broad light of day, allowing it to pick up a different coloration—provided, of course, that the subject does not dictate a night-time setting. In that case, a naked light bulb is the most rudimentary, and usually the most fitting, complement. It lends the graininess or suggests the sepia we associate with early photography or Walter Murch's monochrome still lifes.

A light source functionally locked into the sculpture is the artist's favorite solution, at once formal and coloristic. In recent years, Segal has gone a step beyond that. The light is real, but it is presented as an illusion. A hidden source and an ingenious array of plastic foils, pegs, gels, and letters suggest a faraway landscape or a nearby city street. The light is dim and ambient, but much more colorful. In addition, a dimension of depth has been gained, albeit illusionistic, that only light can accomplish. Segal is aware that by getting deeper into light he is also closing the gap between spatial and pictorial concerns. The painter has jumped back into action, restoring color to form and illusion to space.

On his first visit to Paris, in the fall of 1963, George Segal met Alberto Giacometti. He remembers him as gray, almost cadaverous, frail, and covered with plaster dust. It struck him how much the sculptor resembled his work. "Do all artists resemble their work?" he later asked himself. It is well known that people define themselves by the way they arrange objects and spaces around them. It has also been observed that people start looking like the places they inhabit and the people and things they have been associated with for a long time. An artist, more than anybody, defines himself through his work, so it is not that unusual for him to end up looking like it.

Segal believes that he has to work "in vibration with his body." His casts seem heavier and more voluminous than the models who posed. First, the plaster shell is thicker, by necessity, than the body over which it has been molded. Second, the artist uses a single color, white, which accentuates instead of relieving that impression, and an approach to form which favors mass, large surface areas, and broad contours. But there may be a third reason for Segal's sculptures to look the way they do. The artist is robust, squat, and stocky. He intuits and may therefore choose, consciously or subconsciously, models bearing out the same features. While not having Giacometti's freedom to shape form at will, Segal does have the same relativizing perception of the body—a perception based on the recognition and creative intuition of his own.

Giacometti brought about, in his sculpture, what seemed like a world unto itself. He animated it with his spirit and populated it with forms expressive of that spirit. Man and his art merge in a unique instance of creation and feedback. Beyond the original handling of form and an urgency of expression we recognize in all great sculpture, this may be the supreme test—that the artist fashions a world from which he becomes inseparable to the point of fused identity and actual resemblance. David Smith and his world at Bolton Landing provided us with one such example.

Segal's sculpture has the sense of wholeness we associate with the work of a strong artist. It resembles its maker in more ways than one. Those environments are so familiar to the artist that he could have taken each position now occupied by his models and be perfectly at ease. Segal has forged a language that communicates a truth about people here and now which is intensely

personal, yet abstract enough to be universally understood. His works are at once authoritative as conveyors of a message and impressive as statements about form. They can be "read" either way.

Two artists of Segal's generation have created works similarly expressive of their personality, have tried to make the world conform to their imagination of it, and have ended up looking like their works. Claes Oldenburg imagined a world of Brobdingnagian proportions populated with the polymorphous reflections of his mind and emanations of his body. Less protean, perhaps, but more Faustian, Andy Warhol conjured a silver nightmare, that plastic inevitable para-environment which so brutally exposed those who sought its magic glare. On the same high level of accomplishment Segal has deftly projected, in those plaster people and their quietly pathetic environments, the timeless dilemma of man's choice between imprisonment and freedom.

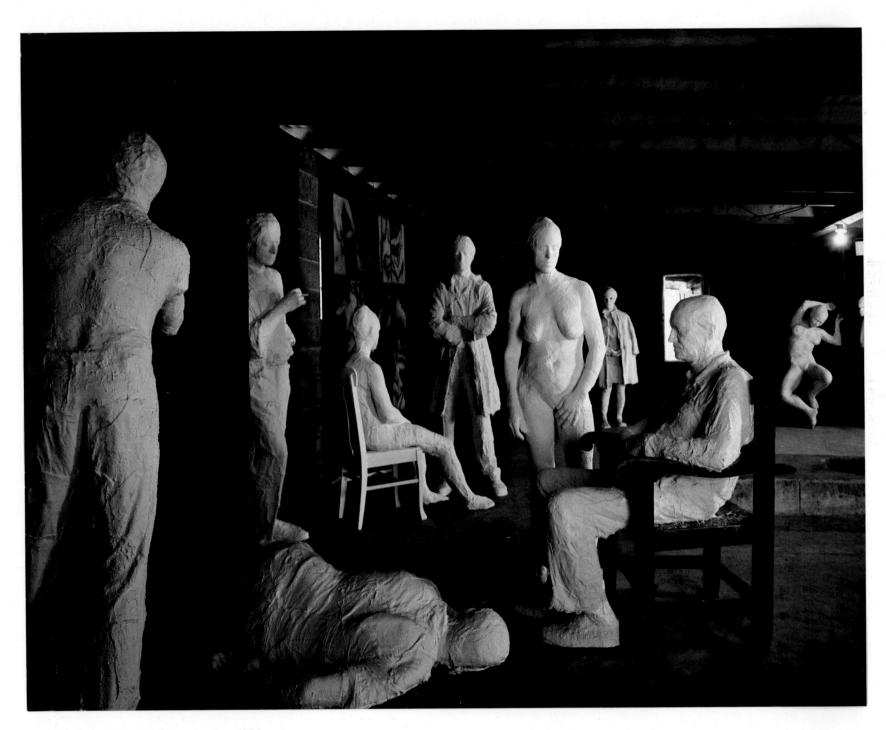

14. View of the artist's studio, 1970

POSTSCRIPT 1974

by George Segal

NOTES ON WALL PIECES

They've been brewing a long time. Started with fragments of bodies, bodied gestures. Strewed them on the floor and walls. They felt like leaves, looked beautiful, I couldn't decide if they meant anything. Accidentally worked with a thin, bony model, got entranced with articulating bones and wrinkles. Cast from the inside, set the fragments into rectangles of rough rolling plaster. The pieces startled me: what each girl was like radiated from these fragments—sexy, voluptuous, naive, defenseless, then hard, brassy, defensive, mocking, then architectural, poised, serene, inner-dreaming, all emerging from rough rock.

THEN TO ISRAEL

First to see the country, then to return in three weeks to work on *Abraham's Sacrifice of Isaac.* Read *Fear and Trembling.* Head full of Kierkegaard's feverish replay of all the possible thoughts in Abraham's head on the trip to murder his son. Which was right? No matter. It was all right—the scenario of all the possibilities. Wasn't prepared for the landscape: heat light vast mountains of raw rock upended by a giant hand smelling of anger and vengeance. Dry grit in your mouth; light-headed hallucinations of mountains of natural rock crumbling into visions of Egyptian and Greek temples. Then green awnings cool shade wine perfume of wisteria, memories of Valentino movies, Lawrence of Arabia, writhing moist belly dancers, dreams dictated by the harsh rocks, the Proud Israelis finishing every paragraph with "... if we had lost, they would have thrown us into the sea." All that fear and nightmare just under the swagger. All those extremes so close.

Abraham ground to a halt on the rock, the hand holding the knife drawn back. The rock-like desolate lunar landscape, the son soft vulnerable trusting, looking at his father. Menasha posed for Abraham, weighing 300 pounds. I cut off some of his belly, careful to leave his breasts, fatty hips, blob of genitals under tight wet pants. Some Israelis quick to pick up: " ... the Hebrew phrase is almost one word: ABRAHAM OUR FATHER ... why do you make him ABRAHAM OUR FATHER AND MOTHER?" Arouh, the artist-diplomat babbling about Ulysses in Nighttown where the Madam goes through a succession of rooms changing identity and sex. The local TV people nervous that I intended political

criticism of the government sending their sons off to die. But I was filled with this place of geologic cataclysm, broad wadis for chariots and tanks, the Levantine energy and shouting that had produced extraordinary human inventions. Abraham had declared the value of human life. Is that secular, political, military, economic, or religious? I prefer impurity.

ON *PICASSO'S CHAIR*

I kept looking at the first wall pieces I had finished. Sometimes they looked like the girls who had posed. Sometimes they looked like Renaissance bas-reliefs or Greek temple figures. Sometimes they reminded me of Cubist paintings with one plane advancing in front of another. A '33 Picasso etching stuck in my head, maybe because my girls were always telling me about trouble in their love lives, Pablo was drawing about trouble and delight in his love life, drawing his girl neoclassic with a coy Victorian gesture, making the cool Cubist structure a bitchy metaphor of a woman with balls in her vagina, fat puffy arms with tiny Pomeranian-dog fingers.

I used the etching as a blueprint and built it as a sculpture in real space, chuckling for two weeks. Sure enough, it started from a back plane, advanced out in simple layers, and the damn thing even stood. Kept staring at the shallow negative space: rich, intense, full of possibilities in small format. Wouldn't do if you had someone lying down and wanted to see feet sticking out. Can't throw away Renaissance deep space, real space, or illusion of space. But lots of use for shallow space. That sly old sceptic knew everything was true and false. Got intrigued with the coy alluring matter-of-fact model gesture of putting on and taking off her robe. All the little crevices made the same packed rhythmic shallow space I liked in my Cubist quote.

THE ROCK

Came back from Israel convinced I was going to do a series of heavy Old Testament pieces. Instead worked on a stream of voluptuous girls emerging from plaster rock. Wanted to do a complete figure of a woman standing in the niche of a huge rock. Used my latex mold of Jerusalem rock, magical with memories of goats, olive trees, dirty kids, screaming Phantom jets, and a paperback Kabbalah. Dumped a load of sand outside my studio, shaped the negative of jagged angles and planes, cast five times, cut and fitted the shapes together to make first a massive vertical, then a pointed horizontal cantilever, to make an oppressively heavy overhang just above the head of the standing woman. The top of the rock should ooze water that will fall as a veil in front of the woman. Think I'll do that.

PLATES

MAN SITTING AT A TABLE

This work was the first Segal cast directly from a live model and fitted into an environment of ordinary home furnishings. The model was the artist. With the aid of his wife, he covered himself with plaster-soaked bandages, one part of his body at a time; after each section had hardened, he removed it and then reassembled the figure, with more plaster to cover, fill, and join the pieces into an integral, self-supporting hollow shell. Table, chair, and window came without alteration or embellishment from the chicken coop/studio in which Segal had been experimenting for some time with freely modeled plaster over wood and chicken-wire armatures.

The shock caused by *Man Sitting at a Table* when it was first exhibited appeared to result from its ambiguous fusion of directness and remoteness, its combination of realism and abstraction, in a manner without precedent or parallel. Segal was exploring new terrain in an area whose layout and perimeters he only dimly perceived. From a literal image with a specialized meaning the artist had distilled a timeless concept. For those unaware of subtle clues indicating formal, spatial, and textural concerns, Segal had violated age-old taboos against making live casts and had substituted artless presentation for artful transformation. While it is true that in 1961 these underlying aesthetic premises had gained credibility in the art world, their application in such a blatantly figurative context raised many eyebrows indeed.

Comparisons with the theater, existentialist philosophy, and other art forms have been made frequently. The sullen but dignified pose, the ready-made props with the plastic table cover and dirty window panes for added opacity, and a theatrical isolation all suggest a play about to begin. The viewer is involved in a disquieting confrontation, not unlike the sudden recognition of a human presence on a darkened stage. Is the man a watchman, a ticket taker, or, more ominously, a judge weighing the guilt of our actions?

The subject appears archetypal, a container of common experiences, in a transformed, intensified, yet muffled way. We sense a fellow human being who is trapped by the plaster but, perhaps even more, by his being alone in a hostile world, unable to reach out. Or is he a simple metaphor for that pervasive mediocrity, without style or articulation, that unites the silent majority into one great brotherhood?

"I deal primarily in mystery and in the presentation of mystery," explains the artist. "If I cast someone in plaster, it is the mystery of a human being that is presented. If I put him next to a real object, it also raises a question about the nature of the real object." Thus art and life are fused and extended into a twilight zone where each partakes of the other and each gains meaning only in the presence of the other.

Ellen H. Johnson has pointed out how their whiteness, associated with all the white marble and plaster figures of the past, places Segal's effigies inevitably in the realm of art. But it is not the whiteness so much as the tranquillity of a pose recalling the mood of Old Kingdom statuary and, in this instance, that unforgettable image of the *Seated Scribe* from Saqqara now in the Louvre. Allan Kaprow has perceptively referred to the detached grandeur of fifteenth-century Italian portrait busts.

"Everybody shares a huge stew of ideas," as Segal once said, and this sharing results from growing up with culture: "When I was a kid from a poor family in the Bronx, I could take a nickel subway ride to the Met and see free the things formerly reserved for kings."

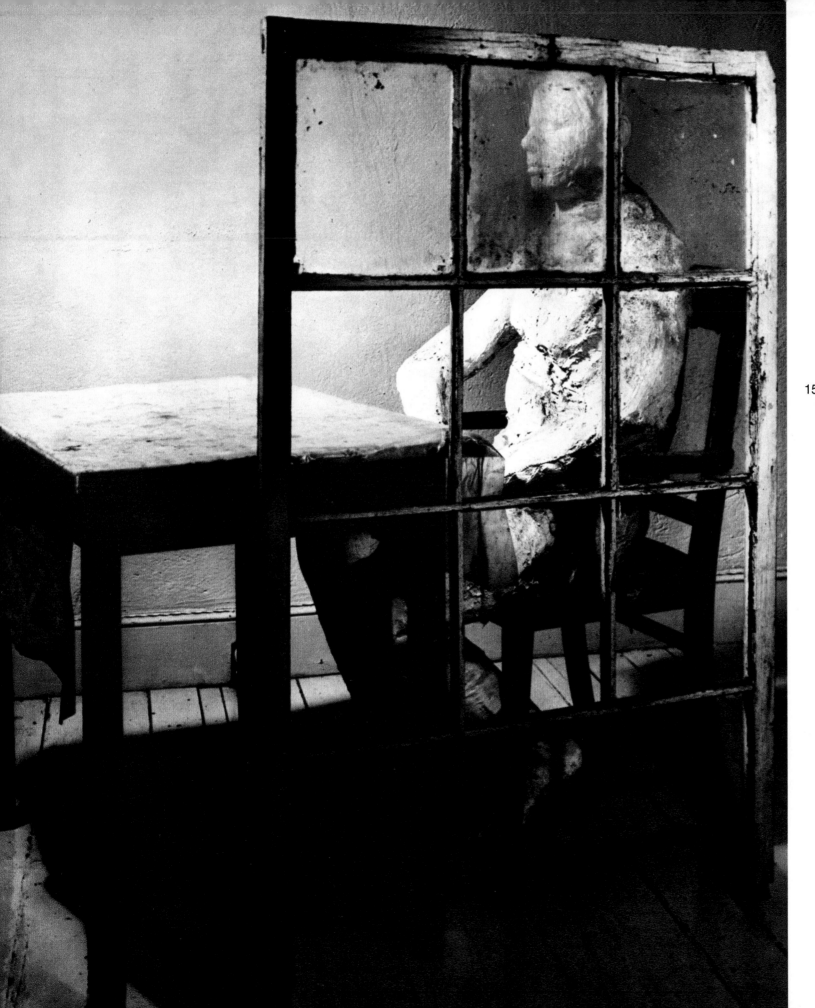

15. *Man Sitting at a Table*. 1961.
Plaster, wood, and glass,
53 × 48 × 48″.
Städtisches Museum,
Mönchengladbach, Germany

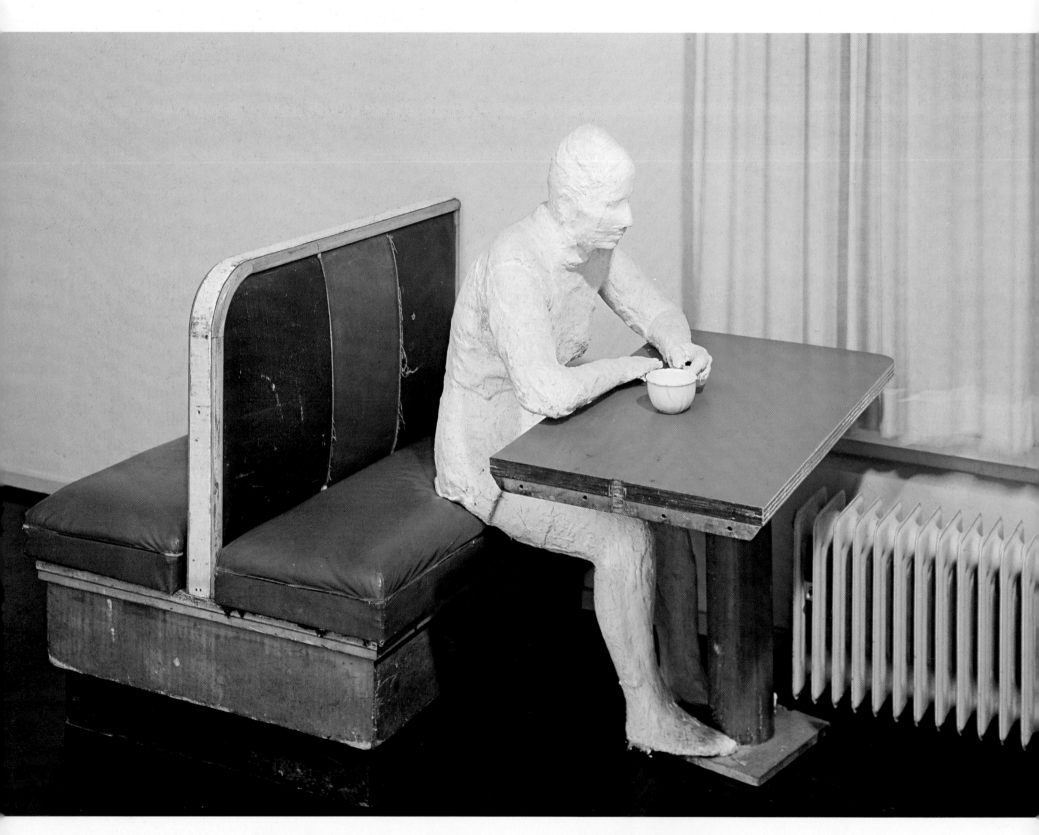

16. *Woman in a Restaurant Booth.* 1961–62. Plaster, wood, metal, vinyl, and Formica, 51½ × 65 × 43¼″
(curtain and radiator are not part of the work). Collection Wolfgang Hahn, Cologne

WOMAN IN A RESTAURANT BOOTH

The artist's wife posed for this "female counterpart" of *Man Sitting at a Table,* which extended the formal and coloristic considerations of its predecessor. The milieu is more clearly defined in terms of common American experience; our attention is drawn to a simple identifiable act, and we are no longer puzzled about stance or posture. If the sitting man kept us at bay—we might just have sneaked around him—the woman sipping her coffee almost invites companionship. Aloofness has yielded to accessibility. The cobalt-blue tabletop and the booth, with its red and green leatherette upholstery and blond wood, radiate an easygoing comfort that the earlier work lacked.

Woman in a Restaurant Booth is as contained and inward-oriented, from a formal viewpoint, as *Man Sitting at a Table* is outwardly extended. The artist recalls being struck by the set of forms inherent in the pathetic discard—"moving on all levels"—that he picked up at a junkyard. Particularly, he was intrigued by the curve of the booth and by the space packed within. Don Judd, then reviewing shows for *Arts,* noted the non-idealistic character of the work, its scroungy and matter-of-fact qualities, which he thought "just great." But he was notably perceptive of a formal feature: "The seat attached behind has no corresponding table, so that the whole seat and the table make two casually reversed T's." Stirred by the "found object" quality of the props that define his environments, Segal is even more delighted when they contain a "found geometry," or an inner rhyme corresponding with his own clear interest in the process of abstraction.

Segal purposely left open the space on the seat across from the woman. It acted implicitly as an invitation to the spectator to observe the woman and her environment intimately, on her level and in her own space. More than just a denial of aesthetic distance and an emphasis on "art space" as different from "real space," it served as an object lesson or probe into what sets one apart from the other. Segal still asks himself where art space yields to the real space surrounding a work of art. Martin Friedman recognized that placement and spatial relationships contribute to the content of a work and saw "the measured vacuum between figure and props as aesthetically and psychologically reasoned."

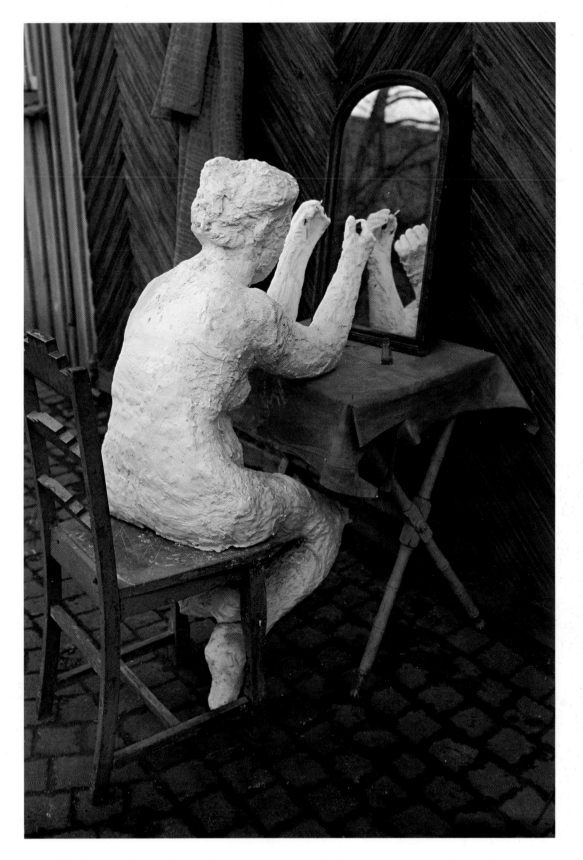

17. *Woman Painting Her Fingernails.* 1962. Plaster, wood, glass, mirror, cloth, and nail polish, 55 × 35 × 25″. Collection Mrs. Fänn Schniewind, Neviges, Germany

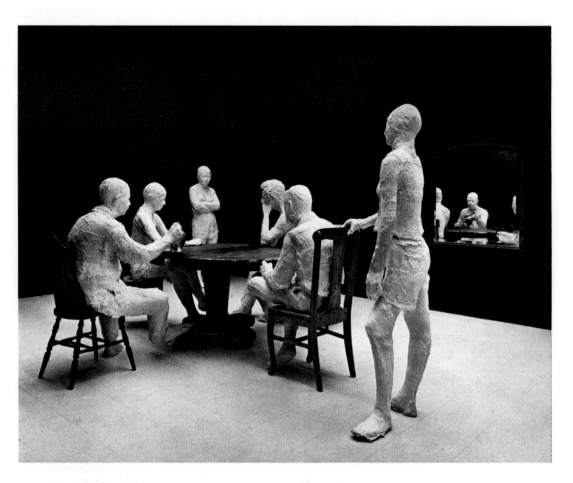

18. *The Dinner Table.* 1962. Plaster, wood, metal, and mirror, 6′ × 10′ × 10′. Schweber Electronics, Westbury, N.Y.

THE DINNER TABLE

This work, the first in which the artist attempted to combine many plaster casts into one lifelike situation, underscores Segal's initial motivation and raises it to a great and simple eloquence: "I had decided to deal with people I knew in simple occupations." Sitting around *The Dinner Table* are his friends Allan Kaprow, Vaughan Kaprow, Lucas Samaras, and Jill Johnston; he included his wife, Helen, as well as himself, wanting to evoke those gatherings "on the farm" without specifically creating portraiture. Yet, Segal is aware of parallels with the famous nineteenth-century subject of artists and writers informally gathered, but rather formally portrayed, in the bohemian surroundings of somebody's studio. It struck him that he was into some kind of magic with this piece—that of shifting interpersonal relationships caught in plaster as well as that of spatial relationships among figures, chairs, and table, the space they occupy, the boundaries of that space, and its illusionistic extension by means of a mirror on the wall.

Segal cites his love for what may have been one among several inspirations for this work: Cézanne's *Card Players.* "As I analyzed that painting, I saw how the leg of the man bore a relationship to the leg of the table and I became very much aware of the space in between; I made the step from legible to real space which went against all I had been taught, for the Abstract-Expressionists had insisted on flatness of surface and lack of illusion."

The greatest challenge of *The Dinner Table* was portraying the relationship of the figures not to the objects in their environment, but to one another, thus creating something resembling a natural conversational gathering. Segal recalls, "I asked the people to sit around a table or stand at the table, having a general idea of knowing that I wanted a certain gravity, that I was composing the empty air volumes along with the positive volumes of their limbs and that the literal quality of the space was important in the composition, all this being a hangover of my old painting days." The result avoids anecdote as well as portraiture, yet it is Segal's first exploration of the theatrical dimension implicit in his larger pieces.

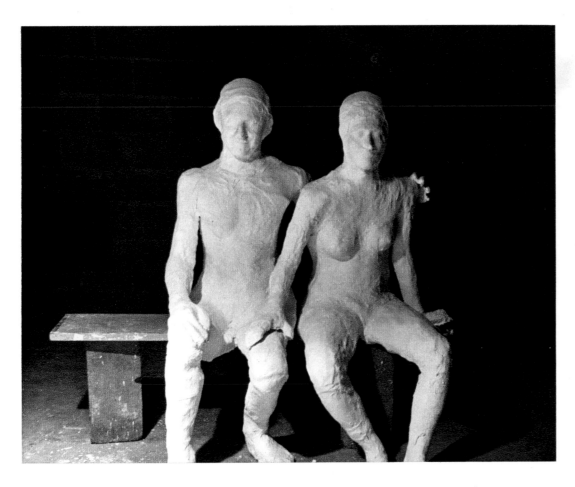

19. *Lovers on a Bench.* 1962. Plaster, wood, and metal, 48 × 60 × 36″.
Collection Dr. and Mrs. Hubert Peeters, Bruges, Belgium

LOVERS ON A BENCH

There is an almost systematic exploration in Segal's work of how people sit or can be seated, with sloppy ease or calculated poise, self-exposure or introspection. Here two young people sit on a park bench, ready to have their picture taken. Then we notice that they are nude, which would seem to indicate an indoor setting. Segal is not as specific about the location as he is about the pose and genesis of this work.

The piece resulted from his knowing the models, newlyweds and always a couple in his recollection. The young man wanted to become a writer, and his wife was an aspiring painter who had on occasion posed for Segal. This had already established a casual atmosphere, and the idea of doing a double sculpture in the nude seemed quite natural to the artist and his models alike. In addition to being the first casting of nude bodies, it is also the artist's first attempt at joining two casts together.

Segal's main formal interest in making this sculpture was to work with limbs and their expressiveness in a stylized situation. A pose mocking togetherness shows the girl as the stronger and more dominating personality. It developed into a contemporary, matriarchal inversion of certain African sculptures, the artist notes, in which king and queen sit in tribal authority. This outcome surprised even Segal, but he explains that he lets his models gravitate toward a pose that comes naturally to them and then often allows his preconceived ideas to evolve or change accordingly.

In *Lovers on a Bench* Segal wanted to show his own sense of ease and casualness about the nude body, until then almost the exclusive subject of his drawings and pastels; this relaxation was not only shared but more strongly felt by his young models, who were that much closer to and familiar with today's sexual revolution. The artist says of his work that he wants to give very strong clues and create situations of his own contriving: "On the one hand I deal with a situation that is unmistakably real, with the verisimilitude of things; on the other hand I speculate about the invisible, I refer to what is not there. That sets up psychological tensions."

20. *The Farm Worker.* 1962–63.
Plaster, wood, glass,
and imitation brick, 96 × 96 × 42".
Collection Galerie Onnasch, Cologne

THE FARM WORKER

We see in this work the same frontal exposure of *Man Sitting at a Table* and *Lovers on a Bench.* In addition, and for the first of many times, a flat, well-articulated background appears. Before an eight-foot-square wall of imitation brick—actually tar paper on plywood—with an old blank and empty window not quite centered, painted blue, and topped by a mullion sagging unevenly old Henry the farm worker takes a nap in the late-afternoon sunlight. He sits on a pink and gray chair, hands on his knees, as perfectly still, blank, and empty as the inanimate background. Wryly the artist observes, "For me this is a world of secondhand factory seconds, including the people."

The owner of the work insists on calling it *Henry's Place,* which *de facto* has become its second title, because of the sitter's identity. The artist tells of the work's origin and how he chose his unlikely model: "Down the road, my wife's mother has had a farm for a long time. On her property is an old shack looking just like the one in *The Farm Worker,* and all the laborers she employed—and there must have been many over the years—used to sit on the same chair at the end of their working day, mindless and expressionless, catching the last rays of the sun. I knew I wanted to do this scene, and I had just the right person in mind." But the person chosen for the role was a kleptomaniac moron who might at any moment have burst out of the plaster and attacked the artist.

While in the audience at a symposium on Pop Art at The Museum of Modern Art, Segal spotted Henry Geldzahler on the stage, sitting for one moment precisely as he had remembered all those farm workers sitting on his mother-in-law's property. He asked Geldzahler to pose, and he not only complied but proved to be a fitting subject. "Realistic and natural in its bounds and its setting—mysterious and removed at its center, in its meaning, in the figure" is the way Geldzahler experienced and described Segal's sculpture.

As an old farmhand, Henry Geldzahler is quite credible. Segal sees in him the rare combination of a lively intellect and a motionless body quite at ease with itself. The sitter revealed to the artist that a few generations ago the family had come from Poland, and the stocky potbellied look and the sullen manner of the plaster figure does show glimpses of what its subject's ancestry may have been.

Two points can be made here, pertinent to this work in particular and to a good many of Segal's sculptures. The plaster cast reveals racial characteristics and sometimes unsuspected ancestry that go unnoticed in the real-life model. It doesn't take a laborer to pose as one, nor does it take a driver to hold a steering wheel or a dentist to operate a drill. In fact, Segal often chooses fellow artists as his models, not only because they are sympathetic and available, but because they are at ease with their bodies and bring a natural grace to work.

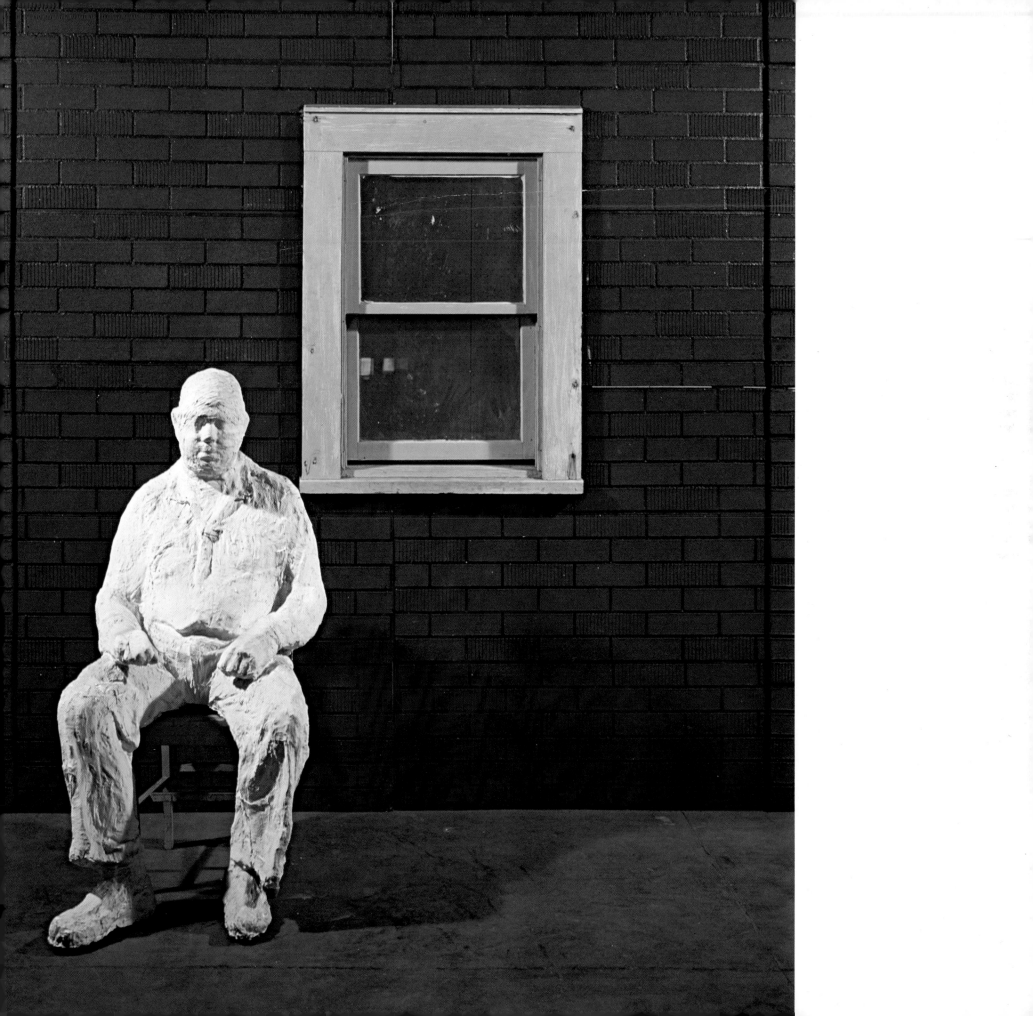

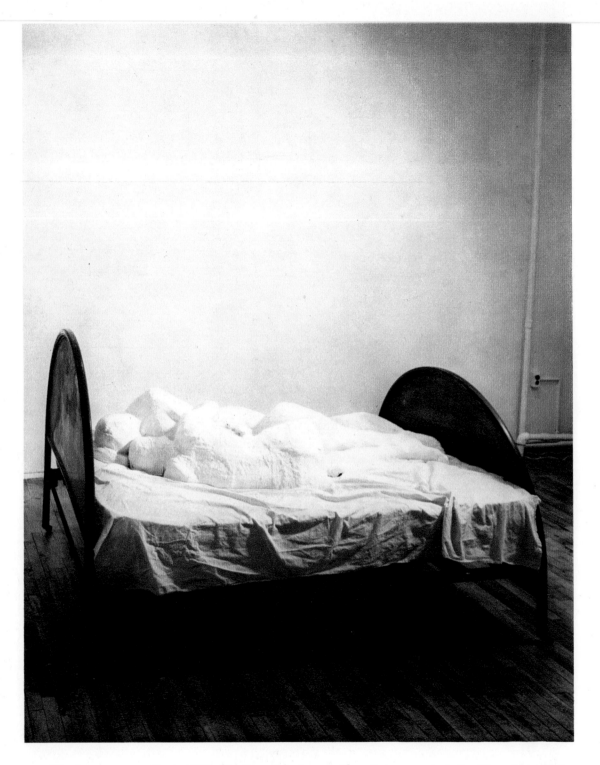

21. *Lovers on a Bed.* 1962. Plaster, wood, metal, mattress, and cloth, 48 × 54 × 70″.
Collection Mrs. Robert B. Mayer, Chicago

LOVERS ON A BED

Not indifferent to the erotic overtones of *Lovers on a Bench,* Segal asked the same couple to pose for him in a more intimate display of affection. He cast them in each other's arms, lying on a bed. Despite their tender embrace, the sheltering superiority of the woman is again evident.

"Plaster is an incredible recorder of what is there," Segal admits, "more effective to me than the movie camera. But I have to hunt for the right pose. . . . The whole thing is a series of choices between internal revelation and external verisimilitude. It does not happen by itself; you have to work at it." As his models tend to bare their souls, the artist is well aware that the need to abstract is no less crucial than the need to empathize. While he cannot control spontaneous expression—"Nature takes care of that for you"—he nonetheless has to direct or choreograph it. A low-keyed interpretation of this role saves him from stilting his subjects. Feeling neither distant nor superior—"I'm right in there screaming with the rest of them"—he gets his models to pose as a motion-picture director gets his actors to perform, naturally, as though it were their idea all along.

An interesting conflict developed between George Segal and the collector who bought this work. The incident sheds light on the importance the artist attributes not only to the plaster figures but also to the ambience in which he places them. Both the candid pose and the seamy bedstead caused embarrassment when *Lovers on a Bed* was installed in the collector's home, so he quietly had the couple removed from the evocative mattress and placed on a clean and artful slab of painted plywood. Unhappy that his work had been tampered with, Segal explained to the collector that the bed was carefully chosen for both formal and psychological reasons to act as a "great horizontal thrust bounded by the severe geometry of the half circles at its head and foot." The bed was purposely old and pathetic, the iron painted to resemble wood, its pretense contrasting with the simplicity of the couple's embrace. The bed, in addition, was to be placed in a space "dim, with the naked baldness of real things intruding, like an old window and an old-fashioned radiator." This was the way the work had been conceived in the artist's studio, and this was the way it had first been shown, to considerable advantage, at the Green Gallery. The collector got the message and restored the lovers to the rumpled sheets, lumpy mattress, and a bed of the same vintage the artist had originally sent him.

23. *The Bus Riders.* 1962.
Plaster, metal, and vinyl, 6′2″ × 4′ × 9′.
Hirshhorn Museum and Sculpture Garden,
Smithsonian Institution, Washington, D.C.

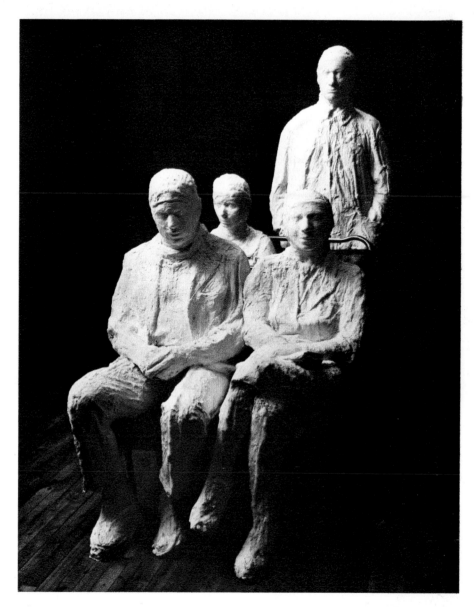

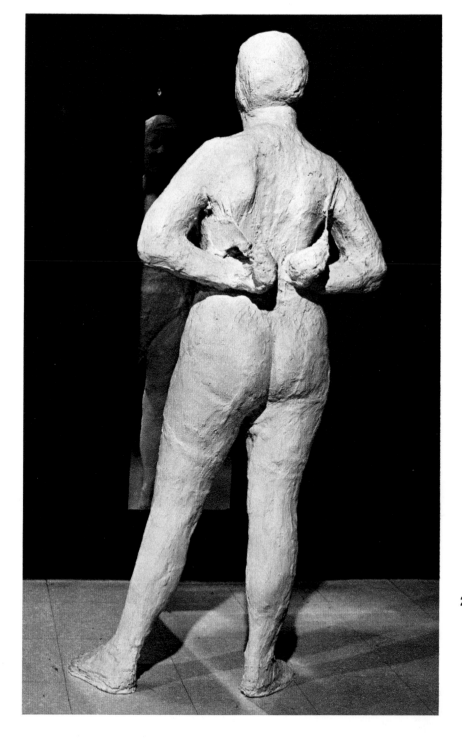

22. *Woman Buckling Her Bra.* 1963.
Plaster, wood, and mirror, 72 × 18 × 30″.
Collection Mr. and Mrs.
Morton G. Neumann, Chicago

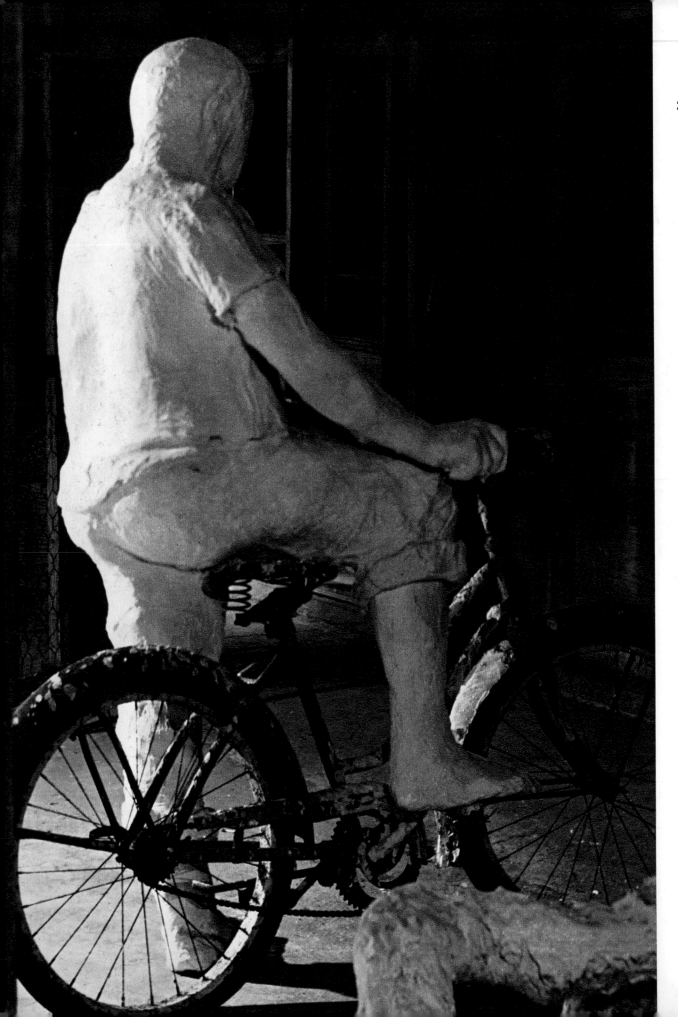

24. *Man on a Bicycle.* 1962.
Plaster and bicycle parts, 63 × 29 × 61″.
Moderna Museet, Stockholm

MAN ON A BICYCLE

Is this a poor relative of *The Bus Driver,* trailing behind on a more modest set of wheels? No, not if we look at the genesis of this work and those features which anticipate *The Bus Driver.* In its earliest version, this work harks back to Segal's first mixed-media experiments, now with a third dimension.

He had just made a crude figure, with some of the armature showing, and had built a box for it to sit on. Then he placed it on a broken-down old chair, and the effect was much more to his liking. Feeling he had found a clue, Segal picked up a seatless bicycle with two flat tires, abandoned by a child across the street.

His knowledge of history played the predictable tricks. He was reminded of Duchamp's *Bicycle Wheel* as well as of Picasso's bicycle seat and handlebars joined into the image of a bull's head. But Duchamp had lifted a wheel out of context and turned it into an abstract object; Picasso had made his bicycle parts into an aesthetic object through the method of collage. With a greater taste for reality, Segal did not want to divorce the bicycle from its function, nor did he want it to look like something else: "I could not see myself isolating beauty or significance from the surrounding world—to me the whole world is dense and packed with beauty and interest.... Most people only see function. Why should the artist go to the extreme opposite of admiring only beauty?"

The first version of *Man on a Bicycle* was typical of the art of assemblage, then in its heyday and about to be canonized with an exhibition at The Museum of Modern Art. The figure was built of two-by-fours and wooden slats, instead of plaster, with a couple of bicycle lamps bolted to its frame—very angular and quite surreal. The artist didn't like it and threw away the man but kept the bicycle. Then he built a wood and chicken-wire armature, and with burlap and plaster molded a rough, bulky figure of a man astride a bicycle. It had the clumsy features of Neanderthal man and was exhibited at the Reuben Gallery. Fred W. McDarrah reproduced it on the last page of *The Artist's World* of 1961 as a work by George Siegel [*sic*]. The final or third version shows the bicycle with a "live" cast of the artist, almost archaic in appearance despite this clear evidence of locomotion, preceding that of *The Bus Driver.*

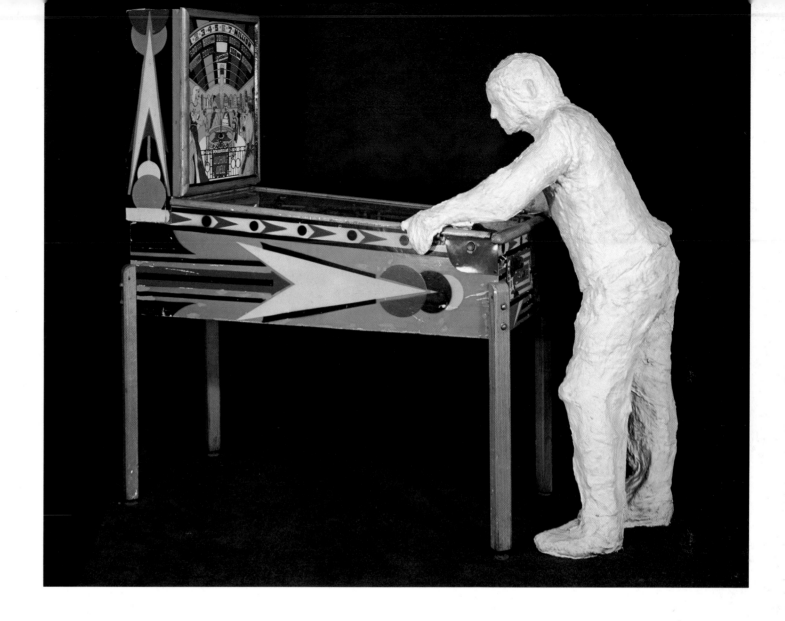

25. *Gottlieb's Wishing Well.* 1963.
Plaster and pinball
machine, 65 × 25 × 76″.
Private collection, Brussels

GOTTLIEB'S WISHING WELL

This is Segal's only work made on foreign soil. Not surprisingly, it asserts the American origins of its creator through his choice of subject matter, more specifically "Pop" than anything else in Segal's total oeuvre. Creating this work in Paris would seem as manifest a rejection of European culture and life style as ordering a hamburger in a gourmet restaurant. Here is an American-made pinball machine, manned by an American (Michael Sonnabend), commissioned by an American gallery, and probably calculated to appeal to a European art lover who prefers his Pop Art straight and undiluted.

On this, his first trip to Europe—to assist in the installation of his first one-man show abroad, at the Ileana Sonnabend Gallery—Segal admitted to culture shock. "What kind of nerve did I have bringing my art to the motherland!" Paris struck him as baroque,

super-decorated, and of a massive grayness to which he was not accustomed. While waiting for *Woman in a Restaurant Booth* to clear customs—treated as used furniture, it had gotten lost—he turned to work as his habitual pastime and diversion.

Pinball machines were then a new craze in Paris. With Michael Sonnabend, Segal went to Pigalle to a garage in which nearly a hundred used pinball machines were stored. Able to choose the one he wanted, at forty dollars for any model, he chose one he particularly liked for its flashy ornamentation, which reminded him of Futuristic painting. The machine lighted up when played and provided him with the timid beginnings of a soon-to-be-developed interest in making light an active and integral part of his compositions. To mold the figure, he could find only a terra-cotta-colored plaster that came from a dental lab. By painting it white he gave the cast its now-familiar Segal look.

27. *The Artist's Studio.* 1963. Plaster, wood, metal, paint, and mixed media, 8′ × 6′ × 9′.
Harry N. Abrams Family Collection, New York

WOMAN LEANING AGAINST A CHIMNEY

THE ARTIST'S STUDIO

Straight from the artist's past, *The Artist's Studio* is a three-dimensional rendering of the environment of a two-dimensional pursuit with all its fondly included, traditional trappings. Segal admits that there is plenty of self-mockery in this piece. The studio is a version of his own attic; the wall and window are rendered in a painted version—another reference to his beginnings as a painter—but the chimney, like the one in his studio, is made of real cinder blocks. To refer to real objects by substituting a painted look-alike was new in Segal's oeuvre. It deliberately compounds that now-familiar dialogue between the real—found or manufactured—object and the simulated presence—but equally real from a material standpoint—of a human being.

With *The Artist's Studio,* Segal has opted for a spatial complexity surpassing anything he had done before. Not only is it difficult to do justice to it in a photograph, but also the eye itself, more than ever before, is drawn between measuring boundaries and focusing on details, both equally rich in visual surprise. On the level of subject and image, the expected model and palette are indeed prominent, but the painter is nowhere to be seen. This is the first instance where Segal portrays his subject *by implication;* in subsequent treatments of the same subject, the artist is there, sketching or fashioning a cast.

The same attic is the environment, so to speak, for *Woman Leaning Against a Chimney,* a work equally biographic, but this time referring to the artist's domestic life. He recalls, "Our chimney in winter is always the warmest spot in the house and in my studio it's the only source of heat. Helen likes to stand in front of it when visiting the studio to keep herself warm." The heat of the chimney and the warmth a woman radiates merge into one image, possibly a symbol of Hestia, goddess of home and hearth. While Segal doesn't object to a mythological reference, truth demands that we make it clear that this is a *post-factum* interpretation with no bearing on the work's creation.

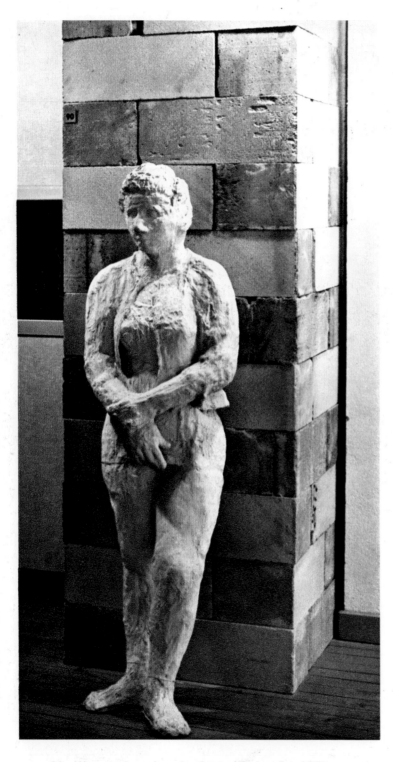

26. *Woman Leaning Against a Chimney.* 1963.
Plaster and cinder block, 96 × 28 × 16″.
Collection Mr. and Mrs. R. Matthys, Ghent

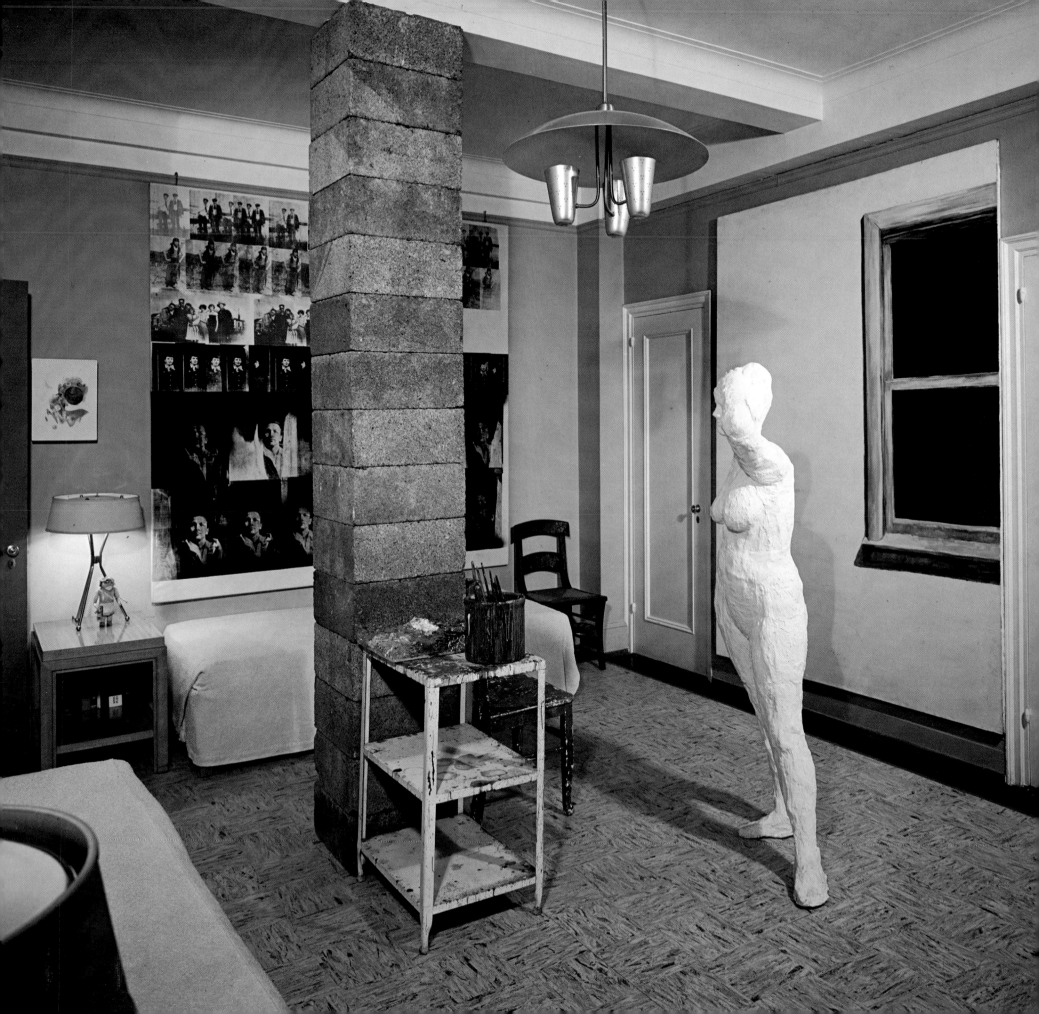

28. *Cinema.* 1963.
Plaster, metal, Plexiglas,
and fluorescent light,
9′10″ × 8′ × 3′3″. Albright-Knox
Art Gallery, Buffalo
(Gift of Seymour H. Knox)

CINEMA

First presented in a group show at the Sidney Janis Gallery, this work was an instant public success. So much light seemed overwhelming to the viewer. The source was fluorescent, and its use in art antedates its Minimal applications. Light art as a fashionable, multi-faceted exploration into the nature of light had not yet been "born." In one masterful stroke, Segal had solved a problem that had plagued him from the beginning: how to incorporate light in his work without creating an atmosphere of drama or suggesting a stage. Here he put the light right into the work or, better yet, the light became the *raison d'être* for the work.

Unlike Segal's earlier pieces, which bore a direct and straightforward resemblance to the sights or situations on which they were based, *Cinema* had been radically removed and abstracted from its original source. We catch an early glimpse here of how the artist prefers not only re-creating—as he already did in *The Farm Worker*—to finding a suitable environment, but also envisioning it abstractly to visualizing it realistically. We must be told by the artist that the work represents a drive-in cinema marquee. All references to the outdoors, the subject's normally elevated position, the precise information to be conveyed—the letter R does not begin to advertise a double feature—and the requirement of distance have been negated or omitted.

Segal remembers that the subject came to him while he was driving home from New York after midnight. In a momentary flash, he saw a man up high and alone, changing the title on a suburban drive-in theater marquee. The image stayed in his mind, as he later observed, not the way it was but the way he had imagined it to be. The sign was actually lighted not from within but by spotlights on the road.

What made his own solution particularly success-ful is that it could be shown indoors and at eye level without losing any of its impact. In addition, the effigy of the man changing the letters would have cast a dark shadow on the marquee, just as he would have been washed out by floodlight. In Segal's piece he appears dark and mysterious in the eye-blinding glow despite his whiteness; the light chewing up the edges of his figure makes him seem less a body and more a phantom, and places a strange emphasis on texture and relief.

If Segal's use of light in *Cinema* first served to define form, space, and volume, it also stressed the expressive possibilities of the medium itself—light *as* form, space, and volume. The light box, no longer a prop or aid in suggesting an environment, is central to the work and proves, if nothing else, how serious Segal is when he says that his plaster figures are only a part of the work. The work's assertive presence contrasts, in a masculine way, with the more reticent and subtle *Dry Cleaning Store* with all its feminine implications. The different use and qualities of light in the two pieces is what clinches that contrast.

The exalted, almost religious connotations of light do not escape the artist, nor is he unaware of them in the work of Dan Flavin, a colleague with whom he showed at the Green Gallery: "I like Dan's work extremely. He tries to express both sensuality and spiri-tuality." Despite any differences between his Judaic versus Flavin's Catholic interpretation of the meaning of light, Segal ventures that Flavin must have as much trouble as he himself feels "in aspiring to the exalted, while sitting on the sensual." He concludes: "That is what makes art the perfect landing place for us lost souls."

29. *Woman Shaving Her Leg.* 1963. Plaster, metal, porcelain, and Masonite, 63 × 65 × 30". Collection Mrs. Robert B. Mayer, Chicago

WOMAN SHAVING HER LEG

This work seems to plunge Segal back into the mainstream of Pop Art, like *Woman in a Restaurant Booth* and *Gottlieb's Wishing Well,* because of its subject matter. The bathroom has been a concern of Pop artists Claes Oldenburg and Tom Wesselmann in particular, as well as of Jim Dine, Roy Lichtenstein, and Robert Whitman. Segal sees nothing unusual in this, and to him it simply reflects his generation's fascination with all aspects of the new American landscape, as well as a semi-erotic preoccupation with the American cult of cleanliness.

On two levels *Woman Shaving Her Leg* relates to the artist's own background and specific interests. The theme comes from the drawings, of course: "I was tipping my hat to Degas, Bonnard and Matisse." Segal also considers it an homage to Hans Hofmann, who revealed this kind of beauty to him and spoke of the sensual glories of life in France when art was still very much at home there. But Segal felt that, if he were to treat this seductively European theme, he had to place it in the context of contemporary American experience. So he copied his own bathroom and in it placed the same model who had posed for *The Artist's Studio.* We see the sensual qualities of the woman against the formal qualities of her environment, and this balancing of contrasts emerges as the theme of this work.

The woman is standing in a tub with one foot on the ledge, with a chrome razor in her hand. This banal cosmetic preoccupation effectively neutralizes any infatuation with the loveliness of a traditional subject. The girl's limbs are purposely thickened, and they appear very massive. She leans over, in the direction of the viewer, but is utterly absorbed in her activity and oblivious to her surroundings. The light is that harsh bathroom variety that drains the body of all natural color. The walls are covered with an imitation tile, of screaming yellow drenched in light; the tub is a gleaming white imitation porcelain; and the highly polished chrome showerhead, handles, faucet, towel bar, and moldings bounce back ambient light and color, providing this showcase enclosure with dazzling reflection.

The proportions of the tub, the regularity of the tiles, and the placement of the fixtures are all rigidly ordered by their function and the American preference for shiny materials and smooth-running machinery. With its tight organization, hard reflections, and deceptive lack of depth, this bathroom at first glance looks like a geometric painting in the sense that modern office buildings mimic Mondrian. Yet the great attention paid to physical detail becomes merely a formal exercise compared to the self-absorption of the subject; Segal recognizes this irony of effort versus effect and capitalizes on its results.

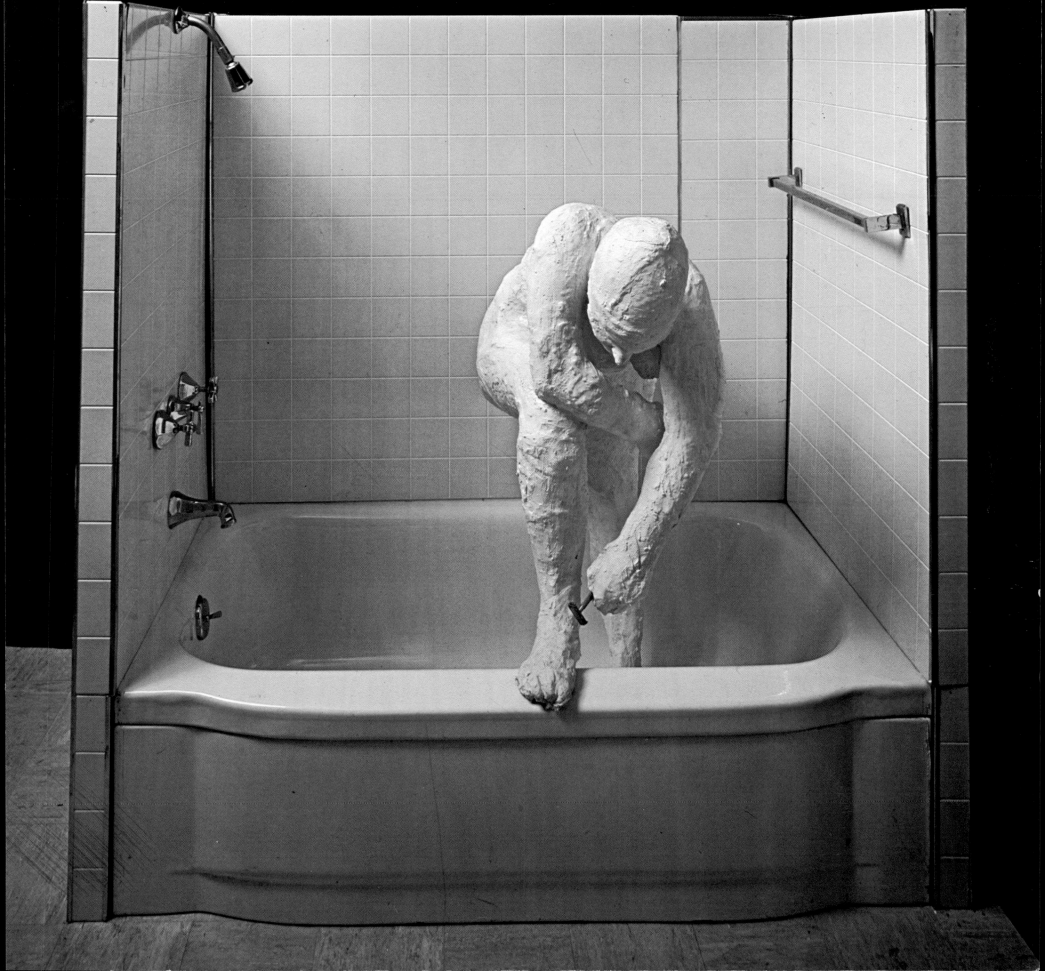

30. *Man Leaning on a Car Door.*
1963. Plaster, wood, and metal,
96 × 48 × 30″. Galerie Müller,
Stuttgart

MAN LEANING ON A CAR DOOR

With fifty miles of turnpike between his South Brunswick home and the Manhattan art scene, Segal has always relied heavily on his car. He loves driving, and it is only natural that a car should be included in one of his sculptures. In a junkyard he found just the right one: a flashy, three-toned, 1956 Mercury sedan. When removing an entire side from bumper to bumper proved impractical, and the piece too heavy to be hauled to his studio, Segal settled for one bulky door and attached it to a rectangular plywood panel which he painted an abstract blue, except for a "shadow" repetition of the door's shape in black.

Art by recontextualization has never ceased to amaze the artist. The natives of New Guinea stand up their richly carved outrigger canoes—and they become either totems or works of art in another context. Segal isolates a car door from a junkyard, props one of his plaster figures against it, and the combination is accepted as a work of art. But then, does the artifact or the industrial product, pried loose from its functional context, also become a metaphor? Does the man leaning over that door become a symbol, an archetype perhaps? Segal could not ignore these questions when what he had intended to be a portrait took on overtones neither the artist nor the sitter had anticipated.

A heavyset man with a vacant stare leans on a car door. His confident pose and possessive gesture could be those of a used-car salesman. How did the model, Robert C. Scull, feel being cast with his hand on that door? Segal admits that his portraits tend to develop in the direction of anonymity or archetype, so to save Scull's portrait, his first commission, from the anony-

mous, he stressed Scull's earthy business activities, since he wanted to avoid conventional, flattering society portraiture. A failure in terms of the sitter's opinion of himself, *Man Leaning on a Car Door* turned out to be a Segal work true to form and very much an archetype.

Central to the artist's method is abstracting from the particular to arrive at the general. But isn't portraiture the art of raising the particular to greater heights for a more poignant depiction of the sitter's individuality? Unable to delineate facial qualities or an elegant appearance, Segal's portraits by necessity rely on expressiveness of body movement, gesture, or musculature on the one hand, and the eloquent support of environment on the other. Bodies not recognizable in their specific features and attributes become anonymous; situations ambiguously defined by props or environment become archetypal to the viewer.

Segal speculates that *Man Leaning on a Car Door* did not relate to the sitter's dreams and aspirations about himself. Nor, in all fairness, did it do more than feature one aspect of his personality. Robert Scull is known to the art world primarily as an early enthusiast of Pop Art and a collector willing to take risks. Segal admits a genuine liking of Scull's brashness. This quality seemed to fit the situation. He recognizes that an artist may put a wrong slant on the person he portrays, but he is never entirely off base. In fact, he has seen instances where an artist has forced internal change upon his subject, making him change his "image" so he will like himself better, in real life as well as in its counterfeit.

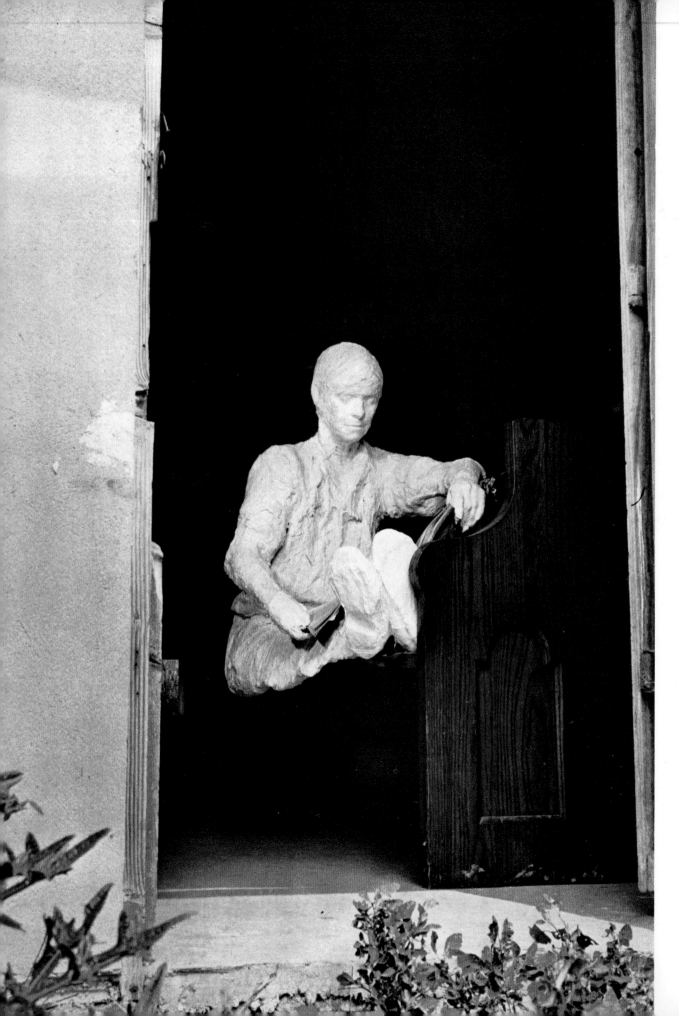

31. *Woman on a Church Pew.* 1964.
Plaster, wood, and paper, 42 × 60 × 24″.
Collection Mr. and Mrs.
Leonard J. Horwich, Chicago

MAN IN A PHONE BOOTH

The man's identity has been allowed to escape from this tight enclosure, even though his plaster effigy is firmly hooked to the telephone receiver. Segal chose his friend Allan Kaprow to model in this position "because he is always on the phone trying to stay in touch with the participants in his Happenings." The booth, a brand-new public telephone, was obtained from a collector who owned stock in International Telephone & Telegraph. Allan Kaprow had done Happenings entitled "Words" and "Calling," and Segal good-humoredly derides him for making a living by talking. "I followed a funny impulse to imprison him in a booth," Segal concedes, and Kaprow obliged by letting him do it.

The image of a phone booth first appeared in a 1959 painting Segal did of the New Brunswick Railroad Station. He likes the booth's form and the way it looms in the dark. Segal calls the telephone booth a marvelous container of space. Solid and transparent, blocking and revealing, structured with geometric precision, it is the closest match, in real life, to Minimal sculpture. A man in a telephone booth is at once contained, defined, and revealed by his glass-cage environment. In addition, he is mysteriously extended by its ambient light. Because the booth carries its own light, the artist is exonerated from finding a solution for that always prickly problem.

To cast somebody with his mouth open was not easy. While it is apparent that the plaster effigy is talking, its silhouette, elongated by the open mouth and beard, produces an unanticipated resemblance to Michelangelo's self-portrait as a saved soul in *The Last Judgment.*

The theme of man in a tight enclosure, or the natural contour of the body framed by the geometric shape of a door, box, or booth, is important to Segal and recurs often and successfully. It provides the artist with the most direct and economical device to demonstrate the polarities and contrasts that are basic to his work.

32. *Man in a Phone Booth.* 1964.
 Plaster, metal, glass, and plastic, 86 × 30 × 30".
 Collection Mrs. Robert B. Mayer,
 Chicago

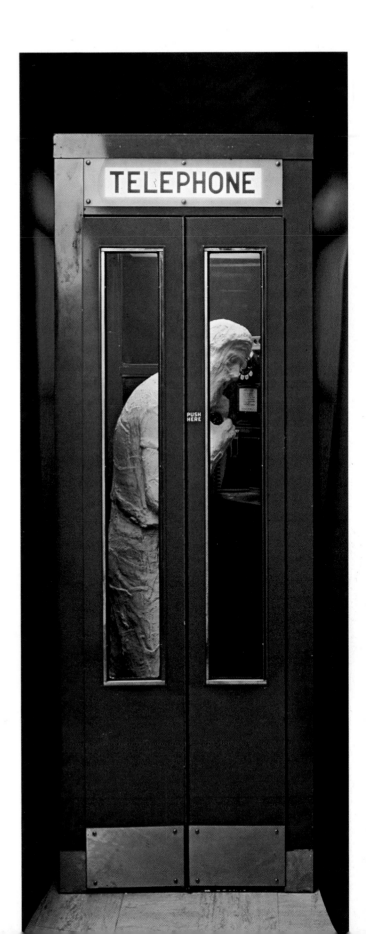

COUPLE AT THE STAIRS

As completely a night-time interior as that of *The Gas Station,* this work has a more realistic spatial definition. It is dominated by the diagonal of the staircase, just as the earlier work related to the horizontal of the road. The associations are the static ones of return and shelter versus the dynamic ones of continuance and speed. A gas station can be seen in passing and is therefore largely a construct of the mind; *Couple at the Stairs* shows a situation literally chanced upon when one "opens" the corridor door. Yet even here the boundaries are only partially defined. The staircase leaves this sculpture as open-ended as the corridor space left *The Gas Station.* We know that one leads upstairs, but both contain an element of the unknown and uncertain, a subtle and obscure reference, perhaps, to death and finality.

Couple at the Stairs recalls the memories and stolen glances of an adolescent world. Segal re-created a tenement hallway, a composite of the hundreds he knew or had seen during his youth in the Bronx and his visits to homes and studios in Lower Manhattan. In it he placed two young people of his acquaintance who were then dating. The poetry of love and its fragility are set off against the seaminess of the environment, with its creaking stairs and shabby hallway. The warning "If only walls could speak!" hangs ominously in the air. The only fixture identifying the space as the ground floor of a building is a row of mailboxes. But their function can be read metaphorically as well. How much hope and expectation have they inspired? How much fear and disillusion? And how much more will pass through these containers of communication? As the lovers hold each other, the empty mailboxes too hold both past and future in the balance—the present is all that counts. With regard to this and other works by Segal, R. D. Kenedy has written: "Segal's accumulative glimpses depict a referential totality of the human landscape. . . . He records the anonymous actuality which lacks the power to define itself."

One might almost ask why Segal bothered to build a full-size staircase and then refrained from using it for spatial theatrics. Another figure might have descended the stairs or stood at the top; the lovers might have been rushing toward each other. The question contains its own answer, inasmuch as Segal abhors spatial theatrics and, given a choice between action and repose, he almost invariably opts for depicting the latter. The stairs are a spatial clue and not a vehicle to him, and if he lavishes so much attention on such an inactive part of his environment, he does so because he admires stairs formally, for what they are, more than functionally, for what they do. The artist has often articulated his ambition to create spaces that rhyme, volumes with voids; he likes processional spacing which can be seen, for example, in stacking or serial repetition. Here he has found the ideal object, descriptive of environment and expressive of the artist's formal predilections.

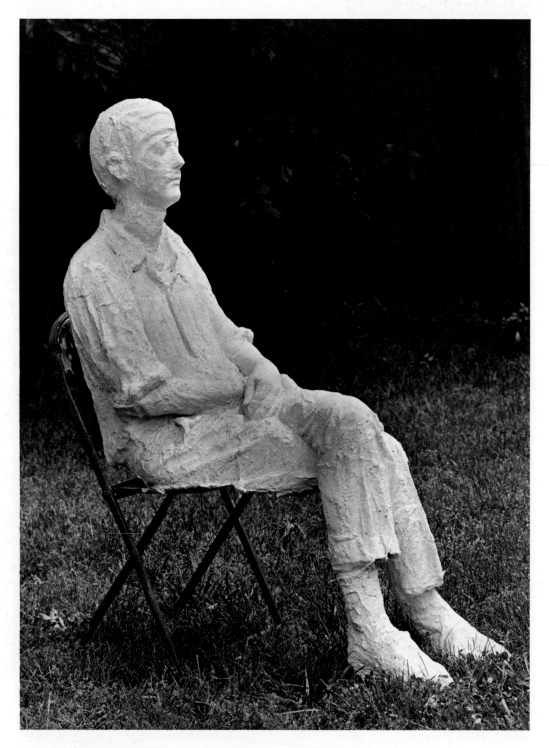

33. *Richard Bellamy Seated.* 1964.
Plaster and metal, 54 × 48 × 48".
Collection Mr. and Mrs. Adam Aronson,
Saint Louis

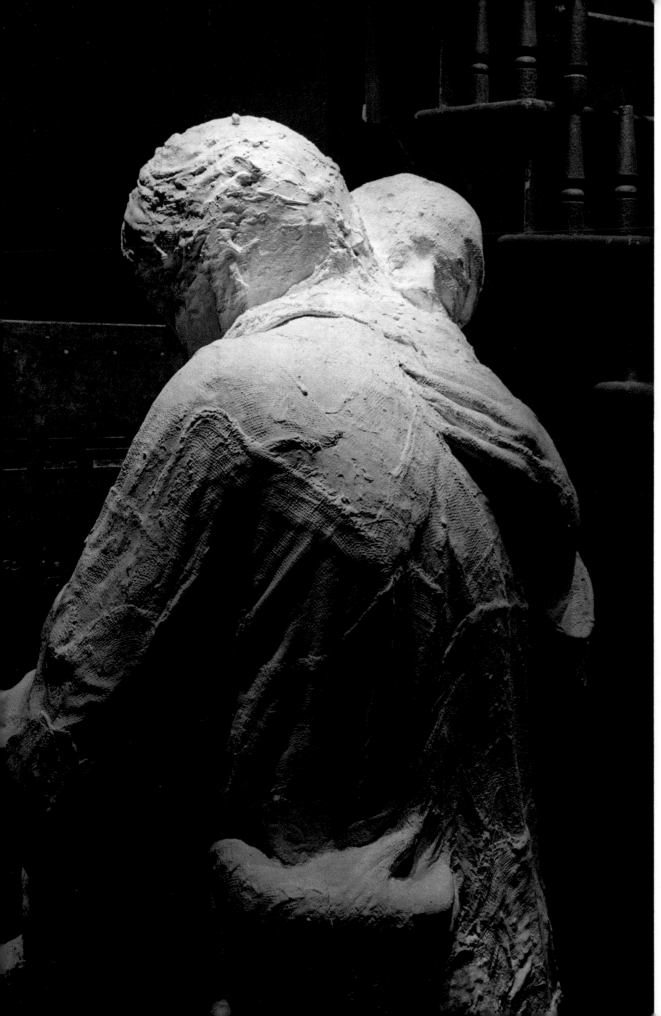

34. *Couple at the Stairs* (detail). 1964.
Plaster, wood, and metal, 10′ × 8′8″ × 8′.
Museum Boymans–van Beuningen,
Rotterdam.
(See plate 10 for another view.)

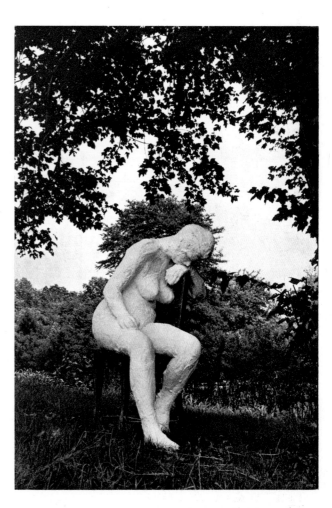

35. *Girl on a Green Kitchen Chair.* 1964.
Plaster and wood, 50 × 32 × 24″.
Collection Mr. and Mrs. Frederick R. Weisman,
Beverly Hills

36. *Rock and Roll Combo.* 1964.
Plaster, wood, tiling, and musical instruments,
84 × 84 × 69". Hessisches Landesmuseum, Darmstadt,
Germany (Collection Karl Ströher)

ROCK AND ROLL COMBO

Segal's works normally do not function mechanically or perform for an audience. His figures rarely face the viewer and, if they do, they tend to look right through him, not at him. In most instances, we see Segal's plaster effigies sitting, standing, or moving quietly, going about their business unaware of being watched. They are like sleepwalkers in a dream state: withdrawn, introspective, reticent, silent, unprovocative, and more remote from the viewer than their physical distance would lead him to believe. Not only is *Rock and Roll Combo* the first exception to this rule, but it serves to illuminate the issue of Segal's use of silence.

The artist recalls that at the time the idea for this work occurred to him, he was going to one party after another where there would inevitably be music and dancing. With a feverish productivity in all art fields, music seemed to lead the way and set a life style. The Beatles were at the height of their popularity, and rock had not yet turned hard and acid. Specifically, this work has elements in common with a scene Segal observed at the Café Metropole on Seventh Avenue near Times Square in New York. Formerly a strip-tease bar, it became a go-go place with the advent of rock;

girls bump and grind on a runway behind the bar and are ogled from as far away as the sidewalk.

In making *Rock and Roll Combo,* Segal asked a girl to dance as he played a record by The Supremes; she balanced herself after the music stopped, and the artist caught her, still in that mood, but striking an almost perfect Greek pose. Despite the fact that the girl is not a dancer and her accompanists are not musicians, what holds the group together is an unheard rhythmical pulse.

For one brief moment, Segal thought about but then rejected the idea of including music. In the first version of *Ruth in Her Kitchen,* he had included a taped version of the woman's solitary rambling talk; but he eliminated it, along with the clutter of her environment, because it did not come across as unselfconscious and natural. He likes time to be fluid and indeterminate, not locked in, and he is loath to obligate the viewer to look for a definite time span before moving on to the next work. In addition, *Rock and Roll Combo* is self-evident: one doesn't need to hear music to know what is going on or what the work is all about.

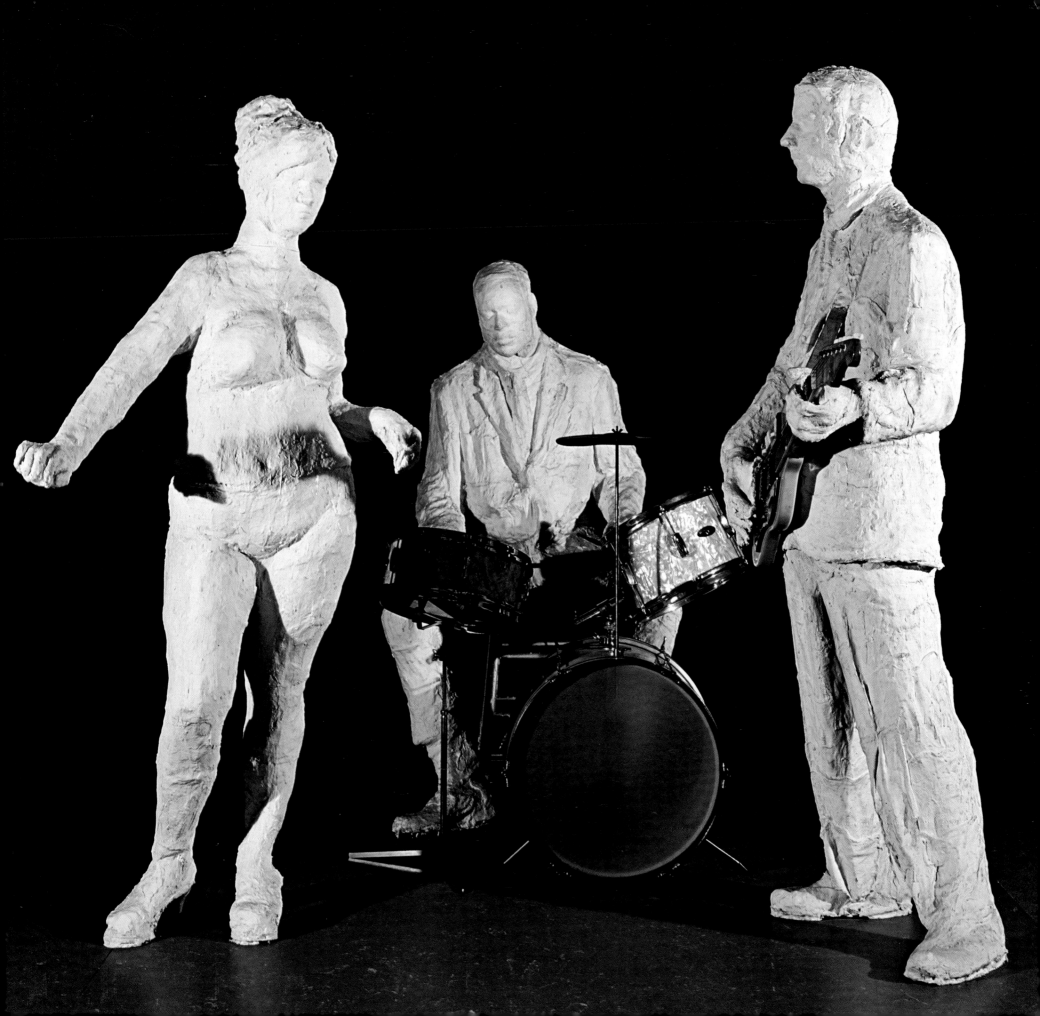

SUNBATHERS ON ROOFTOP

Prone to reconsidering works that have come back to his studio, Segal decided in 1967 to change the configuration of his 1963 *Sunbathers on Rooftop* because it no longer corresponded with his growing sense of austerity and need for clear geometric definition. The scene is typical of downtown Manhattan in summer: a man and a woman have climbed to their "tar beach" and are dozing on the rooftop. The appearance is more that of two exhausted people who have flopped down without bothering to take their clothes off than of casual sunbathers. The circular, baroque-looking ventilator was replaced in 1967 by a more severe skylight of comparable vintage. Other than that, this piece is unchanged and it clearly belongs, in looks and atmosphere, to the early years.

The Tar Roofer of 1964 is kindred in spirit. It was the artist's first straight "work piece," that is, the portrayal of physical labor without the supportive structure of, for example, a gas station or a dry-cleaning establishment. It is rugged and very black and not very ingratiating. The sculptor Gary Kuehn posed for it; Segal describes him as graceful in his movements and a very good worker. Together, they actually did tar the roof of Segal's chicken-coop studio. It prompted Segal to observe that "work is rhythmical and almost automatic; one doesn't think while working; it's like a dream state; work keeps one from thinking." It was the artist's challenge to make a man who was doing hard physical labor look as though he were floating, caught in that nonthinking, hypnotic mood, lulled into a dream state.

The question arises how *Sunbathers on Rooftop* or *The Tar Roofer* would look if installed on a real roof, presumably one like that on which the sunbathers are lying. First, reinsertion into the natural context from which these figures were presumably taken negates that peculiar and unsettling contrast the artist so carefully creates between the plaster figures and the sometimes merely allusive, sometimes highly descriptive, surroundings. Second, art like Segal's, to be fully effective, cannot be or even appear to be either useful or functional; it thrives on alienation from the very subject and environment it describes. Who would recognize two plaster casts, huddling near a rooftop skylight? And the rare rooftop roamer who came across the works might consider them Segal imitations abandoned by their maker.

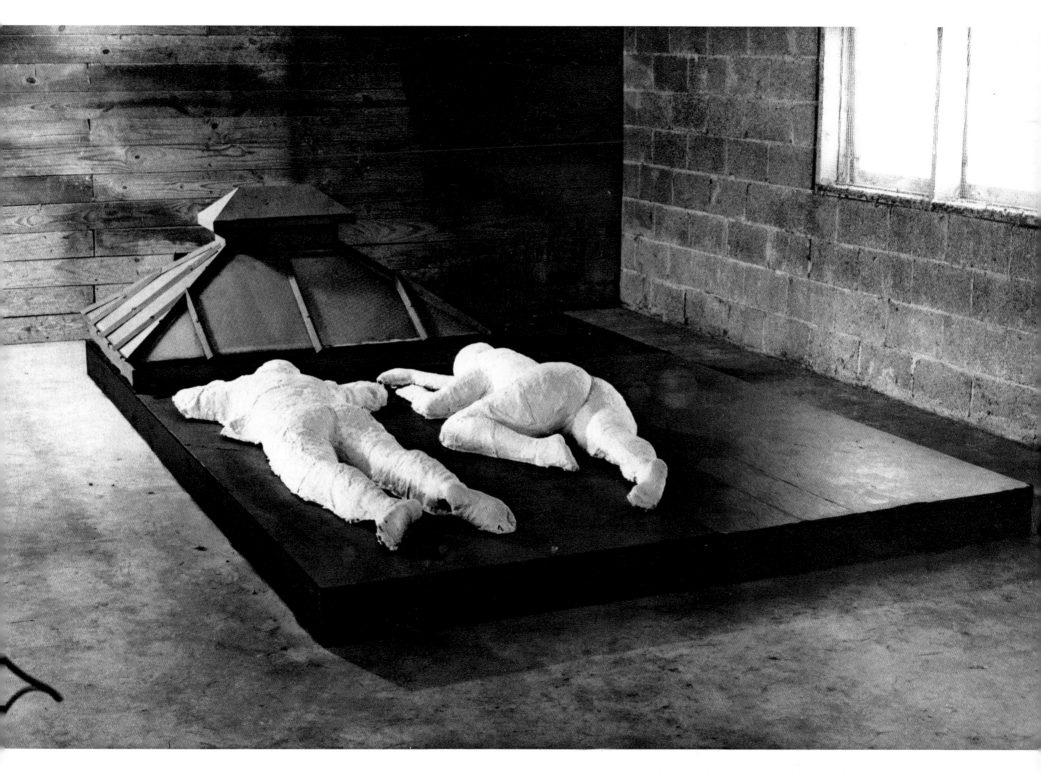

37. *Sunbathers on Rooftop.* 1963–67. Plaster, wood, metal, glass, and tar, 2′6″ × 12′ × 6′6″. Sidney Janis Gallery, New York

38. *Woman in a Doorway I.* 1964.
Plaster, wood, glass,
and aluminum paint, 9′5″ × 5′3¼″ × 1′6″.
Whitney Museum of American Art,
New York

OPPOSITE PAGE:

39. *Woman in a Doorway II.* 1965.
Plaster and wood, 96 × 72 × 96″.
Stedelijk Museum, Amsterdam

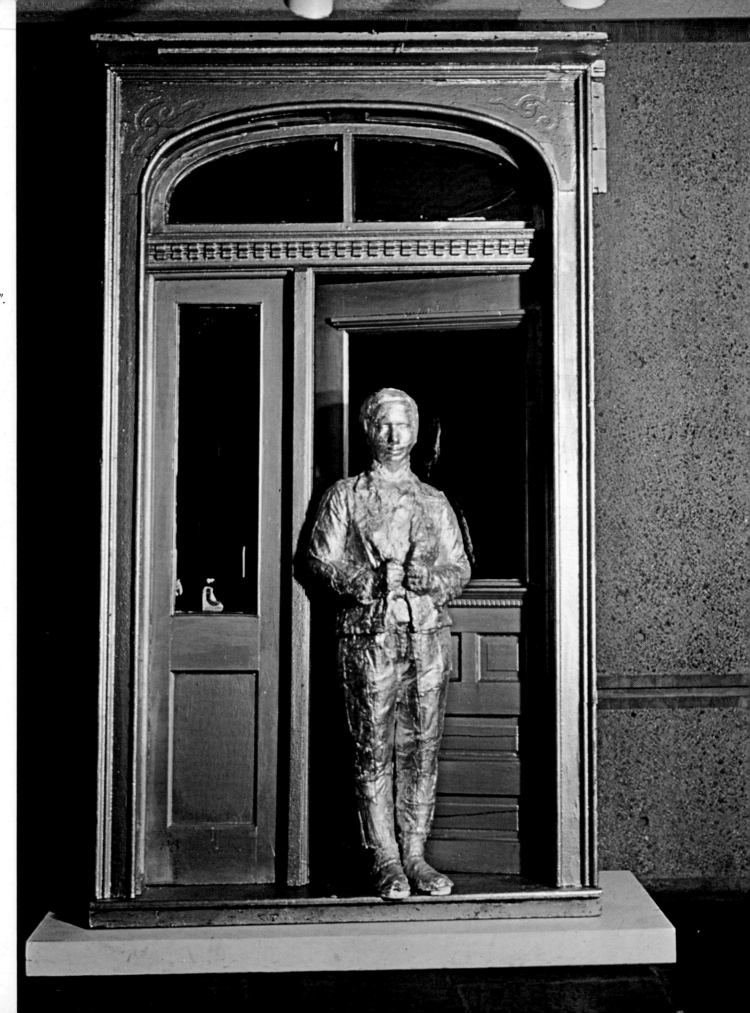

WOMAN IN A DOORWAY I

WOMAN IN A DOORWAY II

Woman in a Doorway is characteristic of Segal, with his fondness for tight enclosures, contrast of inside and outside spaces, direct images, and simple props. In fact, he liked the subject so much that he made two versions in quick succession. One addresses itself to color as a means of formal integration; the other attempts to create a maximum of spatial illusion with a minimum of environmental means. Both are successful in attempting to solve certain problems and in expressing effortlessly certain of the artist's concerns.

In the first version, the architecture of the door demands a great deal of our attention. It is impressive and fraught with memories—the junkyard's proprietor saved it especially for the artist. At first, Segal painted it chocolate brown, but the contrast with the white of the plaster was too harsh; bottle green didn't please him either, so he decided to paint the door a metallic gray. This minimized the door's emphatic, sculptural appearance, but in front of it the white plaster figure still did not work. He then resorted to painting the figure the same metallic gray. René Magritte, whom Segal admires, employed a comparable means of formal integration; he would paint, in an overall texture and color, substances as dissimilar as wood and stone, cloth and metal, water, sky, and foliage in order to heighten or preserve the unity of his picture.

The second version of *Woman in a Doorway* demonstrates that, within the same subject, colors can be differentiated and space can become complex. A beat-up, off-white door opens on to a dark, eight-foot-long corridor with three steps at the end. The corridor is mud-colored, showing the neglect and abuse of a tenement. A woman appears, opening an inner door, half-suspicious and half-welcoming, as may be expected of somebody living in a run-down neighborhood. We catch a glimpse of the room in which she lives, blazing red, like a haven of warmth and comfort. With the simplest of means and in an area that is deceptively small, Segal has mixed the allusive properties of space, color, and human stance to evoke powerfully the predicament of living with fear.

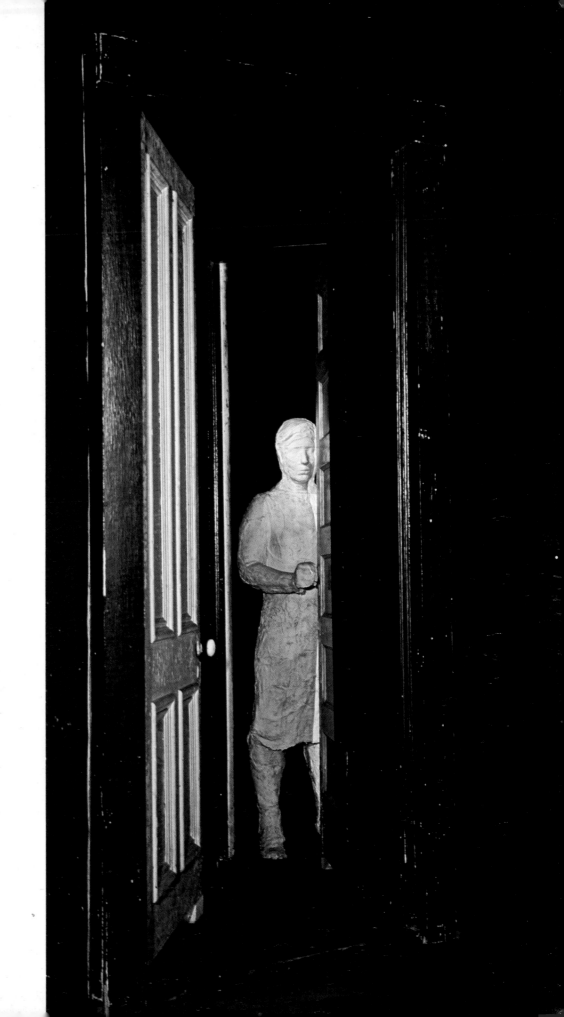

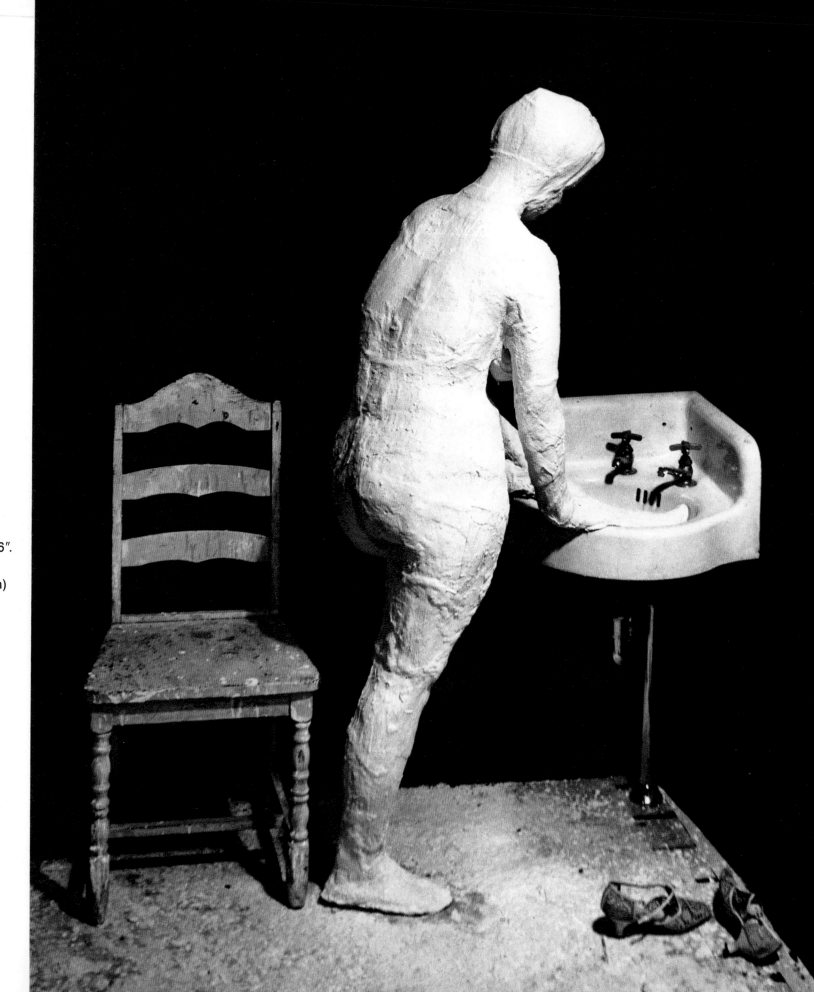

40. *Woman Washing Her Foot
in a Sink.* 1964–65.
Plaster, wood, metal,
and porcelain, 60 × 48 × 36″.
Wallraf-Richartz-Museum,
Cologne (Ludwig Collection)

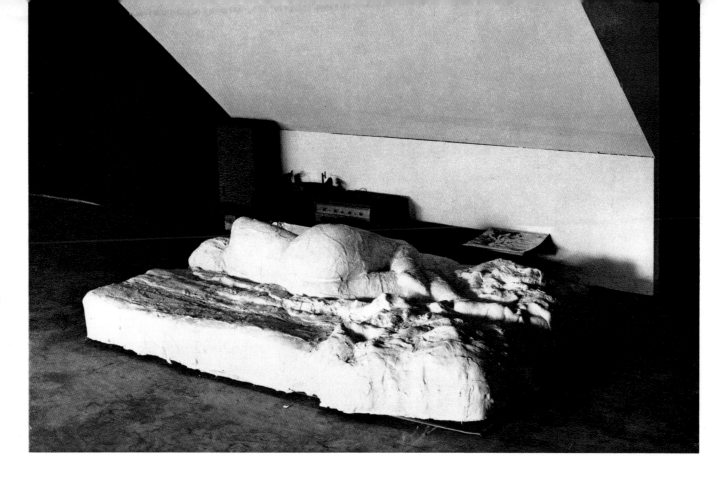

41. *Woman Listening to Music.*
1965. Plaster, wood,
and hi-fi set, 72 × 96 × 72″.
Collection Spencer Samuels
and Co., Ltd., New York

WOMAN LISTENING TO MUSIC

Though it is the ultimate result that counts, and on its intrinsic merits that a work must stand or fall, there are instances where knowledge of the sources inspiring a work transcends the level of anecdote and reveals the workings of the artist's mind as he produces his sculpture. *Woman Listening to Music* is such a case.

In 1963 Segal was taken to a concert at the Scuola di San Rocco in Venice. An orchestra and chorus performed period music in a setting of paintings by Tintoretto lighted by flickering oil lamps. The paintings, already fluid and elusive, seemed to dance in the light. The music, at once exalted and sensual, celibate and erotic, merged with the setting to create a superb and total art experience. The women's voices, soprano and contralto, were "oozing eroticism," as Segal remembers it.

Once home, he rushed to buy a record of the music that had so impressed him that night—Vivaldi's *Beatus Vir.* As he played it in his attic studio, while drawing from a model, he began to imagine himself a monk in his cell, aroused by sacred music and drawn to a vision of female temptation intruding upon his haven of calm and austerity. In that passing moment he understood what he wanted to depict: a woman reclining, nude and expectant, yet faraway and averted, in an all-white environment resembling the studio, listening to those ethereal sounds that make her drawn inward and untouchable. An implied battle of lust and purity, *Woman Listening to Music* is the embodiment of these contradictory sensations—as produced by the music and as experienced by the artist.

Visually simple and direct, yet with subtle and subjective erotic associations, the work shows a woman on a nondescript bed, her back to the viewer, under an acoustic awning. Her sensually undulating back is reminiscent of all the courtly nudes from Rubens to Velázquez to Boucher. Turned around, she could be an odalisque or Canova's *Pauline Bonaparte Borghese as Venus* on her satin chaise.

A record player stands nearby and *Beatus Vir* plays at high volume. For Segal the music is essential here, not just to suggest what went into the making of the work, but to give a clue to the scene portrayed. In contrast to the willful exclusion of music from *Rock and Roll Combo,* the sound of the phonograph record in this work is essential to the mood of the subject. It is a difference between active outward direction and passive inward direction. One work is self-evident, the other can be evinced only with the proper clue—an acoustic clue should the visual fail to be conclusive.

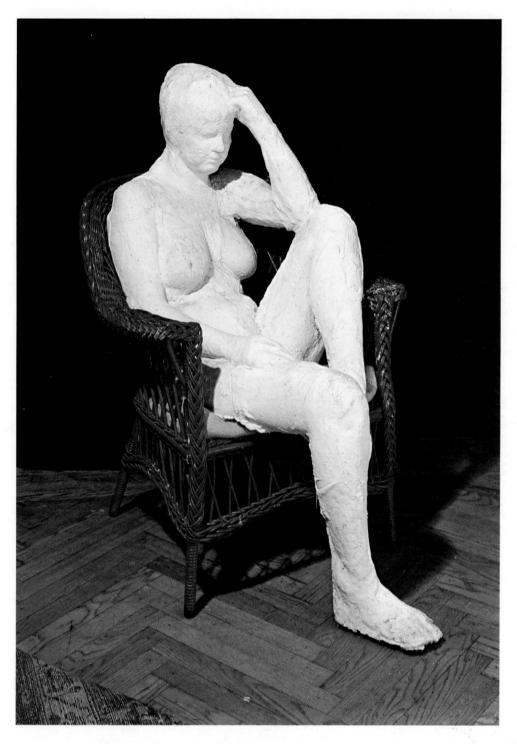

42. *Woman in a Red Wicker Chair*. 1964.
Plaster and wicker, 48 × 32 × 42".
Collection Vivian Tyson, New York

ROBERT AND ETHEL SCULL

Two years after his first and unsuccessful attempt at portraying Robert C. Scull as he leaned on a car door, Segal again addressed the issue of a portrait commission from the same unrelenting admirer. This time it was to be a double portrait of Mr. and Mrs. Scull, and to avoid another failure the sitters specified to the artist what they wanted: a formal portrait, so Segal took them at their word.

He chose a rather "social" setting—a Victorian sofa, upholstered in bottle green and pleasing to him for its voluptuous form. The painting behind the sofa is a perfectly square, bright-red monochrome—a pun on color painting?—and it marks the second time Segal used an actual painting in lieu of resorting to found or manufactured environmental props. The reason may have been that he sought the perfect contrast between sofa and painting, but it also was a means of suggesting that the couple portrayed lives in a house filled with paintings. An alternative would have been an actual painting from the Scull collection, not by Segal. Two years later that alternative was tried for another portrait commission.

As it turned out, *Robert and Ethel Scull* became a superportrait of an era, as typical of the 1960s in America as Jan van Eyck's *Giovanni Arnolfini and His Bride* was of Flanders of the fifteenth century and Goya's *The Family of Charles IV* was of royalty at the eve of the French Revolution. Portraiture is almost incidental to this work, for it stands on its own merits regardless of the models. In fact, it tells more about Pop society than about the individuals' identities, and this is what constitutes its general appeal.

"Part of being portrayed," Segal reminds us, "is putting on one's best face and clothes." So Mr. Scull went on a diet and Mrs. Scull insisted on wearing Courrèges boots. It was the sculptor's idea to give Mrs. Scull sunglasses to wear, perhaps because the jet set affects a not-quite-credible incognito. Segal has a more subtle explanation: "There are people who want to be known but are afraid to be hurt." The cool stance of the 1960s is precisely that: a shield from emotional pain. It has nothing to do with being cold or dispassionate, according to the artist, but it was the way Pop society sought protection.

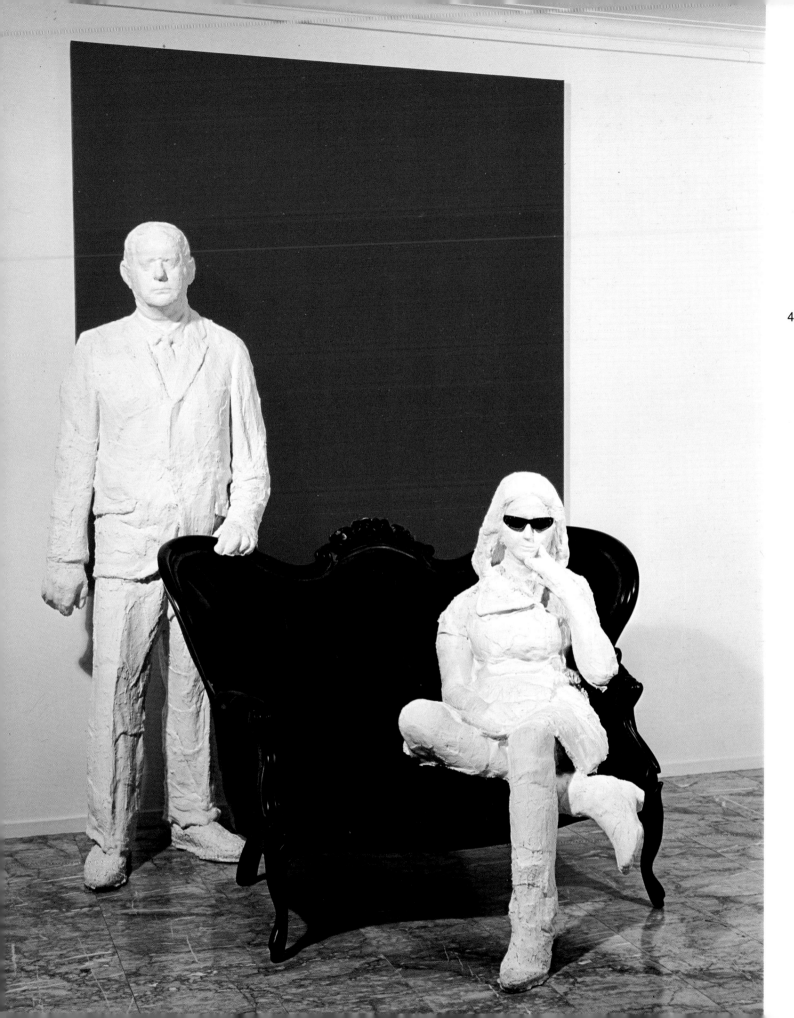

43. *Robert and Ethel Scull.*
 1965. Plaster, wood, canvas,
 and cloth, 96 × 72 × 72".
 Collection Mr. and Mrs.
 Robert C. Scull, New York

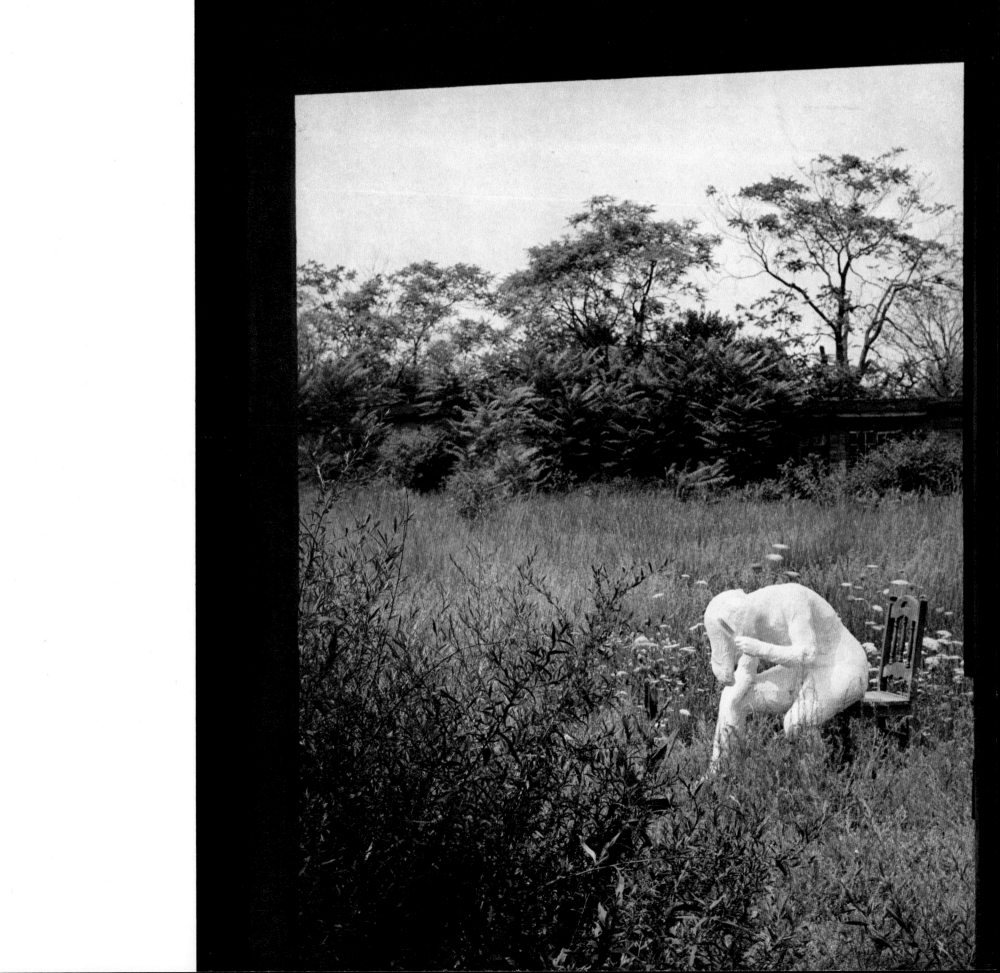

44. *Woman Brushing Her Hair.* 1965.
Plaster, wood, and plastic, 40 × 24 × 46″.
Wasserman Family Collection, Boston

45. *Old Woman at a Window.* 1965.
Plaster, wood, glass, chrome,
and board, 96 × 36 × 48″.
Collection Mr. and Mrs. Melvin Hirsch,
Beverly Hills

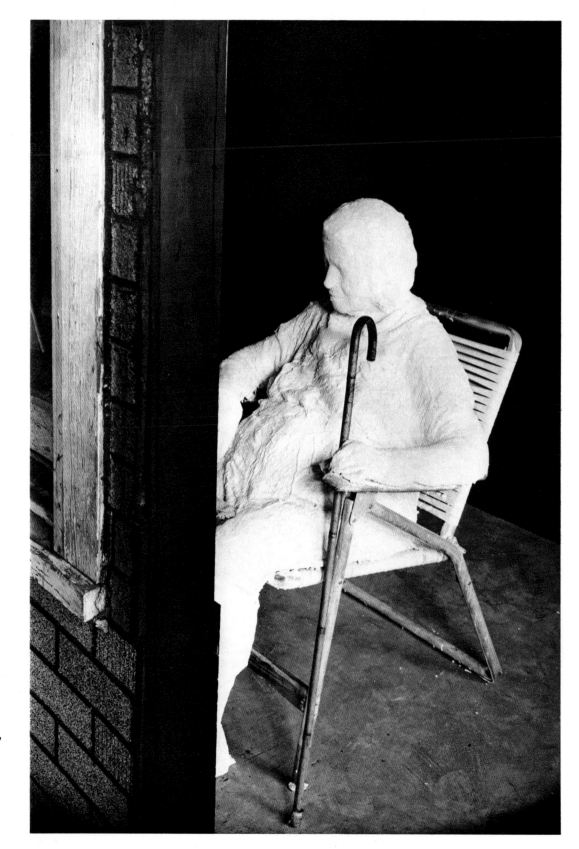

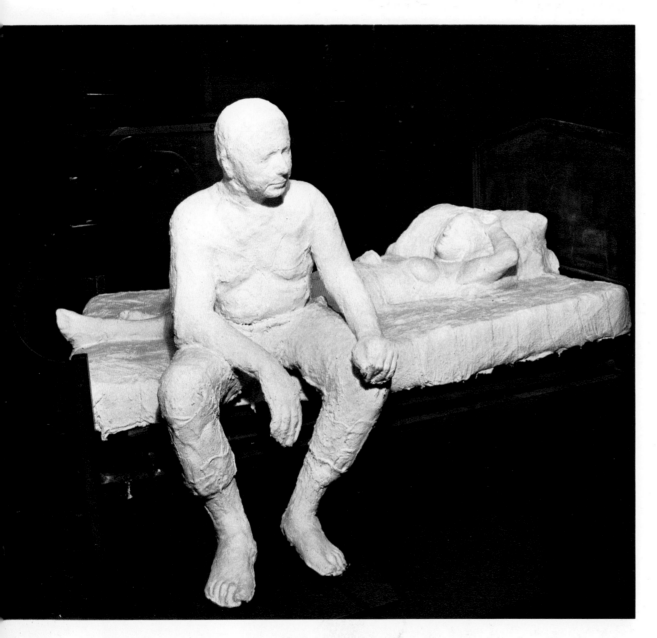

46. *Couple on a Bed.* 1965. Plaster and metal, 47 × 81 × 50″.
Art Institute of Chicago (Mrs. Robert B. Mayer Collection)

COUPLE ON A BED

The theme of two lovers on a bed is treated again, but there is no longer that fresh, romantic togetherness. The bed is properly old and pathetic, like the first one. Mattress and pillows are cast in plaster, like the woman reclining on them. Most striking is the portrayal of conflict, a falling-out between the man and woman. The man is seated on the edge of the bed, brooding and turned away from the woman, who is stretched out and relaxed. ''I have noticed,'' Segal says, ''how quickly after intercourse two bodies exist again within their own boundaries.''

This pessimism can be explained by the fact that a lot of friends' marriages were breaking up at the time the work was done. As Segal describes it, the women were ready to be feminine, open, and welcoming. The men were fraught with self-doubt and hangups, torn by different impulses which prevented any generous giving. They couldn't fulfill the sweet, innocent, physical demands of women. Above all, they wanted to be artists but didn't quite know how to do it. They were ''men having too much trouble being men while women didn't seem to have trouble being women.''

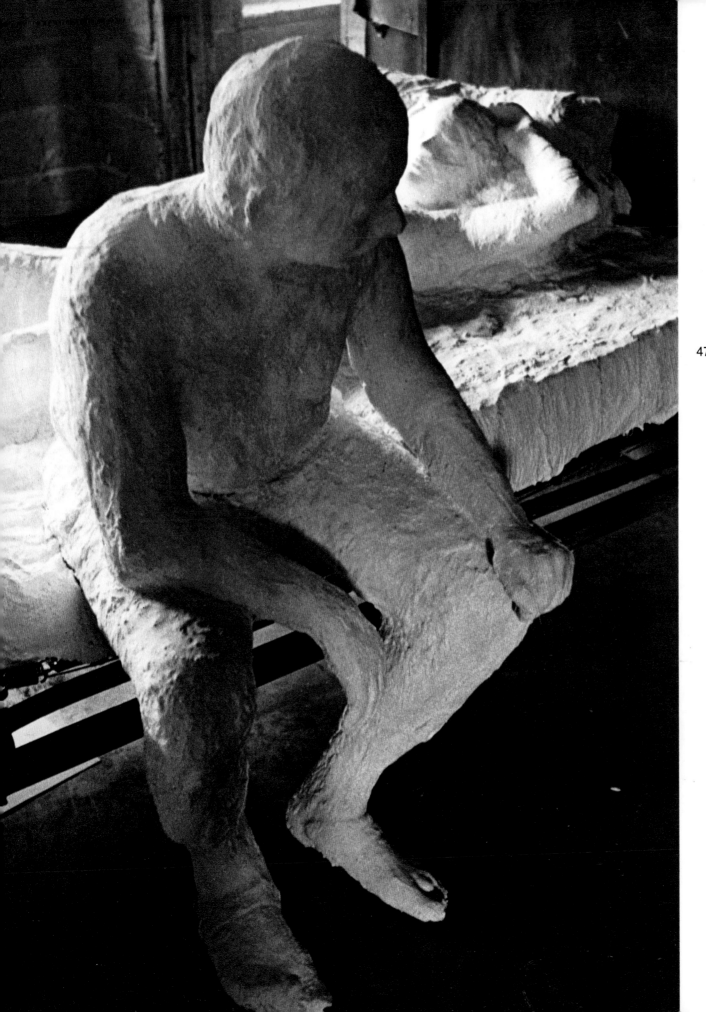

47. *Couple on a Bed* (detail)

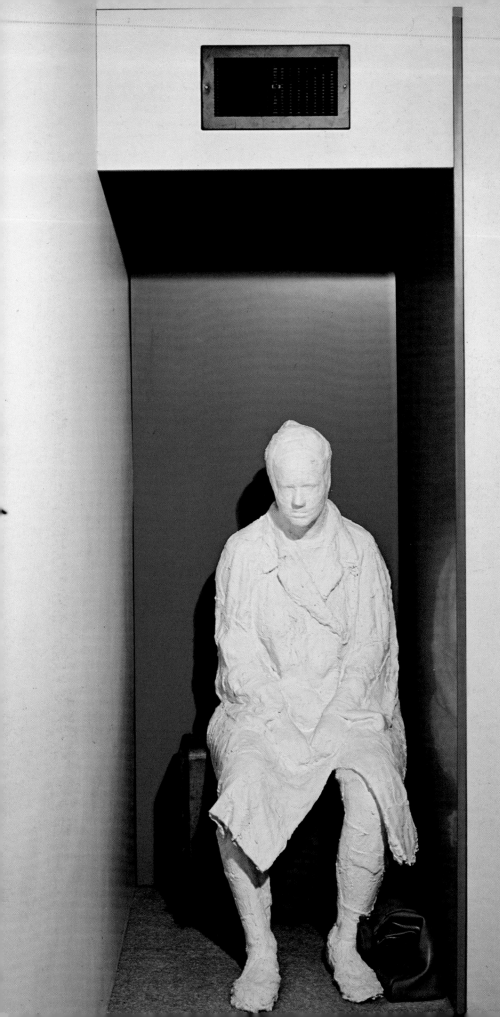

48. *The Bus Station.* 1965.
Plaster, wood, and plastic, 96 × 48 × 24″.
Collection Howard and Jean Lipman,
New York

THE BUTCHER SHOP

Black and somber, but made with the tenderness of memory and the precision of faultless recall, this work was conceived as a monument to the artist's father. Jacob Segal had never wanted his son to become an artist and had settled for his becoming an art teacher so he could support a family. He had died six months before. George loved him very much—unlike most sons, he admits. His mother agreed once more to wield a butcher's knife, as she had done when she helped her husband run a small kosher butcher shop in the Bronx. The artist still shudders at the thought of having to crawl, as a child, on Sabbath's eve through the narrow window space and wipe the blood off the meat hooks. He went back to his old neighborhood and combed the hardware stores for the fixtures he needed. Then he put the piece together.

The front of the piece is the re-creation of a store window, strangely related to the storefronts Christo was exhibiting at that time. Segal admits a liking for those mysterious, unfunctional, and shrouded display spaces. His, of course, is open and fully transparent, made of wood and plastic. The counter is covered with white vinyl tiles; he put in a real, old butcher block and found the same racks, hooks, and hacksaw he remembered. The wood is painted a flat black, but more prominent are the black Formica panels in the back of the shop that reflect the white plaster effigy of the artist's mother as she stands clasping an ax, facing a dead plaster chicken. More chickens hang and lie around—the artist eliminated several others to arrive at a starker image—and the windowpane reads BASAR KOSHER in Hebrew.

The artist has paid minute attention to even the smallest detail in this austere yet revealing tribute to his hard-working family. The organization of the space was most important to him, and so were the formal echoes and reflections. Standing in one particular spot it is possible to see the woman reflected three times. Segal wanted this work, one of his best, to be as strict and severe as a Mondrian painting. On the other hand, he wanted to pack it with as much privacy and reverence as he felt for the subject. These are the carefully combined elements that make up this work of art—the contrasts of form, surface, and texture on the level of composition and, in human terms, the contrast between the starkness of everyday necessity and the compassionate strength of a woman reluctant to kill even a chicken. "If you don't get involved with these specifics," Segal claims, "you are murdered when you try to approach generalities."

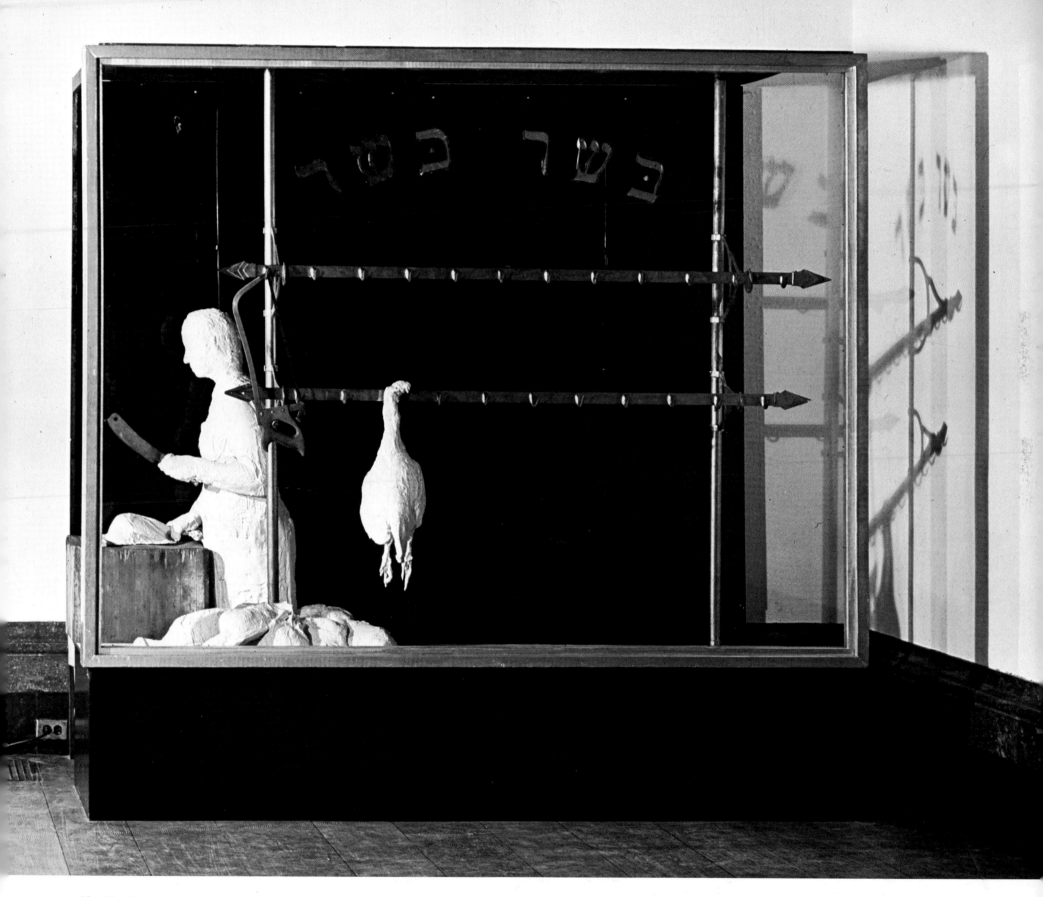

49. *The Butcher Shop.* 1965. Plaster, metal, wood, vinyl, Plexiglas, and other objects, 94 × 99¼ × 48″. Art Gallery of Ontario, Toronto
(Gift from the Women's Committee Fund, 1966)

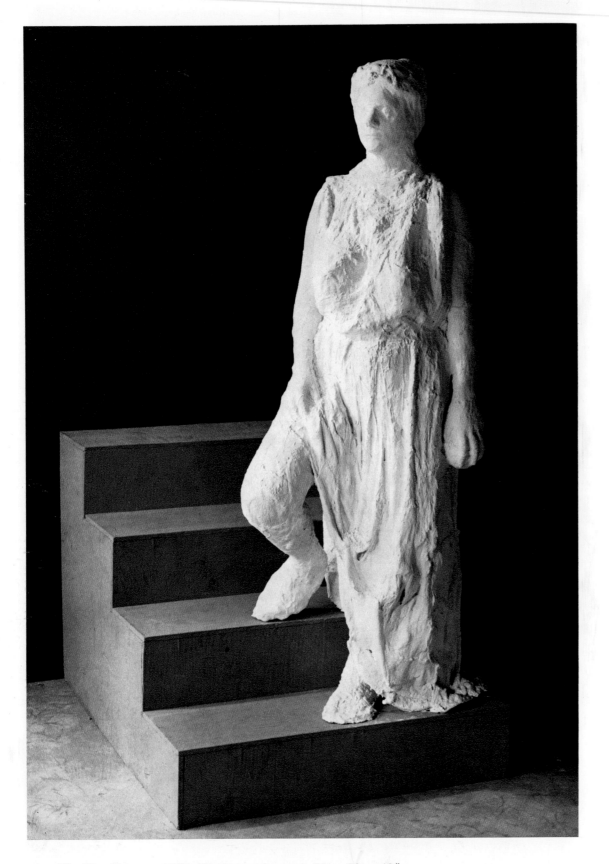

50. *The Actress.* 1965. Plaster and wood, 72 × 36 × 48″.
Hirshhorn Museum and Sculpture Garden,
Smithsonian Institution, Washington, D.C.

THE ACTRESS

Segal is at his best when he deals with contemporary people in everyday settings. Yet he has on occasion ventured into the realms of theater, history, and myth as testing grounds for his subjects—and sometimes for himself—where a specific posture, feeling, or state of mind is analyzed and presented in a broader human perspective. Segal's fine sense of mockery has invariably kept him from going too far; it has also lent saving grace to an occasional failure. Knowing full well that our concept of the past is a distortion approaching fiction and that the plaster effigies of his creation are already "on stage," he still strives to attain that split-level reality of a contemporary woman impersonating a historic role, cast to look timeless in plaster. Is the result a fictional rendering of truth or a truthful rendering of fiction? Since Segal favors a one-to-one relationship with reality and claims that reality is more evocative than fiction, he is saddled with a handicap when the subject he chooses is more easily imagined than seen.

The Actress sprang from the artist's curiosity. One of his models had mentioned to him that she was acting in a Greek play. He wondered if and how an actress "rises" on stage to the role assigned her. Would casting her in that role perhaps provide the answer? Not really taking his own question seriously, he nonetheless put a bedsheet around her shoulders and a rubber ball in her hand. Then he had her come down a few stage steps, poised in an imaginary spotlight. The illusion was credible enough to encourage the artist to translate it into plaster.

From a formal viewpoint, the sculpture is distinguished by a fortuitous correspondence between the descending plaster figure and the ascending plywood stairs, converging to form a V at the bottom. Segal likes

the term "processional," and he applies it to the stride of bodies as well as the march of stairs. Here the two merge happily in a convincing image. From a psychological viewpoint, however, *The Actress* is not nearly as persuasive. She makes us uncomfortably aware of fiction encroaching upon fact, and we hardly believe she is real.

Would not the same girl have looked more natural and acted more convincingly had she stepped nude from a shower stall or from a doorway in street clothes? In fact, by acting herself in a common environment she might have looked as though she were acting in a movie. Neither her stance nor her manner would have betrayed that she was really impersonating somebody else. This unquestionable overlap of a person and her role is what, normally, Segal seeks to capture in his sculpture. Yet, if here he wanted to forsake this principle, how then could he make it clear that the subject is merely acting?

Dress is a limited clue, and it takes a lot of plumage to obliterate that impression of everyday naturalness Segal aspires to create. Mental distance and physical mannerisms are qualities too subtle to be rendered in plaster and are inimical to the artist's method, which makes total ease a prerequisite of successful casting. Caught in this dilemma, Segal had no choice but to resign himself to the amateur look of an actress who was in fact an amateur. Twice removed from reality, through role and through plaster, she looks less herself and less than what we expect from the artist. Segal acknowledges that if he starts with a cultural premise instead of a natural impulse, there is trouble in store for him. But, not wanting to give up the concept entirely, he marvels, "Wouldn't it be great to cast a superb actor or dancer in a historic role?"

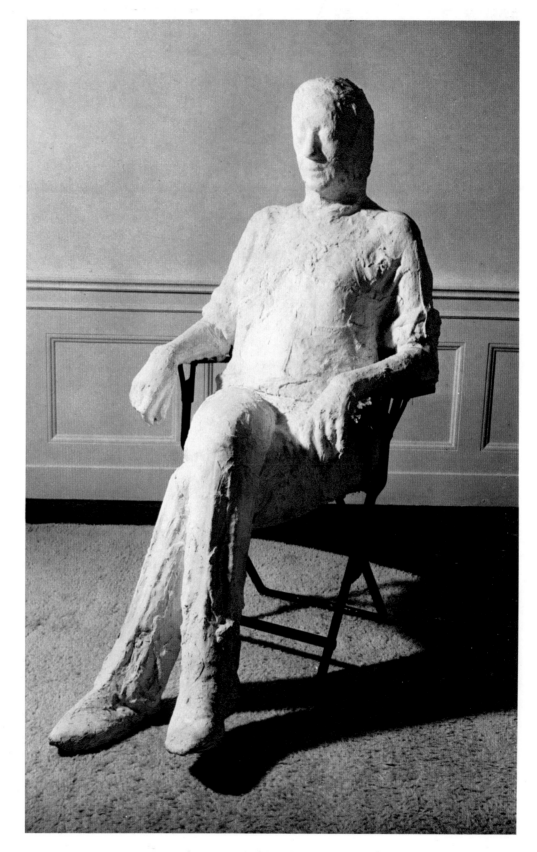

51. *Vera List.* 1965. Plaster and metal, 52 × 27 × 40".
The Albert A. List Family Collection, New York

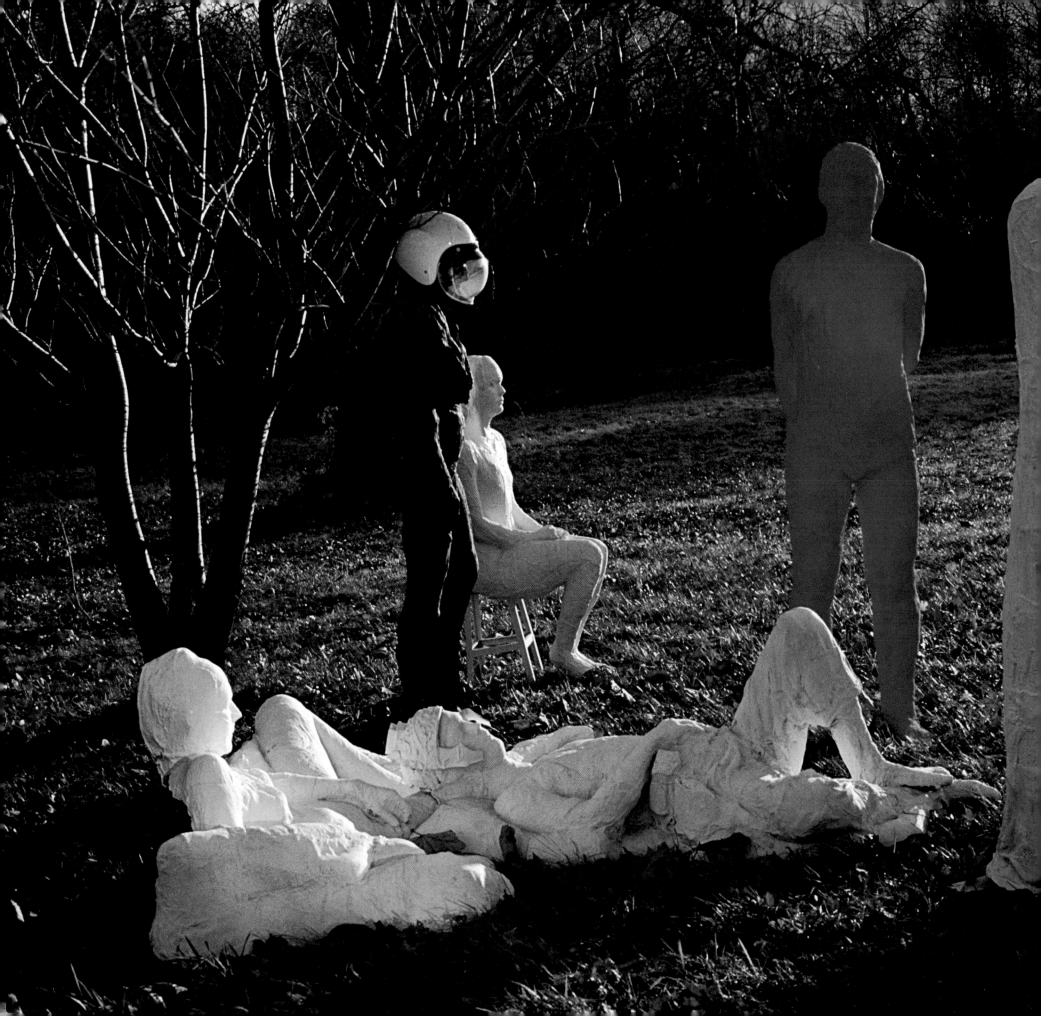

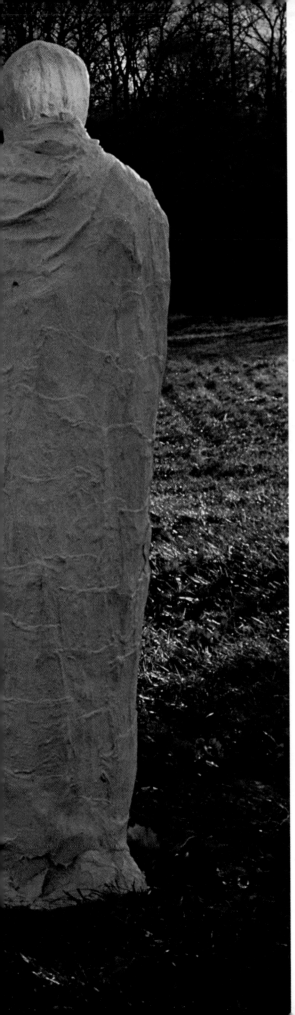

THE COSTUME PARTY

Not since Segal grouped three men and three women around a dinner table had there been a sculpture with as many figures as *The Costume Party*. In fact, the same constellation of three couples has been maintained, and it would seem that the party had broken up in favor of playing games.

The artist tells us that it was the winter of his discontent that drove him to this subject. Anger and frustration had been building up within him. He found it difficult simply to be with people. Only once had he attended a costume party—not of artists but of New Jersey schoolteachers—and he had felt uncomfortable from beginning to end. His trips into Manhattan had shown him that close friends were living the same "bad scene." The artist wanted to externalize his feelings and make his state of mind concrete. Perhaps he hoped it would be an incantation to ward off bad forebodings. Having come to a "stand-off," Segal tried to portray people like himself as they were shedding their excess mental baggage, the clutter of their minds.

As it turned out, *The Costume Party* was a nightmare in three acts, striving toward, but never reaching, catharsis. All Segal knew when he started was that there had to be three men and three women in varied attitudes and relationships to one another. He imposed a false veneer of clarity by sharply defining costumes, characters, and colors. There is the King, dressed to resemble Marc Antony, who reclines on the floor. Then there is the Queen, Cleopatra of course. Nearby stands the High Priest, wearing a donkey mask and looking like Bottom in *A Midsummer Night's Dream*. Huddled on a stool sits the Princess, also known as the Cat Woman, since she wears a yellow mask of cat's fur. All black and forbidding, with her leather vest and motorcycle helmet, is Pussy Galore, a strong woman and royal guard. The center of the stage is held by Superman, young and arrogant, who flaunts a medallion on his chest containing a photograph of his own beautiful profile, and a strapped-on penis that caused a scandal when the work was exhibited in Buffalo.

The original impulse to slide in and out of situations, to differentiate and then blur identities, to push his pieces about on the unlined chess board of his imagination, proved so strong that the work became a

decadent nightmare to the artist, full of frustrated theatrics. There was no plot, and Segal now accepts that. There has been no solution in the several years since the work's inception. There are allusions to deceit and confrontation. History and theater are scrambled and then served up as the artist's private myth, itself far from clear or explicit. The scene is a court, suggesting hierarchy and role playing, and a suitable arena for intrigue, switching of loyalties, secret alliances, threats, and treason. "What is that strange transformation taking place in people who play roles?" the artist wonders.

As shockingly novel as it may have appeared at first, *The Costume Party* could be effective as an image only when colored and festooned. If a dream can be considered white, a nightmare must be colored. Segal painted his actors red, green, yellow, silver, blue, and black. Part of the problem of integrating the six actors into one group was their different colors. A second version of *The Costume Party,* shown at the Art Museum of Princeton University, relinquished any attempt at grouping. The actors were lined up in a row, as though they were taking an imaginary curtain call. Not pleased with this abdication of composition, Segal produced a third, more toned-down version, which was shown at the World's Fair in Osaka. Here, the colors were reduced to white, red for Superman, and black for Pussy Galore. In addition, he stripped the work of most of its accessories, leaving the Princess with her mask, Pussy Galore with her helmet, and Superman with his medallion.

Segal once said, "If I lose the balance between reality and fantasy, I become a surrealist and I'm not interested in that." Digging into his private premonitions of his friends' world ready to collapse on him, the artist came close to upsetting that balance. He pushed beyond the implicit boundaries he had set for his work. It was a risky departure from real people in real situations and an uncertain leap into another realm.

How can one orchestrate a bad dream and bring it to conclusion? By waking up and thus leaving it behind. "Maybe it's too much of a freak," Segal concedes; "I don't usually feel that confused or inclined to travesty."

52. *The Costume Party.* 1965. Acrylic on plaster, metal, wood, and mixed media, 6′ × 12′ × 9′.
Sidney Janis Gallery, New York

RUTH IN HER KITCHEN

Segal made an earlier version of this work in 1964 and, even in its present, stripped-down version, it carries the spirit of Segal's pieces of that period. Ruth is a friend of the sculptor, a strong woman of independent spirit whose surroundings fit her taste and temperament. In *Woman on a Church Pew* she is seen reading not a prayer book but a copy of the *Scientific American;* instead of contemplating the spiritual delights of heaven, she studies a map of the stars. Her taste runs to heavy oak mission furniture, to junk and mementos of all kinds. This quality of Shaker austerity, combined with that of a scurrying pack rat, fascinated Segal and made him decide to do a portrait of Ruth. But first he had her pose on the pew he had picked up in a New Brunswick junkyard.

In the first version of *Ruth in Her Kitchen,* no longer extant, Segal and Ruth worked together in re-creating a corner of her kitchen, a rich and very personal world that looked like a cancerous jungle of scraps and detritus. "Ruth came to my house every day for two weeks," the sculptor reminisced, "arranging all those objects exactly as she had them at home. She requested that fresh flowers be added to the table in season. She stacked and arranged her things for inch-by-inch examination, seemingly oblivious to the overall effect of chaotic glitter and proliferation."

Wanting to create more than a mere physical portrait, Segal not only captured Ruth's appearance and the effect her physical presence had on her environment, but he also tried to lay bare the labyrinthine quality of her mind. "She talks as a stream meanders, without emphasis, going from topic to topic without connection, with minute examination of tiny things," Segal explained. So he made a thirty-minute tape recording of Ruth's ramblings, which he planned to incorporate in the piece. But the sound quality was so bad that he had to scrap the idea; later attempts at recording were too self-conscious. But even if it had worked the first time, he feels he still would have thrown it out with the rest of Ruth's clutter in the second version.

After *Ruth in Her Kitchen* had been returned from an exhibition at the Jewish Museum, with some of the objects broken or coming apart, Segal took a fresh look at the piece. It was clearly beginning to disintegrate—dried flowers crumbled, newspapers were yellowed—and was in need of Ruth's continued attention. The decay and mausoleum aspects repulsed him. There seemed to be too much of Ruth, and his own feelings about the piece weren't evident enough. So he stripped away all the tiny objects, leaving Ruth sitting on the couch at the round table with only her hand-hammered aluminum ashtray. "I felt trapped by some implacable law," Segal explained, "wanting to regain my personal space, silence and austerity, and wanting to get rid of Ruth's labyrinthian tracks."

53. *Ruth in Her Kitchen* (first version; later changed). 1964

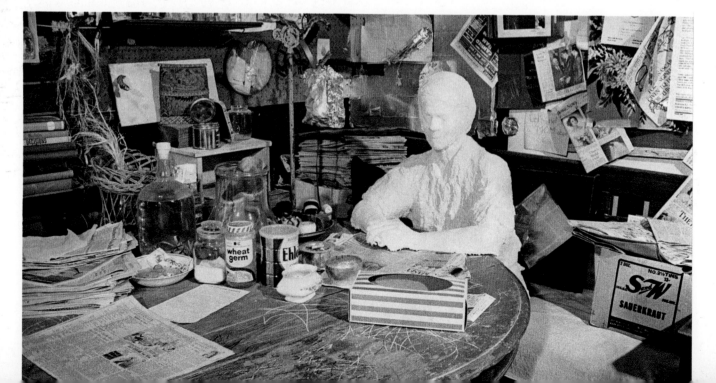

54. *Ruth in Her Kitchen* (final version). 1964–66. Plaster and wood, 50 × 72 × 60″. Von der Heydt Museum, Wuppertal, Germany

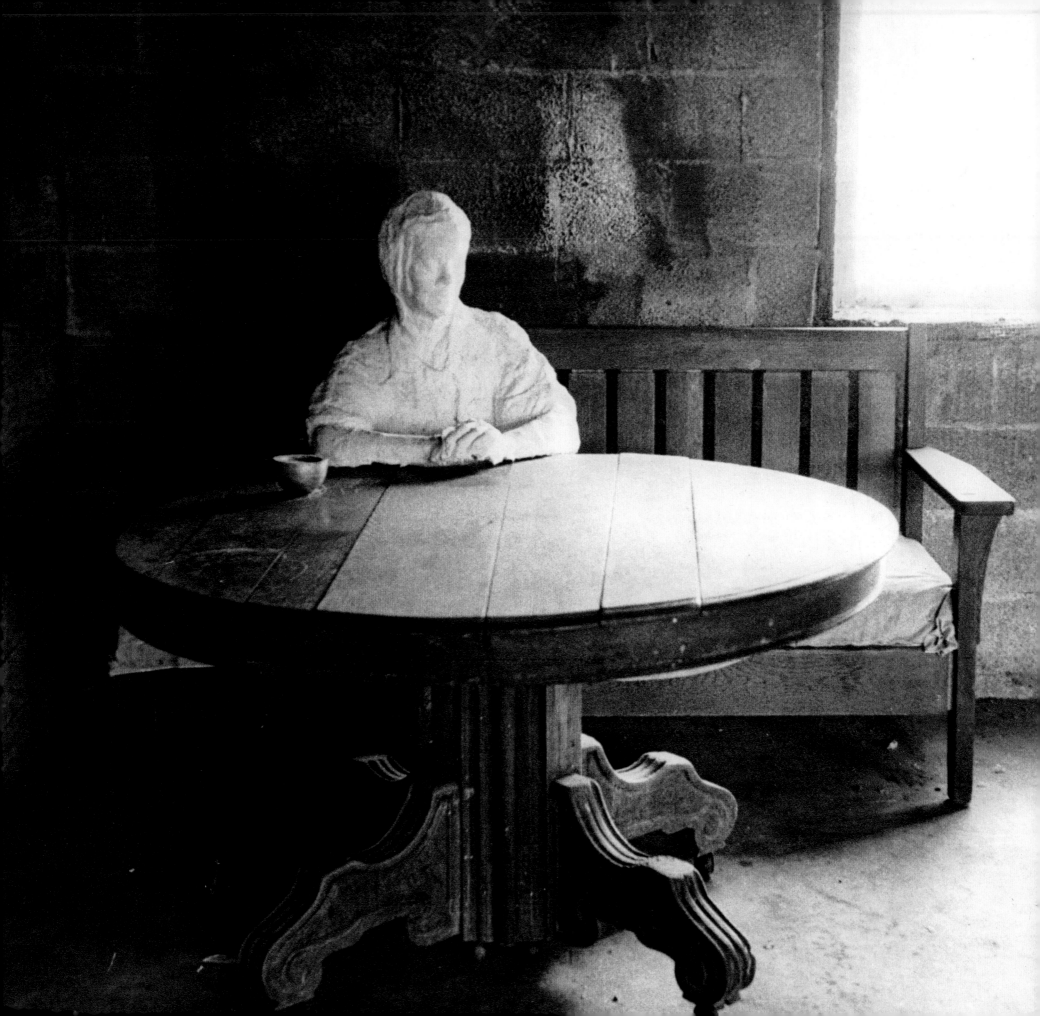

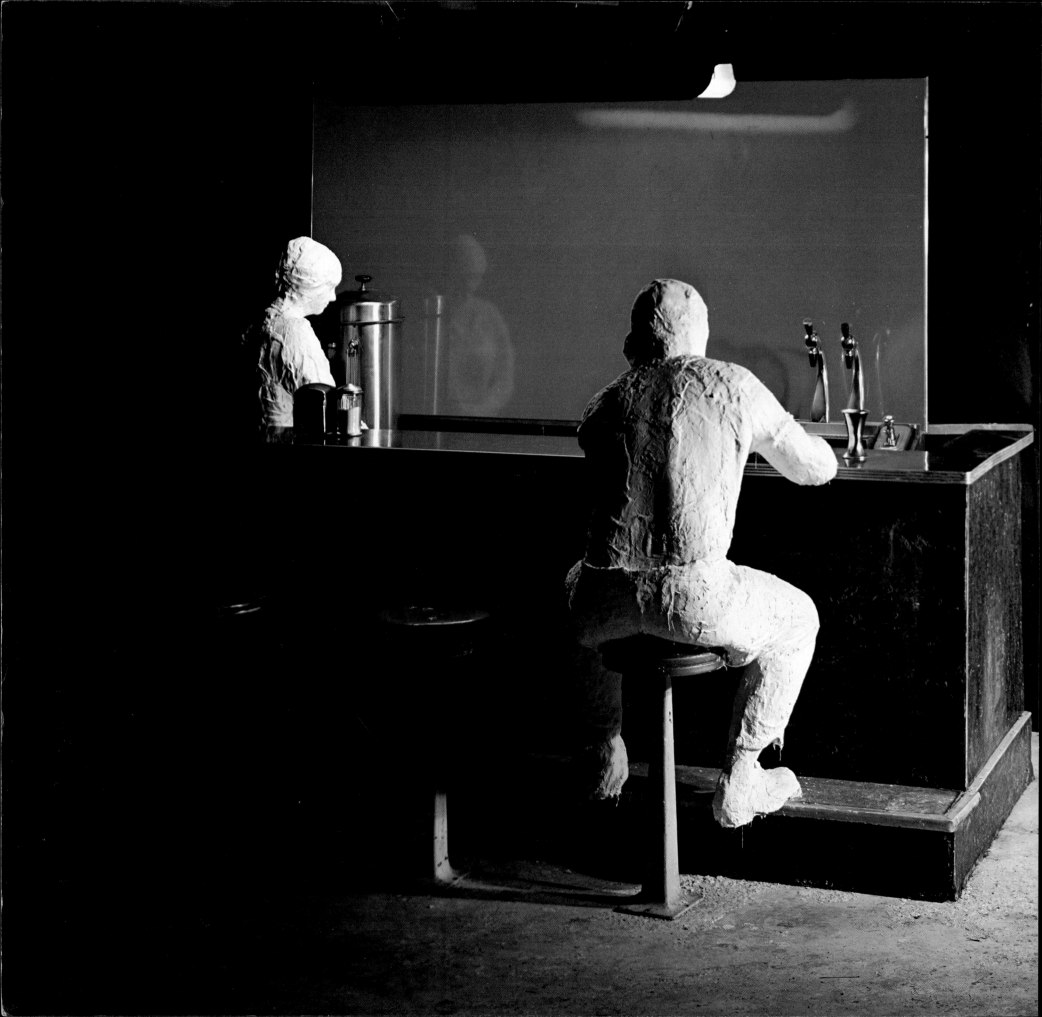

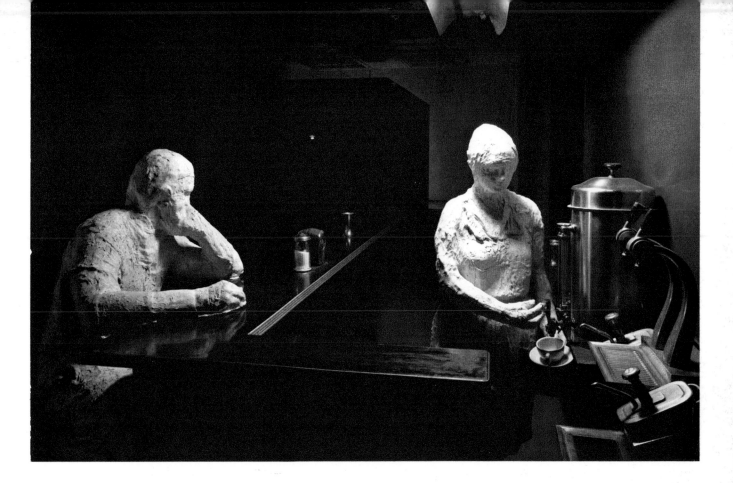

55. *The Diner.* 1964–66.
Plaster, wood, metal,
Formica, Masonite, and
fluorescent light,
8′6″ × 9′ × 7′3″.
Walker Art Center,
Minneapolis

56. *The Diner* (detail).
The relationship of
the two figures
has been changed
from the original.

THE DINER

Could there be a more uniquely American experience than walking into a diner, hoisting oneself onto a leatherette stool, and getting from an indifferent waitress a weak cup of coffee spilling onto the saucer? But is this how a diner impresses Segal? "I'm not that interested in manners, in material comfort and in elegance," he concedes. "This has to do with my early upbringing." But then, does that mean that diners to him are such an everyday experience that familiarity has blunted his feelings about them? No, he too finds them unsettling.

"But I hide my estrangement, I seek invisibility; I can put on a protective coloration, since I was born and raised in this world." Segal explains that what interested him in *The Diner* was its structure: that long corridor space of a converted railroad car, rather than its pure Americana. It is the Minimalist, not the Pop artist who speaks here: "At times I stumble into spaces that move and terrify me.... When that happens, I want to rebuild them and capture their expressive power but not their function."

With its spatial enclosure and self-contained light, *The Diner* conveys that sense of totality which makes it important among Segal's works. It flashes an instantly recognizable image, the embodiment of grubbiness and loneliness—a natural sequel to a realist tradition in American painting exemplified in this century by the Ash Can school and the 1930s Regionalism. Hopper's *Nighthawks* has often been mentioned as a precedent. But Segal's *The Diner* has little in common with Hopper's moody, almost romantic, Depression-era café other than its subject matter and its evocation of a shared American experience. Another comparison can be made with Edward Kienholz's *The Beanery,* an environmental assault of visual, tactile, and olfactory sensations that can be experienced only by being crowded into that space. Kienholz's work bears little or no relation to Segal's quietly solitary and uncluttered re-creation of a space that is sparsely populated and only vaguely defined.

The Diner has not always had the exact positioning of figures we now see. After exhibiting the work at the Sidney Janis Gallery, Segal decided that the girl, standing at the far end of the counter, had to be moved nearer the man on the stool. By clustering the two figures on the right, he opened up the space on the left. Segal observed that, ironically, the psychological distance increased as the physical distance decreased. Does this indicate that distance allows for expectation, whereas proximity breeds contempt?

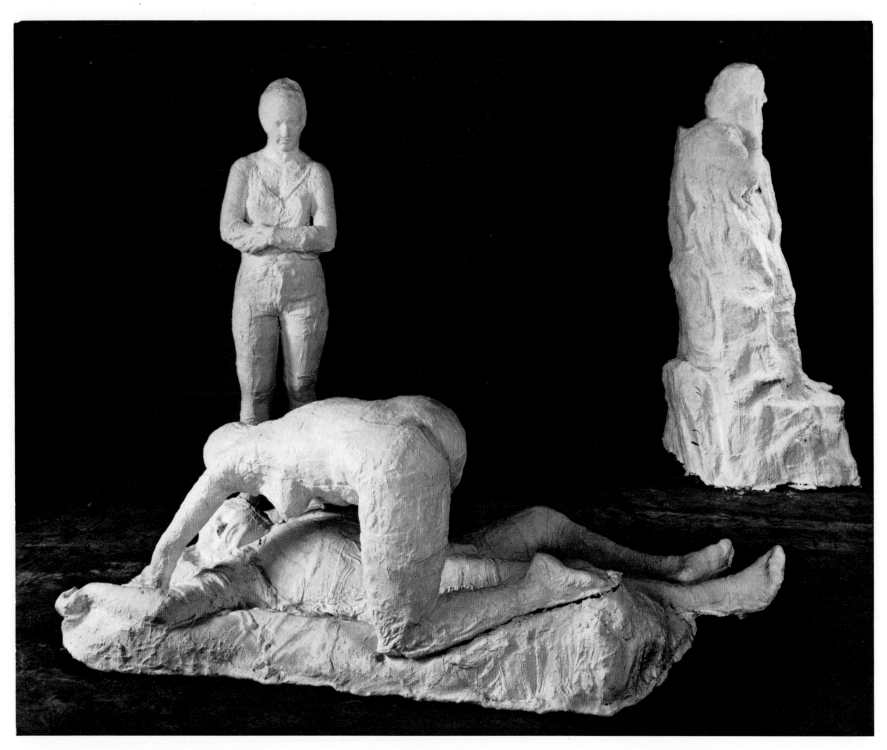

57. *The Legend of Lot.* 1966. Plaster, 6′ × 8′ × 9′. Kaiser Wilhelm Museum, Krefeld, Germany (Lauffs Collection)

THE LEGEND OF LOT

The occasion for this piece was the Sidney Janis Gallery's exhibition, "Erotic Art '66." The impulse for the piece had come from an early interest in the legend of Lot and his family, to which, in 1958, Segal had devoted six paintings. His curiosity was piqued by reading the famous passage in the Bible, and this led him to reflect on the motives involved.

As the only decent man in a wicked city, Lot was deemed worth saving. Why then would an upright man like Lot get drunk and commit incest? An uncle of the artist, both religious and pragmatic, had this explanation: "Lot and his daughters were convinced they were the last people on earth; they ran from cave to cave. The daughters plotted to seduce their father. They did the only thing they could think of to continue the human race." Struck by the idea that the last human beings on earth knew no better way to guarantee the survival of all mankind than through the act of love, albeit incestuous, Segal conceived of this work as a tribute to "that resourcefulness and quality of human response in an extraordinary situation."

As a sculpture The Legend of Lot was not easy to make. Because it seemed to be a good starting point, Segal had himself cast as the legendary drunkard, prostrate on the floor. With proper assistance, this was a simple problem of logistics. The pose of the girl bending over Lot was more difficult to achieve, even though the model was a trained dancer, for here the problem was physical. The sister is standing passively by, awaiting her turn. She was the second girl cast in that role; the first one froze and shrank back, hardly having the proper attitude. The problem of casting the second daughter was psychological.

Lot's wife is caught in the moment of metamorphosis, as she turns to face the destruction of her beloved Sodom and Gomorrah and her flesh solidifies into salt. She is as credible as Daphne turning into a sprouting tree, and that leads us to the fourth problem the sculptor encountered. How could he invest what no eye has ever seen with a recognizable shape? For clearly this was the pivot around which not the action but the meaning of the work revolved. He tried casting rocks to represent her transformation, but abandoned them for a more abstract concept of the mind—not quite his customary procedure.

Ironically, it is neither the dramatis personae nor the morally taboo subject that flaws this sculpture, but it is the pillar of salt as a not wholly convincing reference to the Scriptures. What if the artist hadn't included it? The scene would be read as an inversion of the gang bang, a metaphor perhaps for women's sexual aggressiveness, and a forecast of a new matriarchal society. Yet, while Biblical scholars would have recognized the scene, with or without a pillar of salt, it would have eliminated its dramatically ominous quality, as well as a major clue to the artist's subconscious.

Segal's Legend of Lot is layered with meanings, some referring to the world around him, some to his life as an artist. He admits to having fleshed out a scant number of Biblical verses "according to the nature of people I knew." To underscore the positive meaning of the act portrayed, Segal explains that "so much in my friends had to do with willful destruction, drugs, suicide, unfulfilled promises that a choice for life instead of a choice for death seemed to redeem this otherwise shocking act." With regard to such a prominent show of female initiative, he adds: "I knew a whole matriarchal society down on East Broadway for ten years. In a matriarchal society all kinds of inversions take place; some women turn into aggressors, others into voyeurs."

Setting up these forbidden situations may have intrigued Segal because they referred to people he knew, but he was not unaware of wrestling primarily with his own taboos. The Legend of Lot tells of the wrath of God visited upon a wicked city whose inhabitants had broken His commandments. But was not one of those an admonition against the creation of graven images? Is the artist atoning for his own guilt in portraying the guilt of his race? Abstract art set up a secular version of that injunction and that, too, Segal had flouted in his quest for a new figuration. The pillar of salt itself is a potent metaphor for the way Segal changes warm flesh into cold plaster or, beyond the similarity of salt and plaster, how any sculptor fashions an image from inchoate matter.

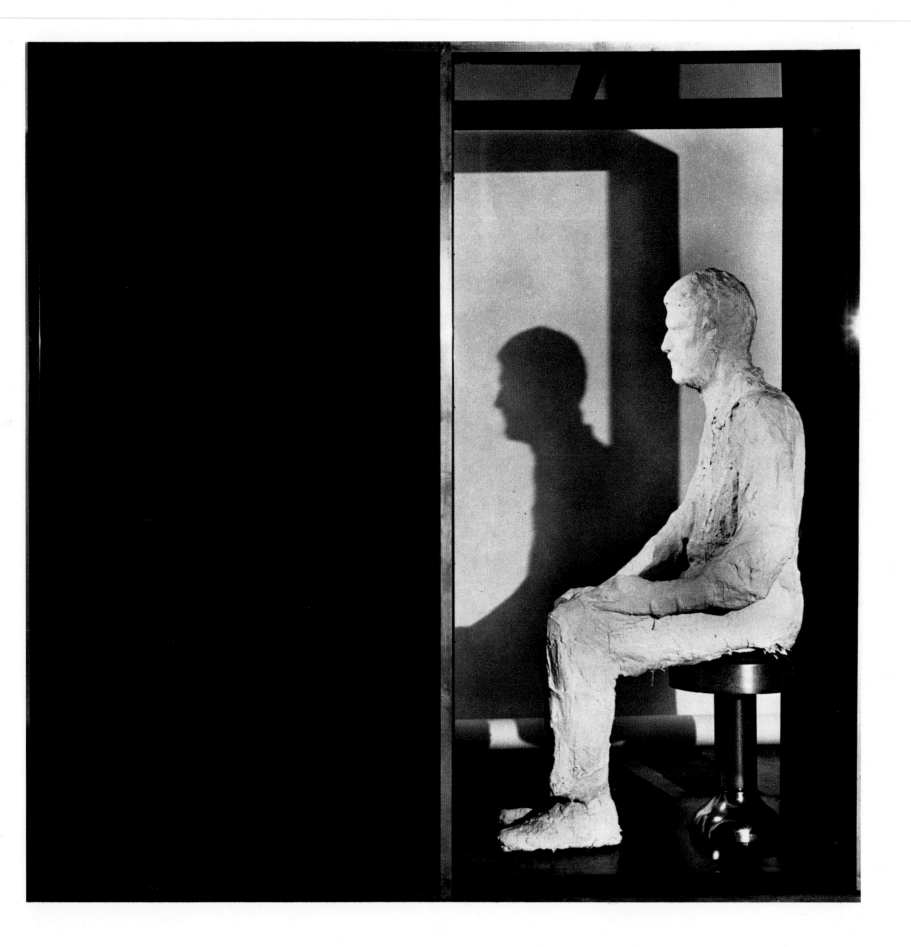

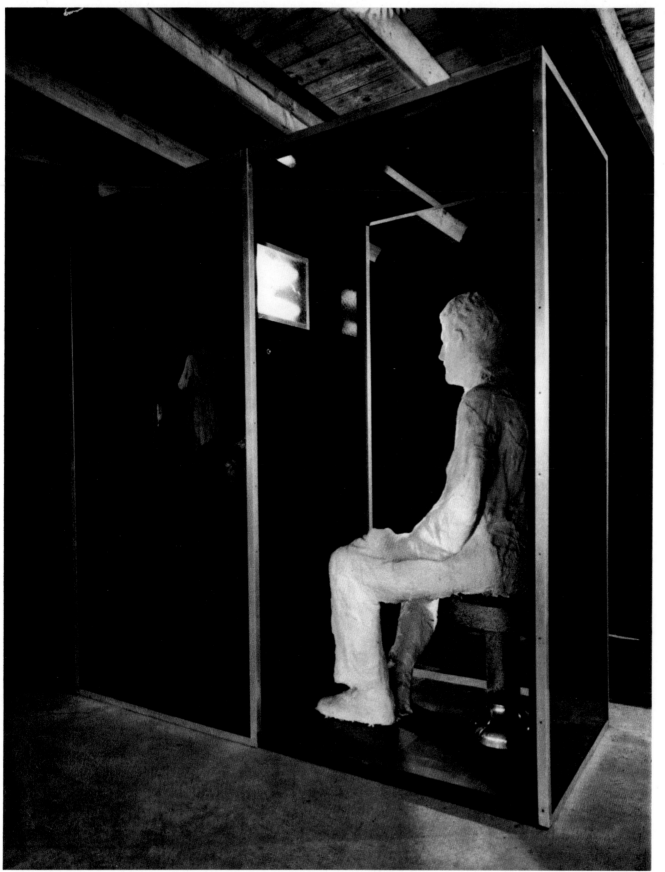

58–9. *The Photobooth* (two views). 1966.
Plaster, wood, metal, glass,
fluorescent and incandescent light,
72 × 73 × 29″. Collection
Dr. and Mrs. Sidney L. Wax,
Thornhill, Ontario, Canada

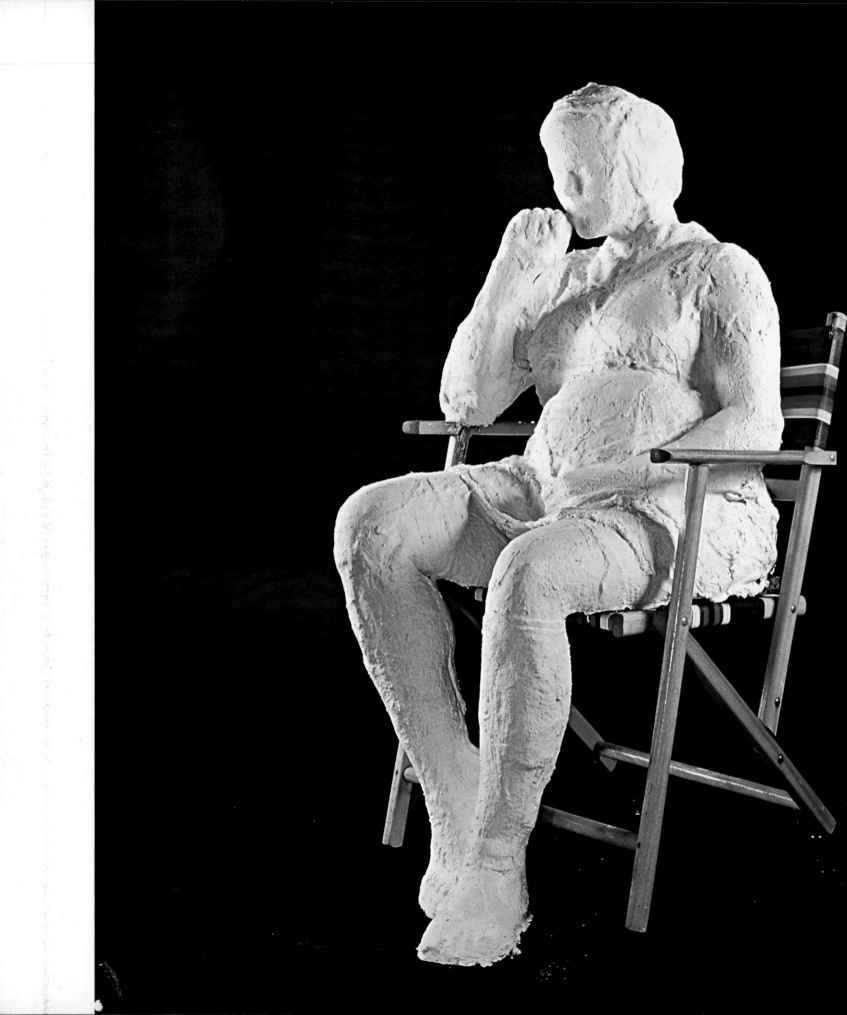

60. *Pregnant Woman.* 1966.
 Plaster, wood, and canvas, 46 × 23½ × 32″.
 Playboy Magazine, © 1966, Chicago

61. *Walking Man.* 1966.
 Plaster, wood, and painted metal,
 85 × 58 × 34″. Collection
 Mrs. Norman B. Champ, Jr.,
 Saint Louis

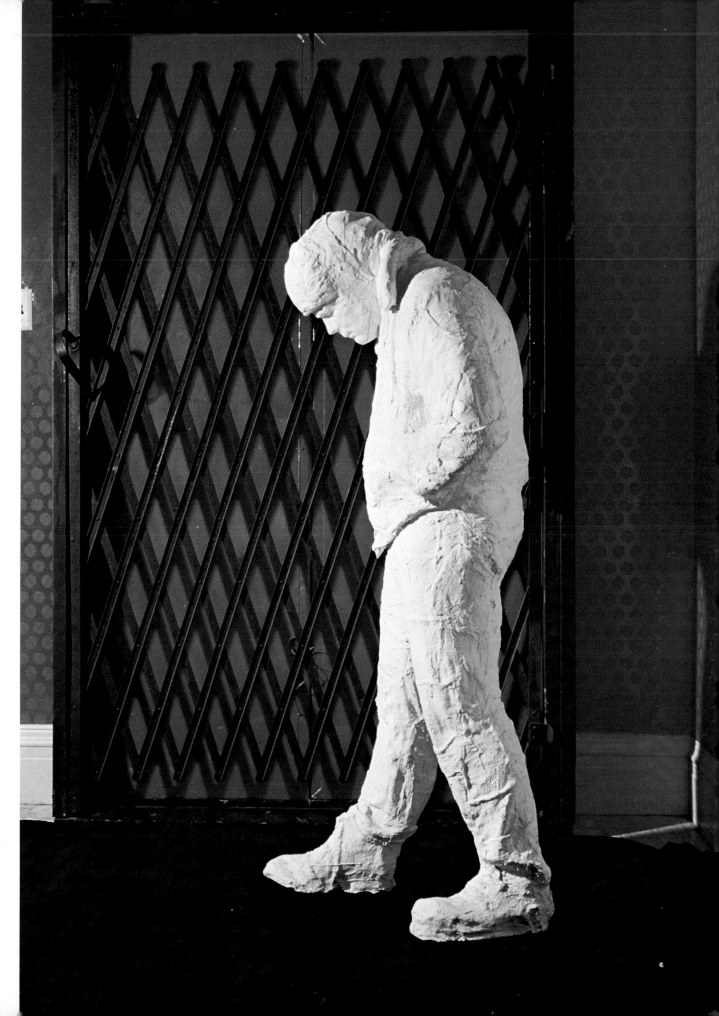

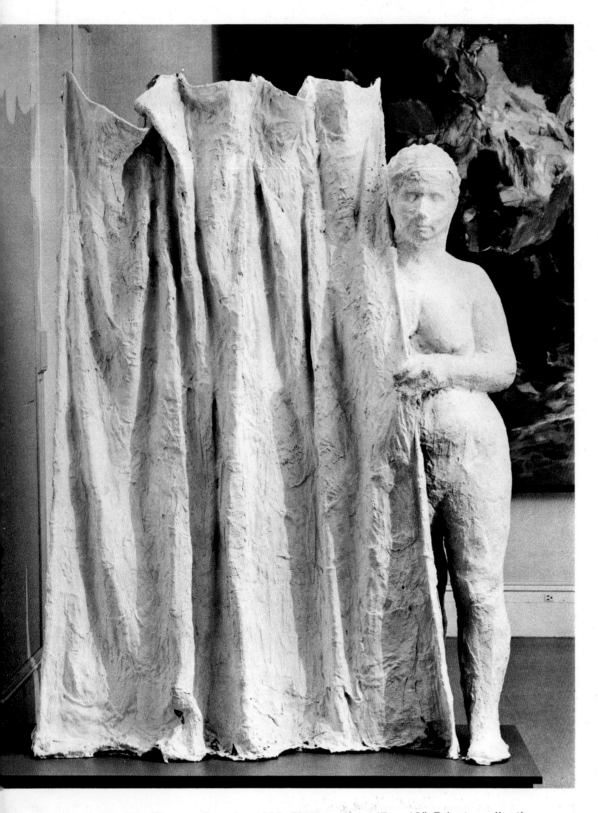

62. *The Shower Curtain.* 1966. Plaster, 69 × 47 × 16″. Private collection

THE TRUCK

This work resembles *The Bus Driver,* but is formally more complex and complete. Both are capsule statements on man behind the wheel. The whole cab of a panel truck has been used in *The Truck* rather than just the entrance platform of a transit bus. Color is a prominent feature, a bright red instead of the bare wood and metal of the earlier piece. *The Truck* is a visualization of night-time driving as, presumably, *The Bus Driver* represents the daytime. The most decisive difference, though, is the compulsory angle of viewing for *The Truck,* as a result of the inclusion of simulated kinetics and additional color in the form of a film, a second level of reality in the piece.

The driver is a neighborhood chicken farmer, and the cab is identical to that of the artist's own red panel truck. It is all firmly rooted in reality and in Segal's life style. Reflected on the windshield by a hidden projector is a three-minute, 8-mm color movie of a night-time drive on busy Route 1. The scene as viewed from the driver's seat is a kaleidoscope of swirling neon, traffic signals, taillights, and glaring headlights, as they pierce the windshield on a moonless night. Lights bobble crazily toward the viewer, stab into the cab, and then swish past the driver's shoulder into blackness. Gaudy, flashing neon signs proclaim outlets for beer, gas, and hot dogs. Red stoplights are slammed on in front of the truck, throwing red pellets of light into the cab.

The driver, raised to his normally elevated position, reclines in his seat with both hands on the wheel and his right foot hovering over the accelerator. This posture of alertness is almost comical in his safely marooned truck, but the impression of motion is entirely credible, particularly when we view the piece from the position where the tailgate would normally be.

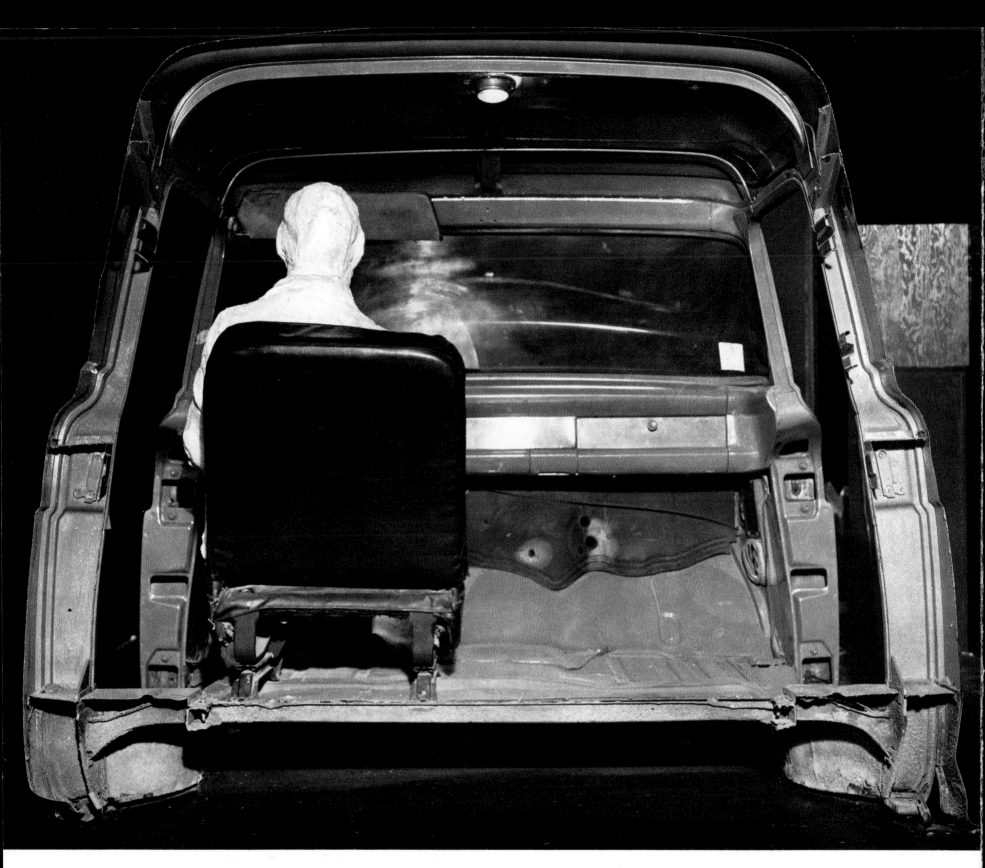

63. *The Truck*. 1966. Plaster, wood, metal, glass, vinyl, and film projector, 66 × 60 × 53″. Art Institute of Chicago
(Mr. and Mrs. Frank G. Logan Fund)

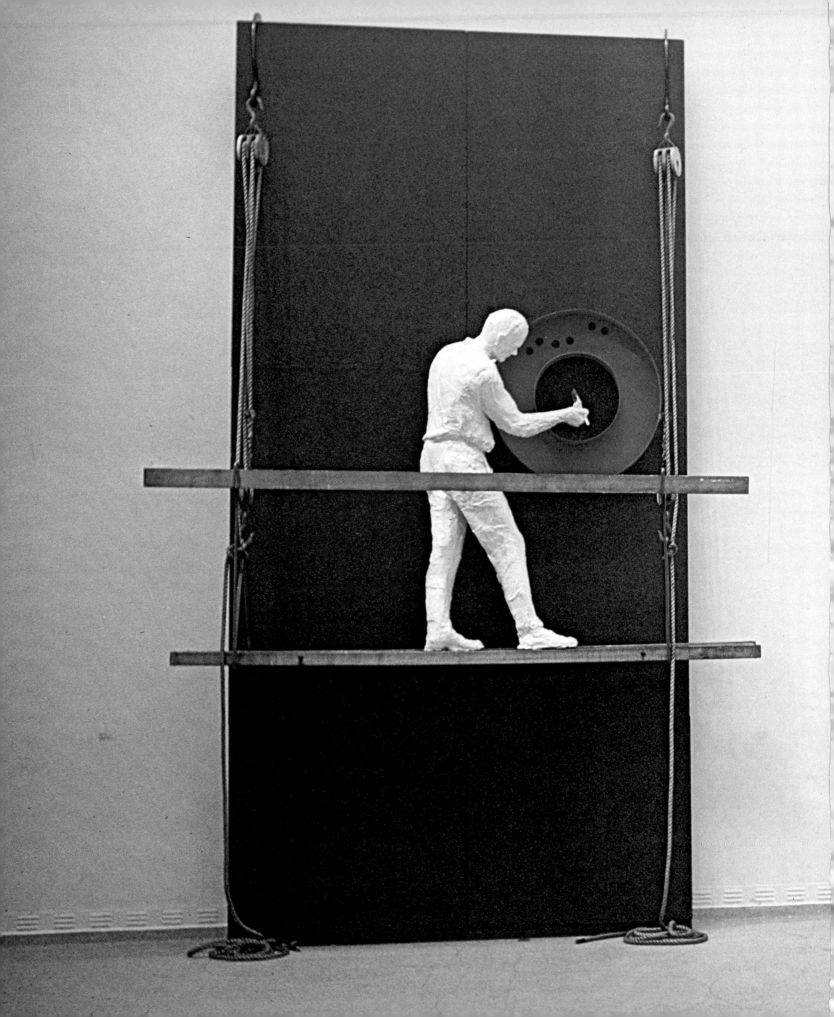

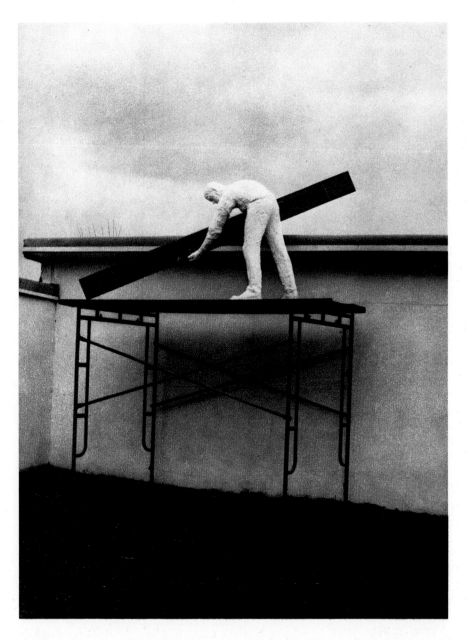

64. *Man on a Scaffold* (first version). 1970. Whereabouts unknown

65. *The Billboard.* 1966.
Plaster, wood, metal, and rope,
15′9″ × 9′9″ × 1′8″.
South Mall Project, Albany

MAN ON A SCAFFOLD (two versions)

THE BILLBOARD

MAN ON A LADDER

MAN ON A PRINTING PRESS

A favorite and recurrent theme groups what the artist calls "work pieces." Segal has profound respect for work and admiration for those who work well. He notices a certain grace in the worker whose mind may be blank but whose body responds, with suppleness and economy, to strain and routine. From personal experience he knows how hard physical work can be, how arduous and fatiguing and dulling to the spirit it often is. He sympathizes with bodies that are weary and he studies gestures made under duress. Believing that the body has its own vocabulary, he has taught himself that special language only bodies convey so he can pick up signals others do not detect. Conversely, he can invest a body unaccustomed to physical work with an array of appropriate responses by carefully directing its stance and action. For Segal, one needn't be a baseball player to swing a bat; he is able to make up for what his models may fail to convey.

The man on the scaffold in *The Billboard* is a sign painter—posed for by a Rutgers University mathematician—who paints the metal casing of a blue O on a black billboard. We recall *Cinema,* but the emphasis there was on light, whereas here it is on the geometry of the scaffold raising the figure to the height it should have been in *Cinema.* Segal facetiously comments that he is back to putting sculpture on a pedestal again. It is rare, indeed, that a Segal sculpture does rise above eye level.

The Billboard contains enough gear—planks, red and green metal hooks, ropes, and pulleys—and careful geometric organization to support the artist's contention, "I like to emphasize structure over image." Though its size has prevented this large work from being shown indoors, it did not keep it from being placed on the Albany Mall.

Man on a Ladder and *Man on a Scaffold* came four years later in the artist's career, but they thoroughly relate to the earlier work in both spirit and execution. The three-dimensional letter which merely lent focus to *The Billboard* is giving light in the smaller *Man on a Ladder.* The plaster effigy of a repairman stands on a three-foot ladder set against a nine-by-eight-foot black field to which, screwdriver in hand, he has just fixed an illuminated, blue plastic and metal letter. The shape of the inclining ladder and that of the W are curiously related. The hue of the fluorescent light appears to disembody and define as real sculpture an otherwise undistinguished ladder.

Man on a Scaffold has heroic proportions that almost insist on an outdoor installation. Our eye is drawn first to the man lifting the board, and then we notice the metal tubing of the platform which, to Segal, must have been pure geometry. The work was installed outside the artist's studio for many months, varnished for protection against the weather, when a heavy wind blew the man off the scaffold. There was little damage, but Segal decided to turn the man around for greater effect and stability. Then, on Halloween night, pranksters removed the plaster figure from the scaffold altogether. Since it was not returned, as the artist had hoped, he cast a new plaster figure to take the place of the old one. In its present form, *Man on a Scaffold* has two tiers of metal tubing, offering both more enclosure for the figure and greater structural interest to the viewer. Instead of bending down with the top of the board touching the scaffold at a thirty-degree angle, the figure now stands upright, letting the board lean on the scaffold at a comfortable forty-five-degree angle.

The last of the work pieces to date, in what appears to be a logical progression in terms of complexity of props, is *Man on a Printing Press.* It is the result of a commission, at first rejected because Segal felt the subject was too limiting and then accepted when he was granted full freedom in the selection and treatment of the subject. The publisher of the *Des Moines Register and Tribune* wanted Segal to make a sculpture for the executive headquarters and invited him to come and see the place for himself. The gigantic printing presses, dwarfing their operators as they stood on gangplanks and ledges, impressed the artist and swung his decision.

With the paper's cooperation he found a fabricator who built a life-size side section of a Hoe folder. With several coats of fire-engine-red enamel paint, the wood looks like the metal it imitates. Segal is ecstatic about this part of the composition. Contrasted against the soft contours of the plaster pressman scaling it, it is strangely reminiscent, as a total image, of Charlie Chaplin's *Modern Times.*

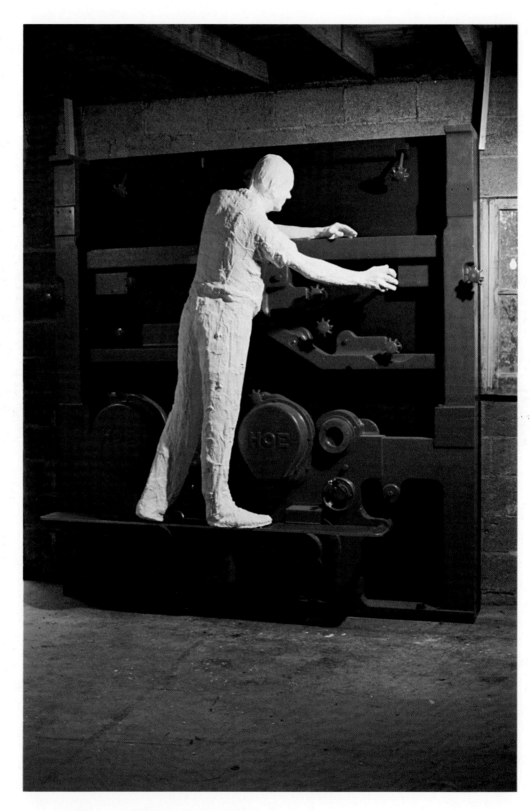

68. *Man on a Printing Press.* 1971.
Plaster, wood, and metal, 96 × 96 × 24".
Des Moines Register and
Tribune Company

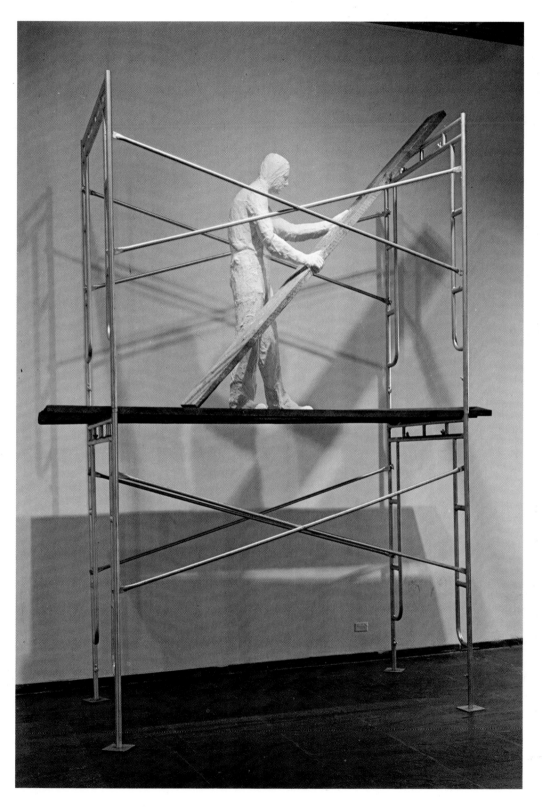

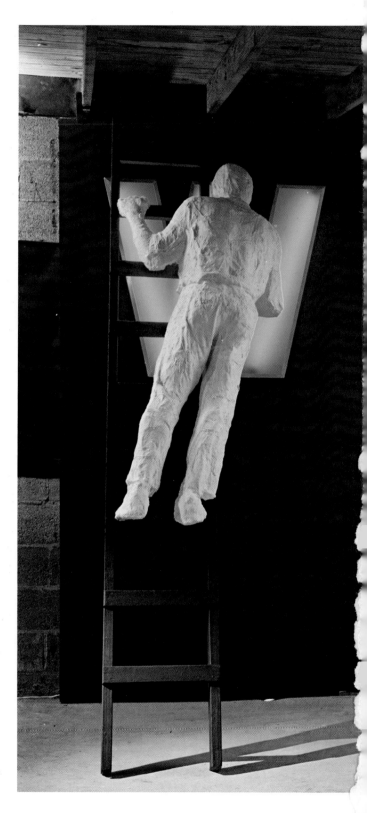

66. *Man on a Scaffold* (second version). 1970.
Plaster, wood, and metal, 12′ × 8′ × 5′.
Sidney Janis Gallery, New York

67. *Man on a Ladder*. 1970.
Plaster, wood, metal, plastic,
and fluorescent light, 9′ × 9′ × 4′9″.
Neue Galerie, Aachen (Ludwig Collection)

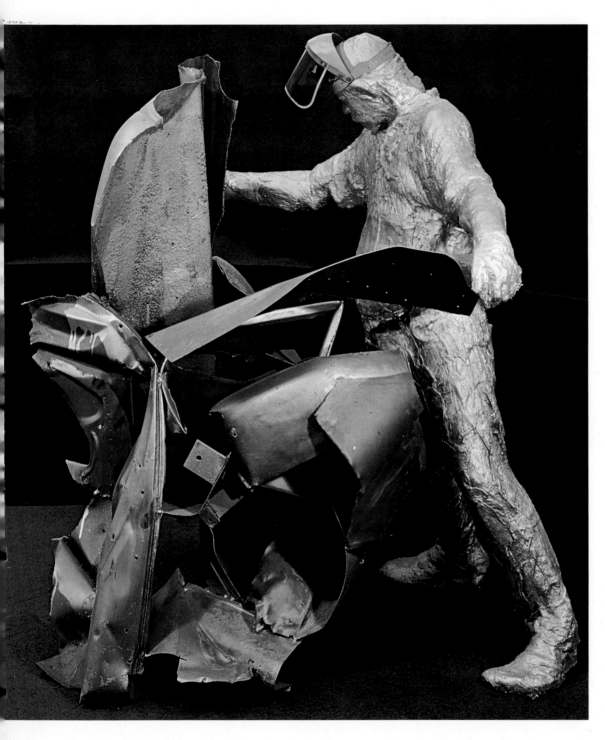

69. *John Chamberlain Working.* 1965–67. Plaster, metal, plastic, and aluminum paint, 69 × 66 × 56″. Collection Mr. and Mrs. William Rubin, New York

JOHN CHAMBERLAIN WORKING

This work is neither portraiture, like *Richard Bellamy Seated,* nor a "work piece" like *The Tar Roofer,* for it yields little direct, but a great deal of circumstantial, information about John Chamberlain's character and skills. *John Chamberlain Working* has much in common with *The Dentist* and *Sidney Janis with Mondrian's "Composition" of 1933,* for all three are capsule statements about men and their professions. It is even closer to, and anticipates in many ways, *Self-Portrait with Head and Body,* completed three years later.

The origins of this sculpture are quite accidental. Segal asked Chamberlain to fix a sculpture of Chamberlain's which Segal had been storing for him; it was sitting outside and rusting badly. Bob Watts had been lined up to bring his welding expertise and equipment. As the repair work progressed, Chamberlain kiddingly proposed that Segal do a sculpture of him which they would own jointly. Bob Watts was kneeling in front of the fender piece to make a weld, and Segal asked, "How about that pose?" "I ain't gonna kneel before no sculpture," Chamberlain replied, but then he simulated a bear hug and inquired whether that would do. "Great!" Segal exclaimed, and this was the way the figure was cast.

Incorporating somebody else's work in one's own, as Segal discovered, is a tricky proposition. The cast of Chamberlain, showing the sculptor with a welder's mask, is splendid, and the crushed fenders had been restored; but the combination of the two was awkward. The Chamberlain sculpture seemed a tangle of small parts—too much of a contrast with the solidity and whiteness of the plaster. Chamberlain didn't really like it either; while his friends had tried to save his sculpture, in his own mind he had already abandoned it. So Segal forgot about the work for a while.

More than a year later, with Chamberlain's permission he chopped off part of the sculpture and gave it and the figure a coat of aluminum paint, in which some flat black had been mixed to lend a leaden look to what once was colored metal and white plaster. This was the third time that a neutralizer such as gray paint had solved the problem of integrating a plaster figure with its demanding counterpart. Only by cutting it down to size and obliterating its colors could Segal force his identity upon Chamberlain's sculpture and make it, in combination with the cast, into a work of his own. Thus what had begun as a joint venture of two sculptors could succeed only as the product of one, Segal.

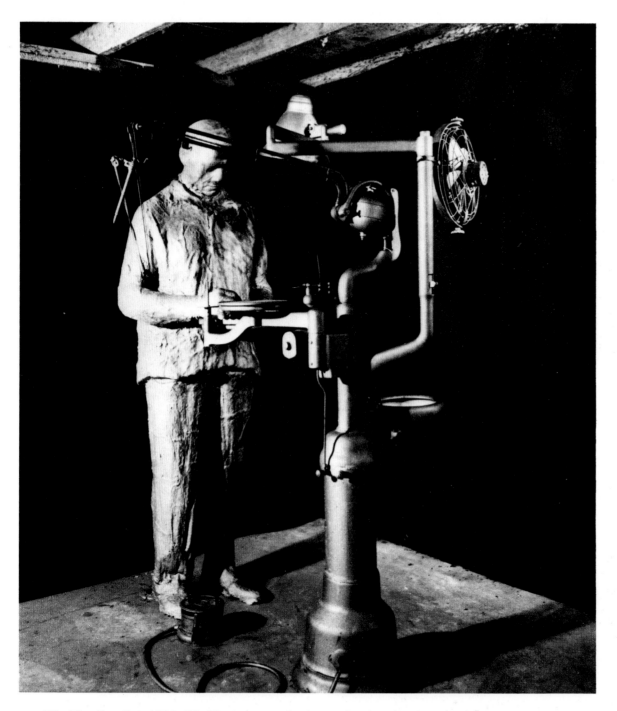

THE DENTIST

A dentist in New Brunswick, who was retiring from his practice and had heard that Segal made real objects into art, called the sculptor and asked if he would preserve the chair and equipment with which he had been working all his life. He did not want to be cast with it, nor did that seem safe at his age. Perhaps feeling that a collector/dentist might buy the work, Segal accepted the gear, though with some misgivings, and had a friend pose as the dentist. But something was wrong from the work's inception—it had never been the artist's idea.

Segal explains that there was too much "spaghetti," spidery tangles and assorted machinery that did not add up to a unified structure. But what had prompted him to do the piece was the dentist's almost jealous attachment to this old-fashioned equipment. "He didn't really want to give up—this is what struck me and this is at the base of the piece I made."

Not wanting to give up seems to have been Segal's attitude as well. Begun in 1966, this work is among the few still standing in his studio. Soon after *The Dentist* returned from its exhibition at the Sidney Janis Gallery, Segal started to prune the piece down to its structural framework. The apparatus was too much of an attention grabber, he felt, and for the wrong reasons. So he removed the chair and most of the nonessential hardware. Then he painted everything that same gray color he had used on the John Chamberlain piece. It may have saved the composition's structure, but it sent the dentist into limbo.

Ironically, Segal received a phone call from the dentist shortly after he had painted the whole piece gray. Would Segal give him his chair back? He had decided to practice dentistry again, in his basement.

70. *The Dentist.* 1966–70. Plaster, metal, glass, plastic, aluminum paint, rubber, and dental cement, 81 × 53 × 53″. Sidney Janis Gallery, New York

THE MOVIEHOUSE

What could have been indulgence in reproducing reality, Segal had the restraint to turn into a treatise on abstraction. Old moviehouses are almost irresistible as environments, yet this one was built from scratch by the artist to conform with a preconceived notion of space without forsaking its familiar appearance. If until recently Segal had used found objects and environments he liked for their formal and spatial qualities, he now increasingly resorted to devising and building his own props and surroundings, which he invested with the qualities he desired. For three months he worked on *The Moviehouse,* concentrating on its architecture as well as its use of light.

The challenge, Segal felt, was to make a moviehouse that would function as sculpture, though not too strongly, and as image, without being too obvious and therefore confusing. How much reality does it need? How much contrivance can it stand? So much emphasis on the background for his sculpture, and so little on the figure itself, might lead to the latter's ultimate "disappearance" from the piece. The result, then, would be a plasterless Segal.

The Moviehouse looks as flat and shallow as a frontier-town reconstruction, a mere support, we suspect, for the magnificent marquee. The only apparent depth is reserved for the box office, in which the placid effigy of a girl is enclosed behind glass on three sides. Blazing red and slightly off-center, it juts forward from two black walls like a shrine holding an icon. A door on the right, just barely visible, can be pushed open to lead to a narrow space, a few feet deep and shaped by the facade in reverse. It mocks the space of a real theater, but it dramatizes the work's most prominent feature—an overhanging marquee, studded with 288 6-watt incandescent light bulbs. A warm yellow pours down from its ceiling, begging us to approach, but pushing top and edges into almost forbidding darkness. The geometric regularity evident in the work's separate features issues from serial repetition and is one of those benefits of mass production on which Segal relies for his materials. He likes the fact that in America today geometrical form is easily achieved and starts at such a humble level.

As form and space are measured against, and are an extension of, the human body, so color is measured against, and is an aspect of, light. Color and light are intermingled in Segal's work, in a subtle and tenuous relationship not generally recognized. In *The Moviehouse,* easily his most ambitious light sculpture since *Cinema,* Segal considers the symbolic associations of black, red, and white (invariably his favorites), as well as the opposing forces of light and dark. Though he does not necessarily equate light with good and dark with evil, or provide us with a moral color key, there is an undeniably Manichaean streak that runs through his own private fantasies about *The Moviehouse.*

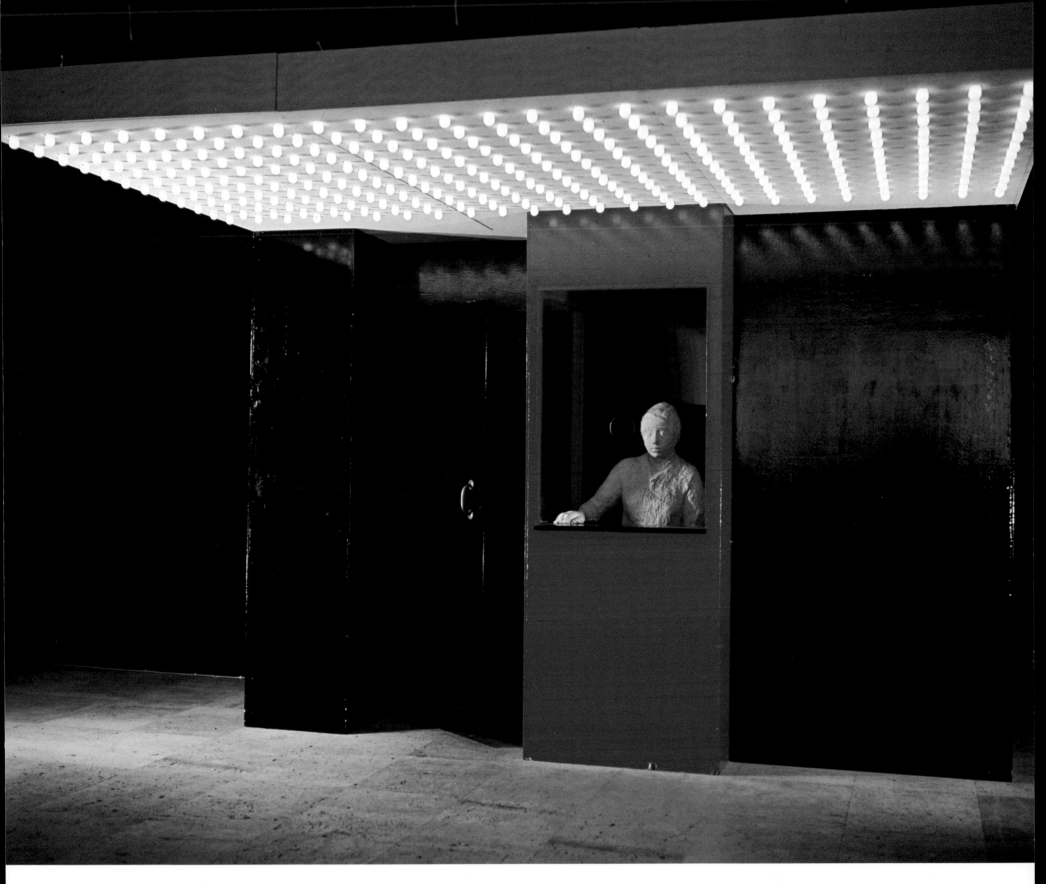

71. *The Moviehouse.* 1966–67. Plaster, wood, plastic, and incandescent lights, 8′6″ × 12′4″ × 12′9″.
Musée National d'Art Moderne, Paris (on loan from Centre National d'Art Contemporain, Paris)

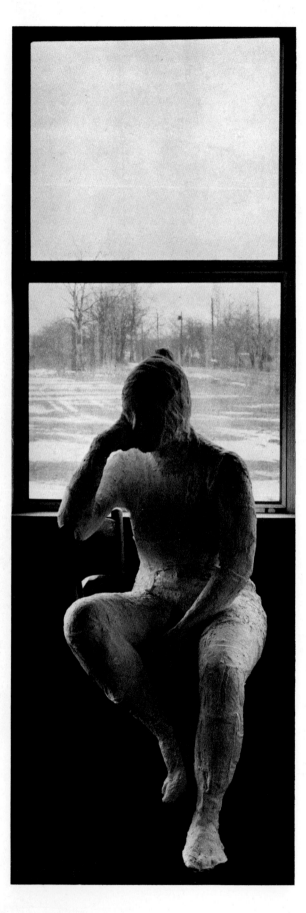

72. *Seated Girl.* 1967.
 Plaster, wood, and metal,
 52 × 42 × 16″. Private collection

THE RESTAURANT WINDOW I

THE RESTAURANT WINDOW II

The original version of *The Restaurant Window* was first shown at the Sidney Janis Gallery alongside *The Truck.* Confident about the successful integration of film—as it offered light, color, and an illusion of motion—on the windshield of his red panel truck, Segal had aimed at a similar but subjective animation for this piece. He went to Hector's restaurant on Forty-second Street with a super-eight movie camera to shoot some footage of a girl sitting in that populated establishment, alone and dreaming. But he wanted to do more than create another woman in a restaurant booth. If there was a precedent for the theme, it related to the man-woman field of tension first set up and explored in *The Diner.* What was the man thinking? What was the woman thinking? Segal was now prepared to go beyond implicit clues and bare the mind of his subject.

Surreptitiously, he made a three-minute color short of what the subject could have seen: coffee cup—inside of coffee cup—tabletop—girl's hand nervously fingering her watchband—old man at next table reading his newspaper—another old man shuffling by in the street. Then he cut to a view of the girl as she left the restaurant, took a subway train, and disappeared on a crowded platform. This film was projected on an opaque restaurant window behind the girl sitting at a table and contemplating her coffee cup. Unfortunately, the film kept burning up, one copy after another, so the artist abandoned this device and changed the arrangement of the piece after it had been returned to his studio.

One could argue that the first *Restaurant Window* was doomed to fail in its over-all effect and was bound to be changed—not only for technical reasons. *The Truck* was superbly effective and totally believable in its image overlay; we can look over the driver's shoulder and see the road go by. But who has ever seen, bouncing off a frosted window, thoughts in a woman's mind? Moreover, her vision in no way coincides with ours; both field and focus distinguish it as hers. In *The Truck* the space-time breakup is real; in *The Restaurant Window,* as first shown, it was merely artful. The

continued on page 139

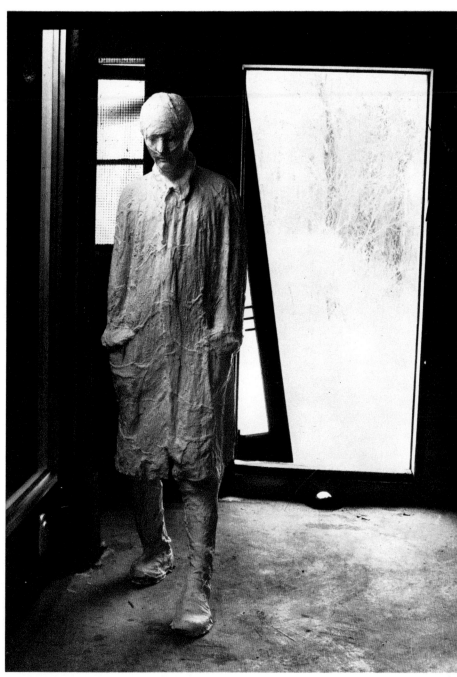

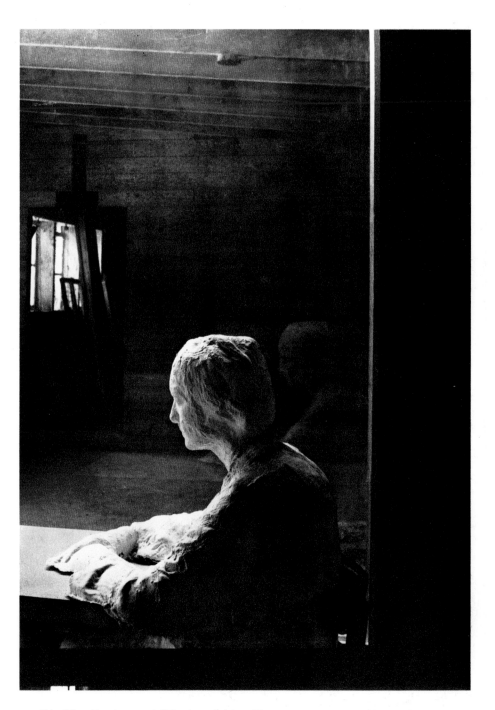

73. *The Restaurant Window I* (detail)

74. *The Restaurant Window I* (detail)

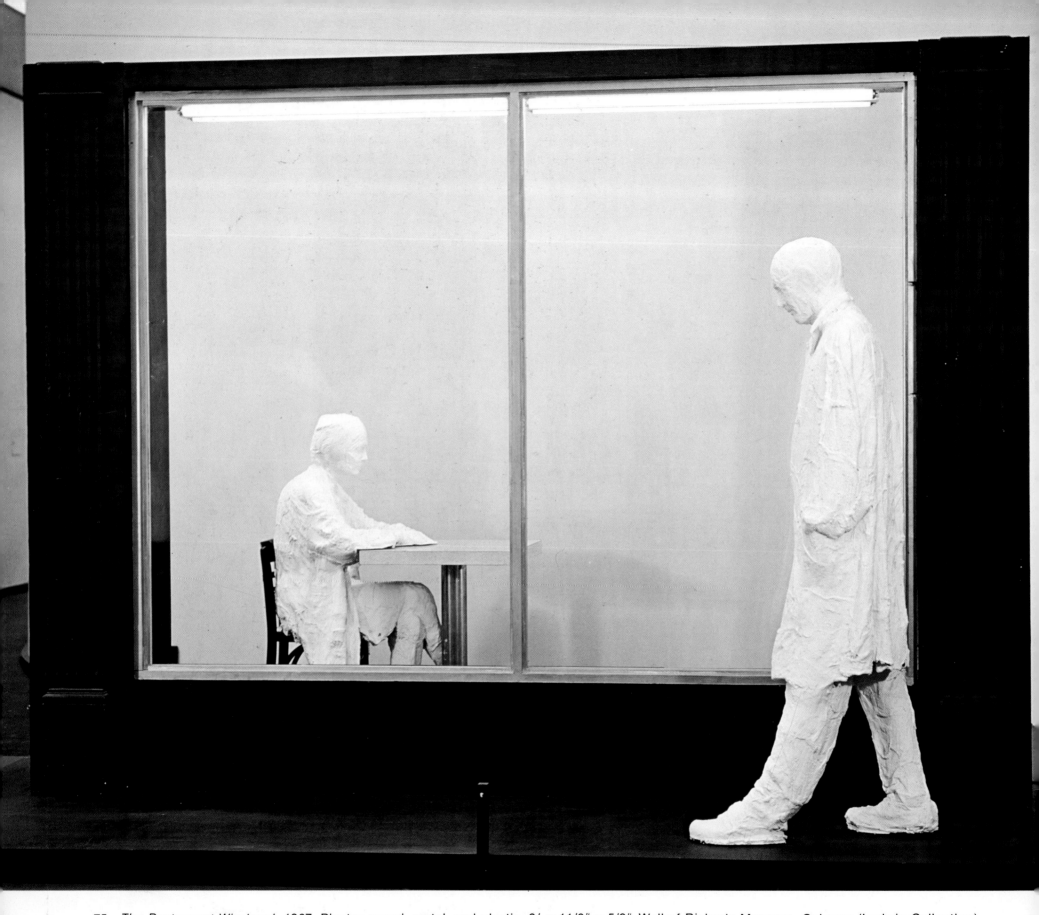

75. *The Restaurant Window I.* 1967. Plaster, wood, metal, and plastic, 8′ × 11′6″ × 5′9″. Wallraf-Richartz-Museum, Cologne (Ludwig Collection)

continued from page 136
difference then breaks down to functional integration and enhancement of reality versus optional addition and diversion from reality.

The second version, now known as *The Restaurant Window I,* is substantially different although it retains, in essence, the artist's original idea. There is still the same woman quietly sipping her coffee. We are no longer privy to her thoughts, but it is not difficult to guess them. Through the large window we see a man walking by. Huddling in a raincoat, he seems immersed in thought, oblivious to the girl's attention. We are back to *The Diner,* psychologically, but in a far more intriguing way. A pane of glass fatefully separates these two strangers, as it separates the "real" environment of the man braving a crisp winter night from the "artificial" environment of the girl nursing her coffee in the comfortable warmth of a restaurant.

Formally, Segal has never wrenched so much effect from a simple glass divider. With a faint hint at Duchamp's *Large Glass,* he separates without blocking and allows the spectator—in fact, forces him—into the picture. On one side we notice a radiator and a fluorescent light tube, the barest indices of an inside space; on the other side, a facade with fake columns and a sewer vent—the perfect counterparts of the inside, equally sparse but fully descriptive. Man and woman are framed by the window, visible from either side, palpably real, deceptively close, yet forever detached. Their three-dimensional separation is loosened and undone, in appearance only, by their integration into one and the same field of vision.

The attraction of *The Restaurant Window II* lies, in part, in its being a reiteration and then again a substitution for that first version which must have haunted the sculptor. Here Segal positioned the woman to face the viewer. He had intended to project the same film on a screen directly behind her. But bad luck and defective projectors pursued the artist, so he discarded the movie once more and substituted for it an aerial view of Manhattan from a restaurant atop an imaginary skyscraper. The reference to the subject's thoughts has been eliminated, and we are left to contemplate what indeed is a major advance in the artist's rendering of deep space. Colored plastic pegs set in hardboard scatter and diffuse a light source behind it to create an eerie illusion of the jewel-like lights in buildings at night. Segal establishes an impression so real that we train our eyes to see lights going on or off in the distance. Whatever the movie might have promised, there is little this window does not deliver successfully.

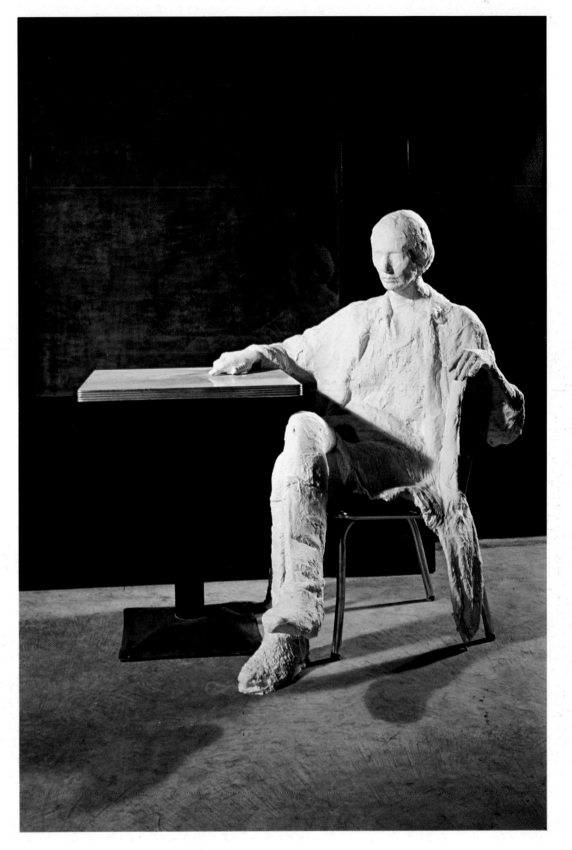

76. *The Restaurant Window II.* 1971. Plaster, wood, metal, plastic, and incandescent light, 72 × 48 × 60". Sidney Janis Gallery, New York

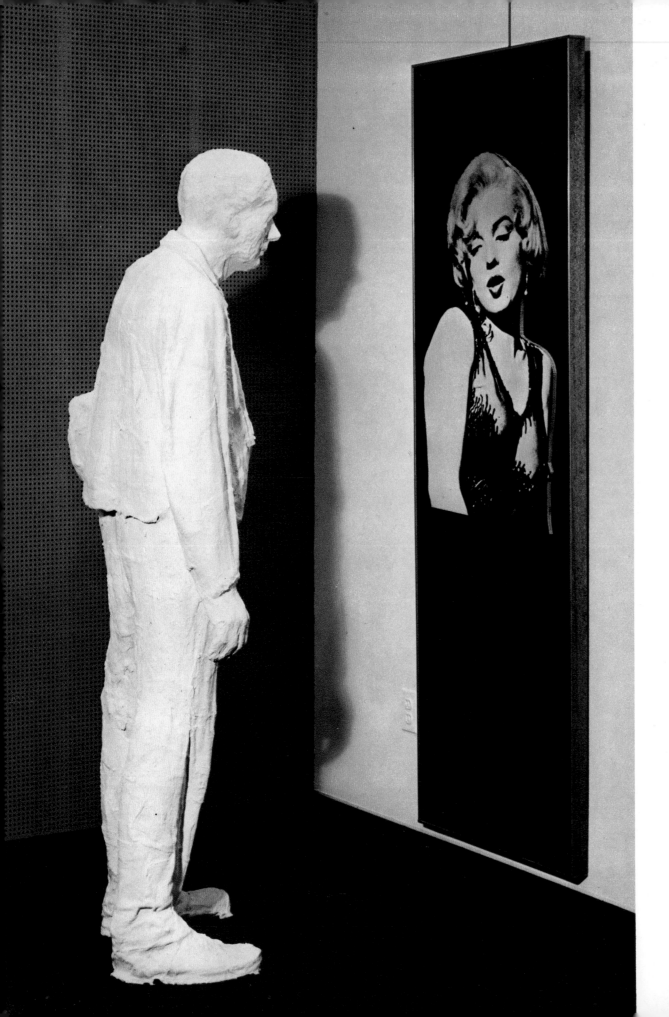

77. *The Movie Poster.* 1967.
Plaster, wood, and photograph, 74 × 28 × 36″.
Collection Kimiko and John Powers,
Aspen, Colo.

THE MOVIE POSTER

From time to time the Sidney Janis Gallery has orga-
nized exhibitions around a specific theme—such as
eroticism, or material—such as rope. As a "gallery
artist," Segal usually created a work especially for the
occasion, although normally he "gropes" for a subject
and prefers to let it mature in his mind. The theme this
time was Homage to Marilyn Monroe, who continued
to mesmerize the Pop generation even after her death.

Segal neatly sidestepped the subject to remain
true to himself. He didn't try to cast a buxom girl and
pass her off as Marilyn, for it would have looked like *an*
actress impersonating *the* actress, and he would have
been right back to the problems he encountered in
casting his Greek actress. Instead he decided to cast a
man—his friend George Kuehn—sunning himself in
the radiations of Marilyn's image. Here, as in other
instances of single-figure representation, the artist's
challenge was to create an arresting scene. By a curi-
ous reversal, perhaps recalling the painter in George
Segal, the emphasis is not on the plaster figure, but—
as it should be to live up to its title—instead on the two-
dollar personality poster at which he is looking. By
making the man turn his back to the viewer, the artist
effectively focuses his gaze as well as our attention.

The scene is that of a worker on his lunch hour. He
carries a paper bag and stops to look at a movie poster
of his favorite star. The implication is that we have
stepped back into the past and that Marilyn is still alive.
Segal has mounted the poster on a six-by-two-foot
plywood panel, painted black, at a height allowing us
to come face to face with the actress. The man appears
so enraptured by the picture that he strikes us as
wanting to charm it off the wall and into life. Without
painting or casting Marilyn, but simply by appropriat-
ing her commercialized image and showing what it
does to people, Segal has enriched the distinguished
iconography of one of our greatest contemporary
idols.

78. *Girl on Chair, Finger to Mouth.* 1967.
Plaster and wood, 52 × 42 × 16".
Collection Mr. and Mrs. Morton G. Neumann,
Chicago

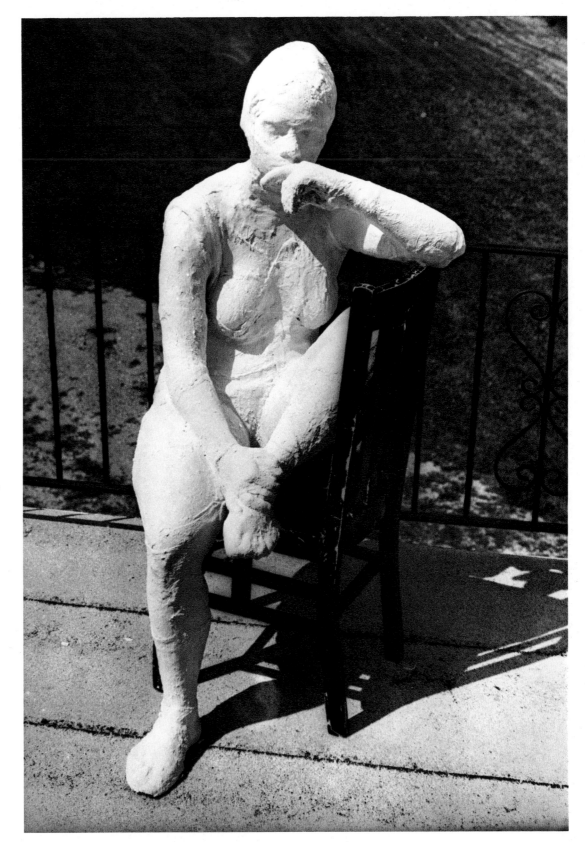

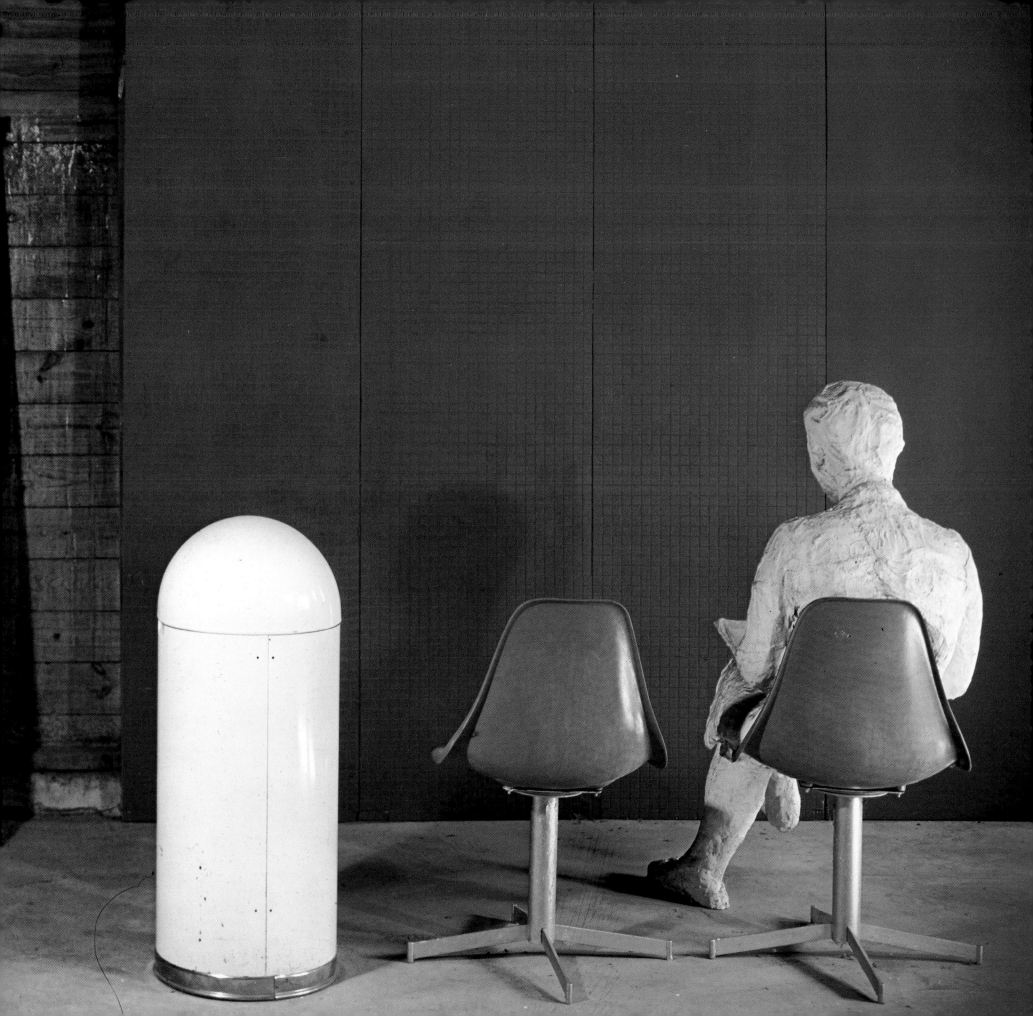

79. *The Laundromat* (late version).
 1966–70.
 Plaster, metal, and plastic, 72 × 72 × 30″.
 Galerie Onnasch, Cologne

80. *Man Leaving a Bus.* 1967.
 Plaster, painted metal, glass,
 chrome, and rubber, 88½ × 39 × 33½″.
 Harry N. Abrams Family Collection,
 New York

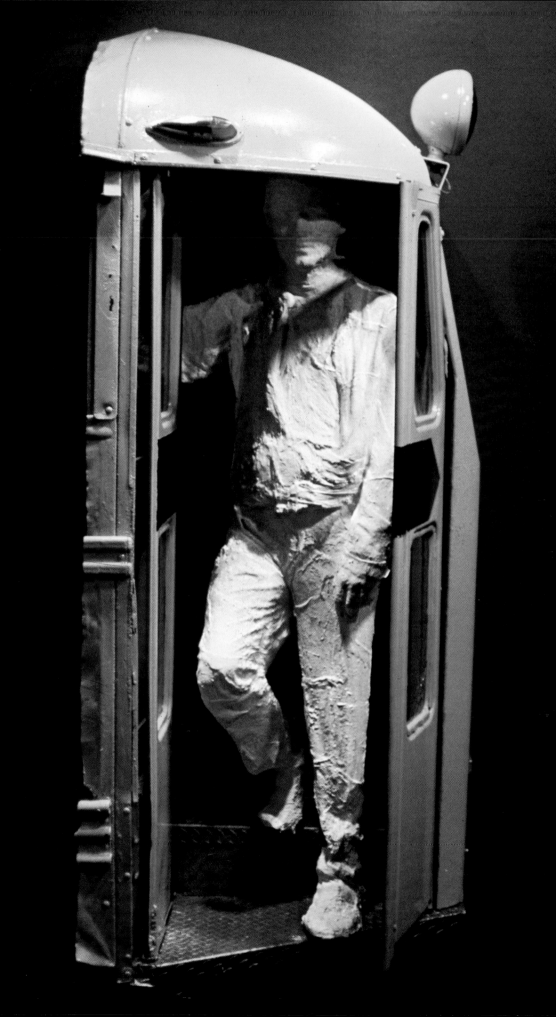

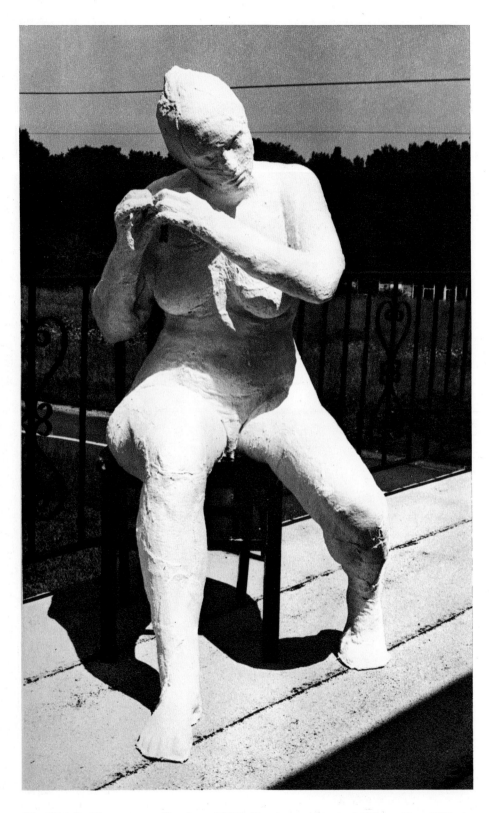

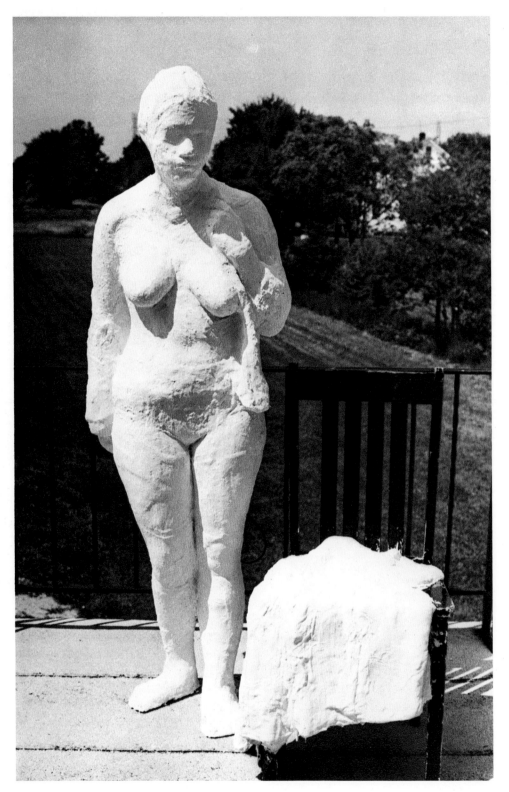

81. *Girl Putting on an Earring.* 1967. Plaster and wood, 50 × 40 × 40″. Collection Joan Avnet, New York

82. *Girl Undressing.* 1967. Plaster and wood, 63 × 34 × 22″. New Jersey State Museum, Trenton (The Governor of New Jersey Purchase Award)

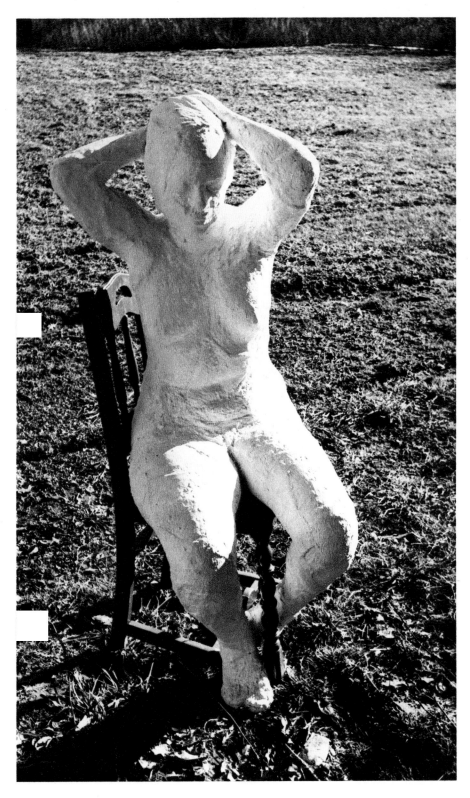

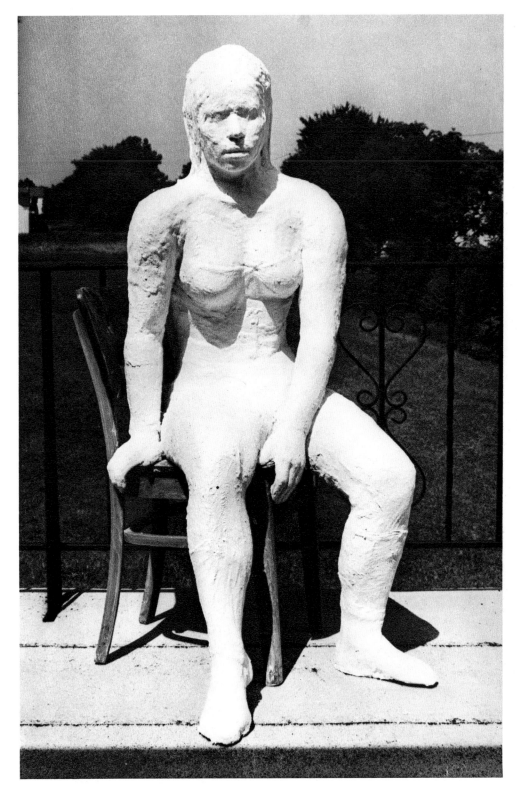

83. *Girl Putting up Her Hair.* 1967. Plaster and wood, 53 × 24 × 26″.
Neue Galerie, Aachen (Ludwig Collection)

84. *Circus Girl.* 1967. Plaster, wood, and plastic, 51 × 32 × 35″.
Collection Mrs. Miriam Keller, Stuttgart

85. *Portrait: Plaster Figure of Sidney Janis with Mondrian's "Composition," 1933, on an Easel.* 1967. Plaster, wood, metal, and canvas, 67 × 50 × 33". The Museum of Modern Art, New York (Sidney and Harriet Janis Collection)

PORTRAIT: PLASTER FIGURE OF SIDNEY JANIS WITH MONDRIAN'S "COMPOSITION," 1933, ON AN EASEL

Asked to do a portrait of his dealer, Segal was at first surprised. "Here was Sidney Janis, whom I had always relied upon to shield me from commissions, himself wanting to be portrayed!" The artist confessed he was at once puzzled, amused, and attracted. From a relaxed relationship that had included long talks about art, he knew of his dealer's admiration for Mondrian and Léger. Though he shares these feelings, he readily admits that it was Sidney Janis's own idea to be portrayed holding his favorite Mondrian. Using a copy of the painting in the sculpture was never even considered. When Segal suggested the painting be on an easel, Janis offered, without a moment's hesitation, his favorite English display easel, a work of exquisite craftsmanship and a match in quality for the Mondrian.

Segal remembers that his subject was adamant about being shown with his hand on the painting. First he construed the gesture as the natural possessiveness of a man about to give up a treasured belonging, or perhaps a subtle reference to his profession as a dealer. Then Janis told Segal that he didn't want anybody to remove the painting after his death and substitute a copy for it. Since touch is an essential concern in his work, the artist sympathized and went along with the gesture. Then he realized that it in fact does nothing to "lock the painting in" or keep it from being replaced by a copy. The real question is, of course, whether the effigy of Sidney Janis will one day be removed and replaced by a copy. The contest between Piet Mondrian, George Segal, and Sidney Janis is for historical relevance and endurance.

Successful by all standards, *Sidney Janis with Mondrian's "Composition" of 1933* convincingly conveys a loving admiration for art, and if we didn't know the subject's identity, we might think he is lecturing in a classroom. But perhaps Janis himself subconsciously permitted such a reading, for he implicitly allows us to admire him for his taste in selecting this Mondrian and his courage to resist "faking it."

A strange thing happened as the work traveled throughout the country with the Harriet and Sidney Janis Collection. When the exhibition was shown at the Minneapolis Institute of Art, a small boy defied the guard in taking a closer look at this piece, was scared away, and in his escape knocked the sculpture over. Sidney Janis lost his head. Tools in hand, Segal rushed to Minneapolis to save his dealer's face.

THE EXECUTION

With *The Execution,* Segal leaped into the area of social protest, which he admits is still unfamiliar and puzzling to him, although, in this work, he has explored its perimeters. "We talk about art being sublimation. . . . The feelings become too real as you try to work them off." He was asked to submit a piece for an exhibition, first called "War and Peace" and then "Protest and Hope," at the New School in New York.

While he knew it was out of the realm of his experience, he sympathized with the organizers, for this was the heyday of protest against the war in Vietnam. Eager to comply, he envisioned a heap of some sixteen corpses of concentration-camp victims. There were no rules against borrowing from one's own racial experience. But it was too much and too gruesome, like casting a heap of dead chickens (which he had done for *The Butcher Shop*). Would he go to the city morgue and cast corpses? He knew that the look of a corpse, limp and lumpy like a pile of dirty laundry, was almost impossible to achieve, but could he capture death in his lifelike plaster casts?

Another difficulty would be finding varied enough poses for sixteen bodies. Is death more resourceful than life, perhaps? Asking himself these questions and finding it extremely difficult to work on a social-protest level, Segal wondered how far he could go into the physical messiness of violence. Finally, he made his decision: he would settle for casting the living, in an execution scene with a small number of victims. As always, he reduced a grandiose vision to a simpler and more realistic one, a solution which invariably improved the resulting work.

Segal tackled the subject with enthusiasm. He built a plywood wall and stuccoed it to look like cement, the sort of wall one expects in a prison yard. Then he borrowed a rifle and riddled the wall with real bullets: "For a short moment I experienced that strange elation that comes with emptying a gun, I who

had to be told how to load and fire one." The real test came in casting the victims, and he chose two men and two women—partisans rather than soldiers. He admits having had a difficult time making them look dead.

The decision to hang one man by his feet was prompted by images that went through the artist's head of ultimate degradation—the fate Mussolini met at the hands of his countrymen or the self-chosen end of the Apostle Peter, who didn't consider himself worthy of dying with head up. Conscious of art history, Segal remembered the famous *Martyrdom of Saint Peter* by Masaccio. Allan Kaprow, inspired by the same images, had, quite coincidentally, organized a Happening entitled "Calling." In the second part of Kaprow's work, which took place near Segal's farm, although Segal did not participate and never saw the work, a cast of characters was hung upside down from trees and stripped of their clothing. The hanging victim in *The Execution* is suspended from a meat hook like a slaughtered chicken. On the left side of the wall, he looks like an inverted crucifixion. The man who posed for it worked very hard at looking realistic, but the artist had to hang himself alongside to demonstrate what he wanted. The model had to hold himself in a curved position, so his rib cage would come out in the casting. This was indeed the most difficult pose Segal ever devised.

The work came out strong and moving—possibly one of the best works of art in our time inspired by war, violence, and oppression. Yet Segal is weary of using the powers of art to change the world: "Confusing a work of art with the real running and manipulation of the world can be appalling—there are basically different processes involved." It is not likely that the artist will get into protest art again, for it suits neither his philosophy nor, for that matter, the nature of his medium.

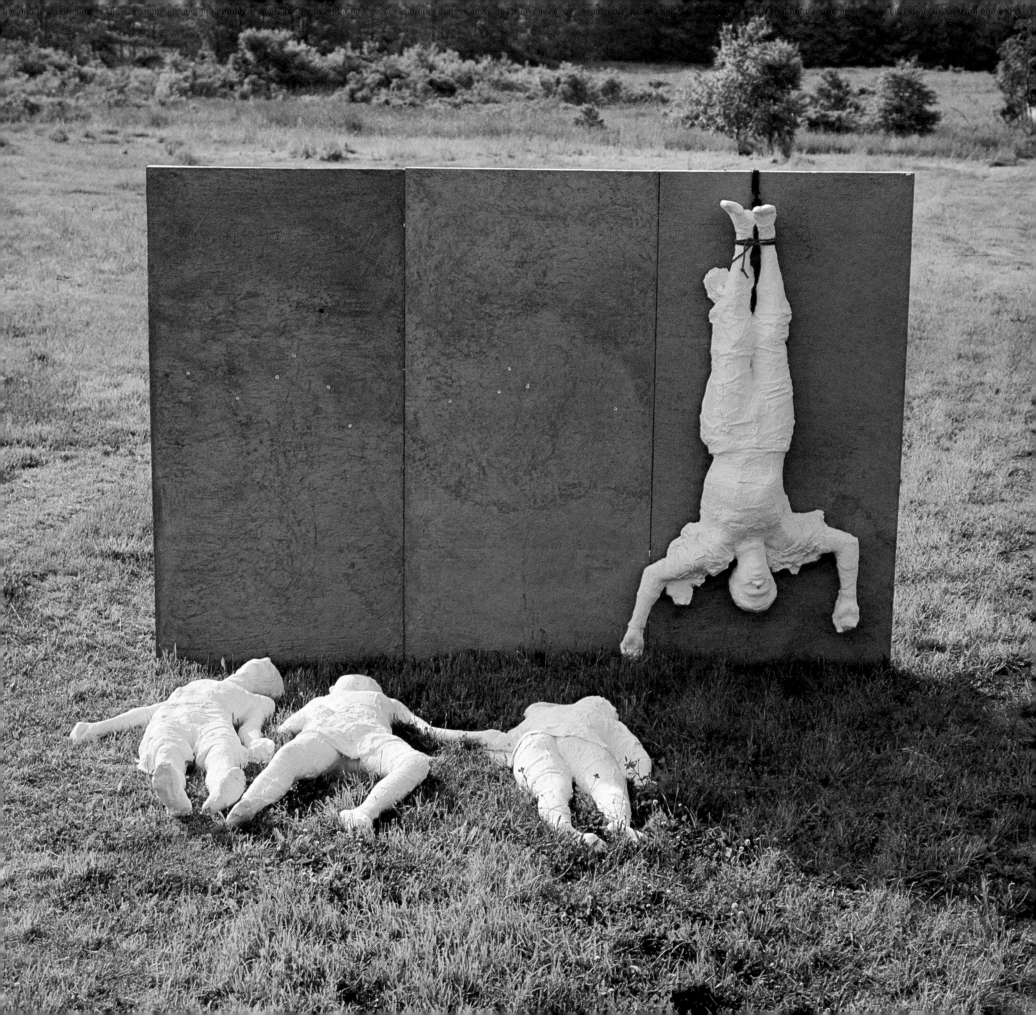

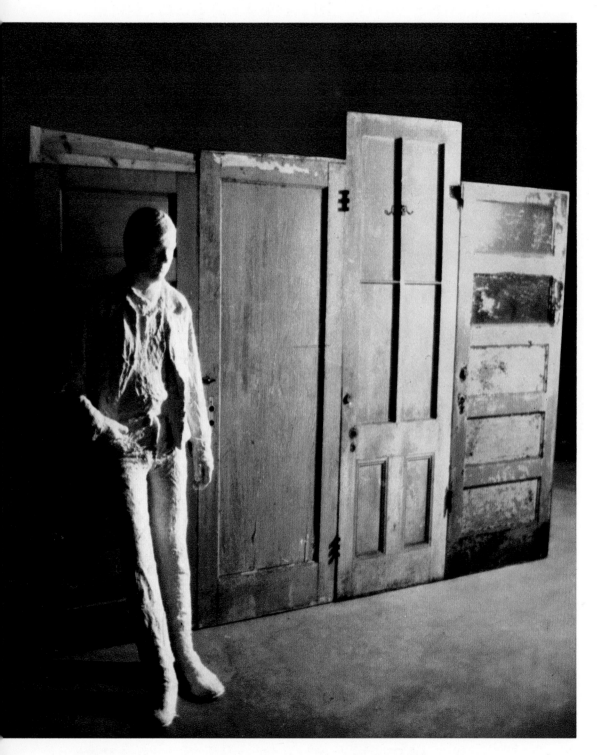

MAN LEANING AGAINST A WALL OF DOORS

As he was indulging himself in casting his longest consecutive series of girls in simple poses and positions, before again undertaking a major work, the Geigy Chemical Company of Ardsley, N.Y., approached Segal with the unusual request that he create a sculpture they could use at a medical convention in San Francisco. It was to advertise, in dramatic fashion, a new wonder drug to combat depression, and the company supplied a long list of all the human ills their product would cure.

It was not like the artist to accept this commission, but perhaps he was encouraged by the success of his Homage to Marilyn Monroe. The device he employed was similar, though much less effective. He set up a series of doors, salvaged from an old building, to suggest a demolition site. Against it he leaned the plaster cast of a young man, loitering and perhaps despondent. On the other side of the wall, he pasted posters advertising pop concerts and records, torn off and replaced again, layer on layer. Then he had half a dozen photostated enlargements made of those ills Geigy's new drug would cure. They read like found poetry, and he interspersed their text in that of the posters. The result was a medley of musical activities, punctuated by states of depression.

This solution to the creation of a visually arresting scene was admittedly cerebral, and the outcome suffered from a lack of pictorial definition, further complicated by the fact that the eye could never *see* and the mind could never *read* the sculpture as one unified whole. Yet the Geigy Chemical Company judged it effective as a display item and, when the convention was over, donated the work to the Hudson River Museum. The curator turned his back on Geigy by installing the sculpture with its back against the wall.

87. *Man Leaning Against a Wall of Doors*. 1968. Plaster, wood, and paper, 10′ × 6′8″ × 3′. The Hudson River Museum, Yonkers, N.Y. (Gift of Geigy Pharmaceuticals, Division of Geigy Chemical Corporation)

88. *Man in a Chair Drinking.* 1968.
 Plaster, glass, plastic, and aluminum,
 42 × 24 × 42″. Galerie Onnasch, Cologne

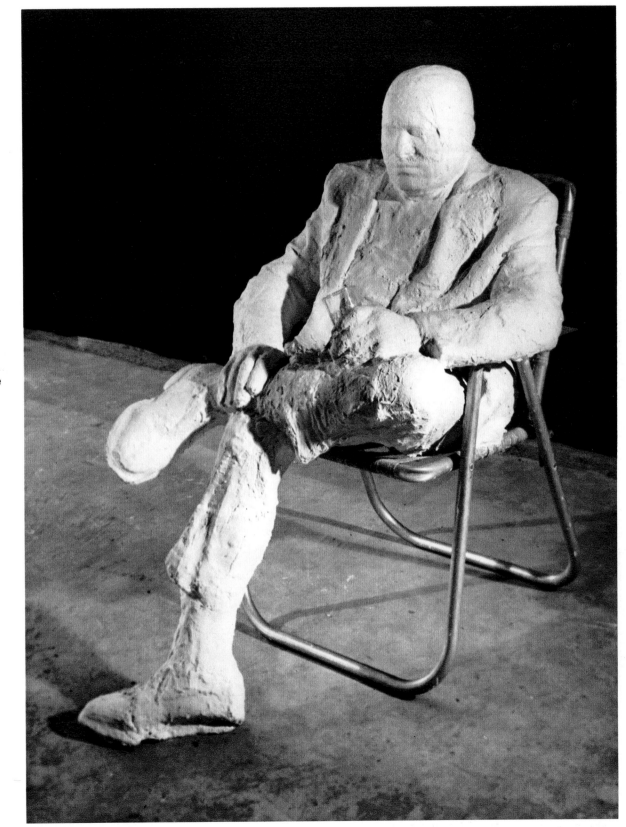

89. *The Artist in His Studio.* 1968. Plaster, wood, paper, and pastel, 8′ × 10′ × 9′.
Galerie Onnasch, Cologne

THE ARTIST IN HIS STUDIO

This work, no doubt, is what that series of girls on chairs was leading up to, like the studies of detail preceding a major composition. While Hilton Kramer considered the artist, at forty-four, "a bit young to be indulging in this sort of retrospective charade," he nonetheless accurately surmises that this is "an apotheosis of the artist at work" and an ambitious attempt at autobiography. In a studio environment defined by two walls, Segal himself is seen sketching two models, a man and a woman, reclining on a nearby mattress. On the table, under the artist's hand, is a completed drawing, and the walls are covered with even rows of figure studies in pastel, presumably of the models posing.

The scene, severely limited to black and white—the back of a red chair in one of the pastels paradoxically emphasizes this starkness—is not contrived, but an accurate reproduction of a corner of the artist's studio. "My place is something like a warm furnace; I tend to surround myself with my work" is Segal's explanation. "The more I would put into the work, the more it would resemble the clutter in my studio, the better it would be." It runs counter to all we know and all Segal has ever said about sparse spaces, pruning of detail, and his search for a simple geometry. But is this really a contradiction?

Self-representation is by definition more descriptive and revealing than the portrayal of others. How can the artist convince us that *he* is that man bent over the table, unless he gives us unmistakably personal clues? Clearly, *The Artist's Studio* of 1963 could have been anybody's studio; the fact that it resembled Segal's studio could be noticed only by those who had climbed to the attic of his house. Such subtle clues as the plaster cast of a model presented with a painted and almost abstract version of a window as background could be read by only those with a knowledge of Segal's beginnings as a painter and his inner struggles between abstraction and representation.

From the earlier to the later work, he has crossed from the anonymous to the recognizable and from the general to the specific. He is in mid-career, having amassed an impressive list of accomplishments, and he should feel justified in including his own pastels on the walls and his own sculptures reclining on the floor. These works are, after all, not somebody else's or merely the usual studio clutter.

There is pride and confidence in *The Artist in His Studio.* And there are several subtle ironies. Had Segal followed the procedures he applies to his other works, the reclining couple would have to be shown not as plaster casts (the artist never draws from plaster casts) but as real people on a real mattress, just as the table is of real wood and the drawings on the walls are real art. It creates an ambiguity of focus and a discontinuity of time. Also, whereas everything else is by Segal—the sculpture of the two reclining figures as well as all the pastels on the walls—the effigy of Segal himself was cast by his wife, though the sculptor put the pieces together. Those standard borderlines between the crafted figure, bearing the "signature" of the artist, and the found or manufactured props, are blurred in *The Artist in His Studio:* the props are unmistakably crafted and bear the signature of the artist, and the artist is a "prop," manufactured in a collaborative effort and required to put the rest of the scene in its proper perspective.

To point out such contradictions may have value as an exercise in "reading" Segal's sculpture. It does not reflect on the artist's inability, real or imagined, to stick with a standard means of representation. Even if we assume for a moment that Segal's art can be neatly summarized by a formula of juxtaposing the found and the created object, then past experience and a review of ten years' work should show us how many ways he juggled that formula to the point, indeed, of making it its own caricature. In *The Artist in His Studio* the formula is so thoroughly upset that Segal's very ability to do this becomes a measure of the work's success. It emerges as the most powerful self-portrait in the history of contemporary sculpture.

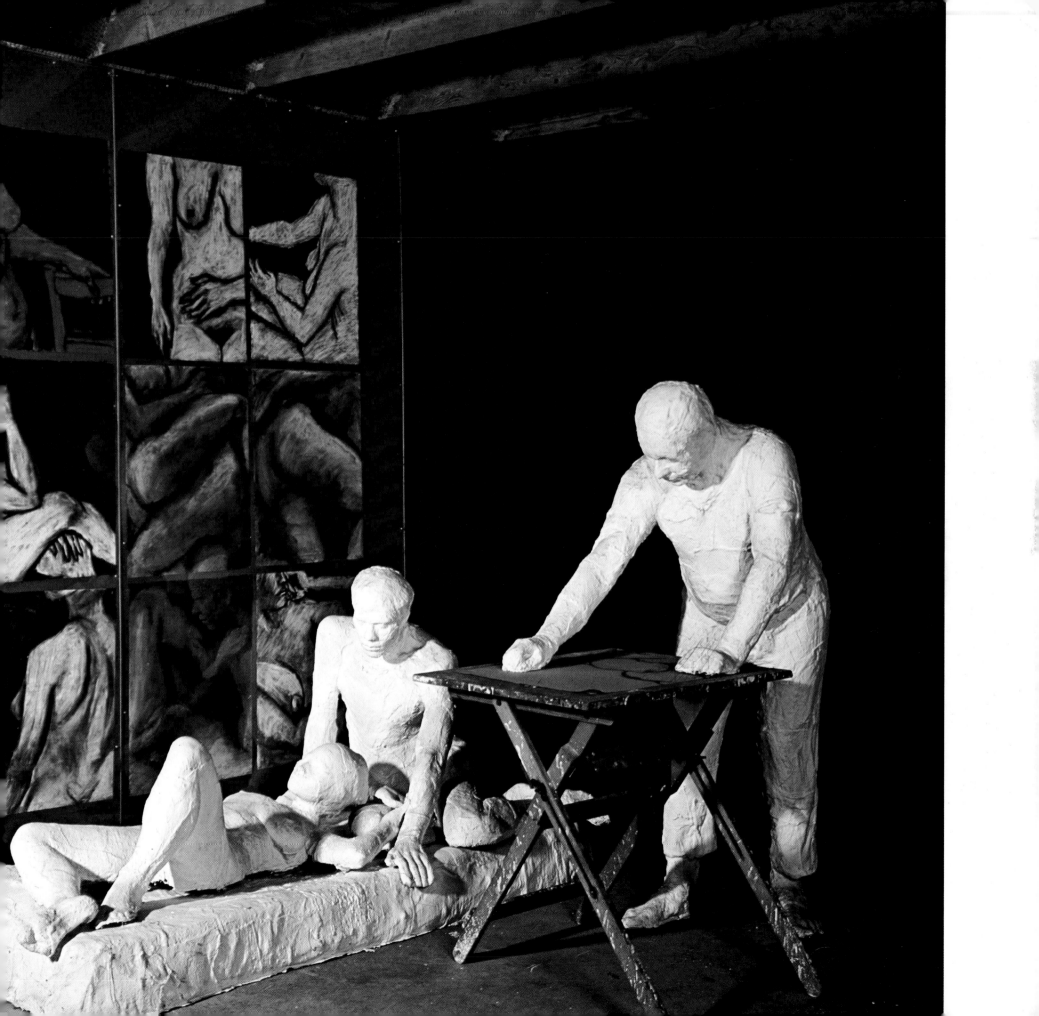

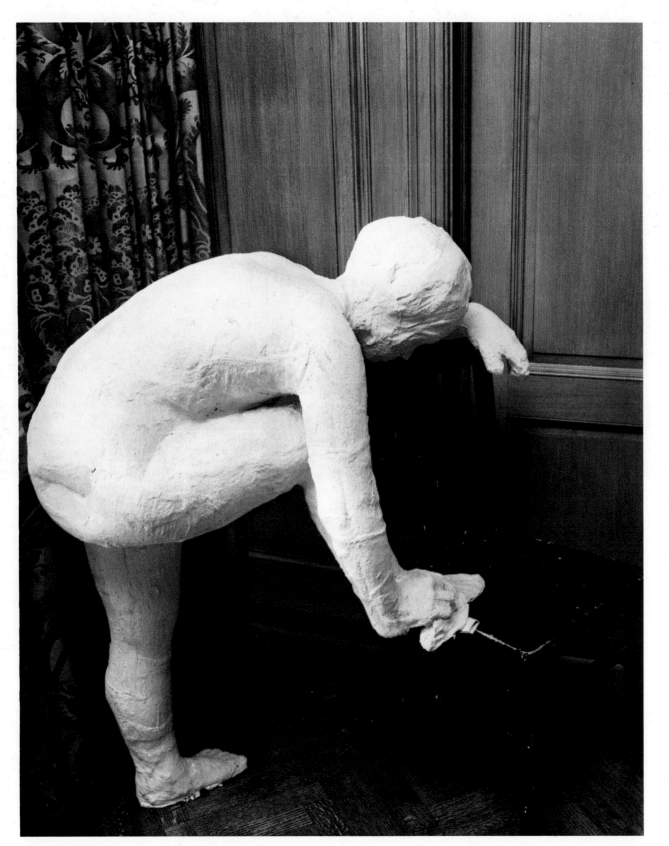

90. *Girl Washing Her Foot on Chair.* 1967.
Plaster and wood, 48 × 24 × 46".
Collection Mr. and Mrs. E. A. Bergman,
Chicago

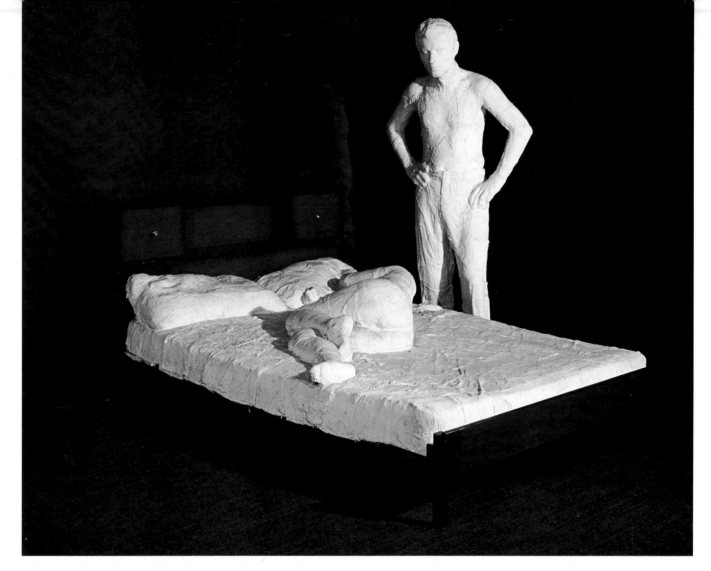

91. *The Motel Room.* 1967.
Plaster and wood, 72 × 78 × 72″.
Collection P. Janlet, Brussels

THE MOTEL ROOM

At first glance *The Motel Room* bears witness to all guilty couples who have ever sneaked away for a surreptitious rendezvous. The atmosphere is illicit; the room is seedy; the bed has a cheap, modern, peel-off veneer. A soap-opera plot perhaps? Soon we realize that there is nothing even vaguely thrilling and romantic about the scene. The man stands poised near the bed in a contemptuous and aggressive mood; the woman huddles on the bed in distress and humiliation. If Segal's first couple on a bed was tender and the second seemed confused, this third portrayal of a bedroom scene suggests cruelty and rejection. The drama is palpable and the models' attitudes and emotions are screaming to be heard.

The plot portrayed—the artist later admitted—is close to that of Paul Morissey's film *Trash*. The model for the man is the artist Lucas Samaras, a stand-in for the female model's husband, who is strung out on drugs, no longer interested in or capable of love. The girl on the bed is indeed sobbing and suffering from rejection. The work grew in Segal's mind as the result of the girl posing for a scene as yet undefined and breaking into tears in the process. She was cast as she confessed her marital problems to the artist—now acting as a surrogate psychiatrist. Segal recalls that she seemed to be talking with her whole body as she told him about the unexpected and rapid shattering of what had been an ideal relationship. So the pose was quite natural, chosen by the subject herself. The piece built from there, propelled by the forces of real-life experience.

SELF-PORTRAIT WITH HEAD AND BODY

The Artist in His Studio, for all its specific references, portrays Segal as a sculptor *by implication only,* for the artist is actually drawing from a model. In *The Artist's Studio* of 1963 the artist's identity is implied but not given, and we do not see him in the picture. In *The Artist in His Studio* the artist is there and is recognizably Segal, but how are we to know that he is foremost a sculptor? In *Self-Portrait with Head and Body* Segal arrived at his most specific self-portrait through a combination of chance and intent.

The idea for *Self-Portrait with Head and Body* came when he was working on a sculpture of a girl sitting on a chair against a wall with a window. As he was composing that piece, it looked for one moment—a torso still without head or legs—like an archaeological find. He was fascinated and wanted to show that effect, yet retain the fully contemporary spirit of the work and identify it clearly as a demonstration of an actual life experience. The obvious solution was to cast himself in the process of putting that figure together.

In making this sculpture Segal asked himself, "How do you put into a work of art what you see here and now and, in addition, those psychological dimensions of flashback and those historical references of memory?" For the sculpture to be effective, the artist had to combine, yet differentiate, what he *saw* and what he *knew* so clearly that the viewer would easily grasp both. This challenge is typical of Segal's wish to create an internal dialogue between image and form, like a rhyme within a rhyme, that defies all but his most perceptive critics.

As our attention shifts from the torso on the chair to the figure of the artist behind it, we move from classic beauty to gothic thrills. The overtone of dismemberment is unsettling. Holding a disembodied head in his hands, he evokes echoes of that miraculous medieval bishop, Saint-Denis, who walked away from his decapitation, head in hand, and who was charitably depicted by Gothic stonecarvers with two heads for good measure. The artist himself is more aware of Biblical decapitations with which his sculpture compares: Holophernes slain by Judith, and Saint John the Baptist, whose head ended up on a platter. There might even be a playful, self-mocking reference to Pygmalion, who fell in love with his sculpture and brought her to life. And yet, Segal has not even begun to put the pieces together!

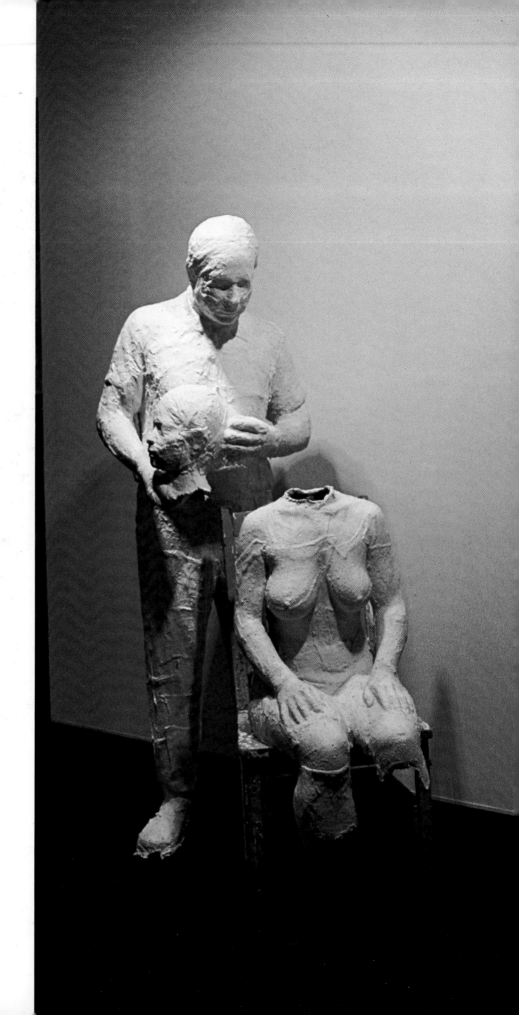

92. *Self-Portrait with Head and Body.* 1968.
Plaster and wood, 66 × 32 × 42″.
Collection Carter Burden, New York

93. *The Shower Stall.* 1968.
Plaster and metal, 78 × 34 × 43″.
Private collection, Italy

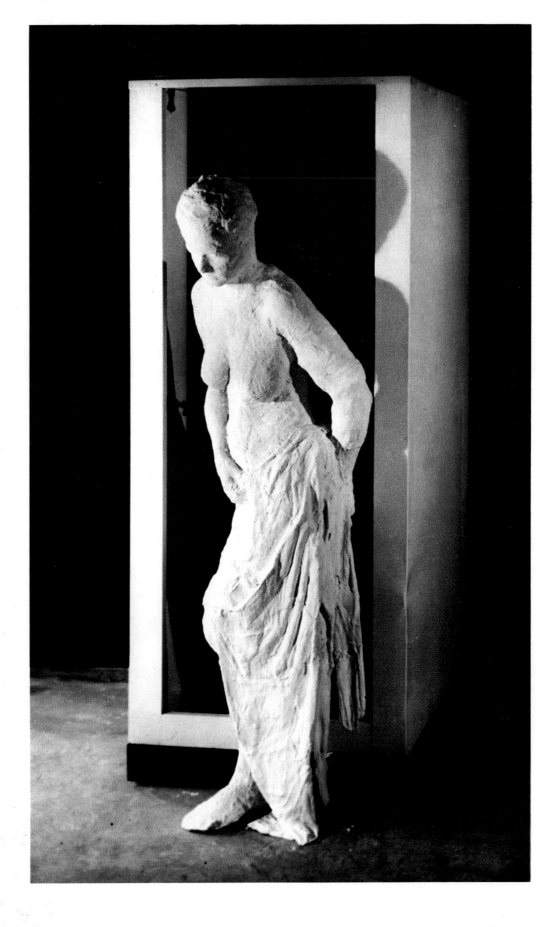

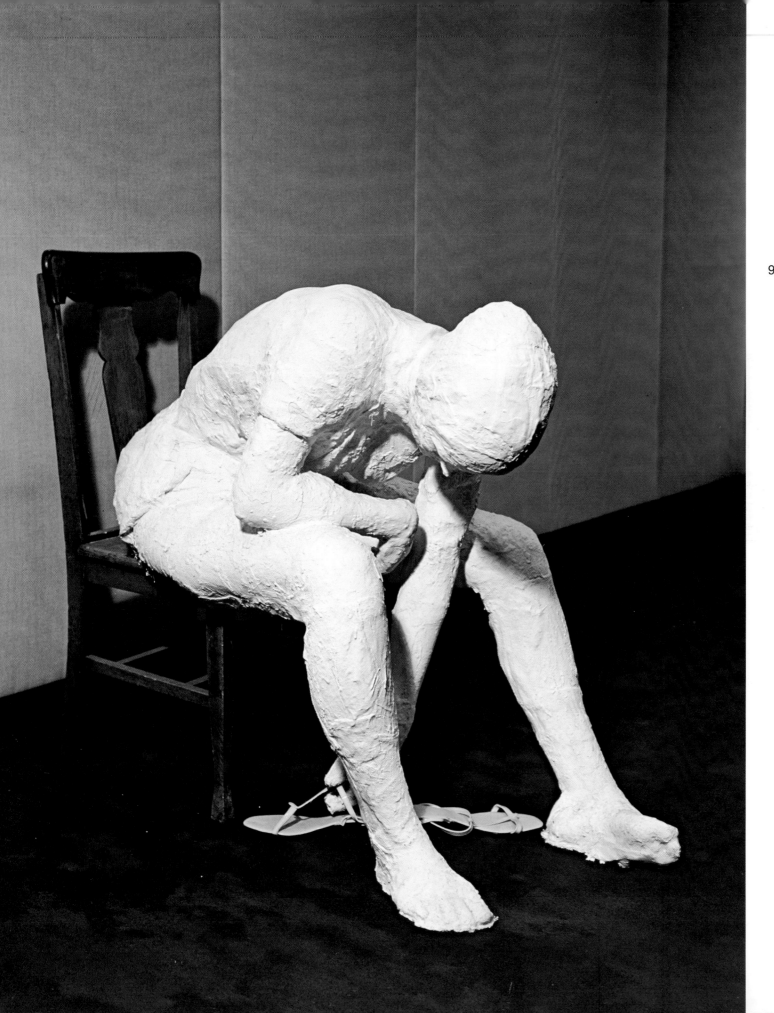

94. *Girl Putting on Her Shoe.* 1968.
Plaster, wood, and plastic,
37 × 24 × 48″. Collection Mr. and Mrs
William S. Paley, New York

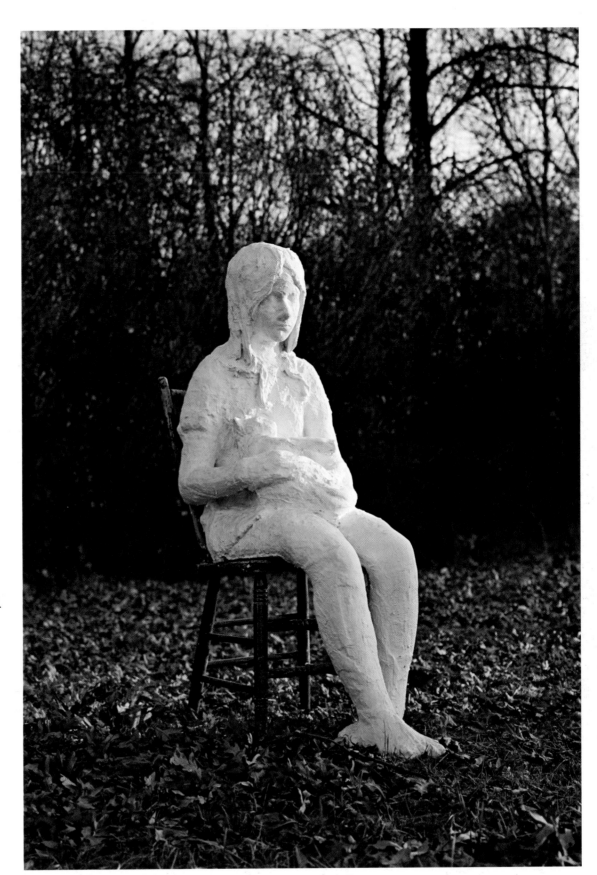

95. *Girl Holding a Cat.* 1968.
Plaster and wood, 48 × 17 × 32″.
Collection Mrs. Helen Segal,
New Brunswick, N.J.

96. *The Subway.* 1968. Plaster, metal, glass,
rattan, incandescent light, and electrical parts,
7'6" × 9'7" × 4'5". Collection Mrs. Robert B. Mayer, Chicago

THE SUBWAY

Public transportation conveyances have always fasci-
nated Segal as neutral yet distinct environments in
which people become blank and introspective as they
are routinely shuttled between points. The subway as a
subject had never been within his reach because of the
near-impossibility of obtaining the necessary hard-
ware. Few subway cars are scrapped in New York, but
through special introductions he was directed to the
only yard in the metropolitan area where a car might
become available. For days on end he waited for union
employees to cut out the section he wanted. Finally, in
anger and frustration he grabbed his own tools and
showed them that he could cut more rivets in five
minutes than they were cutting in an hour. He loaded a
one-eighth section—wall, ceiling, and seats—on his
pickup truck and drove it home to South Brunswick.

Next he had to decide how to populate his subway
car. He immediately rejected the idea of a crowd—it
would get in the way of the geometry of the car's
interior. He wanted the car's "bones" to show. So he
settled for a lonely girl riding home at night—huddled
vulnerably on her seat, carrying a handbag. The space
would easily have accommodated a fellow traveler, but
that would have evoked the specter of mugging or easy
romance, neither of which appealed to him. Traveling
alone in a subway is a more frightening image than
traveling in company, and Segal successfully evoked
that.

Tempted to suggest motion as he had done in *The
Truck,* Segal shot some super-eight movie footage
which he planned to project on the window. The idea
made sense because the environment is more compel-
ling with the sounds and sights of motion. But the film
was bland, with no clue as to where it was shot. It could
have been reshot with a professional crew, but "con-
tracting out" runs counter to Segal's sense of wanting
to control personally the whole work and be totally
responsible for it.

The next-best solution was to suggest lights flash-
ing by. After working with an electronics wizard for
weeks without tangible results, Segal decided to rig up
a simple device of ordinary light bulbs and a revolving
wheel regulating the speed of the lights going on and
off. He created a convincing abstract representation of
motion, similar in a way to a subway-map's abstract
representation of space.

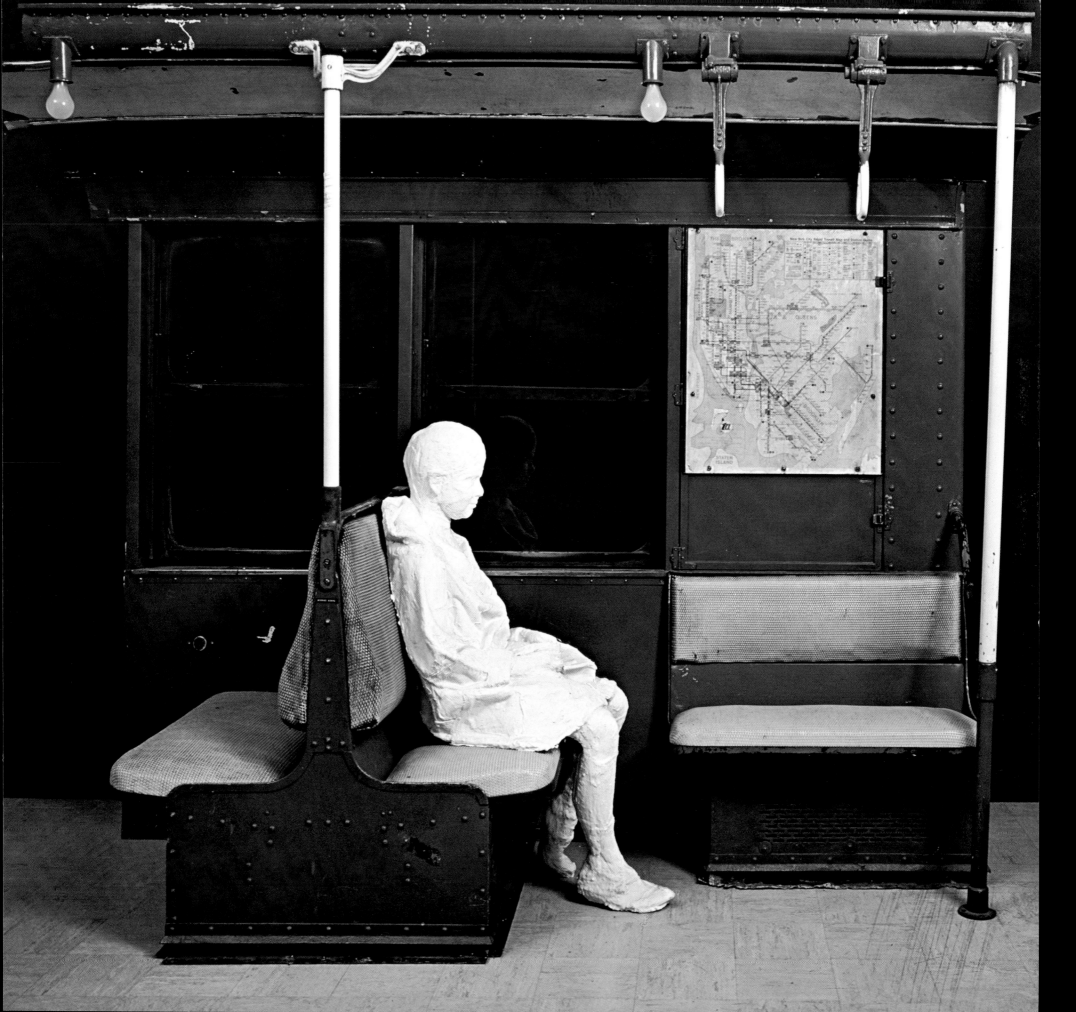

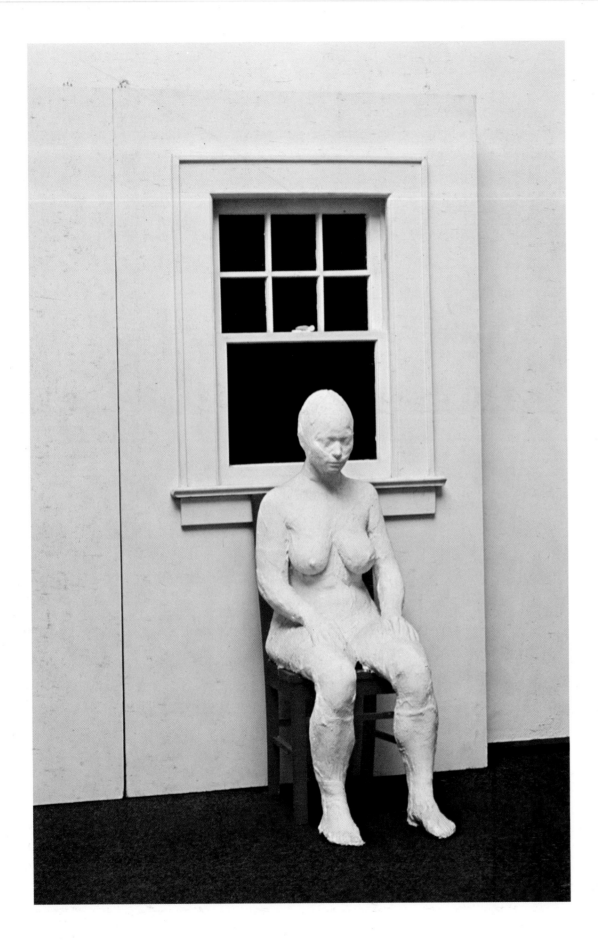

GIRL SITTING AGAINST A WALL I

GIRL SITTING AGAINST A WALL II

It may be easy to rationalize but difficult to deny that a subtle discrimination on the author's part has eliminated individual treatment of those many girls on chairs, putting on shoes, earrings, or mascara, brushing their hair, clasping their hands, or raising their fingers. And what about the girls washing in front of a sink or dressing before a mirror? They were sculpted by Segal not so much for their personalities—although he would claim their personalities show in the way they hold their bodies—but for the grace with which they invest ordinary gestures.

The fact that they are nude probably removes them from portrait considerations. The fact that they are shown without benefit of environment heightens their abstract treatment. They seem to be without history, story content, or formal framework. Yet their function in Segal's oeuvre goes beyond that of conventional studies from the model. For that he actually draws and makes pastels. They are quite complete, each in her own way—fugues or sonatas as compared with full orchestrations. Whenever he gets too deep into the formal complexities of his more ambitious sculptures, Segal tends to go off and cast another girl splendidly isolated in a world of everyday concerns. Sometimes it works the other way. After a series of nothing but girls, he may long to do a tough, almost ugly piece.

What shines through in all these studies is Segal's love for women in all shapes and states—he has cast a pregnant girl—and a peculiar interest in observing them taking care of their bodies. He brings out that vaguely narcissistic and not altogether unerotic look of absorption in the minutiae of daily routine. He finds none of their activities too humble or too trivial for loving treatment, if not outright admiration. His work depends and thrives on watching people around him. Just as he wrests certain qualities from objects—color, shape, texture, memory associations—so he selects pertinent gestures in people, favoring those fragile and

97. *Girl Sitting Against a Wall I.* 1968.
Plaster, wood, and glass, 84 × 96 × 37".
Staatsgalerie, Stuttgart

delicate ones that flash by in an instant but are incredibly telling.

Forever observing gestures and the moods which determine poses, Segal has noticed how some bodies comport themselves regally while others just "flop around." There are women with no innate sense of style whose bodies lack rhythm and coherence. If this is the case with a model, he must decide whether to accept or suppress this awkwardness in putting the final touches to her cast, for he realizes that what appears as stylelessness today may be recognized as style three years hence. One of these seemingly graceless girls was cast standing before a mirror. Who would have expected that the part of her body reflected in the mirror was to bear an almost miraculous resemblance to the Venus of Cnidos?

Both versions of *Girl Sitting Against a Wall,* although two years apart and different in color and detail, have a wall and window as background. This formal anchorage is important for Segal, and he first used it in *The Farm Worker.* It allows for what has increasingly become an abstract handling of form and structure in the guise of providing a simple interior. Is it this spatial foil, or perhaps our accumulated recollections of Constructivist and Neo-Plasticist art, which lends real and spiritual weight to those same girls sitting on chairs?

Framing the image makes it seem starker, more hieratic, and more like traditional art. Segal himself noticed that the cast of a stocky, rather voluptuous girl tended to look erect, frontal, poised, and symmetrical—almost like a mix of Egyptian and African sculpture—once he placed it in front of that severely geometric background. It was a combination of external frame and internal spirit to Segal: "I asked her to hold herself in that fashion, and she was able to do it with great dignity."

98. *Girl Sitting Against a Wall II.* 1970.
Plaster, wood, and glass, 91 × 60 × 40".
Sidney Janis Gallery, New York

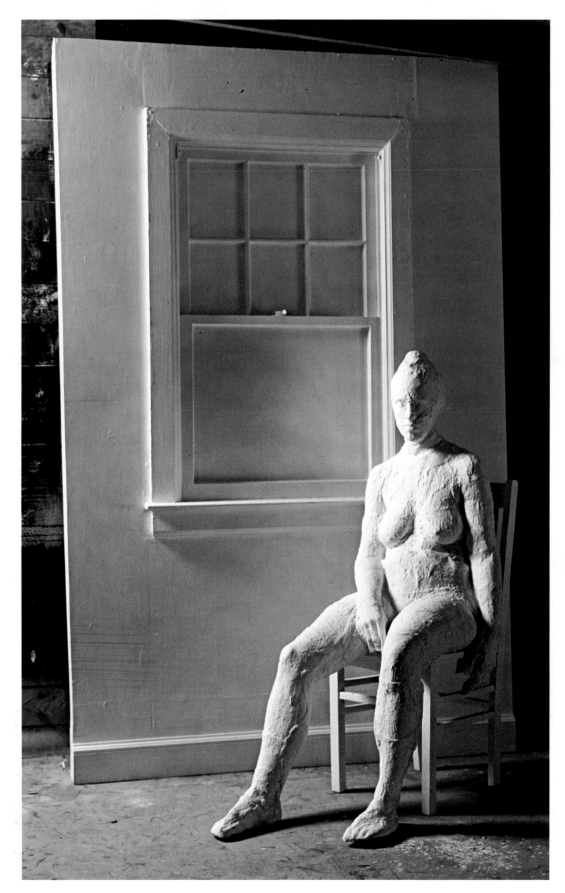

99. *Girl Putting on Mascara.* 1969.
 Plaster, wood, and plastic, 52 × 36 × 21″.
 Suermondt Museum, Aachen (Ludwig Collection)

100. *Girl Putting on Mascara*

101. *Seated Girl, Hands Clasped.* 1969.
 Plaster and wood, 52 × 36 × 21″.
 Private collection, Paris

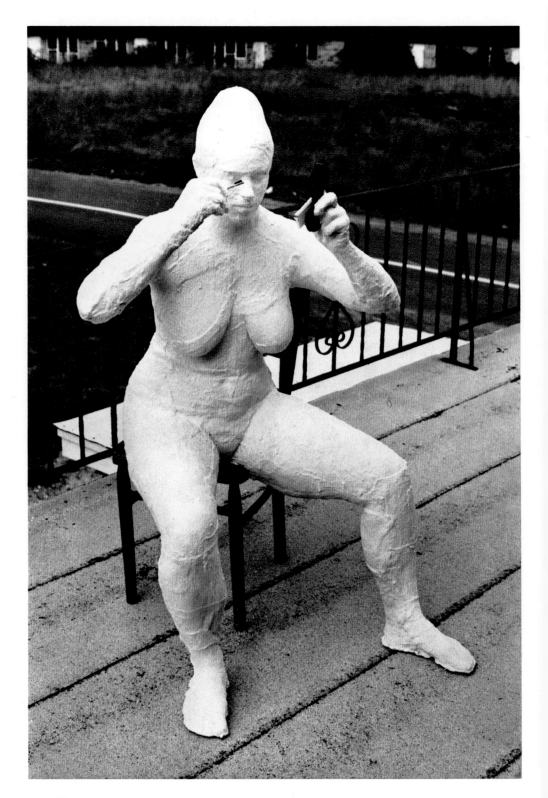

99

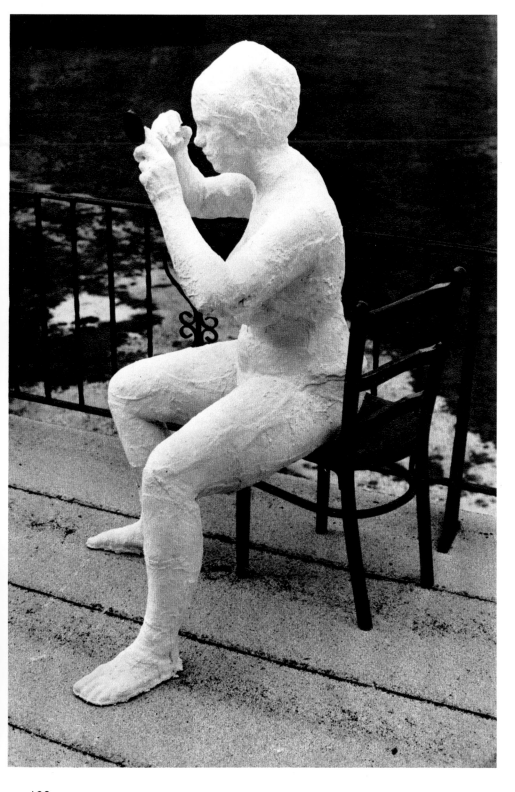

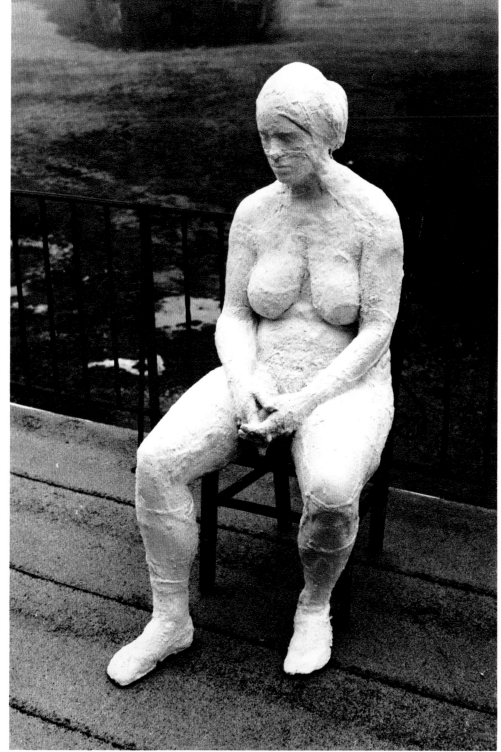

100

101

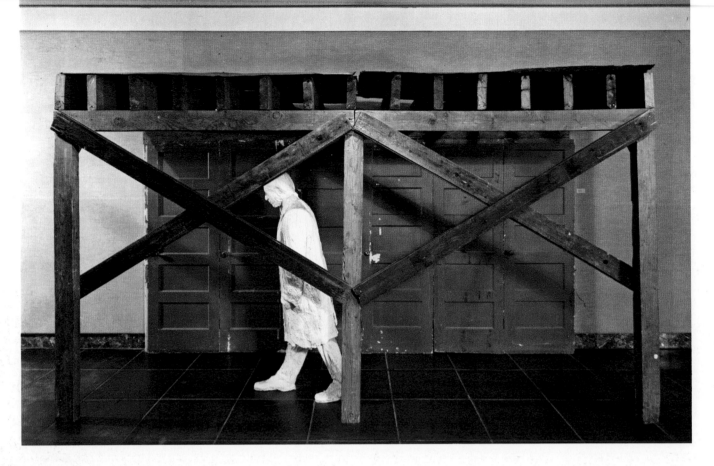

102. *The Construction Tunnel.*
1968. Plaster, wood,
and metal, 14′ × 5′ × 7′9″.
The Detroit Institute of Arts
(Founders Society Purchase).
(See plate 10 for another view.)

THE CONSTRUCTION TUNNEL

Despite its title, this work refers to demolition rather than construction. It is that familiar sidewalk device of doors and lumber discards that shields pedestrians from flying debris. The walking figure and the corridor space recall *The Gas Station.*

Segal wanted somebody broad and stocky to walk through the tunnel—a visual counterpart, we may assume, for the weightiness of the beams. The image sprang from a dream the artist had at the age of thirteen: he walked endlessly through a dark tunnel that snaked into infinite distance. This is the first instance he remembers in which a dream revealed to him so clearly the concept of endless space and time. So, he decided to cast himself in this portrayal of a childhood fantasy, a grown man trapped in a time-space tunnel.

Such experiences are impossible to visualize and can only be hinted at; even then they may fail to become apparent. Obviously, the tunnel has to be open on one side for the figure to be seen. So Segal summarily closed it off with two pairs of crossed wooden slats, and the man shows no signs of being observed.

The doors on the other side of the tunnel are nailed shut and cannot be opened. Is there a hint of Sartre's *No Exit*?

Segal does not refute symbolic readings, considering his own revelation of the work's subconscious genesis. But he doesn't give undue emphasis to the symbolism: "I can build a piece and in one second all these references that may take pages to describe shoot to the surface." They appeared most noticeably when *The Construction Tunnel* plus *Couple at the Stairs* and *The Moviehouse* were shown, cramped together but to wonderful advantage, in the Darthea Speyer Gallery in Paris. Loosened from its American context and dropped down in the most picturesque quarter of Paris, each of these three works, mysteriously united when viewed through the gallery's glass facade, gave off symbolic and metaphoric meanings. Together they wove a fabric, dense and intricate enough to invite a thesis on "Segal and the American Experience of Loneliness."

103. *The Parking Garage.* 1968. Plaster, wood, metal, electrical parts, and light bulbs, 10′ × 12′8″ × 4′. Newark Museum, N.J.

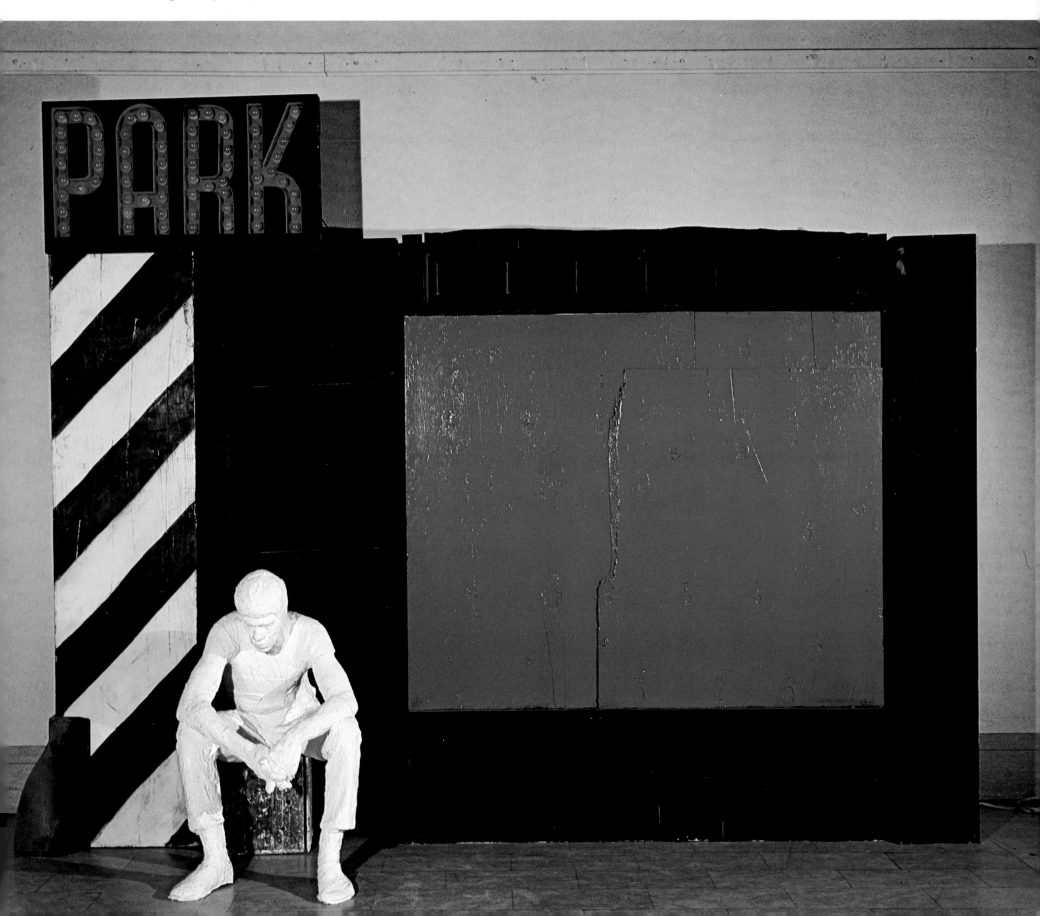

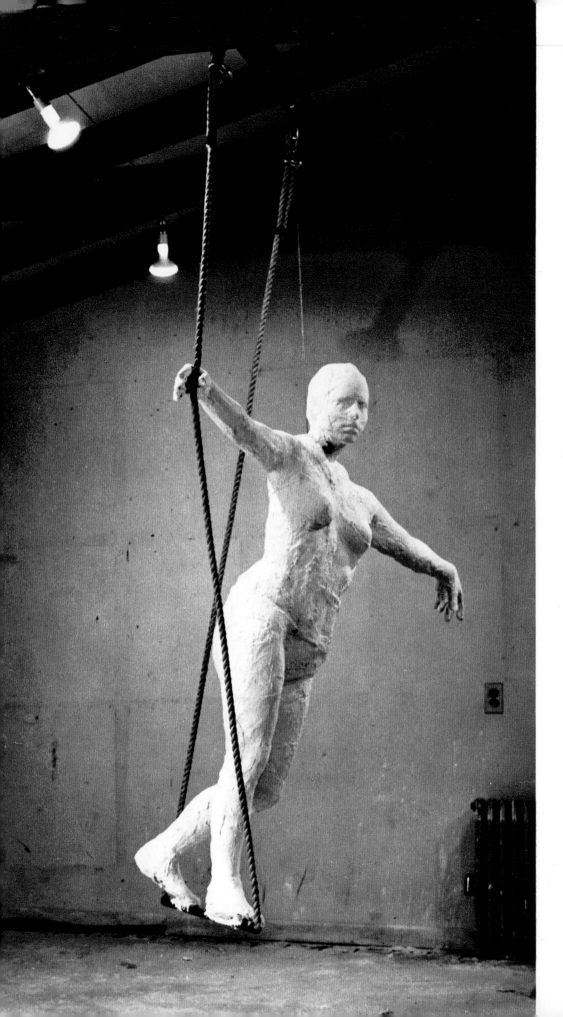

THE GIRL FRIENDS

Strong taboos of any kind seem to be too private and specific for Segal to handle, since his art is invariably introduced into a public context and tends to stress what binds instead of divides people. Making a sculpture of Jill Johnston and her girl friend Polly posing together had been the artist's idea. He reminds us, by way of explanation, that in the late 1960s he had done a painting after Courbet's *Sleep* of 1866.

On New Year's Day of 1969, he cast Jill and Polly in one session as they sat nude on a mattress, somewhat uneasily enjoying one another's company. As she recounted her adventure in *The Village Voice* (January 9, 1969) under the heading "Casting for 69," Jill Johnston wrote with tongue in cheek: "I was wondering if I'd do a 69 for George to get his year off to an interesting start. I told him he needed a shocking sculpture to celebrate our only 69."

Segal had expected that Jill wanted to flaunt her feelings for Polly and would insist on a brazen pose. But their mutual relationship, as expressed by two people quietly facing each other, interested him more than the particulars of their affection. He wanted to explore the give-and-take in a lesbian relationship. Neither girl seemed noticeably inhibited, but it did become obvious when the cast was completed that Polly was holding back—her spine was very rigid—whereas Jill was more outgoing and complying. Segal adopts a philosophical attitude in the matter: "Female homosexuality is an area I don't know enough about to handle with authority."

104. *Girl on the Flying Trapeze*. 1969.
Plaster, metal, and rope, 96 × 60 × 24".
Collection Mrs. Robert B. Mayer, Chicago

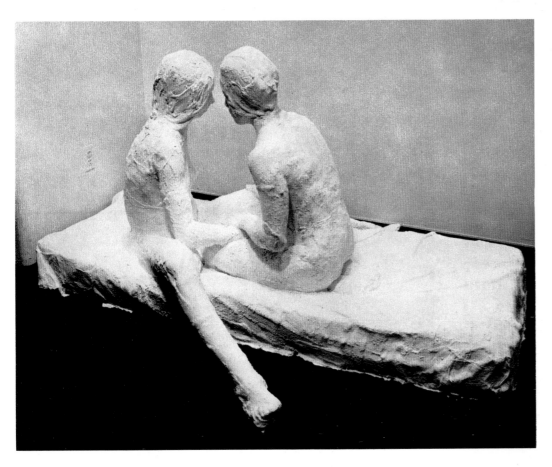

105. *The Girl Friends.* 1969.
 Plaster, 41 × 72 × 42".
 Sidney Janis Gallery,
 New York

106. *Sleeping Girl.* 1969.
 Plaster and metal, 22 × 73 × 33".
 Collection Dr. E. Stünke,
 Cologne

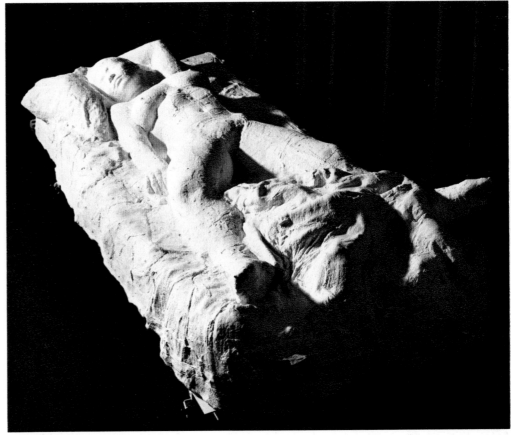

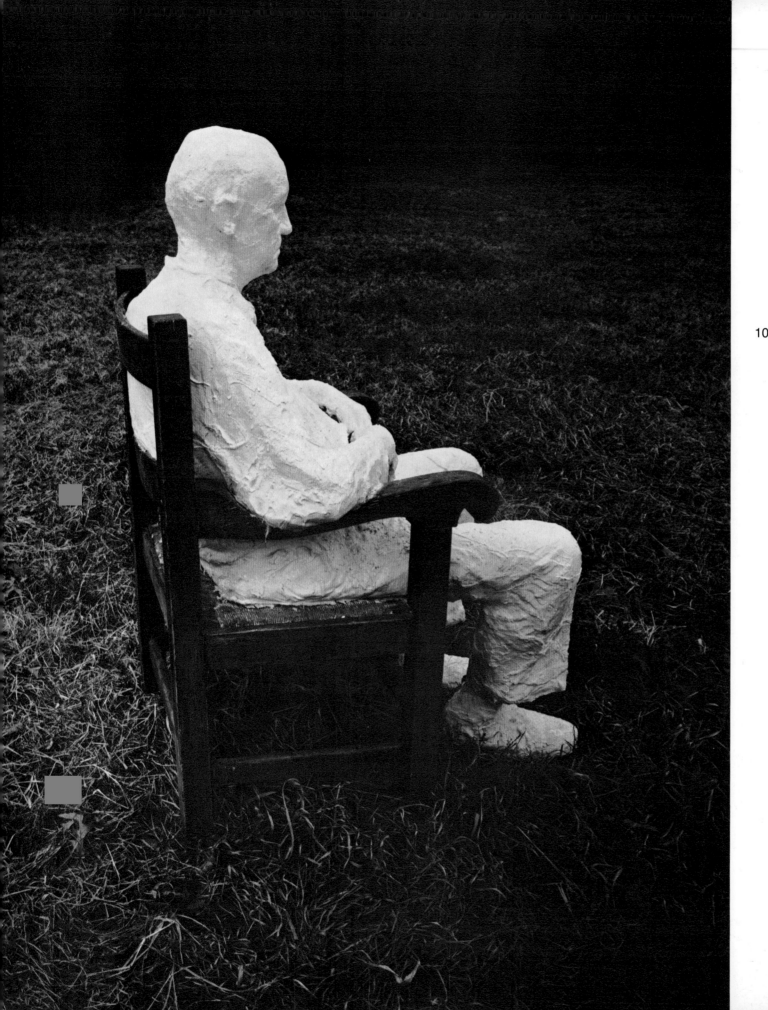

107. *Man in a Chair
(Helmut von Erffa)*. 1969.
Plaster and wood,
50 × 29 × 36″.
Collection Panza di Biumo, Milan
(See plate 111 for another view.)

108. *Tightrope Walker.* 1969.
Plaster, metal, and
rope, 6′6″ × 17′ × 5′.
Museum of Art,
Carnegie Institute,
Pittsburgh

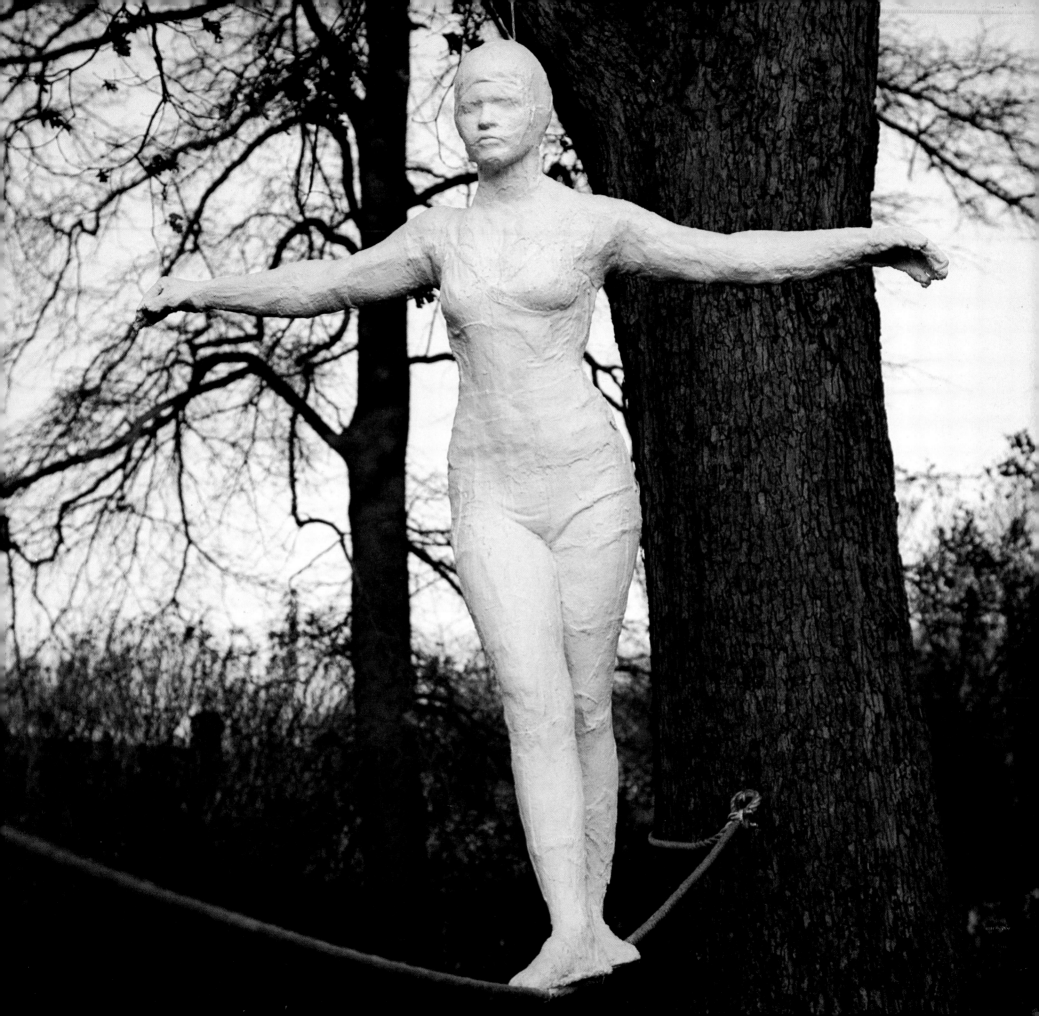

109. *The Artist in His Loft.* 1969.
Plaster, wood, metal, glass,
and porcelain, 90 × 69 × 60″.
Galerie Onnasch, Cologne

THE STORE WINDOW

THE ARTIST IN HIS LOFT

The environment framing the girl in *The Store Window* as she waits for a bus or a pickup is an exact replica of a little store near the New Brunswick station. "I liked it for its proportions and I was charged up on the space and shape of that very narrow doorway to the right of the shop window," Segal says. The original was dirty white, and a timetable of the Suburban Transit Corporation always hung in the window. The artist rebuilt that entrance in his studio and painted the interior white and the entrance black. He remembers making the uncanny discovery after he finished that the original had just received a new coat of paint in those same colors.

Increasingly in recent years the artist has used as a point of departure not people seen or remembered in revealing situations, but forms and places seen and appreciated for their sculptural and spatial appearance. If this applies to *The Store Window,* it is equally true of *The Artist in His Loft,* on which he worked simultaneously. Here the aggregate of plumbing and cabinetry—all painted white and a composite of what he had observed in the living-lofts of his Lower Manhattan artist friends—was the inspiration for the sculpture, and the artist shaving in front of it a counterpart of neatness. The sink, pipes, shelves, and cabinets of the loft relate to the venetian blinds and slatted siding of *The Store Window* as a Constructivist sculpture relates to a Constructivist relief. They betray too much loving attention, though not at the expense of their plaster accompaniments, to be passed off as environmental props serving as a foil for the sculpture. These surroundings *are* the sculpture as much as, if not more than, the figures they frame.

The girl in the doorway had been cast some years

before. She was a reject from *The Legend of Lot;* the second daughter who shrank from the ignominious act could not be made to fit her role and had subsequently been abandoned. Segal clothed her in a dress and raincoat and put a pair of glass eyes into her sockets. The only time he has done this, it takes the detailing of features a step beyond Ethel Scull's sunglasses or the "Cat Woman's" furry mask. The artist's reasons for this are spatial, but with a psychological implication: "I was hunting for a connection between the way the girl stands and the enclosure in which we see her. She is shrinking back but her eyes come forward very aggressively." There is no doubt that Segal wanted to cancel that effect of shrinking back, which had made this plaster cast unusable in the first place, by inserting eyes which tend to push the figure forward and establish a connection with what lies ahead. In *The Store Window* he makes a fortuitous use of this feature, psychologically as well as formally.

Formally, the scene is composed of two hollows—the recessed window and the doorway corridor. As a positive balance they need a figure coming forward, not one that withdraws in search of shelter. Psychologically, a girl standing in a doorway at night is a pawn in the mating game. If she was too shy in her eyeless version, that wondrous addition has made her game. Segal refers to that feeling all men know when they pass a girl, are struck belatedly by her beauty or the thought of a missed opportunity, turn their head, and discover that the girl too is looking. He has captured that one moment when eyes meet, in promise, indecision, or embarrassment, making the scene heavily suggestive of adventure, welcomed or avoided.

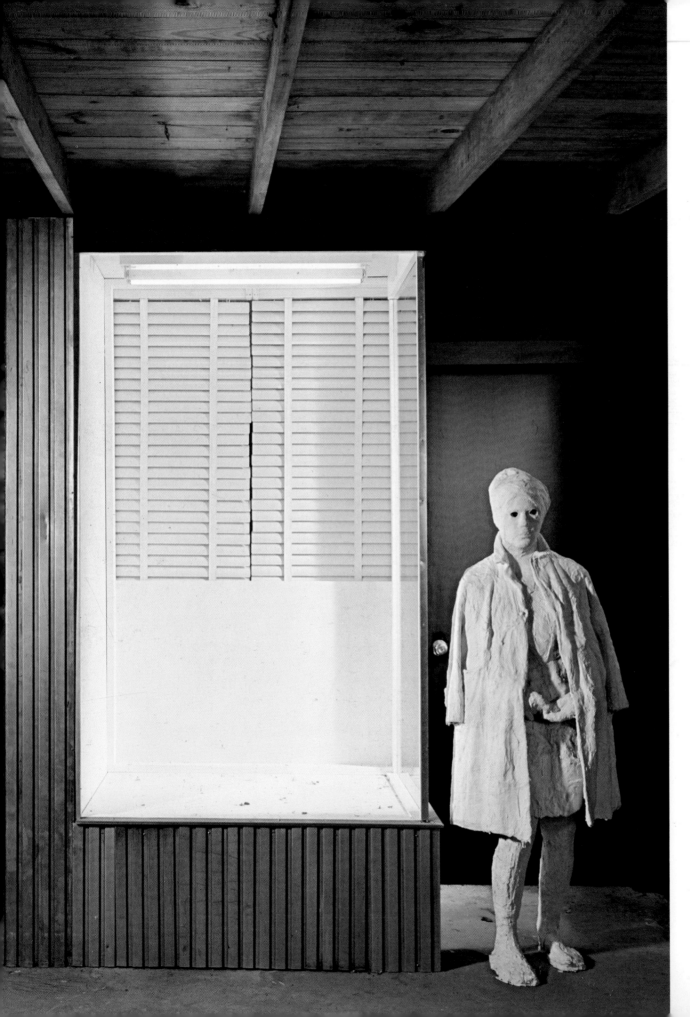

110. *The Store Window.* 1969.
 Plaster, wood, plastic,
 and aluminum, 8′ × 8′8″ × 3′.
 Milwaukee Art Center
 (Gift of Friends of Art, 1970)

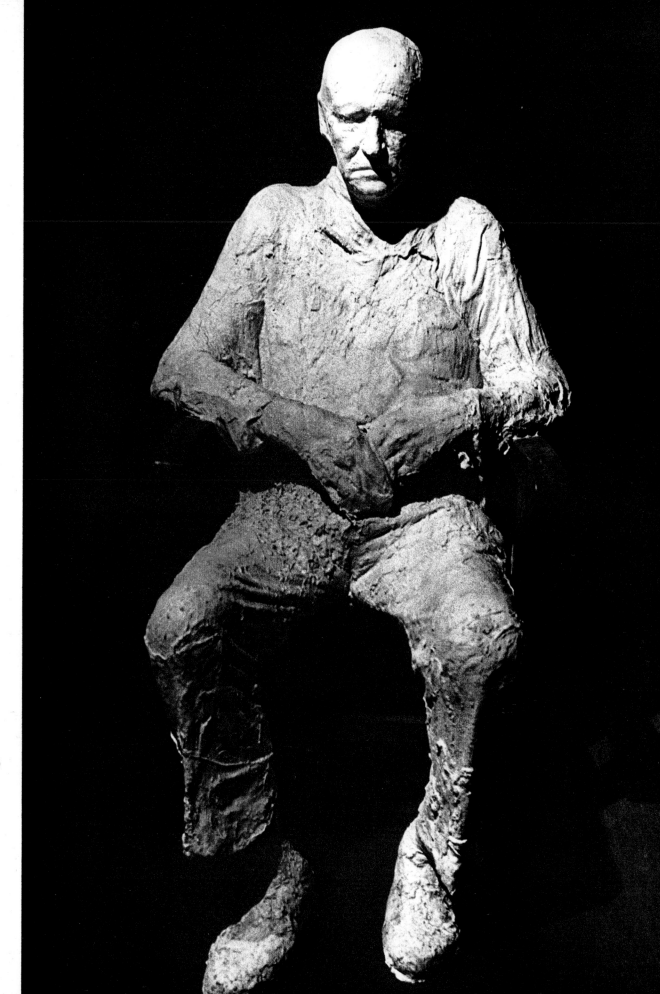

111. *Man in a Chair*
 (Helmut von Erffa).
 (See plate 107 for another view.)

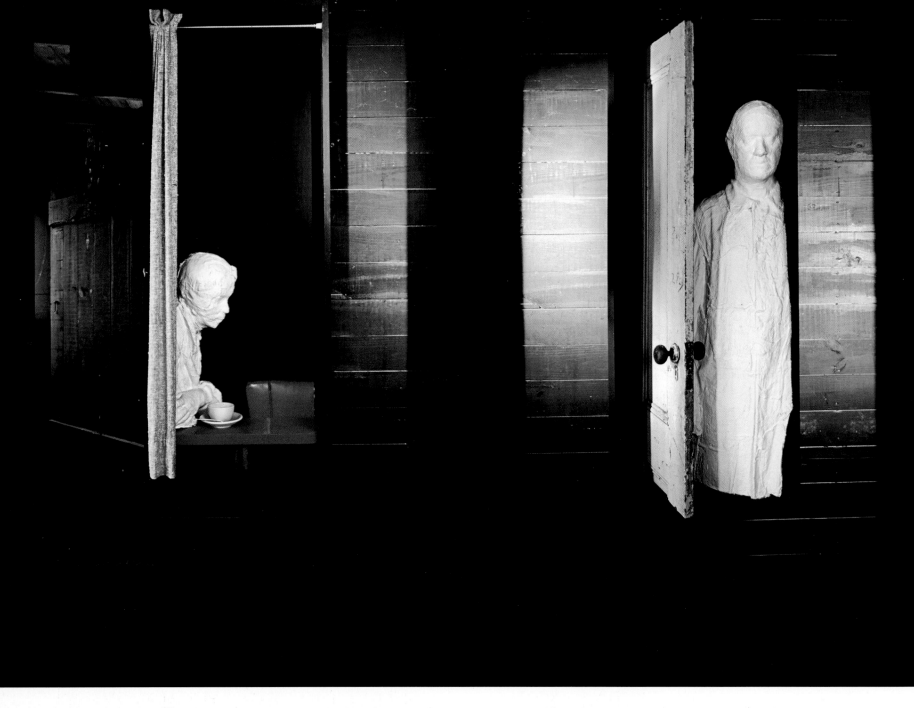

112. *Box: The Coffee Shop.* 1969. Plaster, wood, metal, plastic, and cloth, 60 × 24 × 12″. Collection I. Lechien, Brussels

113. *Box: The Open Door.* 1969. Plaster, wood, and metal, 60 × 24 × 12″. Collection the artist

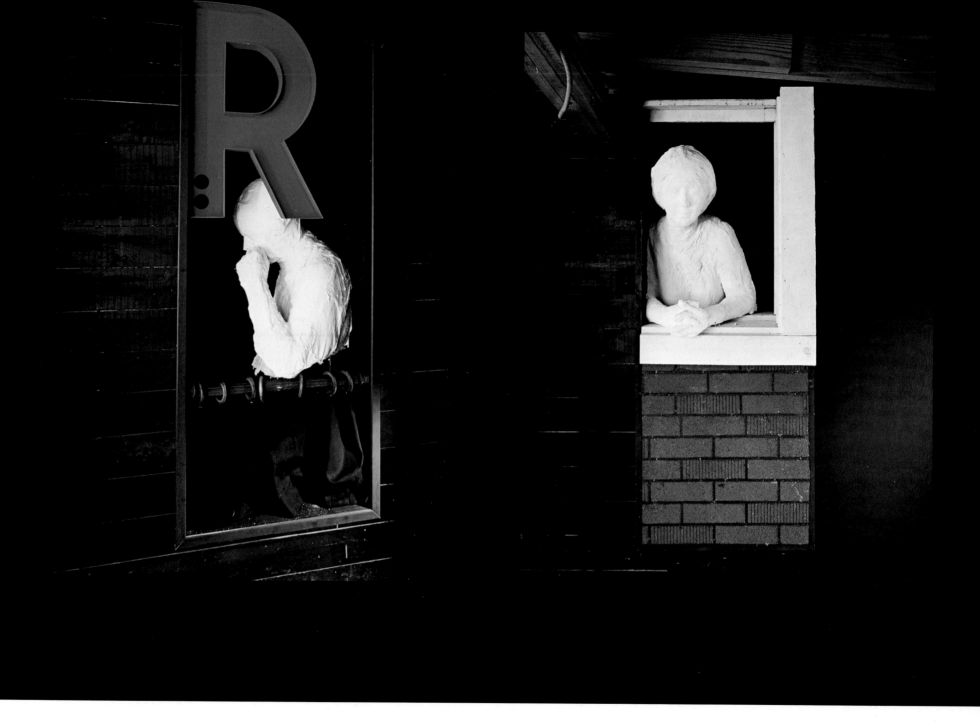

114. *Box: Man in a Bar.* 1969. Plaster, wood, metal, and cloth, 60 × 24 × 12″. Collection Mr. and Mrs. E. A. Bergman, Chicago

115. *Box: Woman Looking Through Window.* 1969. Plaster, wood, and celotex, 60 × 24 × 12″. Collection Serge de Bloe, Brussels

GIRL WALKING OUT OF THE OCEAN

The most striking feature of this lyrical work is the illusionistic handling of everything surrounding the figure, truncated just above the knees. Suddenly we realize that the stark realism we have come to expect from the artist has been ignored and that whatever we see is made out of plaster. In creating the impression of depth perspective, Segal has resorted to the illusionistic method that is the hallmark of the painter. This throwback is acceptable to Segal as an illusionistic extension of his means to portray reality, not unlike the incorporation of film and light. A vertical plane of plywood covered with a plaster and cheesecloth texture gives the viewer the impression of infinite water and sky—pure space, like that of the painter.

For Segal, the only way to create enclosure is to set up a realistic, three-dimensional, interior re-creation of an exterior situation. This excludes such imponderables as horizon, sky, clouds, growing or living organisms, and water. Deep space, at this point, could be suggested in a night-time situation only by the use of black. That may account for Segal's predilection for nocturnal scenes. (If some of Segal's simpler situations—girls on chairs, *Girl on the Flying Trapeze,* and *Tightrope Walker*—appear to be at ease out-of-doors, it is only because they were photographed outside. The artist neither includes a corner of his back yard with the figure, nor does he even suggest that the figure be exhibited outside.) In *Girl Walking out of the Ocean* Segal has broken this interior/exterior deadlock and regained a new freedom of which he had not yet fully taken advantage.

The girl emerges from the "water" at the height we would see her should we too rush out into the surf. This adds to the credibility of the subject as it reinforces the spatial illusion. Less than a year before, Segal had cast a sleeping girl on a mattress. Body and support were fused so effectively that when the work was stood up on end, it could almost be read as classical high relief; the mattress became as abstract as neutral space. Seeing this potential may have inspired Segal to make *Girl Walking out of the Ocean;* or, more accurately, the principle may have surfaced at the appropriate time.

Segal explains what actually prompted *Girl Walking out of the Ocean.* "I got knocked out by a color poster advertising some tropical paradise or an airline that would take you there." No *September Morn',* the girl on the poster is cool, svelte, scantily clad, and at ease in the surf. Yet, nothing of that hard-sell glamour lingers. It has become a moody and reticent piece, infused with memories of Provincetown in a more innocent era. "Hans Hofmann told us about swimming in the nude with his girl friend in the Mediterranean—I dote on that kind of sensuousness."

With figure and environment conceived as a whole in subtly tempered plaster, the pull and push between the created and the found, the spiritual and the banal, have been resolved in favor of the former. White plaster has become the unique and triumphant material and light its magic constituent. Never has Segal come closer to the concept of classical sculpture and never has he demonstrated the poetic timelessness of sculpture more successfully.

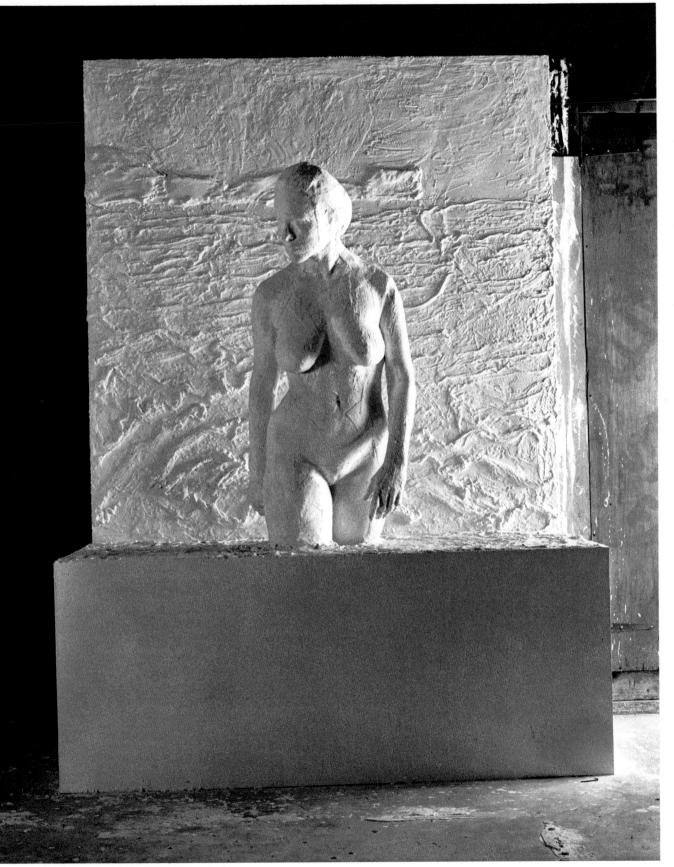

116. *Girl Walking out of the Ocean.* 1970.
Plaster and wood, 84 × 60 × 28½″.
Private collection, Brussels

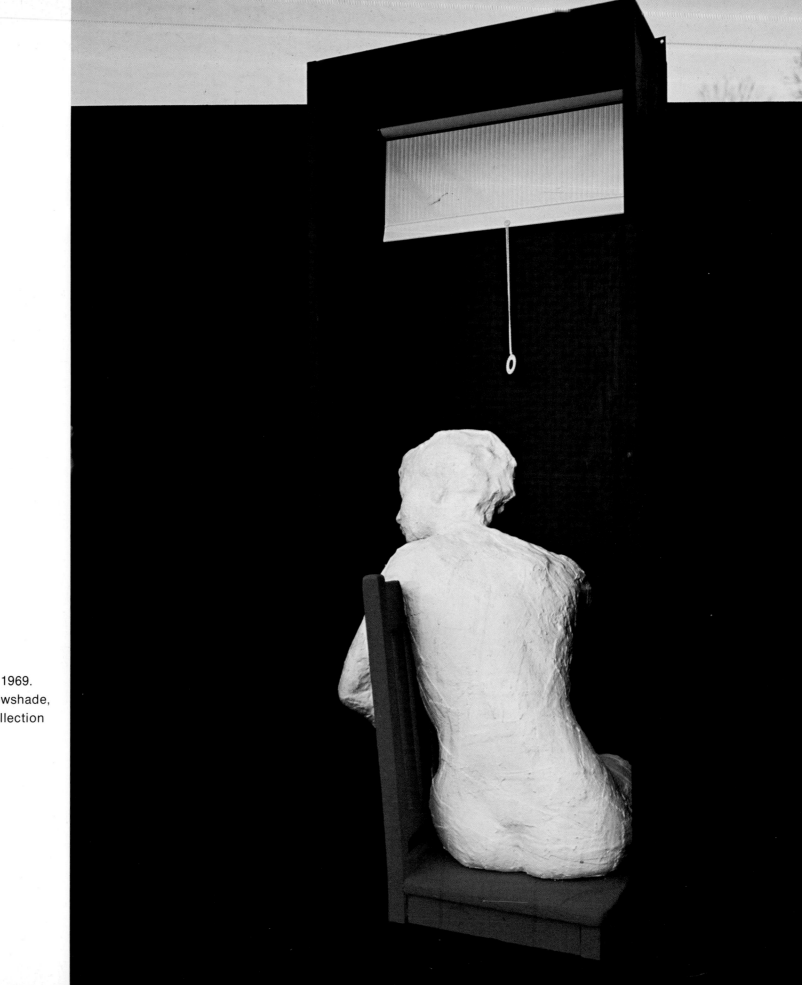

117. *Box: Woman on a Chair.* 1969.
Plaster, wood, and windowshade,
60 × 24 × 12″. Private collection

18. *Girl Looking into Mirror.* 1970.
Plaster, wood, and mirror,
72 × 28 × 27″. Collection Mr. and Mrs.
Frederick R. Weismann, Beverly Hills

119. *The Aerial View.* 1970.
Plaster, wood, plastic, incandescent
and fluorescent light, 8′ × 8′9″ × 4′.
The Art Museum of the Ateneum,
Helsinki (Collection Sara Hilden)

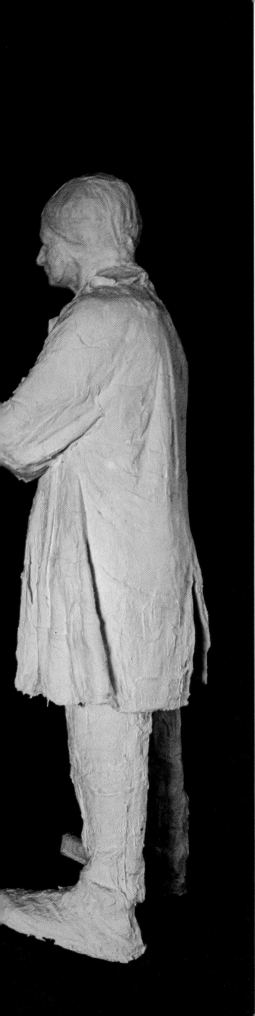

THE AERIAL VIEW

If in *Girl Walking out of the Ocean* Segal extracted himself from the predicament of suggesting, in plaster, the bright light of day, he also found a means of depicting life, lights, and animation in deep dark space. *The Aerial View* is a key work in Segal's developing grasp of his medium in much the same way.

The work came about by trial and error, but the artist always felt he was on to something. Segal explains that he was entranced by the way the city looks at night from an airplane. He wanted to do a work that included a vast horizontal surface—like the earth from above—suggesting depth and distance and studded with lights. To measure the idea's potential and make color slides of the view, he took a helicopter ride one night, from Newark Airport to Kennedy Airport and back. Then he translated these aerial photographs into their material equivalent—an eight-by-eight-foot plywood panel into which he drilled hundreds of small holes to accommodate varicolored, light-conducting, plastic pegs; he then placed the panel on an incandes-

cent light box. It didn't work. It simply wouldn't duplicate the view from that plane, and the idea of colored lights stretching out as far as the eye could see was lost. Then he stood the panel up on one side and suddenly the perspective "leaped into place."

Once he knew that his background was right and terribly exciting, he searched for a plausible situation. The seat of an aircraft was promptly dismissed because that view could never be seen through a porthole. Then he constructed a big picture window, but that looked too much like somebody's expensive penthouse apartment. He also tried cinder blocks to suggest that the man he had cast, wearing a windswept raincoat, was looking down from an airport observation deck. But would he have such a magnificent, bird's-eye view from that height? Finally, Segal built a simple enclosure of eight-by-eight-foot side panels and a roof under which the figure stands, as he looks into the distance. "I decided to leave it ambiguous and up to the viewer to fancy his own spatial context."

120. *Lovers on a Bed II* (detail)

LOVERS ON A BED II

The title refers, and is a sequel, to Segal's first "bed piece" of eight years before. Earlier, the young models were characterized by the artist as "awkward, virginal, still alone, not yet knowing much about giving." This first piece was intimate and poetic—quite different from some of the later bed pieces, which were marked by self-doubt, disenchantment, and visible hostility. "Every time I feel the impulse to treat this theme," the artist explains, "it is because I'm struck by the enormous variety of relationships possible between a man and a woman." But he also admits that besides the objective there is always the emotional angle: "Is it envy for youth, its vitality, its loveliness?"

Segal reminisces about that first couple he cast. As they lost their self-consciousness in his presence and grew increasingly bold, they urged the artist to cast them while making love. The cold wet plaster did not dampen their eagerness. However, as time went by, feelings of aggression had overtaken them; the vibrations were no longer right. The relationship between his young friends had deteriorated in a year's time to the point where a deep-seated hostility on the part of the man foiled his attempts to act lovingly. Segal was dissatisfied with the cast, and it killed his desire to put the pieces together. He pondered the difficulty of "plunging in, almost as a participant, yet keeping the distance required for doing the job."

Lovers on a Bed II radiates ease and relaxation; these people are obviously comfortable with each other and they seem to revel in a sensual bath. Joy permeates this piece, and there is a natural acceptance of each other's body. The modest austerity of the headboard in the earlier piece has been replaced in the 1970 version by an open and baroque wrought-copper ornament. Segal has been able to translate physical sensation and bodily confidence into an image of still but affecting beauty.

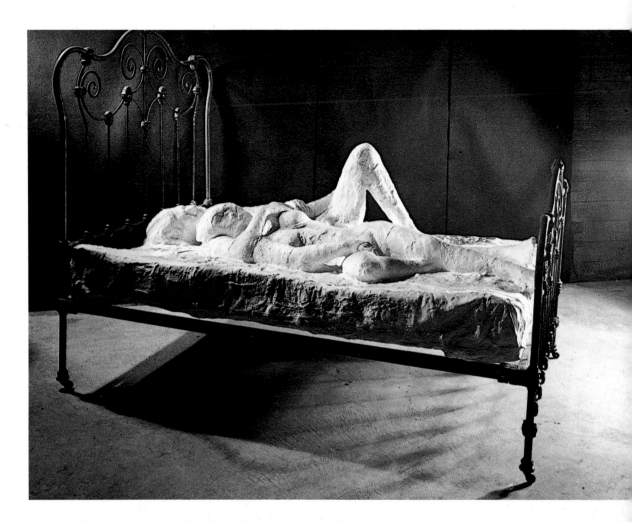

121. *Lovers on a Bed II.* 1970. Plaster and metal, 62 × 56 × 84". Sidney Janis Gallery, New York

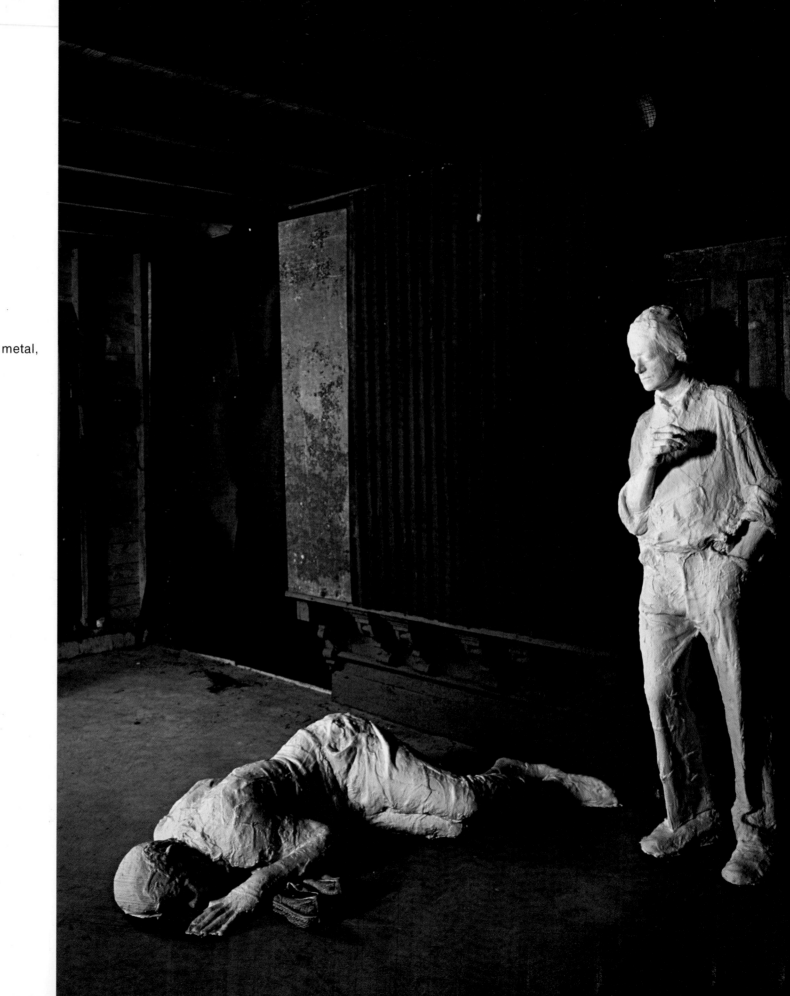

122. *The Bowery*. 1970.
Plaster, wood, and metal,
96 × 96 × 72″.
Kunsthaus, Zurich

THE BOWERY

As we have come to expect, Segal speaks in this work more of architecture than anecdote, more about stance than story, more about fact than fiction. "The three-dimensional bas-relief thrust of supposedly flat and ordinary walls knocks me out whenever I walk around the city, especially below Houston Street." Two years before, in *The Parking Garage,* Segal had shown that same interest in boarded-up windows and the profiles of old buildings and, in fact, had created an atmosphere evoking this starkness. In *The Bowery,* that three-dimensional bas-relief thrust is so pronounced that the men seem literally to seek shelter under it.

The enclosure set up for two derelicts, one standing and one prostrate, suggests a boarded-up store window. Galvanized and rusty corrugated iron have replaced the window, jutting out on a heavy base of carved molding. In front of the old door, which once gave access to the store, a bum has stationed himself, cigarette in one hand, the other hand in his pocket. He gazes with indifference at his buddy, snoring on the sidewalk with an elbow extended to protect his tennis shoes from being stolen. Simple gestures in this work are exquisitely revealing—they are a second set of clues, lest the first set go unnoticed.

The standing man's weary pose informs the viewer that the man stretched out on the sidewalk is not an apoplexy or traffic-accident victim, but the everyday sight of a wino catching a nap. Neither anecdote nor moral disapproval seems to color the scene. It is as matter-of-fact and unemotional as its model in real life. Right or wrong, the sight has become as familiar to New Yorkers as those of office workers on a subway platform, prostitutes in Times Square, children on a concrete playground, and sunbathers on a tar beach.

ALICE LISTENING TO HER POETRY AND MUSIC

Segal's work may be layered with meaning, but it rarely demands explanation. It can be understood and enjoyed quite simply because it reflects every man's experience. But exceptions occur when the sculptor depicts a highly personal vision of either subject or setting and is unable to find a means of conveying it unequivocally. *The Aerial View* and *Alice Listening to Her Poetry and Music* both suffer from the same imbalance for different reasons, and neither is defined clearly enough. For an image to jell, private vision must communicate as human experience, and the separate parts of a composition should do more than simply add up to an integrated whole.

Segal was struck by the sensitivity and vulnerability of the poet Alice Notley, and he wanted to incorporate her frailty in his work. She was timid and seemed to be shivering, in need of protection. He remembers her sitting, fragile and erect, almost too shy to talk. She was listening to a recording of her own voice and liked the sound, as many poets do, almost more than the meaning of the words. Bodily features can be rendered in plaster, but how does one convey a gift for poetry? The sculptor was back to the problem of *Ruth in Her Kitchen*. Could he make Alice talk or read? He went to Judson Church, where she was reading, to record her voice, but the quality of the tape was poor. Yet he wanted to retain that timbre of her voice, the quality of diction in a public performance with its spontaneity, hesitations, and peripheral sounds.

In the first version, exhibited in December 1970, Alice faced the viewer, sitting next to a kitchen table while a recorder on the table played back her poetry. What was wrong? Segal could not make it plausible that Alice, although ostensibly reciting, had a voice of her own. There was no way to hide the tape recorder and make the sound come from the girl herself. So he made her listen, but listening does not require, and is almost contradicted by, her formal pose.

In a second version, first exhibited in the spring of 1971, Alice is sitting before a kitchen table, with her back to the viewer. On the table stands a new tape recorder, in front of a window that mirrors her reflection. The present version is tighter in composition, more intimate and intriguing. But what Alice is doing has become even more arcane. Segal has satisfied his sense of beautiful structure between the austere lines of chair, table, window, and the mirror reflections, but he has left Alice, as well as the viewer, suspended, as we search for an explanation of what, specifically, is said in this work.

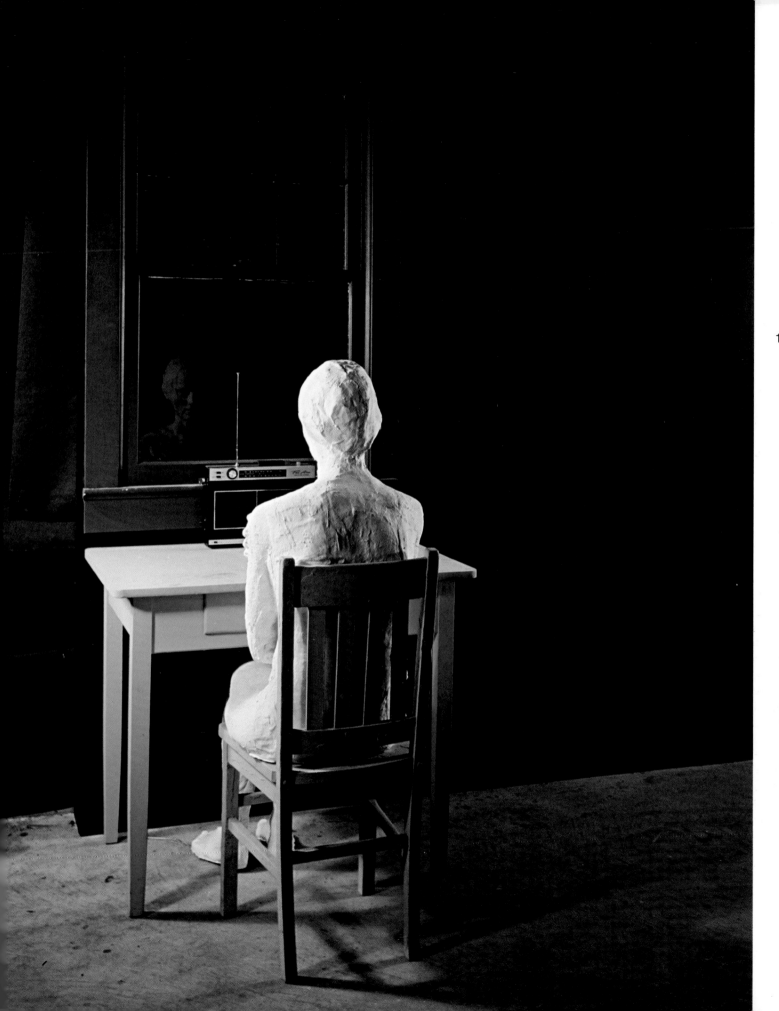

123. *Alice Listening to
Her Poetry and Music.* 1970.
Plaster, wood, glass,
and tape recorder, 96 × 96 × 33″.
Staatsgalerie Moderner Kunst,
Munich

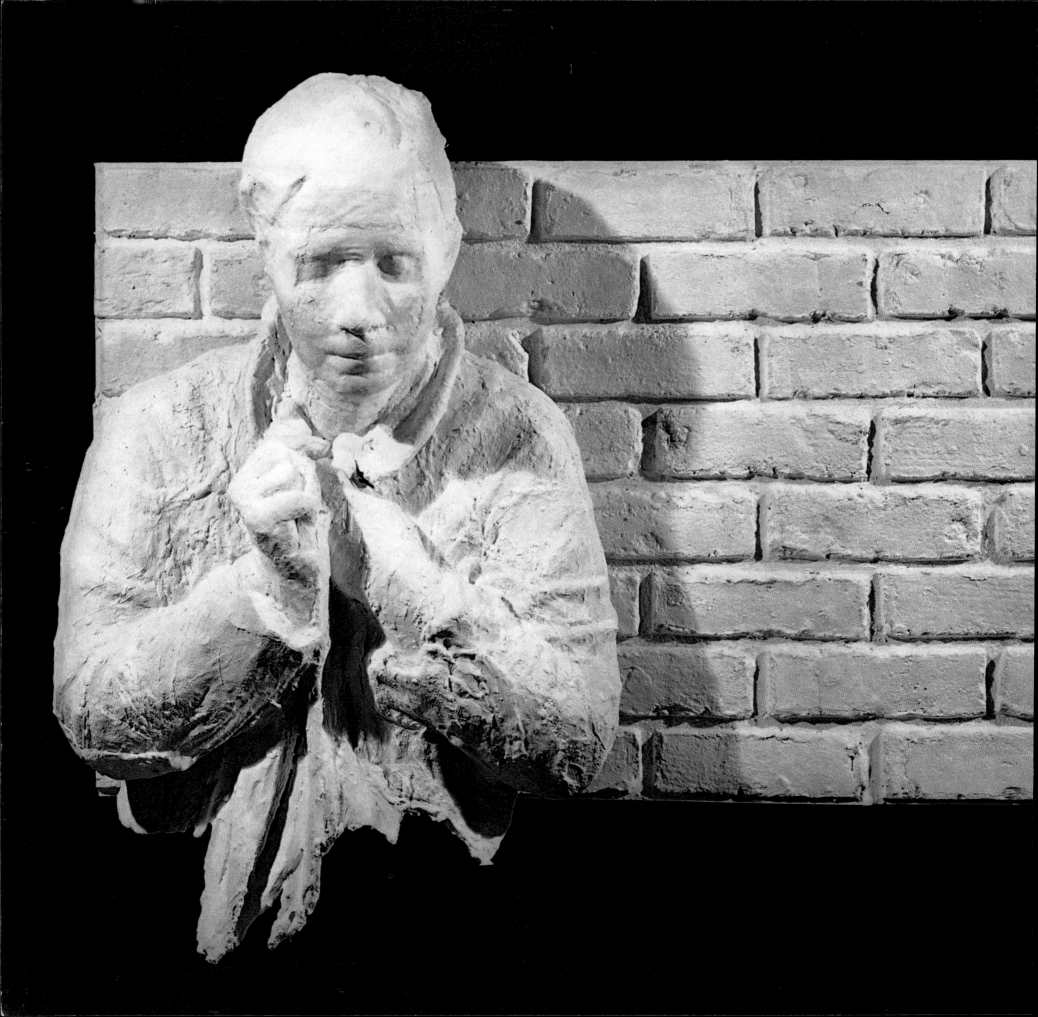

124. *Girl Buttoning Her Raincoat.* 1970.
Plaster, wood, and plastic, 24 × 48 × 15″.
Collection Mrs. Kenneth Newberger

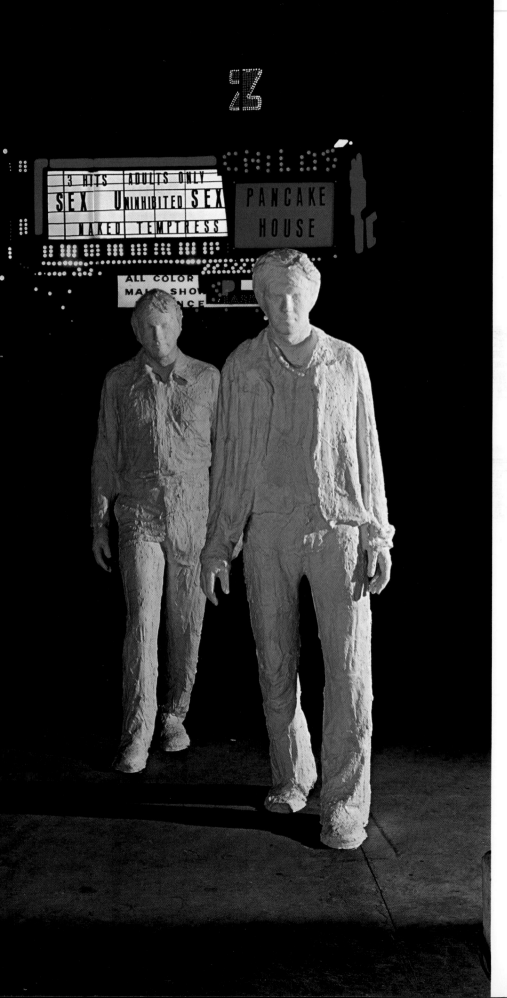

TIMES SQUARE

GIRL LEANING AGAINST A DOORWAY

If *Times Square* succeeds where *The Aerial View* failed, this is due to many factors. The locale leaves no room for doubt, nor does the level on which background and foreground merge seem at all confusing. The two men are clearly out for a stroll; they belong to the landscape in a way the man in *The Aerial View* did not. The movie and restaurant marquees, while illusionistic like Manhattan and Queens at night in *The Aerial View,* are hard and descriptive instead of soft-focus and semi-abstract. Segal has progressed from glimpsing an idea to treating it masterfully. And he has solved two problems at once: how to make deep space come alive and how to incorporate color prominently.

Times Square is a strange meeting place for the human race. Segal went there with a camera to record the sights and the oddities, the telescoping of space, the refraction of light, the overlay of images. The painter in him was again coming out, craving to get involved in this orgasm of color. Could he show it all and yet fit it into his sober and exacting frame? He realized hé could do it only by creating a direct relationship with its real-life model, unambiguous, specific, and head-on. The mode of activity was not hard to choose, and if one man walking is a loner, two men walking are the beginnings of a crowd. From the start, there was a logic to *Times Square,* a clear sequence to the artist's decisions that built up to a successful conclusion.

The background of *Times Square* is an intricate

125. *Times Square.* 1970.
 Plaster, wood, plastic, incandescent
 and fluorescent light, 9′ × 8′ × 5′.
 Joslyn Art Museum, Omaha, Nebraska

collage of light. In a black plywood panel, holes were made and sections cut out and filled with colored gels, plastic sheet, and pegs. On top of these, stick-on plastic letters compose the lurid and appetizing legends that give the scene its authenticity. To read the space properly, the positioning and distance of the two men walking is extremely important. They should not close in too much on the background, they should hold themselves to the right of center, and they must overlap each other just enough to suggest that one is following the other on the sidewalk. The correct spacing occurs when we read *Times Square* as "picture perfect," that is, we no longer doubt the reality of the background and the figures as part of it.

 Times Square has a thematic counterpart in *Girl Leaning Against a Doorway.* The suggestion in this work is of a side street, just a few blocks away from the action; the atmosphere is secretive, not blatant, and the girl promises what the movie marquees of *Times Square* cannot deliver. The works seem to have been conceived in tandem. We can further speculate that the girl seeks the darkness, enclosure, and safety of a nearby doorway, while the men stride out in the open, unsheltered and unprotected, apparently sure of where they are going. This night-time situation meshes with *The Bar* and *The Restaurant Window II,* all shown together to great advantage in Segal's show at the Sidney Janis Gallery in 1971.

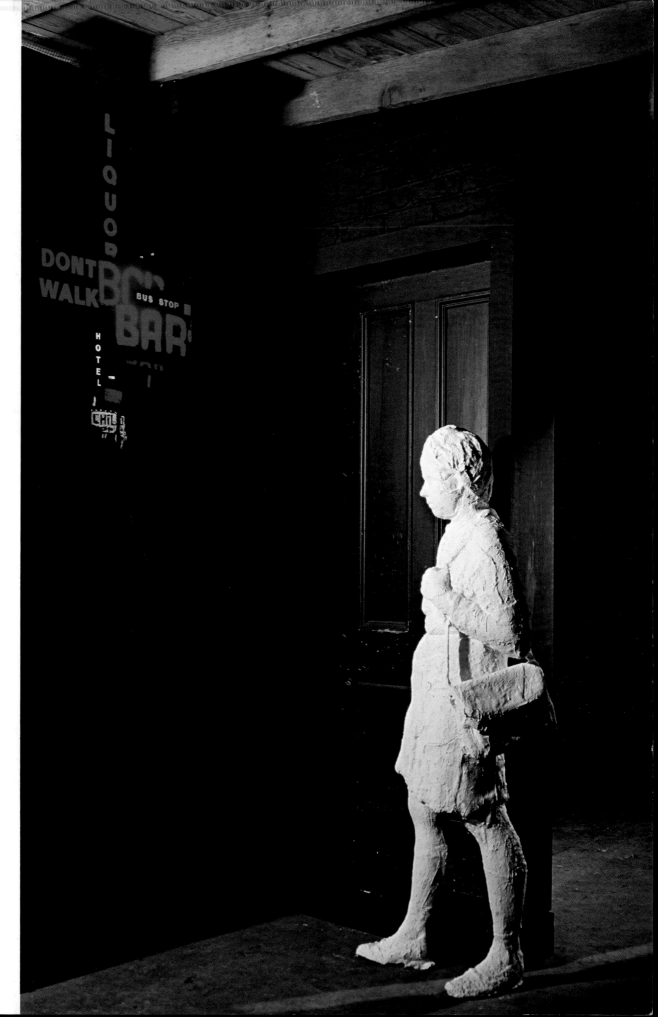

126. *Girl Leaning Against a Doorway.* 1971.
Plaster, wood, plastic,
and incandescent light, 9′ × 12′ × 4′.
Sidney Janis Gallery, New York

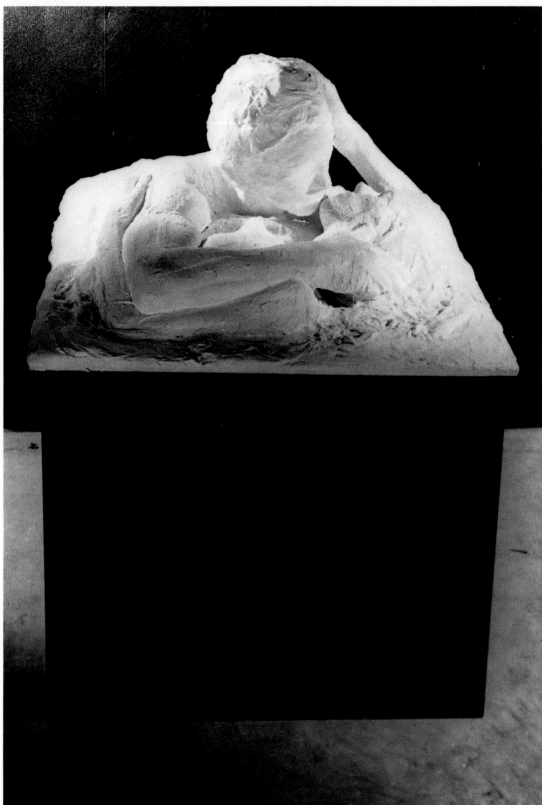

127. *Fragment: Lovers II.* 1970.
Plaster, 36 × 24 × 24″.
Collection Ms. Renée Lachonsky,
Brussels

128. *Fragment: Lovers II* (detail)

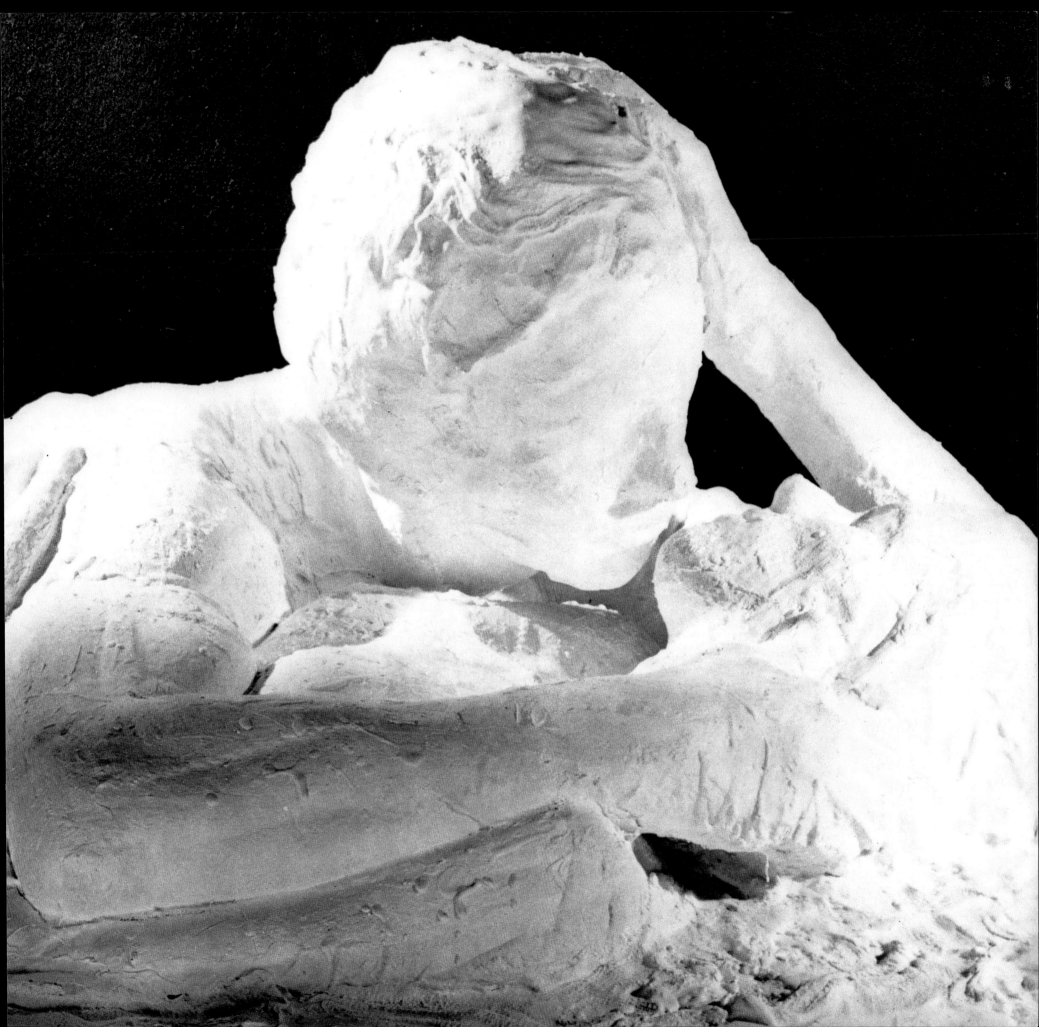

129. *The Brick Wall.* 1970.
Plaster, wood, and plastic, 8′ × 12′8″ × 3′6″.
Sidney Janis Gallery, New York

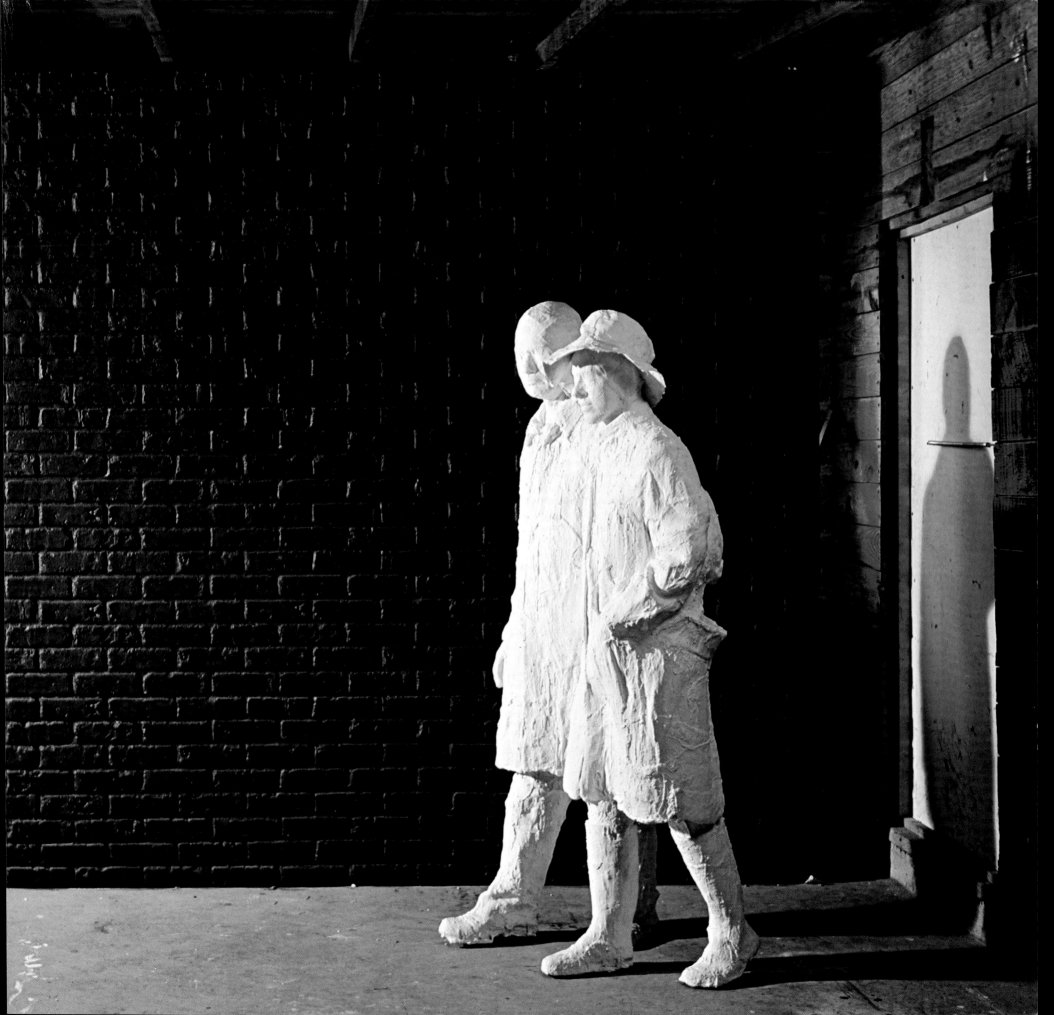

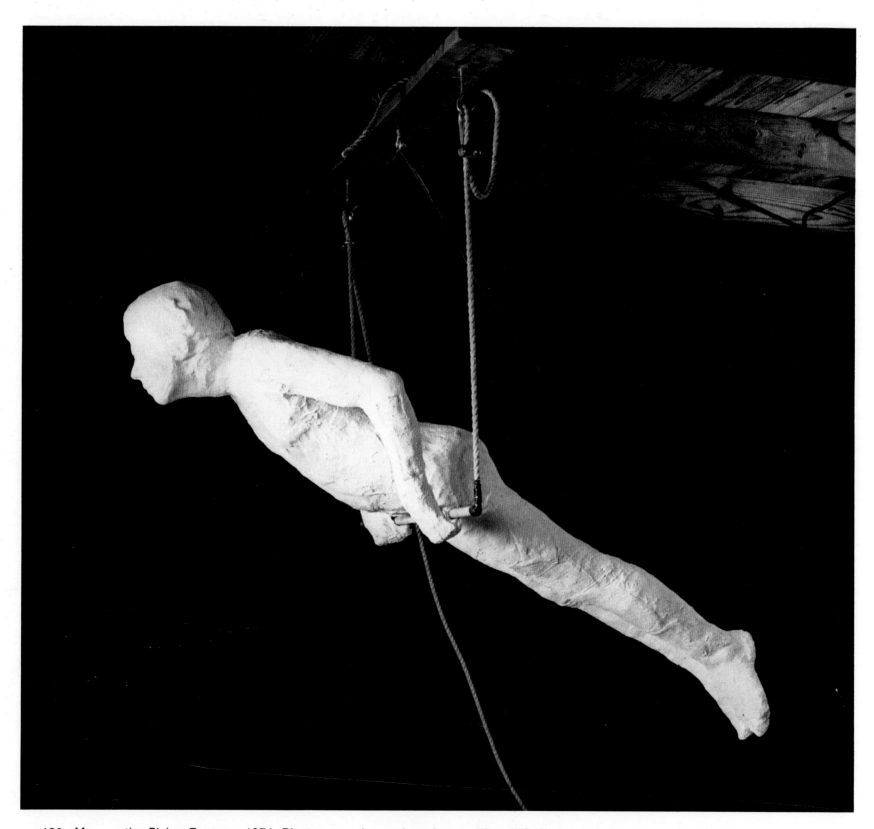

130. *Man on the Flying Trapeze.* 1971. Plaster, wood, metal, and rope, 72 × 36″. Wadsworth Atheneum, Hartford

131. *Girl Washing Her Hair
 at a Sink.* 1971.
 Plaster, wood, metal,
 and porcelain, 62 × 60 × 30″.
 Indiana University Art Museum,
 Bloomington (Gift of
 Mr. and Mrs. Henry R. Hope
 and Dr. Richard D. Youngman
 and purchased with the
 aid of funds from
 the National Endowment
 for the Arts)

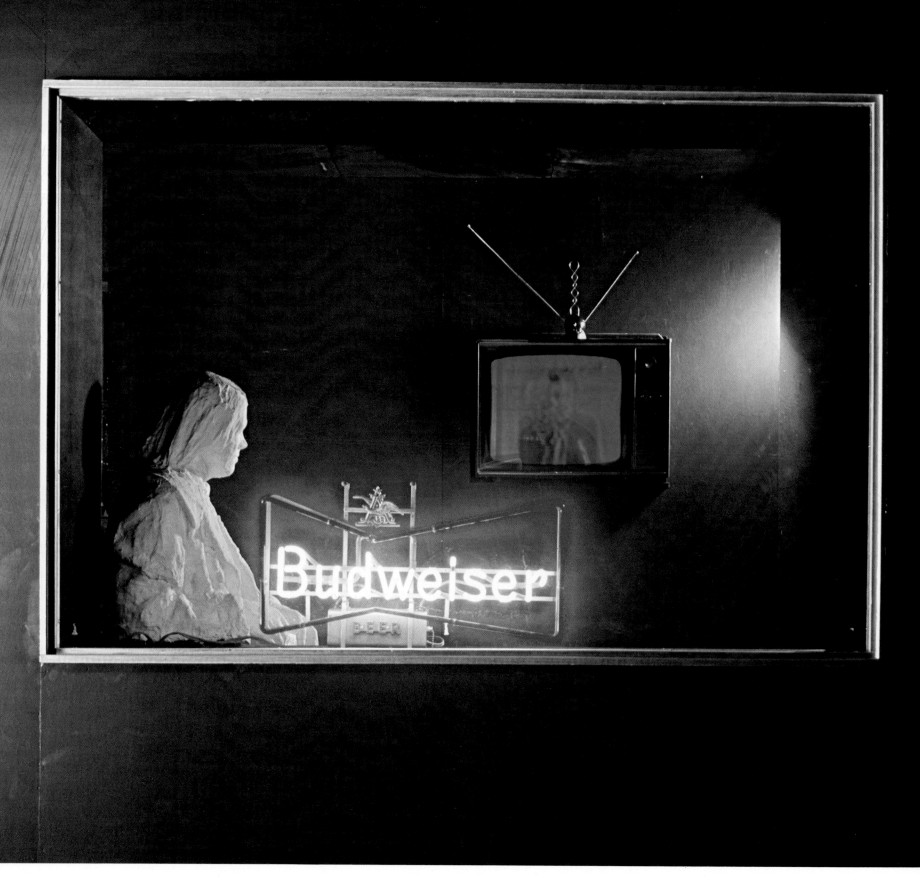

132. *The Bar.* 1971. Plaster, wood, metal, glass, plastic, neon light, and television, 8′ × 8′6″ × 3′. Sidney Janis Gallery, New York

THE BAR

Subjects seem to dance in and out of Segal's thematic presentations with the predictability of a well-choreographed duet. A single woman, tucked into *The Restaurant Booth,* reappears, but in the presence of a man, as the waitress in *The Diner* and then again as a woman sipping a cup of coffee in *The Restaurant Window.* A man, ogling a waitress in *The Diner,* is seen again as a passerby in *The Restaurant Window,* barely noticing the girl inside. To balance this musical roundabout and end on a one-step, Segal chose the image of a man alone, seated in a bar. Two years earlier his *Box: Man in a Bar* had dealt briefly with the same subject, but he reserved a full-blown environmental treatment for this work.

The subject is a familiar night-time scene. A man sits on a bar stool, leaning his elbow on a windowsill and watching a television across the room with moronic attention. His face is lighted in the dark by the flickering reflection of a television screen. We wonder whether the plaster or the sickly light is responsible for his ghostlike appearance. With a fine sense of counterpoint and coloristic compensation, Segal has included a neon beer advertisement in the bar window enclosure. Its gaudiness casts a warm and reassuring glow over the man's chilling contours. For the first time since *Dry Cleaning Store,* the artist has resorted to neon for purposes of both light and color. Spatial partition—which, in the earlier work, the neon sign had failed to provide—is no longer demanded of the sign alone; wall and window divide the lighted interior from the crepuscular exterior space. Beyond the evocative uses of light, Segal distinguishes himself also by his astringent manipulation of space.

The Bar is open-ended to the extent that it can be viewed from the outside as well as from the inside. As we look through the window with its Budweiser sign, we see both the man and the television set he is watching. Without in any way becoming part of the work ourselves, we can visually grasp it, and by shifting our position the picture window will give us the "frame" we desire. But then there is an alternate, even more alluring vantage point if we enter *The Bar* and, in so doing, invade the "art space." It is one of the artist's unique accomplishments that he can make his work so distinctly accessible—visually from one side and physically from the other. The night-time ambience, moreover, fuses the image we see with the space we experience, so that there is no real dichotomy or separation between the two.

As we position ourselves to the left of the man on the bar stool, he appears like a phantom, caught between his own reflection in the window and the images on the screen. He is plugged into an imaginary circuit linking the opposites of white-on-black and black-on-white, the deep space of reality and the shallow space of illusion. We even fear that if we cross that field of tension, we may intrude on and momentarily interrupt the artist's design for the work. It makes us bodily aware of what Segal must have consecrated as "art space" within the context of a gallery situation.

Compared with the filmed image, used in *The Truck* and abandoned in *The Restaurant Window,* the televised image is a more compliant physical and illusionistic means of extending the work of art. It offers, in addition, a welcome element of chance, although, in equal measure, it can be said to be outside the artist's control. The atmosphere and composition of *The Bar* are randomized, however imperceptibly, by the choice of channel, the time of day, and the location in which we see it. Besides providing ambient light and an anchor in the "real" world, this live television set makes the artist's work perpetually self-recreating.

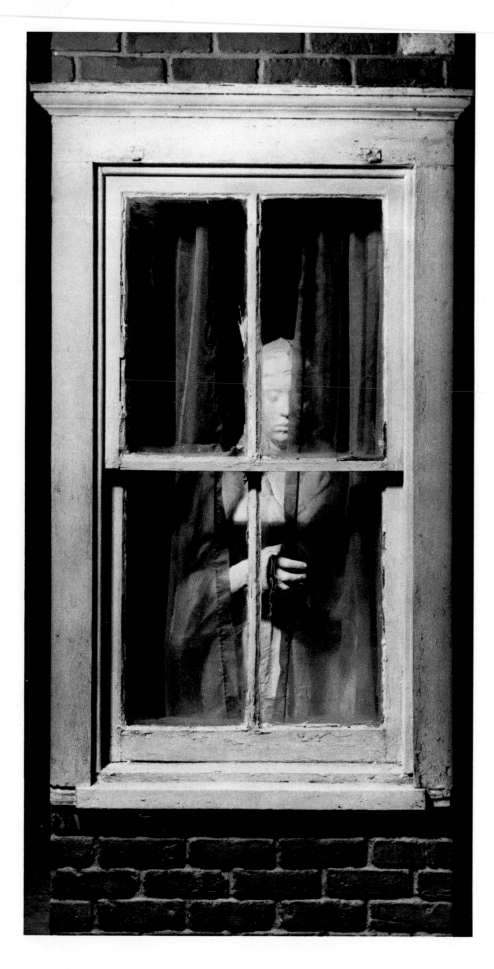

133. *Girl Looking Through Window.* 1972.
Plaster and mixed media, 96 × 36 × 24″.
Museum Boymans–van Beuningen, Rotterdam

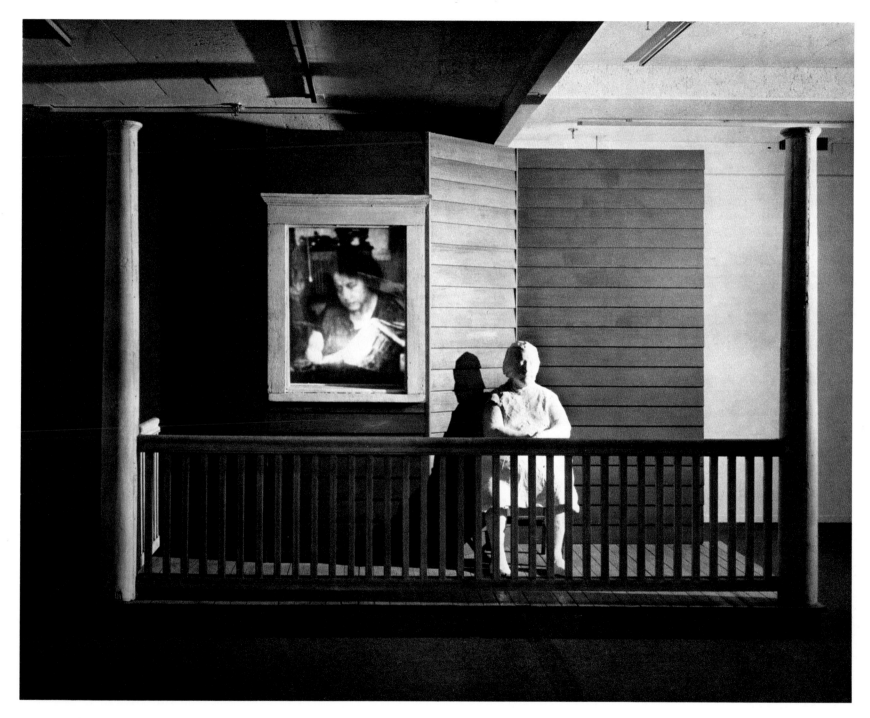

134. *Gertrude: Double Portrait.* 1972. Plaster, wood, plastic, super-8 film. 96″ × 12′ × 72″

TO ALL GATES

"The Port Authority Bus Terminal is forever on my mind," said Segal in referring to *The Bus Station* of 1965. That work shows a woman sitting on a suitcase under an air-conditioning duct, apparently lost or stranded. The blue and orange cheerfulness of the earlier portrayal is gone in *To All Gates,* and so is its spirit of disorientation. Erasing all traces of locale and specific occurrence, Segal ended up with a solemn abstraction of man in transit.

Are we in the halls of death and heading for the gates of purgatory? The two women, cast in the austere anonymity of a passageway, do little to contradict this impression. Their ghostlike shapes are reflected in the black Formica backdrop, and the orange light box emits a fiery glow. They look not lost or stranded, but attentive and waiting for a disembodied voice to announce the next departure. A stern warning seems to have been served that nobody can turn back, although allowance has been made for short stops and pauses.

It may seem far-fetched to read so much allegory into the piece, but isn't traveling a metaphor for the course of life between birth and death? The experience is archetypal because it is shared by all. In this forbidding environment, women seem more vulnerable and somehow more out of place, less in control and more in need of direction. Or is there something mysterious about these women travelers? Bogged down with their belongings, they have an accrustation of history which invites speculation. They hardly move, but they are poised for action. The artist has cast them in that moment of stasis we now recognize as a hallmark of his style. The corridor directs our eye along a horizontal thrust, through the dynamic spacing of formal elements and, in particular, through the use of a band of light along the top of the work.

Segal has eliminated what impeded, and discarded what proved incidental or distracting to, this forward thrust. Initially the figure of an itinerant hippy had been planned to flesh out the composition. But the cast's stance and Christ-like features proved unconvincing, so the sculptor discarded it, along with the idea of using a third figure. Two is a crowd to Segal; a walking man would have cluttered our view of that sweeping corridor. By the same logic, a life-sized panel with gate announcements was eliminated. Its matter-of-factness and gaudy appearance would have clashed with the stern and mysterious atmosphere. Form aspires to abstraction as figures aspire to isolation, within the leanest configuration, in Segal's sculpture.

The square pillar joins the figures in their imaginary march from right to left. It also lends depth and spatial definition to the eight-by-twelve-foot rectangle framing the composition. If, for a moment, we ignore the figures, we can then conceive of the background as an unbroken monochrome plane with a band of color along the top—a prototype of Systemic painting. Or, if we consider that background one large field, then the pillar, itself a prototype of reductive sculpture, appears like the "crack" in a Barnett Newman painting. Far-fetched? Not so for Segal, who is as obsessed with two-dimensional as he is with three-dimensional abstraction. The processional arrangement of space is Segal's contemporary and abstract equivalent of the frieze of a Greek temple, the colonnades on Venetian paintings, and the dances of death of the late Middle Ages. Perhaps we may draw a comparison with Barnett Newman again, whose *Stations of the Cross* shows the same stasis within a dynamic continuum created by Segal in *To All Gates.*

It may be evident, therefore, that the artist was as interested in creating a compelling space as he was in presenting an arresting image. The fact that they are mutually reinforcing, in this case, lifts *To All Gates* out of the realm of narrative into that of allegory. The formal code employed by Segal is post-Bauhaus modern, of which marble and stainless-steel bank lobbies are the fair, and peel-off and stick-on terminal decorations the dark reflections. He presses "found" geometry into service to set an anonymously contemporary stage for a poignant portrayal of transience.

135. *To All Gates.* 1971. Plaster, wood, metal, plastic, and fluorescent light, 8′ × 12′ × 8′.
Des Moines Art Center (Coffin Fine Arts Trust Fund)

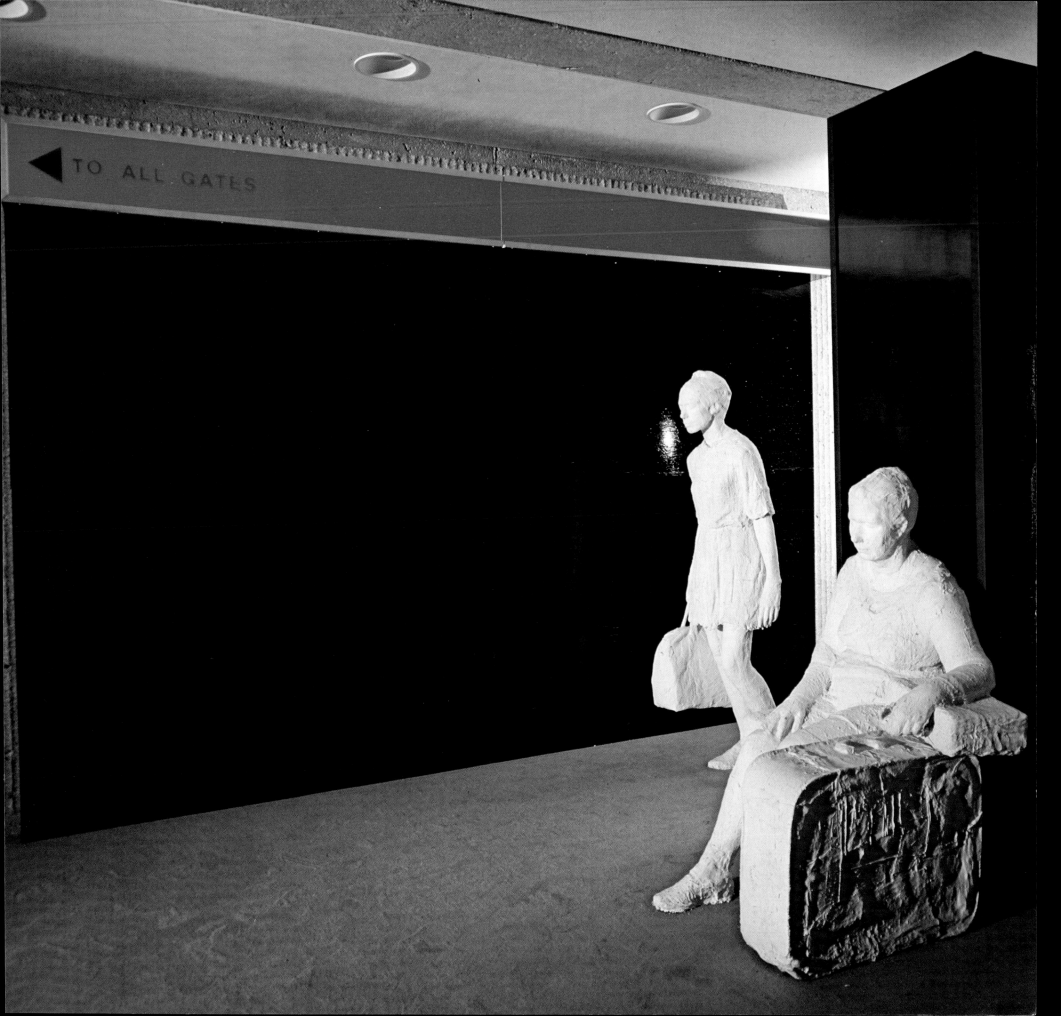

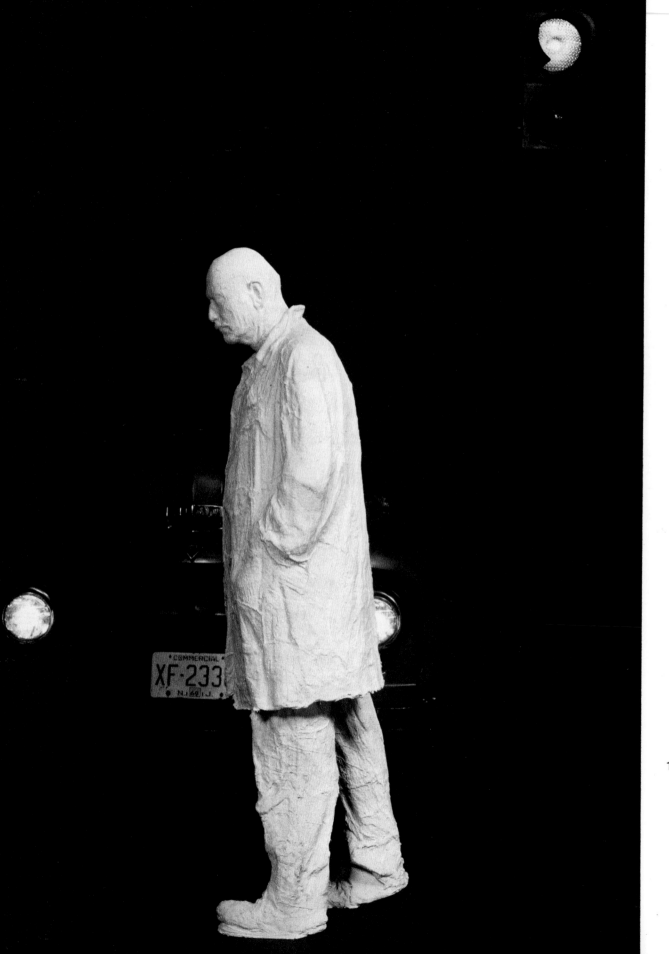

136. *The Red Light.* 1972.
Plaster, mixed media,
9′6″ × 96″ × 36″.
Cleveland Museum of Art
(Andrew R. and
Martha Holden Jennings Fund)

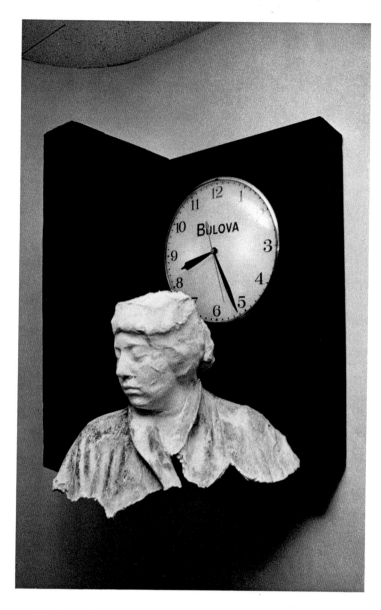

137. *Bas-Relief: Girl with Clock.* 1972.
Plaster, wood, electric clock, 33½ × 24½ × 17½".
Harry N. Abrams Family Collection, New York

138. *Bas-Relief: Girl in the Shower.* 1972.
Plaster, ceramic tile, chrome.
42 × 28 × 10"

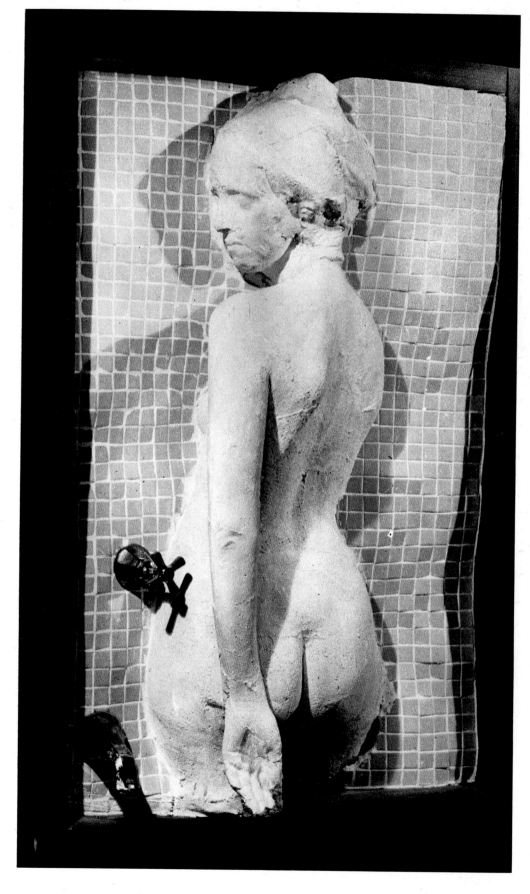

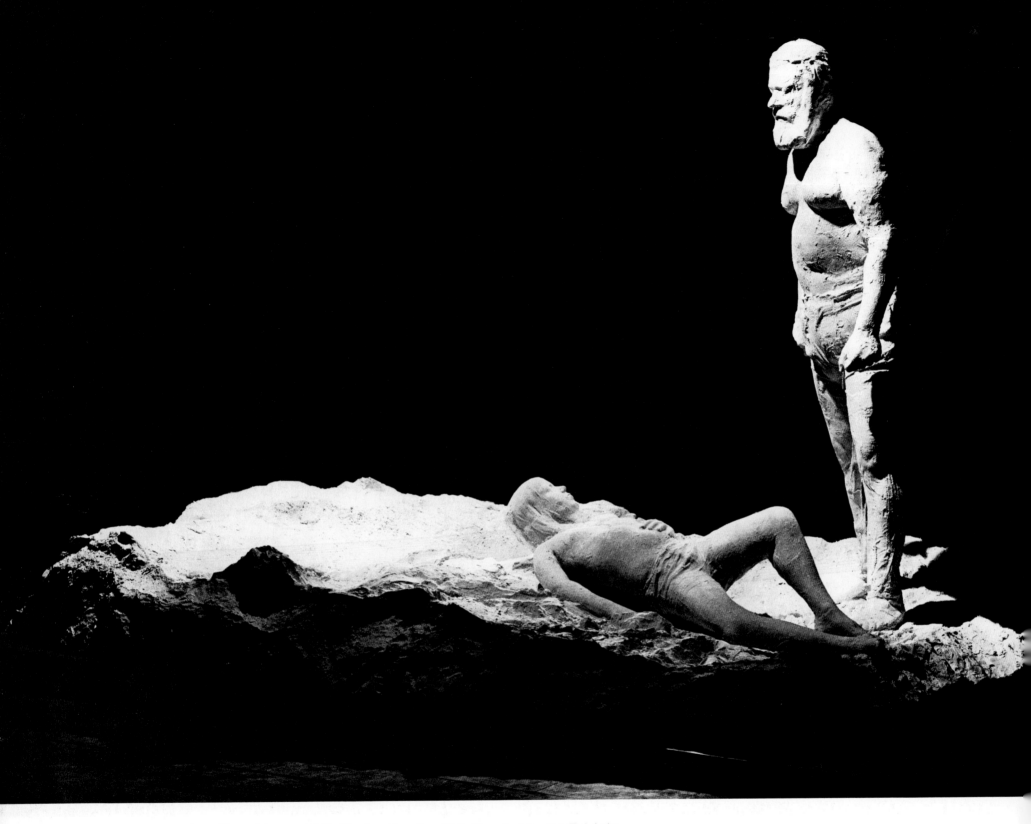

139. *Abraham's Sacrifice of Isaac*. 1973. Plaster, 7 × 9 × 8½'. Donated by the Tel Aviv
Foundation for Literature and Art to the city of Tel Aviv-Yafo

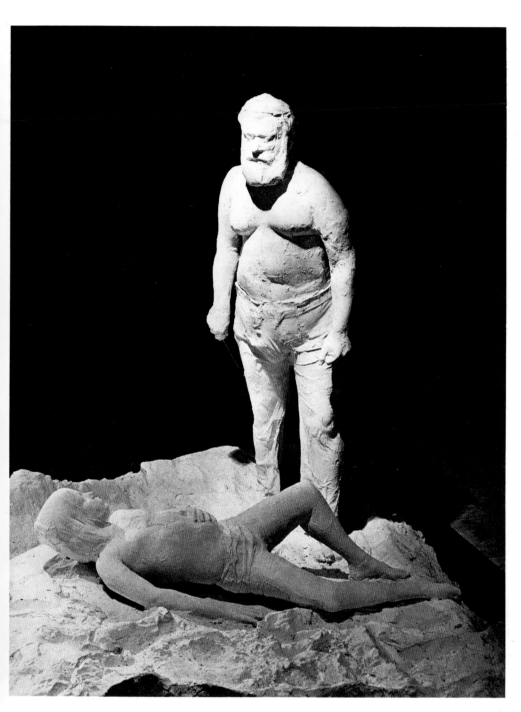

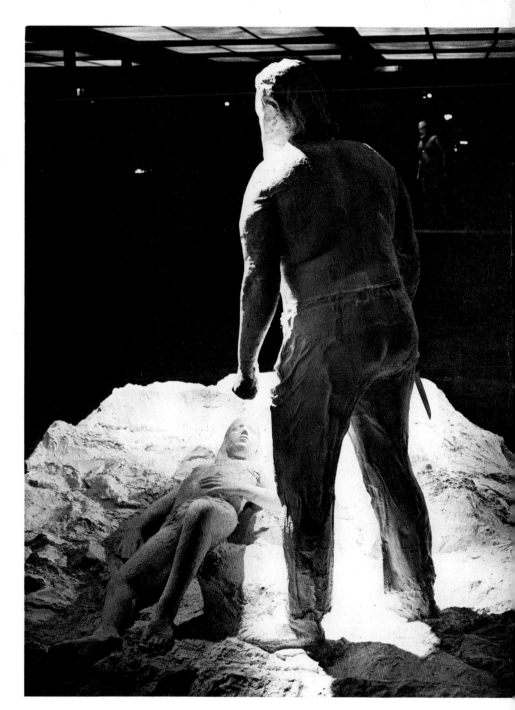

140. *Abraham's Sacrifice of Isaac*

141. *Abraham's Sacrifice of Isaac*

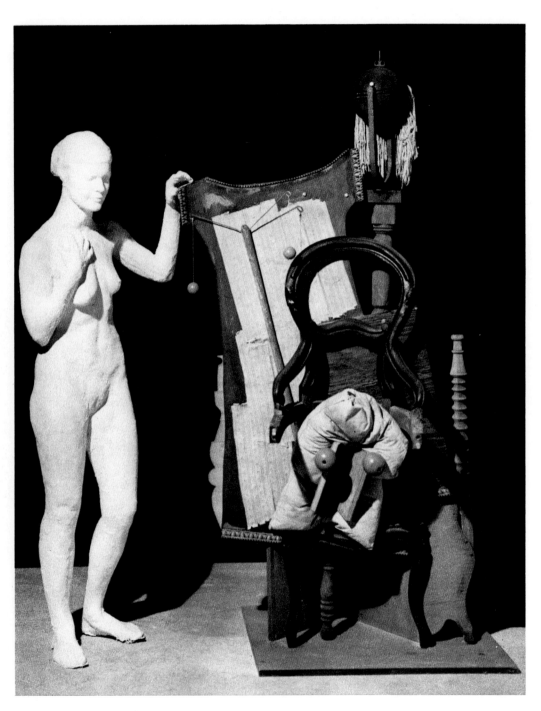

142. *Picasso's Chair*. 1973. Plaster and mixed media, 6'6" × 5'.
Milton D. Ratner Family Collection

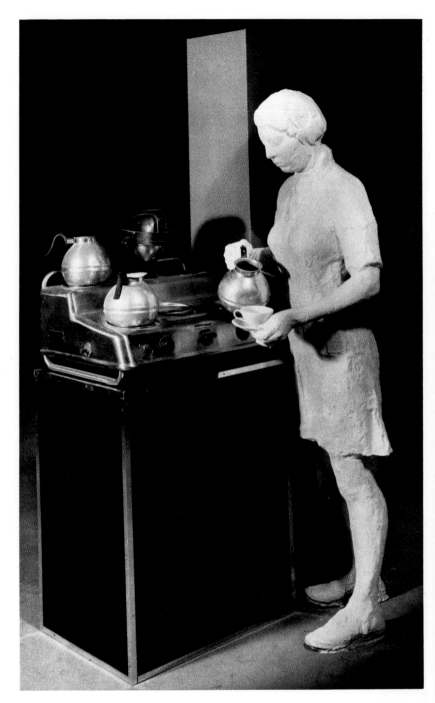

143. *Waitress Pouring Coffee*. 1973. Plaster,
wood, metal, and porcelain, 76 × 42 × 34"

145. *Girl on Red Chair with Blue Robe.* 1974.
Plaster, wood, and acrylic,
67¼ × 29¼ × 16½″

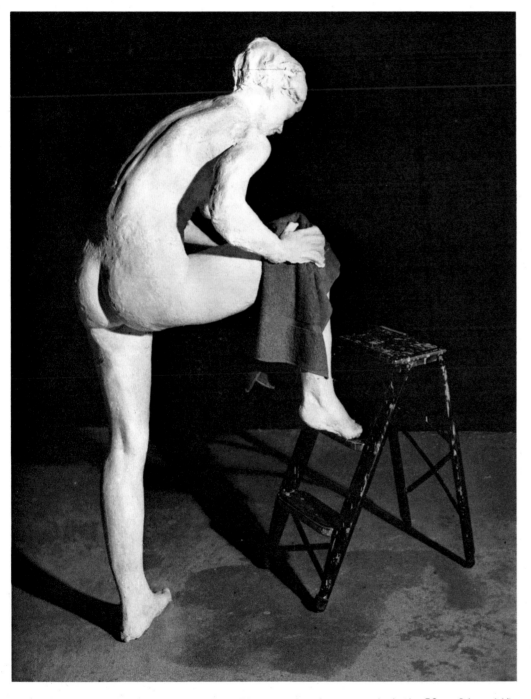

144. *Girl Drying Her Knee.* 1973. Plaster, aluminum, and cloth. 59 × 24 × 44″.
Collection Ercole Lauro, Naples

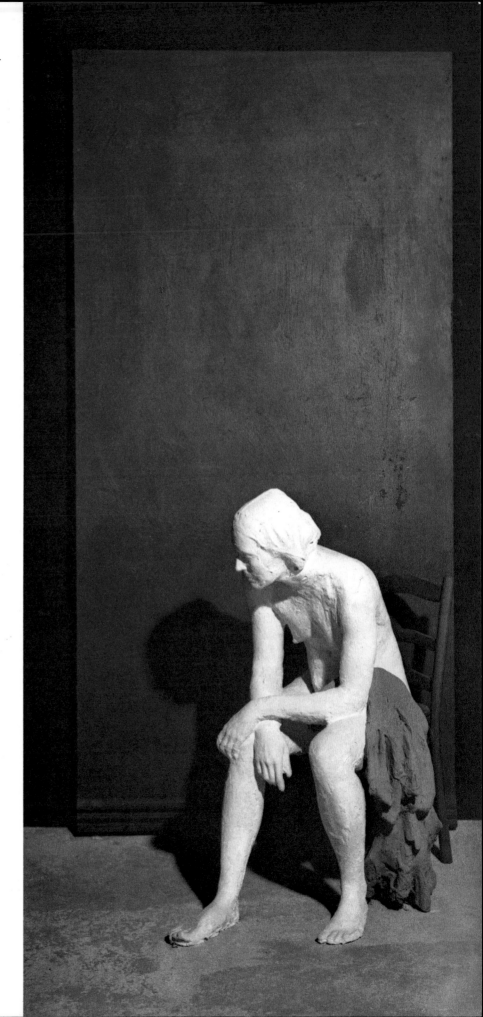

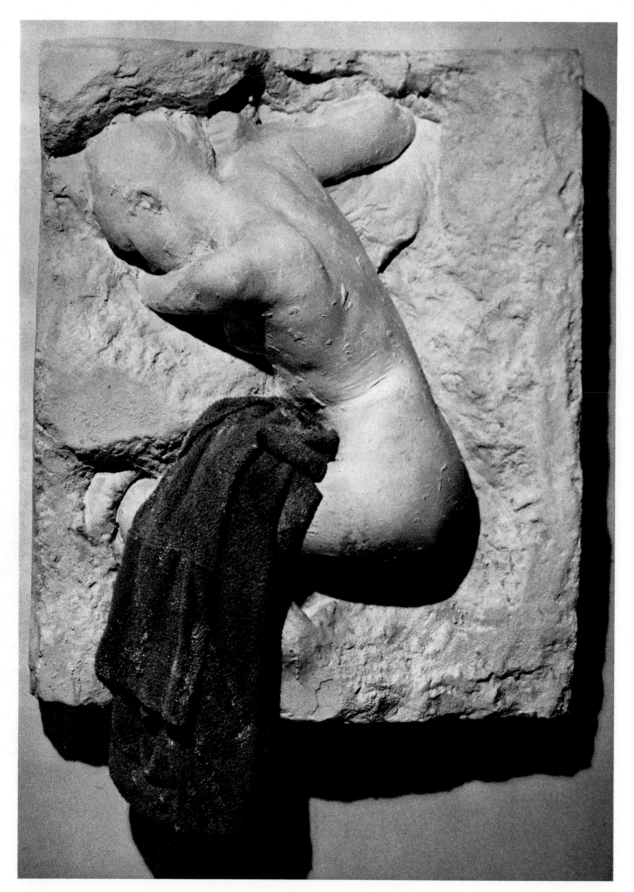

146. *Bas-Relief: The Blue Robe.*
1974. Plaster and cloth,
49 × 36¾ × 14½″

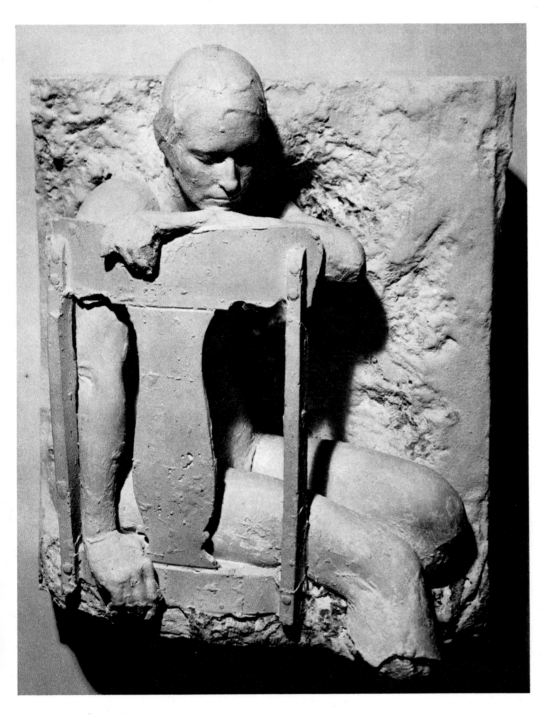

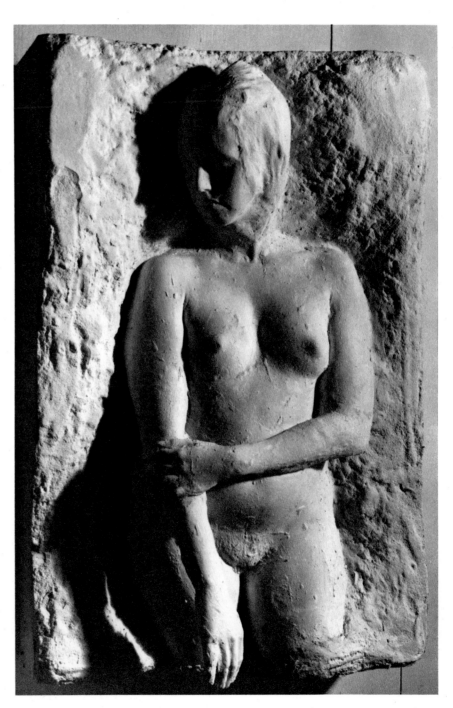

147. *Bas-Relief: Seated Girl, Chin on Wrist.* 1974.
Plaster, 36⅛ × 30¼ × 21¼″. Collection the artist

148. *Bas-Relief: Standing Girl Looking Right.* 1973.
Plaster, 42 × 28 × 13″. Collection Galerie HM, Brussels

149. *Nude Turning*. 1974.
 Plaster, 37¾ × 33¼ × 14″.
 Collection Mr. and Mrs. Albert A. List

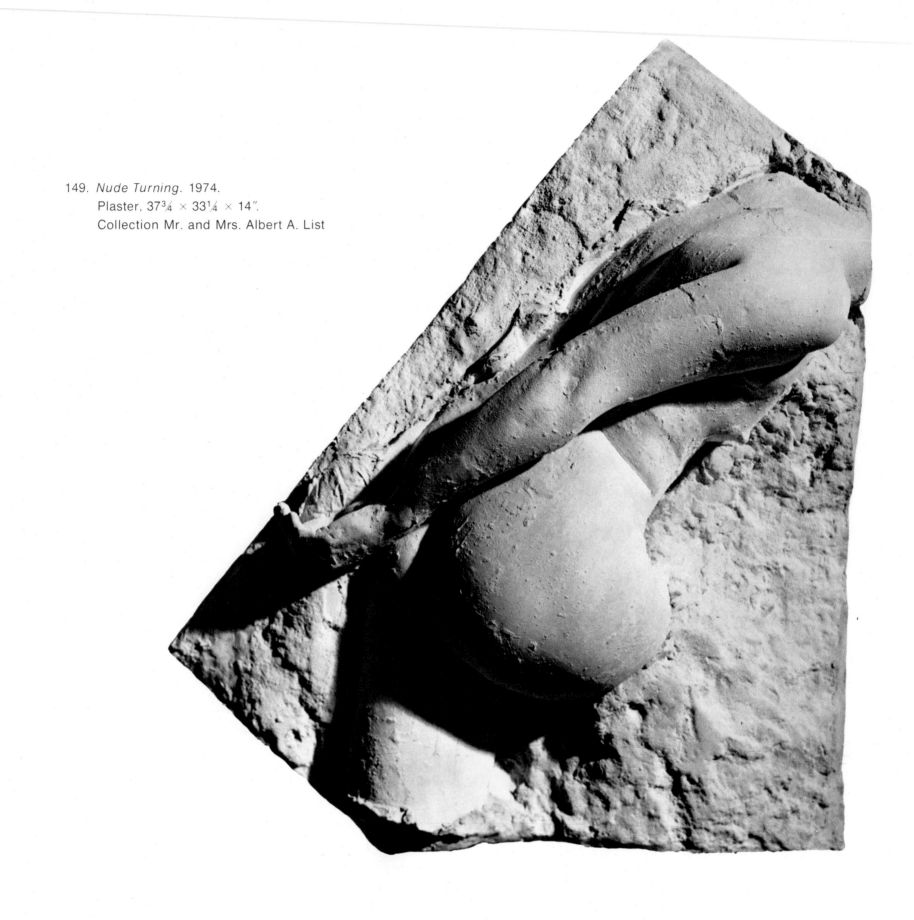

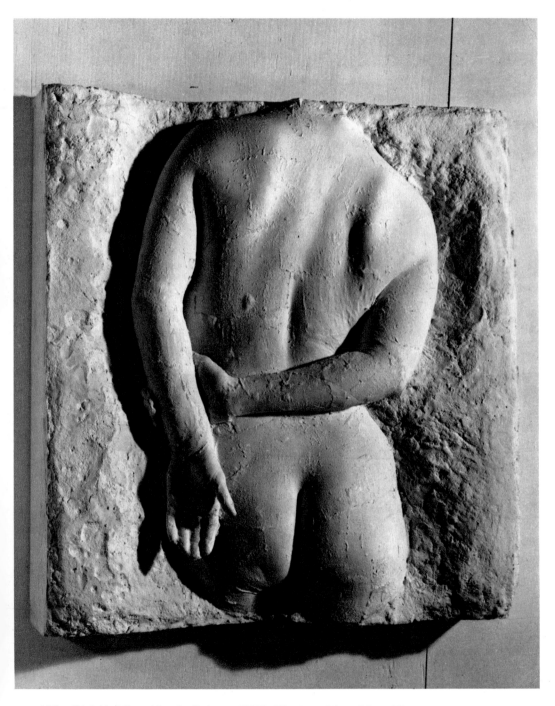

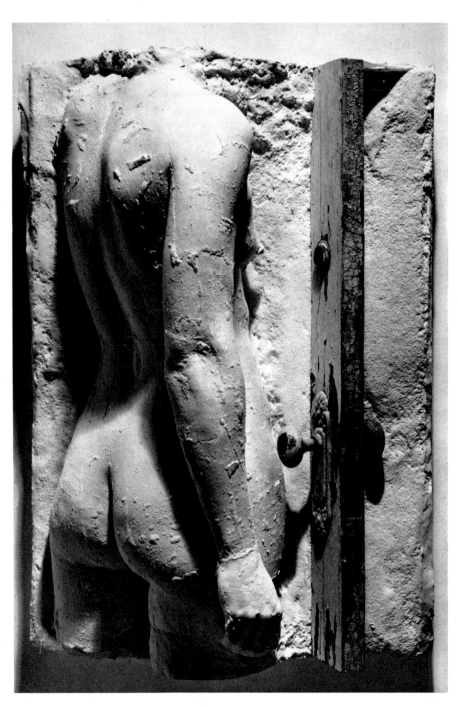

150. *Girl Holding Her Left Arm.* 1973. Plaster, 31 × 28 × 7".
Private collection, New York

151. *Girl Entering Doorway.* 1974. Plaster, 33 × 23 × 14½"

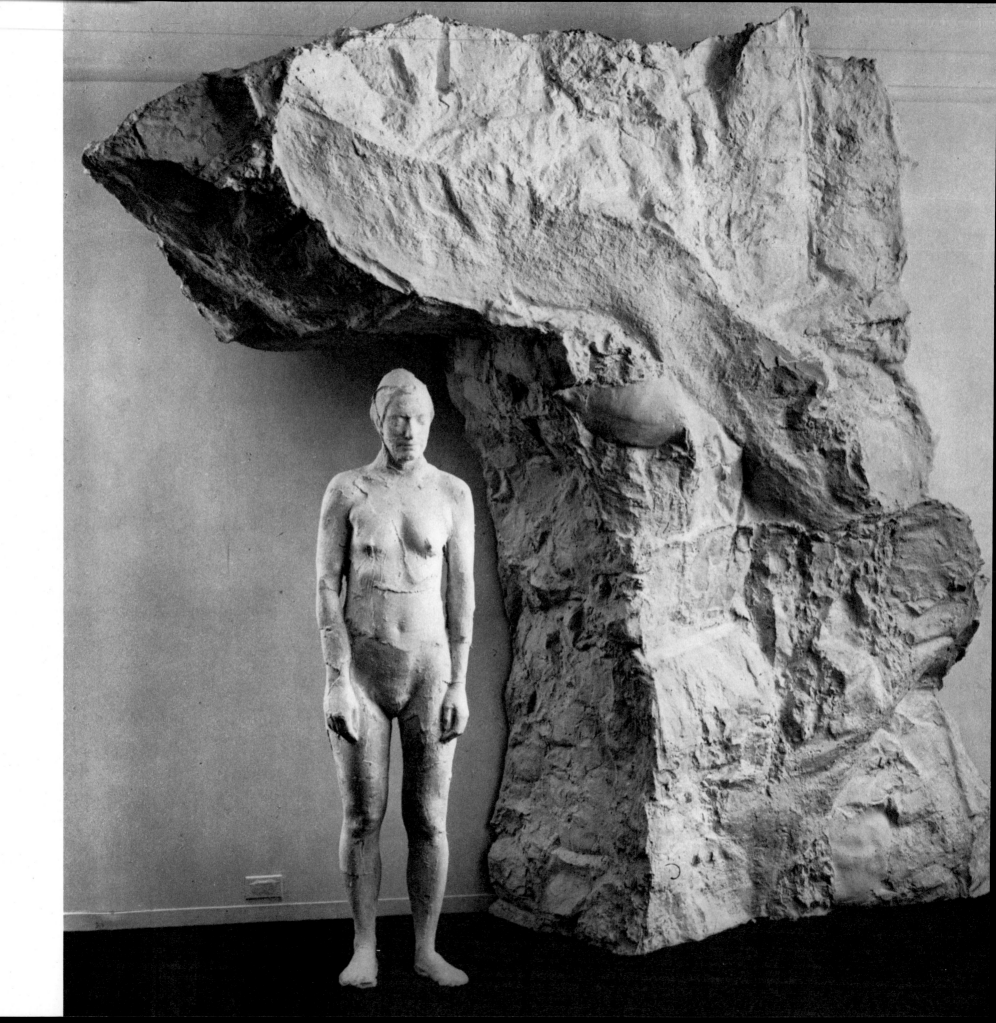

153. *The Curtain*. 1974.
Plaster and mixed media,
84 × 39 × 32″

152. *The Rock*. 1974.
Plaster prototype,
9′6″ × 10′ × 3′

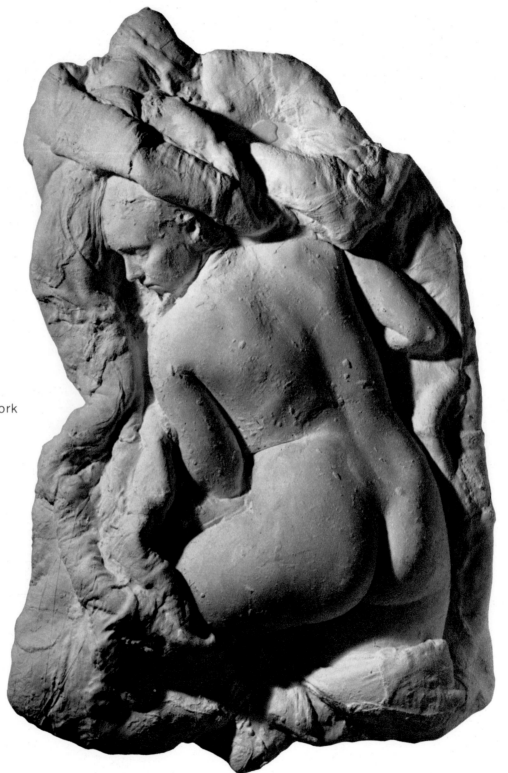

154. *Girl on Blanket: Finger to Chin.*
1973. Plaster, 56 × 36 × 9″.
Collection Xavier Fourcade, New York

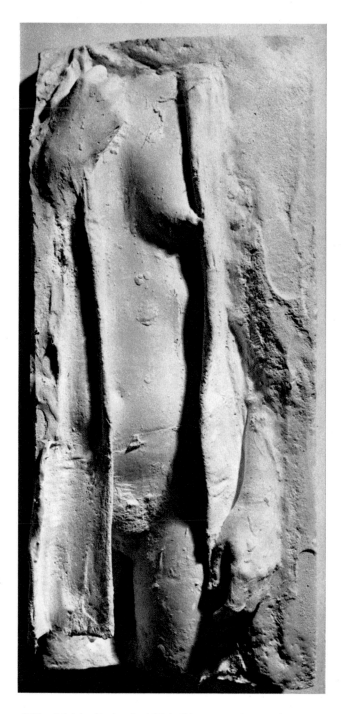

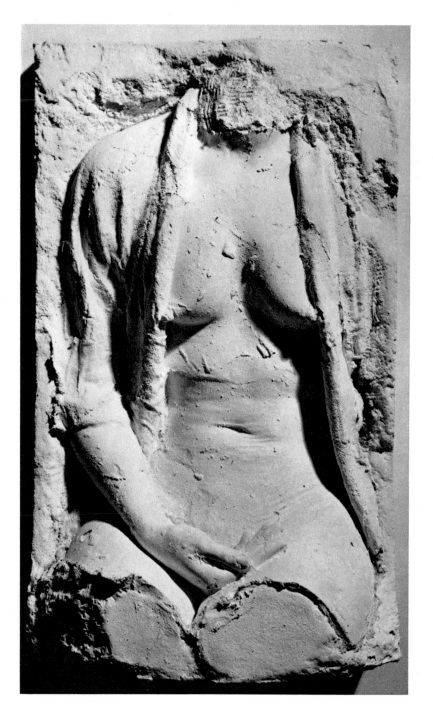

155. *Girl in Robe I.* 1974. Plaster. 33 × 14¹₂ × 8″ 156. *Girl in Robe II.* 1974. Plaster. 29¹₂ × 18 × 9¹₂″

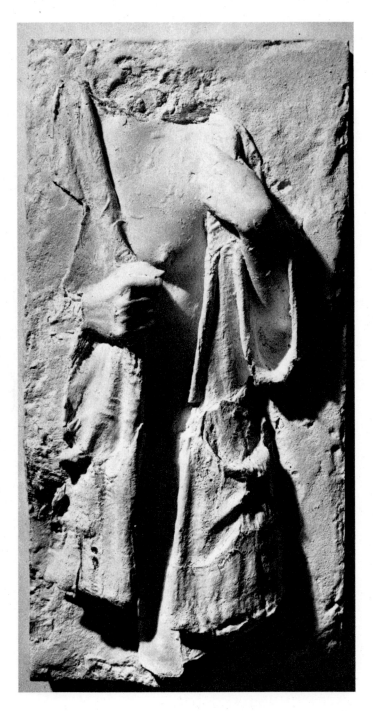 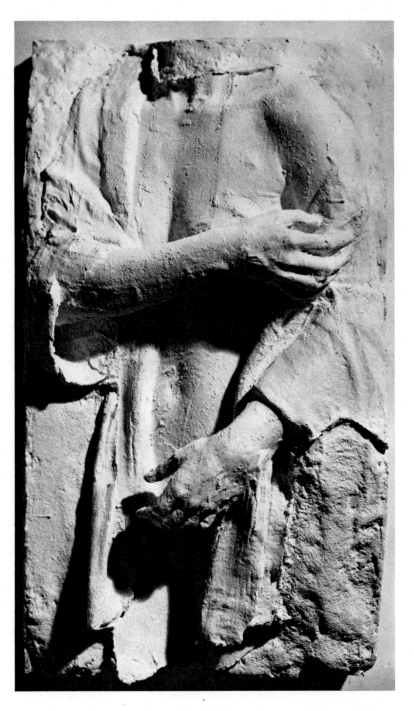

157. *Girl in Robe III.* 1974. Plaster, 36¼ × 18 × 9″ 158. *Girl in Robe IV.* 1974. Plaster, 32¾ × 18¼ × 8½″

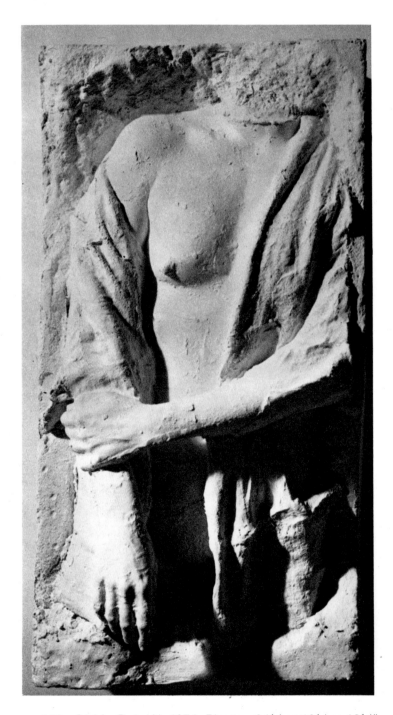

159. *Girl in Robe V*. 1974. Plaster, 34¼ × 18¼ × 12½″

160. *Girl in Robe VI*. 1974. Plaster, 25¾ × 16 × 7″

NOTES

1. *Pop Art* (New York, 1966), p. 102.

2. "George Segal as Realist," *Artforum* (New York), vol. 5, no. 10 (Summer 1967), p. 84.

3. *New York Post,* November 18, 1962.

4. "An Interview with George Segal," *Artforum* (San Francisco), vol. 3, no. 2 (November 1964), p. 26.

5. William C. Seitz, *Hans Hofmann* (New York, 1963), p. 7.

6. M.F.A. Thesis, Rutgers University, 1963.

7. Hans Hofmann, *Search for the Real and Other Essays,* edited by Sara T. Weeks and Bartlett H. Hayes, Jr., rev. ed. (Cambridge, Mass., 1967), pp. 50–51.

8. "George Segal as Realist," *Artforum* (New York), vol. 5, no. 10 (Summer 1967), p. 84.

9. M.F.A. Thesis, Rutgers University, 1963.

10. *Art News* (New York), vol. 56, no. 10 (February 1958), p. 11.

11. "The Legacy of Jackson Pollock," *Art News* (New York), vol. 57, no. 6 (October 1958), pp. 56–57.

12. Robert Frank made his film *The Sin of Jesus* on Segal's farm; the artist provided furniture but did not build any props—nor has he ever built props for Happenings directed by his friends.

13. Reproduced in *Artforum* (New York), vol. 5, no. 10 (Summer 1967), p. 84; it is postdated by four years.

14. *Arts* (New York), vol. 33, no. 5 (February 1959). p. 57.

15. Lucy R. Lippard, *Pop Art* (New York, 1966), p. 74.

16. *Art News* (New York), vol. 57, no. 10 (February 1959), p. 16.

17. Curator of Art Gallery of Ontario who organized "Dine–Oldenburg–Segal," 1967.

18. *Pop Art* (New York, 1966), p. 15.

19. "Pop Art and Non-Pop Art," *Art and Literature* (Summer 1964), reprinted in John Russell and Suzi Gablik, *Pop Art Redefined* (London, 1969), pp. 53–56.

20. "ABC Art," *Art in America* (October–November 1965), reprinted in *Minimal Art, A Critical Anthology,* edited by Gregory Battcock (New York, 1968), pp. 280–81.

21. *The New York Times,* March 22, 1962.

22. *The New Yorker,* November 24, 1962.

23. *Recent American Sculpture,* The Jewish Museum, New York, 1964, p. 25.

24. *Minimal Art, A Critical Anthology,* edited by Gregory Battcock (New York), 1968, p. 20.

25. *Arts Magazine* (New York), vol. 36, no. 10 (September 1962), p. 55.

26. "Notes on Sculpture," *Artforum* (February 1966), reprinted in *Minimal Art, A Critical Anthology,* edited by Gregory Battcock (New York, 1968), p. 226.

27. "Art and Objecthood," *Artforum* (Summer 1967), reprinted in *Minimal Art, A Critical Anthology,* edited by Gregory Battcock (New York, 1968), pp. 116–47.

28. *Minimal Art, A Critical Anthology,* edited by Gregory Battcock (New York, 1968), pp. 175–79.

BIOGRAPHICAL OUTLINE

1924 Born November 26, in New York City.

1930–40 Attended P.S. 70 in the Bronx and Stuyvesant High School in Manhattan. Moved with family to South Brunswick, N.J.

1941–42 Studied at Cooper Union, New York City; was enrolled in the foundation art course there. When older brother was drafted, started working on his parents' chicken farm.

1942–46 Part-time student at Rutgers University, attending courses in psychology, literature, history, and philosophy.

1946 On April 7 married Helen Steinberg.

1947–48 Studied at the Pratt Institute of Design.

1948–49 Studied at New York University, and earned a B.S. in Art Education.

1949–58 Operated a chicken farm on Davidson's Mill Road in Middlesex County, New Jersey, across the road from his parents.

1957–64 When chicken farming was no longer profitable, in order to avoid bankruptcy taught English at Jamesburg High School (1957–58), then industrial arts at Piscataway High School (1958–61), and art at Roosevelt Junior High School (1961–64).

1961–63 Was enrolled in the M.F.A. program at Rutgers University. Earned his degree with a thesis on his own work and an exhibition of his early sculptures at Douglass College.

1964 Began to devote himself entirely to his sculpture.

1968–69 Lecturer in Creative Arts (Sculpture), Princeton University.

1970 Received honorary doctorate from Rutgers University.

Lives with his wife, son Jeffrey, and daughter Rena, in South Brunswick, New Jersey.

LIST OF EXHIBITIONS

Exhibitions of collections in which Segal's work is represented are not mentioned here; exhibitions held in New York unless indicated otherwise.

1956 *One-Man:* Hansa Gallery

1957 *One-Man:* Hansa Gallery
Group: "The New York School, Second Generation," Jewish Museum

1958 *One-Man:* Hansa Gallery

1959 *One-Man:* Hansa Gallery
Group: "Below Zero," Reuben Gallery; 1959 Annual Exhibition of Contemporary Art, Whitney Museum of American Art

1960 *One-Man:* Green Gallery
Group: Reuben Gallery; "Figurative Painting in the United States," American Federation of Arts traveling exhibition (1960–61)

1961 *Group:* "Work by New Jersey Artists," Newark Museum

1962 *One-Man:* Green Gallery
Group: "New Realists," Sidney Janis Gallery; Pace Gallery, Boston

1963 *One-Man:* Douglass College Art Gallery, New Brunswick, N.J.; Green Gallery; Galerie Ileana Sonnabend, Paris; Galerie Schmela, Düsseldorf
Group: Sixty-sixth Annual American Exhibition, Art Institute of Chicago; "New Work, Part I," "New Work, Part II," and "Morris, Segal and Others," Green Gallery; "Ten American Sculptors," VII São Paulo Bienal, Brazil

1964 *One-Man:* Green Gallery
Group: "Ten American Sculptors," Walker Art Center (Minneapolis), San Francisco Museum of Art, City Art Museum of St. Louis, The Dayton Art Institute; "Ten from São Paulo," Howard Wise Gallery; "New Work, Part III," Green Gallery; "Amerikansk Pop Konst," Moderna Museet, Stockholm; "American Pop Art," Stedelijk Museum, Amsterdam; "Nieuwe Realisten," Gemeentemuseum, The Hague; "Pop, etc., etc.," Museum des 20. Jahrhunderts, Vienna; "Neue Realisten," Akademie der Bildenden Künste, Berlin; "The Atmosphere of '64," Institute of Contemporary Art, University of Pennsylvania, Philadelphia; "4 Environments by 4 New Realists" and "3 Generations," Sidney Janis Gallery; "The Artist's Reality," New School Art Center; The 1964 Pittsburgh International Exhibition of Contemporary Painting and Sculpture, Carnegie Institute; "Recent American Sculpture," Jewish Museum; 1964 Annual Exhibition of Contemporary Art, Whitney Museum of American Art

1965 *One-Man:* Sidney Janis Gallery
Group: "In Focus: A Look at Realism in Art," The Memorial Art Gallery, University of Rochester; "The New American Realism," Worcester Art Museum; "Pop Art and the American Tradition," Milwaukee Art Center; "Nouveau Réalisme et Pop Art," Palais des Beaux-Arts, Brussels; "Recent Work by Arman, Dine, Fahlstrom, Marisol, Oldenburg, Segal" and "Pop and Op," Sidney Janis Gallery; Corcoran Biennial, Washington, D.C.; "Etats-Unis: Sculpture du XXe Siècle," Musée Rodin, Paris; "Art of the '50s and '60s," The Aldrich Museum of Contemporary Art, Ridgefield, Conn.; "Portraits from the American Art World," New School Art Center; "Eleven from the Reuben Gallery," The Solomon R. Guggenheim Museum; "New Jersey and the Artist," New Jersey State Museum, Trenton; "Selected Work by Contemporary New Jersey Artists,"

Newark Museum; "Sculpture 20th Century," Dallas Museum of Fine Arts; "Ten from Rutgers University," Bianchini Gallery

1966 *Group:* Sixty-eighth Annual American Exhibition, Art Institute of Chicago; "Erotic Art '66," Sidney Janis Gallery; "Eight Sculptors: The Ambiguous Image," Walker Art Center, Minneapolis; "Art of the United States 1670–1966," Whitney Museum of American Art; "Environmental Paintings and Constructions," Jewish Museum; "The Found Object: Can It Be Art?" Institute of Contemporary Art, Boston; 1966 Annual Exhibition of Contemporary Art, Whitney Museum of American Art

1967 *One-Man:* Sidney Janis Gallery
Group: "Dine-Oldenburg-Segal," Art Gallery of Ontario, Toronto, and Albright-Knox Art Gallery, Buffalo; "American Sculpture of the Sixties," Los Angeles County Museum and Philadelphia Museum of Art; "7 for '67," City Art Museum of St. Louis; "Focus on Light," New Jersey State Museum, Trenton; "Environment U.S.A.: 1957–67," IX São Paulo Bienal, Brazil; The 1967 Pittsburgh International Exhibition of Contemporary Painting and Sculpture, Carnegie Institute; "Protest and Hope: An Exhibition on Civil Rights and Vietnam," New School Art Center; "Homage to Marilyn Monroe," Sidney Janis Gallery; Guggenheim International, The Solomon R. Guggenheim Museum; "Original Pop Art," Städtische Kunstausstellung, Gelsenkirchen

1968 *One-Man:* Museum of Contemporary Art, Chicago; The Art Museum, Princeton University; Sidney Janis Gallery
Group: "The Sidney and Harriet Janis Collection," The Museum of Modern Art; "Environment U.S.A.: 1957–67," Rose Art Museum, Brandeis University, Waltham, Mass.; 4. Documenta, Kassel; "In Honor of Dr. Martin Luther King, Jr.," The Museum of Modern Art; 1968 Annual Exhibition of Contemporary Art, Whitney Museum of American Art; "Menschenbilder," Kunsthalle, Darmstadt; "3," Galerie Rudolf Zwirner, Cologne; "Art from New Jersey," New Jersey

State Museum, Trenton; "3 Environmental Happenings," Newark Museum

1969 *One-Man:* Galerie Darthea Speyer, Paris
Group: "The Obsessive Image," Institute of Contemporary Arts, London; "7 Artists," Sidney Janis Gallery; "Ars '69," The Art Gallery of Ateneum, Helsinki; "Neue Figuration USA," Museum des 20. Jahrhunderts, Vienna; "American Sculpture of the Sixties," The Grand Rapids Art Museum; "Pop Art," Hayward Gallery, London; "New York 13," Vancouver Art Gallery, Norman MacKenzie Art Gallery (Regina), Musée d'Art Contemporain (Montreal); "New York Painting and Sculpture: 1940–1970," Metropolitan Museum of Art

1970 *One-Man:* Sidney Janis Gallery
Group: "String and Rope," Sidney Janis Gallery; "Art from New Jersey," New Jersey State Museum, Trenton; "Expo 70," Expo Museum of Fine Arts, Osaka; "American Artists of the Nineteen Sixties," Boston University School of Fine and Applied Arts Centennial Exhibition; "Figures Environments," Walker Art Center, Minneapolis; The 1970 Pittsburgh International Exhibition of Contemporary Painting and Sculpture, Carnegie Institute; "7 Artists," Sidney Janis Gallery; 1970 Annual Exhibition of Contemporary Art, Whitney Museum of American Art

1971 *One-Man:* Sidney Janis Gallery; Galerie Darthea Speyer, Paris; Onnasch Galerie, Cologne; Kunsthaus, Zurich; Hessisches Landesmuseum in Darmstadt
Group: IVe Exposition Internationale de Sculpture Contemporaine, Musée Rodin, Paris; "La Métamorphose de l'Objet. Art et Anti-Art 1910–1970," Palais des Beaux-Arts (Brussels), Museum Boymans–van Beuningen (Rotterdam), Nationalgalerie (Berlin), Palazzo Reale (Milan); Third Triennial New Jersey Artists, Newark Museum; "White on White," Museum of Contemporary Art, Chicago

1972 *One-Man:* Museum Boymans–van Beuningen, Rotterdam; Städtisches Museum, Leverkusen; Centre National d'Art Contempo-

rain, Paris; Tübingen Museum; Städtische Galerie, Munich; Palais des Beaux-Arts, Brussels

Group: "La Métamorphose de l'Objet. Art et Anti-Art 1910–1970," Kunsthalle (Basel); Musée des Arts Décoratifs (Paris); "Recent Painting and Sculpture," Munson-Williams-Proctor Institute, Utica, N.Y.; "Abstract Expressionism and Pop Art," Sidney Janis Gallery; "Green Gallery Revisited," Emily Lowe Gallery, Hofstra University, N.Y.; "Recent Figure Sculpture," Fogg Art Museum, Harvard University, Cambridge, Mass.

SELECTED BIBLIOGRAPHY

BY THE ARTIST

Statement (French translation) in *Segal,* Galerie Ileana Sonnabend, Paris, 1963; (Swedish translation) in *Amerikansk Pop Konst,* Moderna Museet, Stockholm, 1964; (German translation) in Dienst, Rolf-Gunter, *Pop-Art,* Wiesbaden, 1965, pp. 135–36.

Geldzahler, Henry, ''An Interview with George Segal,'' *Artforum* (New York), vol. 3, no. 2 (November 1964), pp. 26–29.

Statement in ''Métamorphoses: L'Ecole de New York,'' a film by Jean Antoine, *Quadrum* (Brussels), vol. 18 (1965), pp. 161–64.

''George Segal on the New York School,'' *Gallery Notes,* vol. 29, Albright-Knox Art Gallery, Buffalo, N.Y. (Autumn 1966), p. 2; reprinted in *São Paulo 9,* organized by the Rose Art Museum for the United States Section of the IX São Paulo Bienal, Brazil, 1967.

''Everyone Shares a Huge Stew of Ideas,'' in ''Sensibility of the Sixties,'' *Art in America* (New York), vol. 55, no. 1 (January–February 1967), p. 55.

''Segal s'explique,'' *Aujourd'hui* (Boulogne), vol. 10 (January 1967), pp. 128–31.

''Jackson Pollock: An Artists' Symposium—Part II,'' *Art News* (New York), vol. 66, no. 3 (May 1967), pp. 29, 69–70.

''The Sense of 'Why Not?': George Segal on his Art,'' *Studio International* (London), vol. 174, no. 893 (October 1967), pp. 146–49. Introductory statement by William C. Lipke.

''A Conversation with George Segal,'' edited by Don Cyr, *School Arts* (Worcester, Mass.), vol. 67, no. 30 (November 1967), pp. 30–31.

''Interview George Segal,'' *George Segal,* Onnasch Galerie, Cologne, 1971.

Catoir, Barbara, ''Interview mit George Segal,'' *Das Kunstwerk* (Stuttgart), vol. 24, no. 3 (May 1971), pp. 3–8.

Tuchman, Phyllis. ''Interview with George Segal,'' *Art in America* (New York), vol. 60, no. 3 (May–June 1972), pp. 74–81.

ON THE ARTIST

Books

Amaya, Mario. *Pop Art . . . And After.* New York: The Viking Press, 1965.

Dienst, Rolf-Gunter. *Pop-Art. Eine kritische Information.* Wiesbaden: Limes Verlag, 1965.

Calvesi, Maurizio. *Le Due Avanguardie.* Milan: Lerici Editori, 1966.

Compton, Michael. *Pop Art.* London: Hamlyn, 1970.

Kreytenberg, Gert. *George Segal: Ruth in Her Kitchen.* Stuttgart: Philipp Reclam Jun., 1970.

Lützeler, Heinrich. ''Kunst und Literatur um 1960. Drei Stücke aus der Sammlung Ludwig: George Segal, Das Restaurant Fenster, 1967,'' *Festschrift für Gert von der Osten.* Cologne: DuMont Schauberg, 1970.

Calas, Nicolas and Elena. *Icons and Images of the Sixties.* New York: E. P. Dutton, 1971.

Pluchart, François. *Pop Art & Cie.* Paris: Martin-Malburet, 1971.

Hunter, Sam. *American Art of the 20th Century.* New York: Harry N. Abrams, 1972.

Rotzler, Willy. *Objekt-Kunst. Von Duchamp bis Kienholz.* Cologne: DuMont Schauberg, 1972.

Seitz, William C. *Segal.* Stuttgart: Gerd Hatje; New York: Harry N. Abrams, 1972.

Catalogue Introductions

Courtois, Michel, and Kaprow, Allan. *Segal.* Paris: Galerie Ileana Sonnabend, 1963.

Geldzahler, Henry. "George Segal," *Recent American Sculpture.* New York: Jewish Museum, 1964. (Reprinted in *Quadrum* [Brussels], vol. 19 [1965], pp. 115–16.)

van der Marck, Jan. "George Segal," *Eight Sculptors: The Ambiguous Image.* Minneapolis: Walker Art Center, 1966.

Pincus-Witten, Robert. "George Segal," *Dine-Oldenburg-Segal.* Toronto: Art Gallery of Ontario; Buffalo: Albright-Knox Art Gallery, 1967. (Reprinted in *Art & Artists* [London], vol. 2, no. 10 [January 1968], pp. 38–41.)

Rauh, Emily S. "George Segal," *7 for '67.* Saint Louis: City Art Museum, 1967.

Kelleher, Patrick, and Backlin-Landman, Hedy. *George Segal.* Princeton: The Art Museum, Princeton University, 1968.

van der Marck, Jan. *George Segal: 12 Human Situations.* Chicago: Museum of Contemporary Art, 1968.

Friedman, Martin. *George Segal.* Paris: Galerie Darthea Speyer, 1969.

Friedman, Martin. "George Segal," *Figures Environments.* Minneapolis: Walker Art Center, 1970.

van der Marck, Jan. *George Segal.* Zurich: Kunsthaus, 1971. (Reprinted and translated in subsequent catalogues accompanying this exhibition on its 1971–72 tour through Europe; the most complete catalogue with, in addition, reprints of earlier texts by George Segal, Donald Judd, Allan Kaprow, Robert Pincus-Witten, and Ellen H. Johnson; translated into French, was published by the Centre National d'Art Contemporain in Paris as no. 5 in the CNACARCHIVES.)

Magazine Articles

Rosenberg, Harold. "The Art Galleries: The Game of Illusion," *The New Yorker,* November 24, 1962.

Rose, Barbara. "Dada, Then and Now," *Art International* (Lugano), vol. 7, no. 1 (January 25, 1963), pp. 23–28.

Rudikoff, Sonya. "New Realists in New York," *Art International* (Lugano), vol. 7, no. 1 (January 25, 1963), pp. 39–41.

Johnston, Jill. "The Artist in a Coca-Cola World," *The Village Voice* (New York), January 31, 1963.

Sottsass, Ettore, Jr. "Dada, New Dada, New Realists," *Domus* (Milan), vol. 399 (February 1963), pp. 27–32.

"Pop Art: A Dialogue Between Sidney Tillim and George Segal," *Eastern Arts Quarterly* (Kutztown, Pa.), vol. 2, no. 1 (September–October 1963), pp. 6–19, 38.

Friedman, Martin. "Mallary, Segal, Agostini: The Exaltation of the Prosaic," *Art International* (Lugano), vol. 7, no. 8 (November 10, 1963), pp. 70–71.

Rosenberg, Harold. "The Art Galleries: Passage of Time," *The New Yorker,* January 18, 1964.

Kaprow, Allan. "Segal's Vital Mummies," *Art News* (New York), vol. 62, no. 10 (February 1964), pp. 30–33, 65.

Johnson, Ellen H. "The Sculpture of George Segal," *Art International* (Lugano), vol. 8, no. 2 (March 20, 1964), pp. 46–49.

Solomon, Alan. "The New American Art," *Art International* (Lugano), vol. 8, no. 2 (March 20, 1964), pp. 50–55.

Eland, Ursula N. "Trends and Traditions, Recent Acquisitions," *Gallery Notes* (Albright-Knox Art Gallery, Buffalo, N.Y.), vol. 27, no. 2 (Spring 1964), p. 12.

Kozloff, Max. "American Sculpture in Transition," *Arts Magazine* (New York), vol. 38, no. 9 (May–June 1964), pp. 19–25.

Ashton, Dore. "Unconventional Techniques in Sculpture: New York Commentary," *Studio International* (London), vol. 169, no. 861 (January 1965), p. 23.

Gablik, Suzi. "Meta-trompe-l'oeil," *Art News* (New York), vol. 64, no. 1 (March 1965), pp. 46–49.

Billeter, Erika. "'Pop' im Examen (Atelierbesuche bei fünf New Yorker Künstlern)," *Speculum Artis* (Zurich), vol. 17, no. 9 (September 1965), pp. 25–27, 50–57.

Rose, Barbara. "The Second Generation: Academy and Breakthrough," *Artforum* (New York), vol. 4, no. 1 (September 1965), p. 61.

Hakanson, Bjorn. "George Segal Skulpturer," *Konstrevy* (Stockholm), vol. 42, nos. 5–6 (1966), pp. 232–34.

Irwin, David. "Pop Art and Surrealism," *Studio International* (London), vol. 171, no. 877 (May 1966), pp. 187–91.

O'Doherty, Brian. "Urogenital Plumbing," *Art & Artists* (London), vol. 1, no. 8 (November 1966), pp. 14–19.

Bannard, Darby. "Present-Day and Ready-Made Styles," *Artforum* (New York), vol. 5, no. 4 (December 1966), pp. 30–35.

Restany, Pierre. "Le Pop Art: Un Nouvel Humanisme Américain," *Aujourd'hui* (Paris), vol. 10, no. 121 (January 1967), pp. 129–32.

Alloway, Lawrence. "Hi-Way Culture: Man at the Wheel," *Arts Magazine* (New York), vol. 41, no. 4 (February 1967), pp. 28–33.

Pincus-Witten, Robert. "George Segal as Realist," *Artforum* (New York), vol. 5, no. 10 (Summer 1967), pp. 84–87.

Rosenberg, Harold. "The Art World: The Art of Bad Conscience," *The New Yorker,* December 6, 1967.

Tuchman, Phyllis. "George Segal," *Art International* (Lugano), vol. 12, no. 7 (September 20, 1968), pp. 51–53.

Perreault, John. "Plaster Caste," *Art News* (New York), vol. 67, no. 7 (November 1968), pp. 54–55, 75–76.

Kenedy, R. C. "George Segal at the Galerie Darthea Speyer," *Art & Artists* (London), vol. 4, no. 3 (June 1969), pp. 20–21.

D'Harnoncourt, Anne, and Hopps, Walter. "Etant donnés 1° la chute d'eau, 2° le gaz d'éclairage. Reflections on a New Work by Marcel Duchamp," *Philadelphia Museum Bulletin,* vol. 64 (April/September 1969), pp. 50–53.

Calas, Elena. "George Segal's Earthbound Ghosts," *Colóquio Artes* (Lisbon), vol. 13, no. 3 (June 1971), pp. 34–37.

Biemel, Walter. "Pop Art und Lebenswelt. Die zwischenmenschlichen Beziehungen," *Aachener Kunstblätter* (Düsseldorf), vol. 40 (1971), pp. 212–14.

van der Marck, Jan. "George Segal: Love's Labors Cast," *Playboy* (Chicago), vol. 18, no. 12 (December 1971), pp. 195–200, 259–260.

van der Marck, Jan. "Spatial Dialectics in the Sculpture of George Segal," *Artscanada* (Toronto), vol. 29, no. 2 (Spring 1972), pp. 35–38.

Barrio-Garay, José Luis. "La escultura de George Segal: imágenes de amor y muerte," *Goya* (Madrid), vol. 108 (May–June 1972), pp. 370–77.

Deschamtes, Madeleine. "Le musée humain de Georges Segal," *Cahiers de France* (Paris), vol. 400 (June 1972), pp. 20–25.

INDEX

232

233

PHOTOGRAPH CREDITS

For their help in supplying photographs, we wish to thank the artist, the Sidney Janis Gallery, museums and other institutions, and the following photographers.

The numbers refer to plate numbers.
Bob Abrams (New York): 80; Geoffrey Clements (New York): 20, 41, 43–45, 48, 50, 51, 77, 94, 105, 106; Louis Loose (Brussels); 25, 85, 91; Roger Peskin *(Art Now):* 122; Piaget Studio (Saint Louis): 61; Eric Pollitzer (Garden City Park, N.Y.): 9, 42, 66, 69, 79, 88, 93, 124, 125, 131, 133, 134, 136, 138, 139, 140, 141; Charles Uht (New York): 62; Etienne Weil: 71